The
Joy of
Photography

Editorial Design by Bernard Quint

By
the Editors
of
Eastman Kodak
Company

The Joy of Photography

The Joy of Photography Staff

Eastman Kodak Company

John R. Robertson	General Manager and Vice President, Consumer Markets Division
William K. Pedersen	Director of Advertising and Promotion and Assistant Vice President
John I. Fish	Director of Publications, Consumer Markets Division
Moises Rubiano	Director of Publishing Operations, International Photographic Division
Martin L. Taylor	Author
Robert H. Kretzer	Project Manager
Robert E. Brink	Production Supervisor
Richard J. Boden	Photographic Supervisor
Keith A. Boas	Editorial
Eileen M. Nemeth	Editorial
Christine S. Bushey	Editorial
Norman C. Kerr	Photography
Peter D. Gales	Photography
Raymond Miller	Photography
Charles W. Styles	Production
Annette L. Dufek	Production

Addison-Wesley Publishing Company

Warren R. Stone	Vice President and Publisher, General Books Division
Ann E. Dilworth	Editor-in-Chief
Joyce Copland	Manager, Advertising and Sales Promotion
Doe Coover	Editor
Bernard Quint	Editorial Designer
Donald Earnest	Text Editor
Catherine Redlich	Copy Editor
Jim Georgeu	Vice President of Manufacturing
Barbara M. Kirk	Production Supervisor
Tess Palmer	Production Editor
Catherine L. Dorin	Design Coordinator
Bonnie M. Pauley	Production Artist
Bob Trevor	Production Artist
Lorraine Hodsdon	Production Artist

ISBN 0-201-03915-X pbk.
ISBN 0-201-03916-8
ABCDEFGHIJ-KR-89876543210

Library of Congress Cataloging in Publication Data
Main entry under title:
The Joy of Photography

Includes index.
1. Photography. I. Eastman Kodak Company.
TR146.J69 770 79-54162
ISBN 0-201-03916-8
ISBN 0-201-03915-X pbk.

The title page photograph is by Ernst Haas.

Third Printing February 1980

Contents

Part II

The Tools

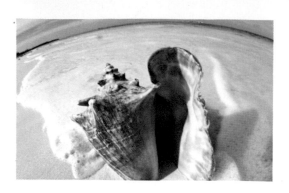

Part III

The Image

Part IV

The
Process

Part V

The
Joy

Photo Credits

Introduction

Photography is one of the fastest growing hobbies in the world. Perhaps this is because, as Ernst Haas explains, if art is aristocratic, photography is its democratic voice. With a critical eye, some imagination, a steady hand, and a little technical know-how, anyone can produce exciting pictures that make a personal statement. Photography appeals to some of us because of its immediacy and realism and to others for the artistic interpretation it allows. And for almost everyone, photographs are mementos of occasions and people who mean something to us.

Whatever our reasons for taking pictures or our level of experience in photography, there is a happy anticipation we all share in waiting for a roll of film to be processed. We want to see how well we've met the challenge of a new technique or a difficult situation and to share the results with others. *The Joy of Photography* is aimed at helping you improve those results and develop a personal style of picturetaking. Whether you're just beginning to explore photography or you are an experienced camera handler, this book should help you see and photograph your subjects with more sensitivity, ability, and confidence.

In Part I, The Vision, we discuss the visual elements that create a photograph—line, shape, pattern, texture, and form—and some basic techniques of composition, such as camera angle and framing. We also examine the properties of light, for, like the painter's oils, light is the photographer's medium. Special essays and portfolios by Gordon Parks and Ernst Haas illustrate the very different and distinctive personal styles of two master photographers.

In Part II, The Tools, we present basic information on how to operate a camera and describe the wide array of equipment available to photographers: lenses, filters, flash attachments, tripods, and other accessories. In this section you'll see how to use equipment to get the results you want and how to solve some of the most common photographic problems.

Part III, The Image, is designed to provide you with the tools and techniques for the specific kinds of pictures you take, whether they are pictures of people, landscapes, wildlife, sports, architecture, or still-life arrangements.

Part IV, The Process, offers introductory information and step-by-step instructions for many darkroom procedures, both black and white and color, as well as tips on several imaginative darkroom techniques.

And in Part V, The Joy, you'll learn how to make the most of your pictures—how to care for them, how to mount and display them, and how to use them for a variety of purposes.

The Joy of Photography has been a labor of love for many people—photographers like you who delight in seeing and taking pictures. We at Eastman Kodak and Addison-Wesley are proud of this book because we think it captures the excitement of photography—an enduring passion for us all. We hope that you will share our feeling as you turn the pages, and even more as you begin to apply the information to your own personal brand of picturetaking.

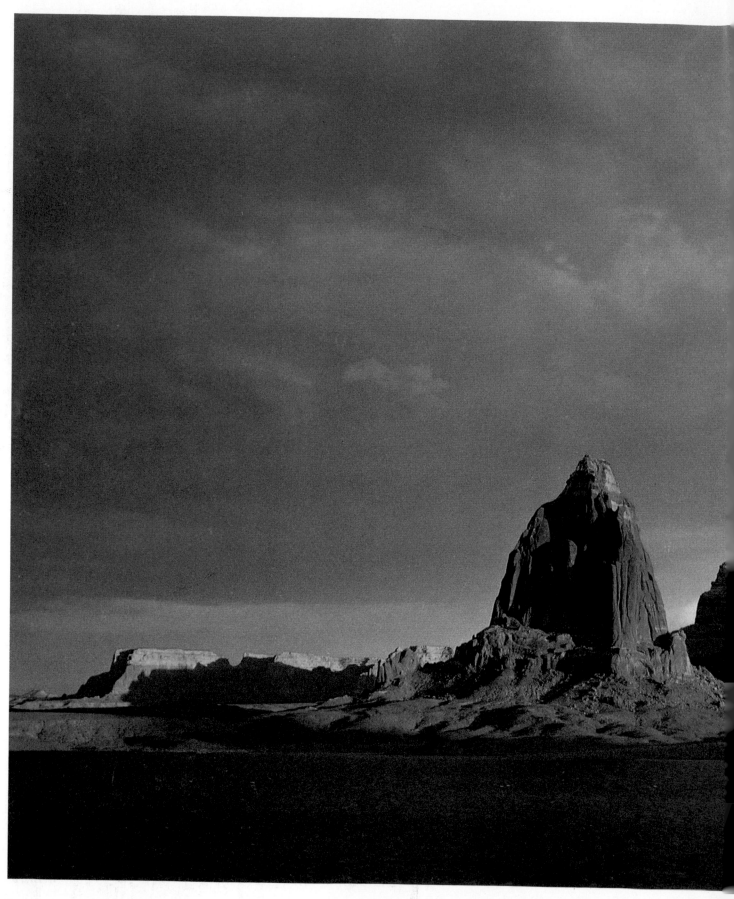

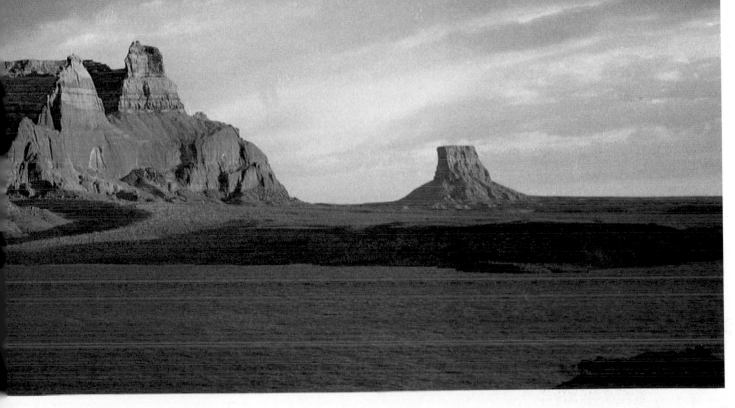

Part I

The Vision

The joy of photography is learning to see

...to reflect and respond

The world of photography is a personal one. We take pictures to express our feelings about people, nature, and the world around us. And as in any art of communication, be it writing, music, or art, we experience great pleasure when the results of our efforts communicate what we set out to say.

What makes a good photograph? Opinions differ, but most established photographers would agree that the effectiveness of a picture can be judged by the response it evokes. Irving Penn, a widely admired professional who is best known for his portraits and commercial work, says that a good photograph "startles the eye." Minor White, one of the undisputed masters of the more artistic aspects of photography, asked simply, "Does it pull my heartstrings?"

An effective photograph will undoubtedly reflect in some way your vision of the world. But how do you translate vision into something as tangible as a photograph? What makes a picture successful? If you find that your photographs fall short of your expectations, perhaps you didn't have a sufficiently clear idea to begin with, or, if you did, you weren't sure how to capture it on film. Like all art forms, photography takes practice—in seeing as well as in doing. Seeing better pictures is the first step toward taking better pictures.

The Joy of Photography will help you learn how to sharpen your personal vision and how to become visually articulate.

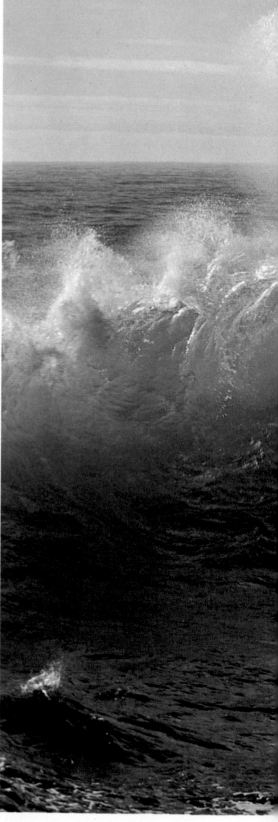

A photograph conveys mood. Below, the tranquility of a lazy summer day is evoked by a boy and his dog drifting in an inner tube, while the great swell of waves, at right, evinces the power and turbulence of natural forces.

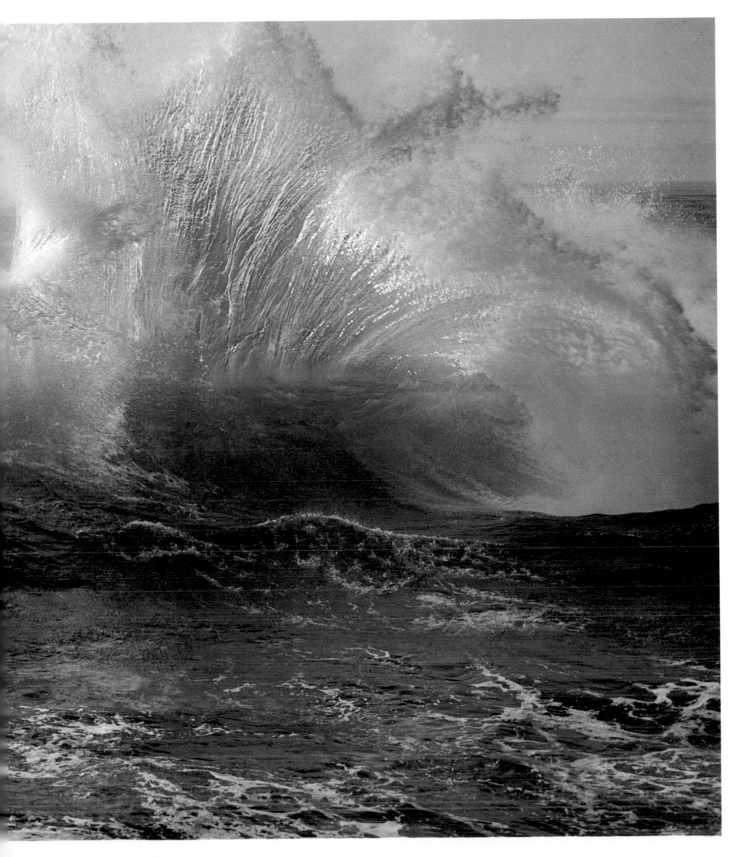

...to expect the unexpected

To take effective pictures, you need to train your eyes to see the world as the camera does. When you observe a scene, for example, you see selectively. Cluttered backgrounds or foregrounds virtually disappear. A camera is not so discerning, however. Similarly, while you are able to perceive the three-dimensionality of a subject, your camera can only create a flat, two-dimensional image. And although your eyes can adapt to changes in the intensity of light, a camera can compensate for these differences only in a limited way.

This section of the book is designed to help you see photographically. The first steps are to identify the several basic elements that make up a photographic image—shapes, lines, patterns, and textures—and to analyze how each affects our perception of a picture. Then, using ideas about composition, balance, framing, and angle of view, we will look at how these elements can be combined to express vividly the concept you wish to convey. Finally, since light is the source of the image in photography, we will consider the qualities of light—its origin, intensity, direction, diffusion, and its daily and seasonal changes—factors that dramatically affect the outcome of both black-and-white and color photographs.

Learning to see photographically is more influential in the creation of a good picture than a great amount of technical know-how. The basic mechanics of photography are fairly simple; they are easy to learn and, with practice, will become second nature to you.

The visual surprise of an unexpected angle is the key to many good pictures. Photographer Art Twomey climbed down into a deep crevice in a rocky southwestern desert to obtain this shot of a jagged fragment of vivid blue sky. The young man glimpsed on the overhanging ledge emphasizes the enormous size of the fissure.

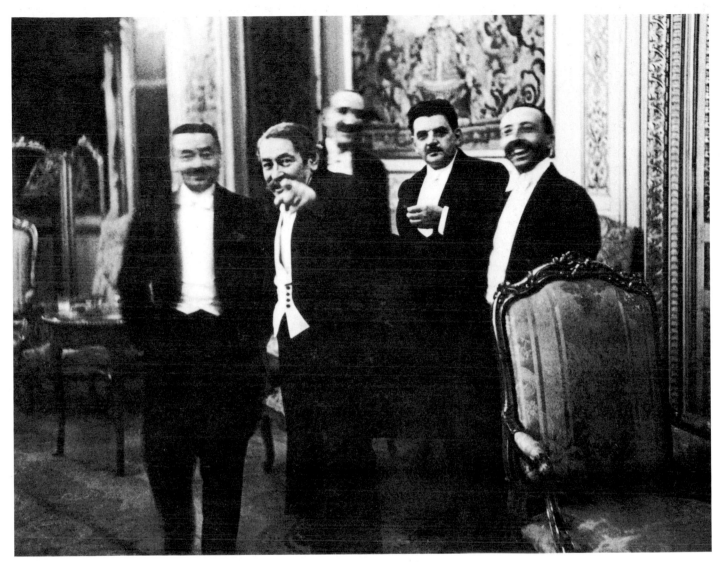

The best photographers are alert as well as unflappable. Pioneer photojournalist Erich Salomon, who used an early miniature camera to get candid shots of Europe's top statesmen, was caught in the act when he tried to photograph the French premier with a group of his cabinet ministers at a banquet in 1931. Even as his presence was discovered, the photographer was quick enough to capture his subject's good-natured reaction.

Although a good part of this book is devoted to mechanics—for technical expertise is important—imaginative "seeing" ultimately separates the inspired photographer from the merely competent one.

The heart of good photography is capturing on film those aspects of the world that appeal to you visually. If you are at a loss for a subject, simply take a look at the world around you. What things strike your eye or arrest your attention? It may be the expression on a person's face, a stark grove of trees in winter, or the gleaming lines of a passing automobile.

You don't need to go to exotic places to take good photographs. Some of the world's most famous pictures were taken close to home.

Edward Steichen, one of photography's prime movers, took hundreds of pictures of a shadblow tree near his house in Connecticut over a fifteen-year period. "Each time I look at those pictures," he said, "I find something new there. Each time I get closer to what I want to say about that tree."

Beginning photographers especially need to remember that seemingly unremarkable subjects can make remarkable photographs. Most important is simply being alert and continually ready to respond to people and actions, as Erich Salomon was for his famous photograph, "Briand's Surprise." If you give yourself the freedom to discover fresh perspectives, the results will surprise you.

...to develop a personal style

The more photographs you take, the more distinct your personal style of photography will become. You may find yourself drawn to certain subjects or to certain techniques. Eventually, your photographs will bear your unmistakable imprint.

The portraits of Tennessee Williams and Janet Flanner on these pages are the work of Jill Krementz. A photographer who considers herself a photojournalist as well as a portrait photographer, Krementz is famous for her relaxed, revealing photographs of writers. She almost always photographs people in their homes or other surroundings where they feel comfortable—hence the informal directness in her photographs.

The shot of playwright Tennessee Williams was taken at his home in Key West, Florida, and his stance and boisterous laugh create a vital, interpretive portrait. Krementz's picture of *The New Yorker*'s Paris correspondent, Janet Flanner, is entirely different in mood. Taken only a few years before her death, the picture is solemn and pensive. Krementz's close range and the subject's cigarette and curling smoke contribute to the mystique. Both of these portraits are excellent examples of Krementz's distinctive vision and her photographic style—evocative portraits that capture the essence of their subjects.

Learning to trust your instincts and to experiment with new techniques and unusual perspectives is what creating a personal style of photography is all about. And when it all comes together—when the shutter clicks and you know it's right—that is the joy of photography.

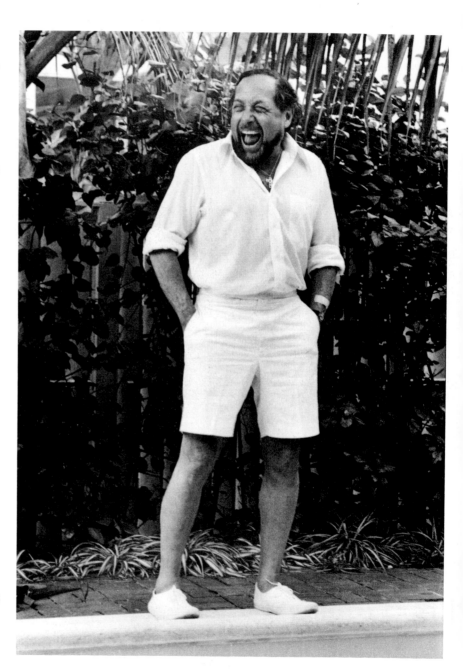

In the two portraits here, Jill Krementz has reacted to Tennessee Williams and Janet Flanner with very different approaches. The full-length outdoors shot of Williams is vibrant and alive, whereas the close-up facial portrait of Flanner, dark and brooding, suggests a thoughtful, serious nature.

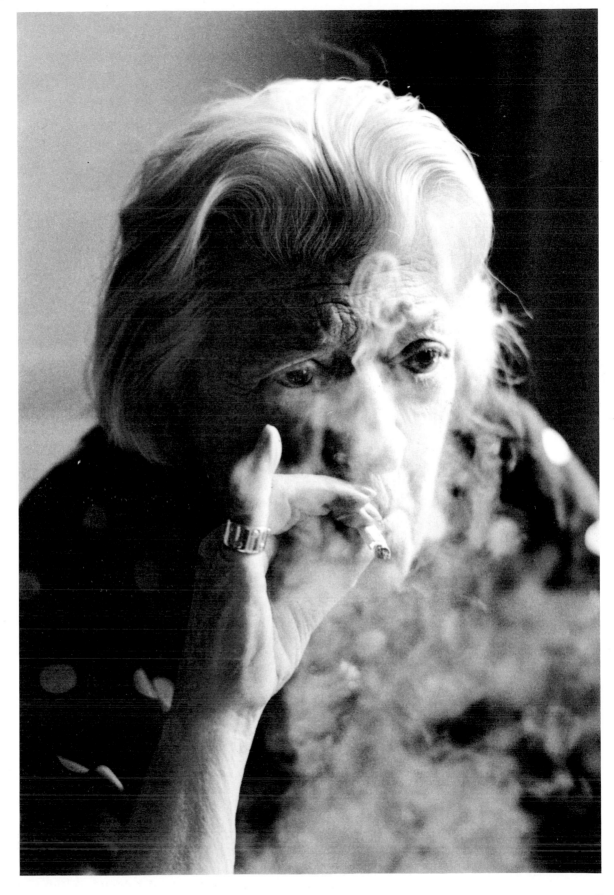

Capture the decisive moment

Time never stops. The world is continually changing—people move about, seasons pass, the sun rises and sets. Snap the shutter on a camera, however, and you have preserved a sliver of time. Because cameras have the unique ability to capture split seconds, every photograph you take says something about your attitude toward time.

There are several different ways of using time creatively in a photograph. One of the most familiar techniques is capturing the "decisive moment"—that fraction of a second in which all the elements in a scene work harmoniously together to express the event in the best way. The leading advocate of this approach is the noted French photojournalist Henri Cartier-Bresson. In the two pictures shown at right he captures the proud expression of a boy bearing wine and the intrepid daring of a puddle jumper suspended in midair, only an instant before his inevitable splash landing. Such expressions and scenes may never be repeated. To freeze the fleeting moment or the surprise move, you must, paradoxically, continually expect the unexpected.

Another way to record time, an approach especially favored by today's documentary photographers, is to show a slice of life—a random glimpse of everyday time. The snapshots we take are examples of the slice-of-life photo, and, in a way, so is Cartier-Bresson's picture of the boy with the wine.

As the following pages illustrate, photography also may be used to convey a sense of speed or, conversely, to stop the clock and reveal the enduring quality of a timeless scene.

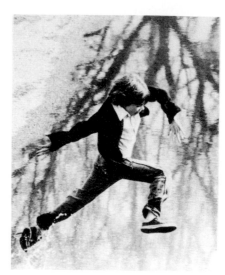

Quick reflexes were needed to snap the instance of adolescent agility shown at right. By planning ahead, you can often locate a vantage point from which to record an unfolding scene.

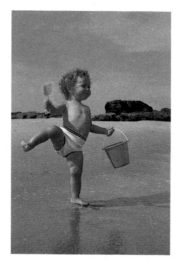

The young beachgoer above has been caught in the midst of a precarious balancing act, an effective and amusing way of expressing the often reckless enthusiasm of toddlers.

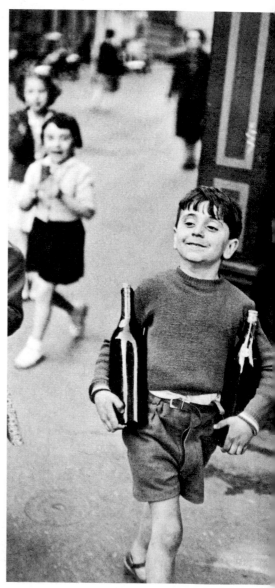

The "decisive moment" is not always one of intense, dynamic action. Rather, it may be a fleeting facial expression or a revealing interaction, as Henri Cartier-Bresson demonstrates in this shot of a self-satisfied young boy on a Sunday morning errand.

Even while capturing the dramatic midair moment at far right, Cartier-Bresson had an uncanny eye for composition. Not only are many of the forms balanced with their mirror images in the water, but the man's leaping silhouette is repeated by the dancer on the poster in the background. In this instance, all the elements work to create the picture's provocative mood.

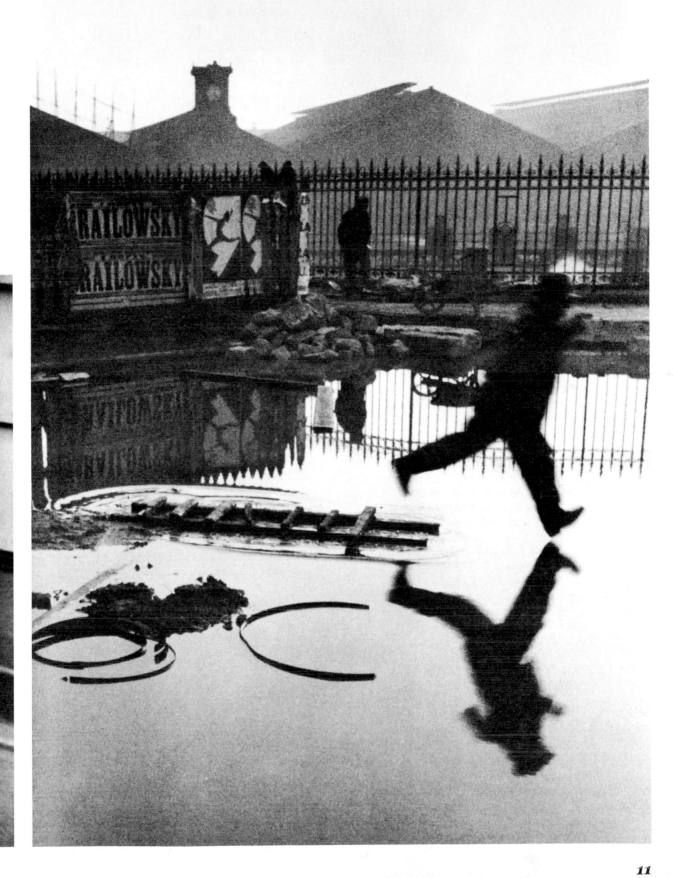

Freeze action...record movement

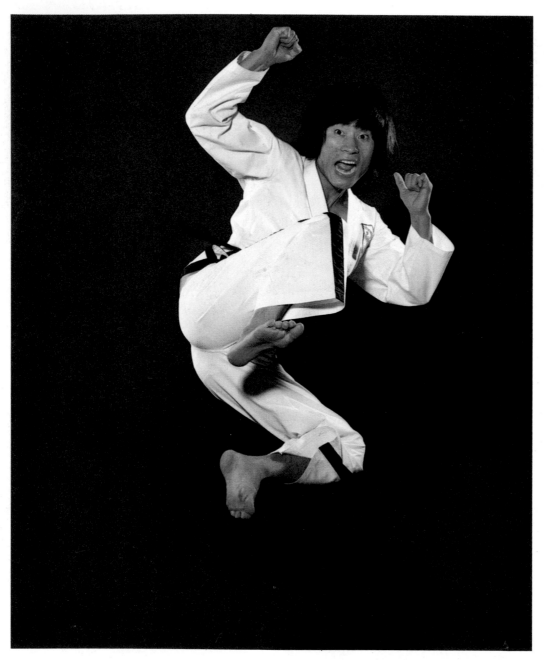

Dynamic, vigorous activities can best be portrayed by stopping the action at its peak.

The fierceness and energy of a karate black belt are suggested by freezing his flying kick as he sails directly toward the camera.

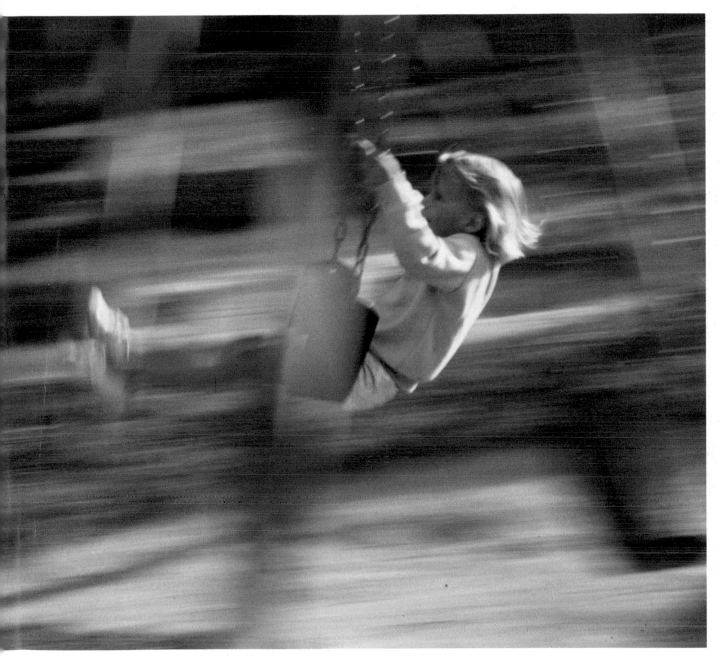

The blurred streaks in this shot of a little girl swinging are far more effective in conveying motion than any perfectly sharp image could be. The picture was made by panning—that is, following a moving subject with the camera, a technique that is explained on page 181.

...and show the serenity of endless time

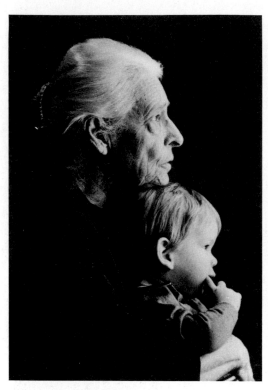

The dramatically lighted profiles of an elderly woman and her grandchild are evocative of the changing human seasons, the cycle of life. Both are gazing into the distance—the woman perhaps contemplating the past while the child peers toward the future.

A rowboat mirrored on a perfectly placid lake is a strikingly beautiful image, as well as a visual representation of the constancy and serenity of the natural world.

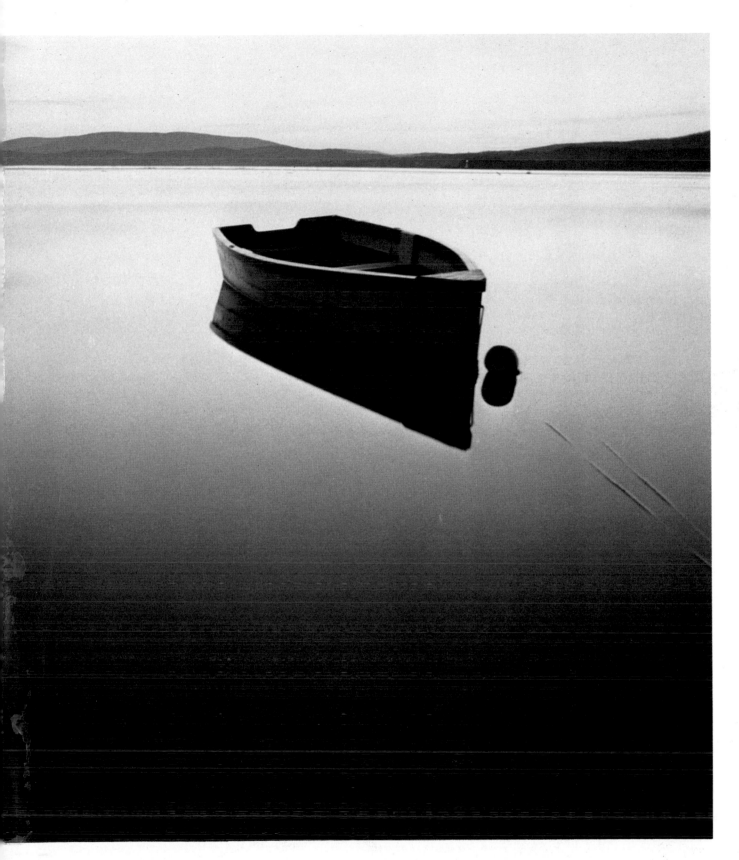

Identify shapes

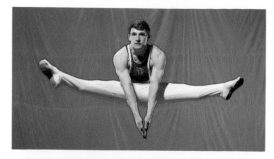

The human figure reduced to simple geometric shapes is a striking image. In this shot of a gymnast seemingly suspended motionless in midair, the arms create a strong inverted triangle while the legs spread to form an almost straight line.

The basic outline of an object—whether the bare branches of a lone tree or the slender neck and fan wings of a swan—usually has the greatest initial impact on a viewer. We recognize familiar forms in a picture before we pause to appreciate more subtle qualities, such as texture or linear movement. The good photographer understands this and knows how to use shape to advantage.

As the images here show, photographs that emphasize shape can have dramatic impact. One way to achieve this effect is to isolate a single form against a plain, contrasting background. Move close to the object you want to emphasize and shift your camera's position or angle to eliminate distracting details. The result will be a photograph that is strikingly simple and uncluttered.

In more complex compositions, shapes are basic building blocks. They can echo each other's form or be played against one another to create balance or tension. Shapes can even add a touch of mystery, as when a subject is portrayed from an unexpected angle or only a tantalizing segment of an unknown object is revealed.

Be on the lookout for shapes whenever you take pictures. Some will be obvious—like the eclipse of the sun below or the silhouette of a statue against the sky. Some will not be so immediately apparent, such as a gymnast caught in midleap or a line of urban row houses.

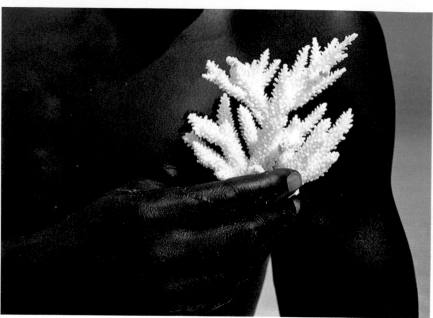

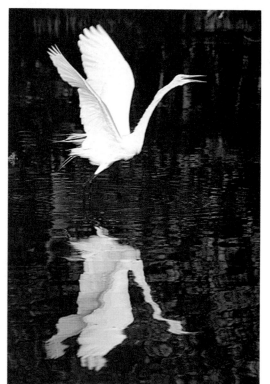

The composition above uses shape in two very different but complementary ways. The branching limbs of the stony coral skeleton stand out against a dark background, which the viewer slowly recognizes, from the hand and other visual clues, as a man's body.

Shapes mirrored in water often lend a pleasing symmetry to a picture. Since the water in the scene at left is almost as dark and green as the background foliage, the wavy distortion in the lower shape is the only confirmation that we are seeing a reflection.

A snow-covered foreground blending almost imperceptibly with a milky, overcast sky sets off the expressive silhouette of the tree at right. The color is so subdued that it almost appears to be a black-and-white photo.

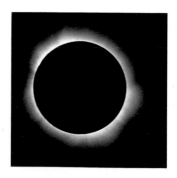

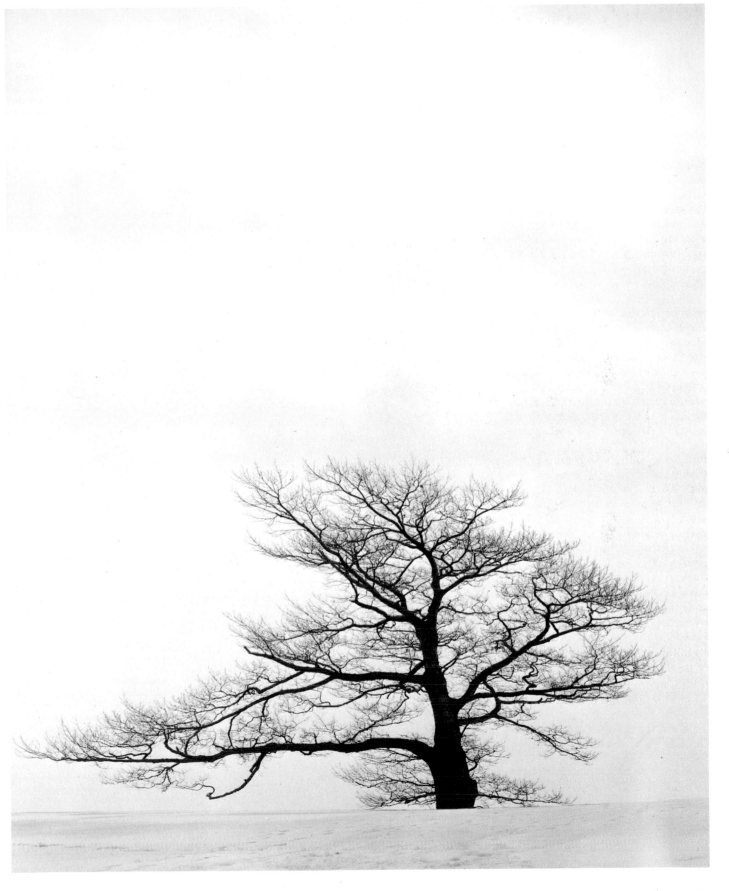

Notice lines of direction and distance

The angle at which light hits an object can emphasize—or even create—lines. Light from the side glancing off the edges of this cutaway chambered nautilus shell highlights its perfectly formed, graceful curves. Had it been more fully lighted, the overall shape and interior of the shell would have received equal or greater emphasis.

Lines are avenues for the eyes. They show direction and distance; they describe the edges of shapes and define boundaries. They can also convey the impression of action or force. Lines are very important in photography, for they can lead viewers to the center of interest in your photographs.

Photographers often use lines to create a sense of depth in an otherwise flat, two-dimensional surface. This impression of depth is strongest when parallel lines recede toward a point on the horizon, as they do in the shots shown here of San Francisco's Golden Gate Bridge and of a young cyclist. These lines do more than create a sense of perspective. They lure the viewer toward that faraway point, and any object that appears at or near that juncture will be perceived as important. The distant tower on the bridge, for example, becomes a stronger element than its relatively small size would seem to suggest.

Hard-edged, well-defined lines have the strongest visual impact, and they are also the easiest for the beginning photographer to recognize and explore. Curving lines usually convey a softer, more graceful feeling, as in the spiraling lines of the nautilus shell shown here.

In a composition with several elements, lines can pull our eyes from one form to another or provide a visual connection between objects that are usually considered unrelated. Lines also give us vital clues about the direction of a force or action. In the rodeo picture on page 20, imaginary lines of energy connect the two cowboys with the calf, generating the photograph's tense action.

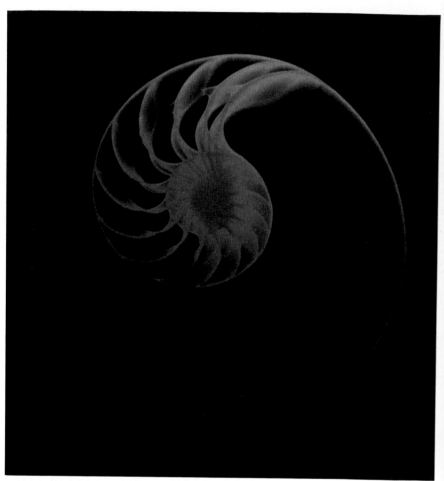

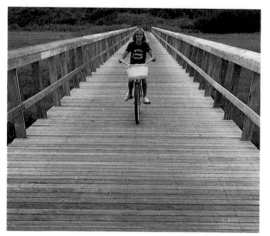

A young cyclist pedaling across a wooden footbridge immediately commands our attention. Again, the converging lines created by the bridge's side rails make her the photograph's inescapable focal point.

Vertical as well as converging lines are at work in this shot of San Francisco's Golden Gate Bridge. The harsh geometrical effect of all these straight lines is balanced by the soft, golden fog, lending a surreal aspect to the scene.

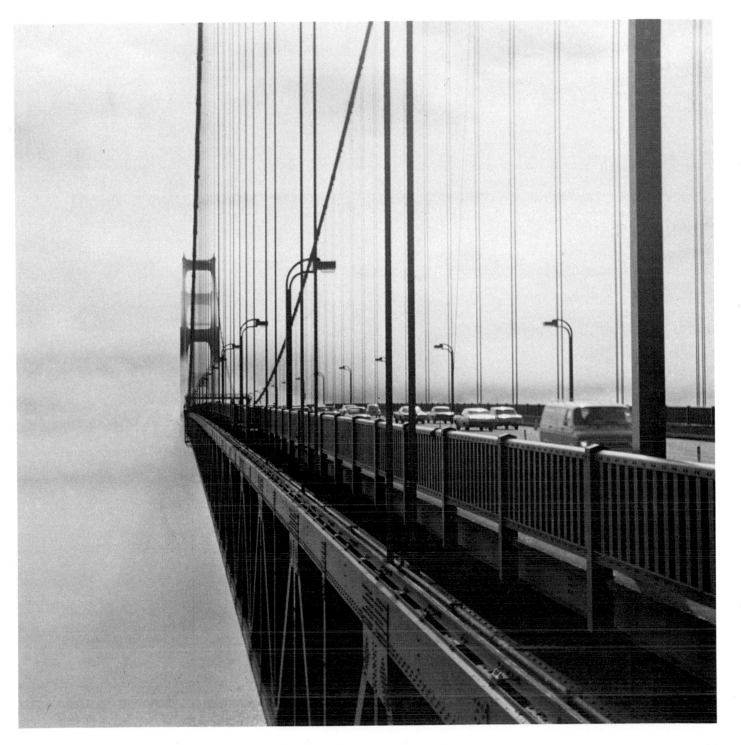

Emphasize lines of action and force

Action is often expressed in the opposition of curved and straight lines. In this overhead shot of a rodeo, the unnaturally arched body of the lassoed steer and the cowboy's taut rope convey visually the violent forces at play. Simultaneously, the rope serves as a vector connecting two elements in the triangular composition.

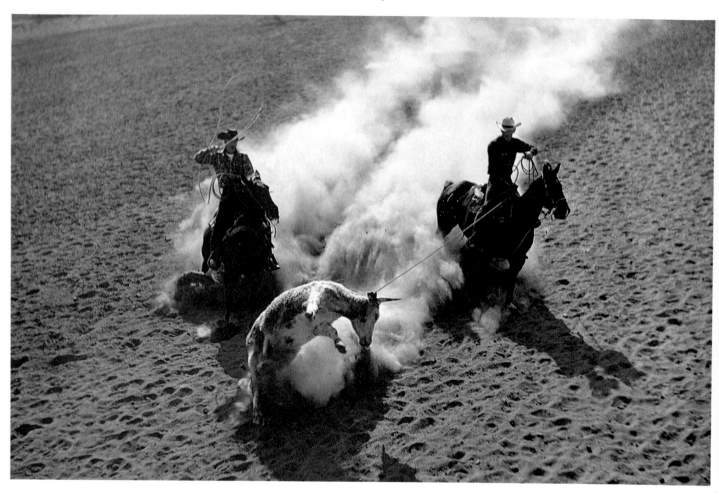

In this picture of a seagull taking food from a person's hand, the upward-reaching arm, the angle of the gull's long wings, and even the position of the other birds are all linear elements that focus attention on the central action.

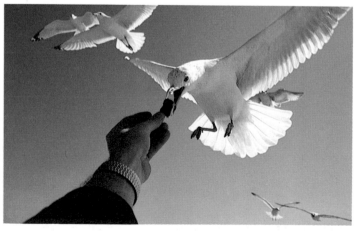

A straight-on shot of a building usually emphasizes its static, vertical lines. In the photograph at right, taken an instant after detonation, those familiar lines serve as reference points for the lines of force moving explosively upward and outward. We also are aware of the more irregular lines and shapes created by flying chunks of rubble and clouds of smoke.

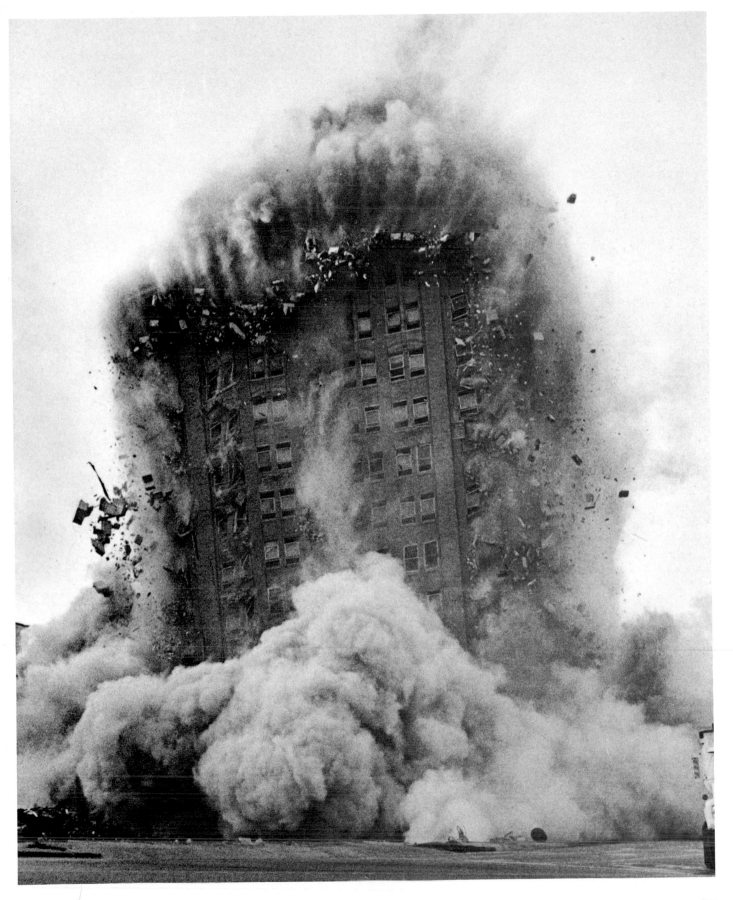

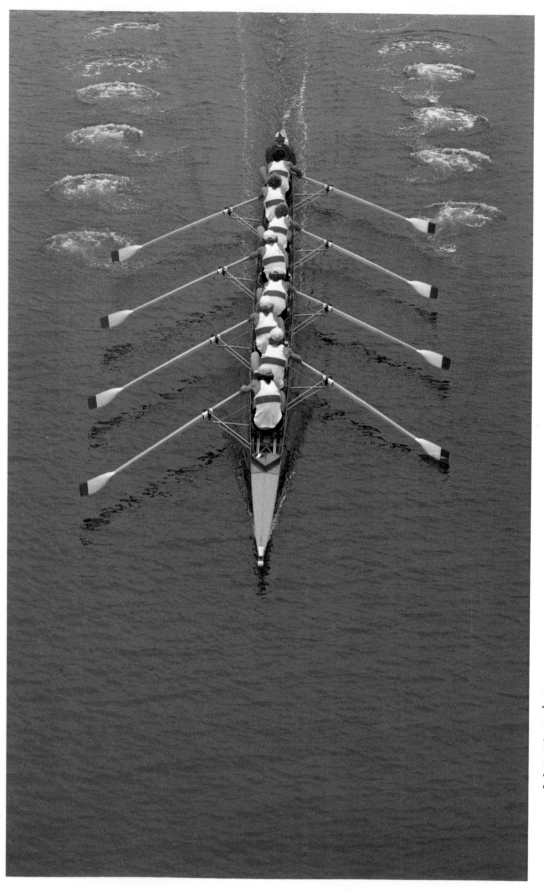

In the overhead shot of a rowing crew at left, the dominant pattern created by the oars is echoed by the splashes they have left behind and by the bright red oar tips and the crewmen's tops.

A straight-on frontal view of Canadian guardsmen standing rigidly at attention forms a striking pattern. Every element of their ceremonial regalia, from beaver helmets to brass buckles, is repeated down the line. By judiciously cropping the top and bottom of the picture, the photographer further emphasized the photo's horizontal design.

Shapes need not be all the same size or color to suggest a pattern. Backlighted by the low winter sun and all tacking at the same angle, these iceboats—and their faint reflections in the frozen lake surface—are just different enough in size and sail to create a sense of depth. The width of the lake itself is emphasized by the tiny sail in the background at center.

It is the recurring bright yellow jackets rather than the motorcyclists themselves that bring order to this chaotic shot of a dusty road race. The yellow stands out because it is the predominating hue, contrasted only by an occasional red or blue jacket.

Find rhythm in patterns

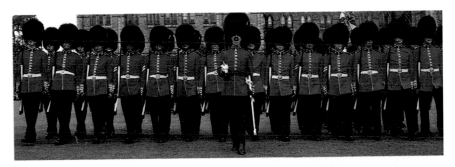

When similar shapes, lines, or colors are repeated at more or less regular intervals, they create patterns. An abundance of these patterns, both natural and man-made, surrounds us—cars in a parking lot, people lined up for a movie, a row of pine trees. You can use these repeating forms to imbue a photograph with a sense of orderliness and harmony that is as pleasing to the eye as a melodious refrain is to the ear.

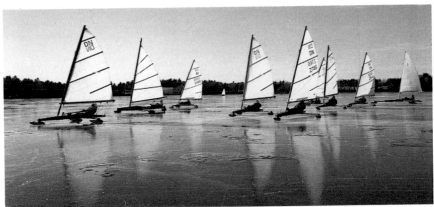

At the same time, the rhythmic effect of pattern can convey deeper feelings about the subjects in a picture. The pattern formed by the oars of the racing shell at far left eloquently expresses the repetitive rhythm of rowing. In the orderly line of guardsmen above, we sense the discipline inherent in ceremonial precision.

Because patterns are strong visual forces that give harmony and unity to a picture, even the merest suggestion of a pattern can be eye-catching. This is especially true when the elements come together by chance, as in the motorcycle race pictured at lower left. The visual rhythm is more random here, but the arrangement of yellow jackets imposes pattern on an otherwise cluttered scene.

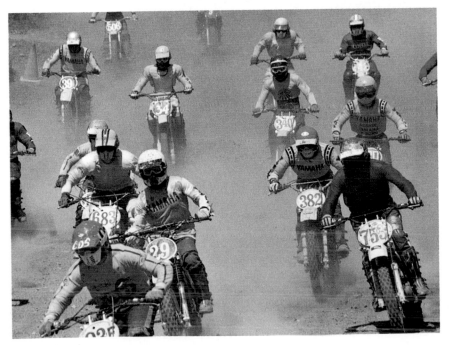

On the other hand, in pronounced and almost perfect patterns, the eye is invariably drawn to any disruption in the rhythm of recurring forms. In the shot of the guardsmen, for example, the group leader stands out because of his slightly forward position and his open mouth. As with other visual elements, you can learn to use patterns by first isolating them and then experimenting with their many possibilities.

Recognize the texture of form

Texture adds a strong sense of realism to photographs, because it appeals directly to our sense of touch. Texture reveals the nature of a surface, whether it be a rough, splintered piece of wood or the smooth, waxy shell of an egg.

When we look at a photograph of a piece of rope or an egg in a carton, we respond to the tactile qualities of these objects and get a sense of their three-dimensionality. They are no longer just two-dimensional shapes—they can now be called forms, because they convey the third dimension of depth. By giving this impression of solidity, texture helps us sense the weight and bulk of an object as well as its softness or hardness, its coarseness or smoothness.

Strong light raking obliquely across the side of an object accentuates its surface characteristics in sharper detail than any other source of illumination and is especially effective in black-and-white shots. In color photographs, minute gradations of surface hues can often be conveyed more effectively by soft, evenly diffused light.

Texture, although usually best revealed in close-ups, can also be dramatically conveyed in a more distant shot. In the photograph of an autumnal forest at the top of the facing page, the photographer has stepped back to capture the sweep and texture of fall foliage.

In the shot below of a cross beam lashed to an upright, we can almost feel the edges of the rough-hewn wood and the fibrous texture of the rope.

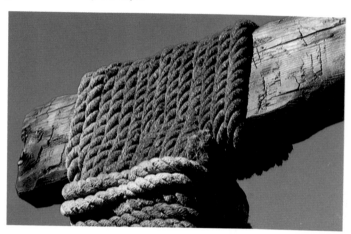

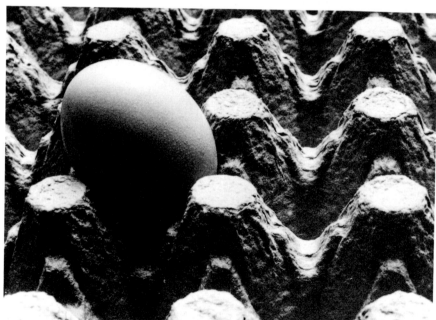

Sidelighted objects frequently become startlingly graphic in black and white, as illustrated in the shot above of a smooth egg resting in a coarse-grained paper carton.

Skin texture is an important design element in the picture at right of a mother elephant and her offspring. The contrast between the older animal's leathery hide and the young elephant's softer, hairy skin reinforces the arresting variations in color.

Autumn leaves viewed from afar form a finely variegated pattern both on the trees and in the clearing, where they accentuate the gently rounded form of a slight rise. In color photographs, texture is often revealed by subtle differences in color intensity rather than by strong dark-light contrasts.

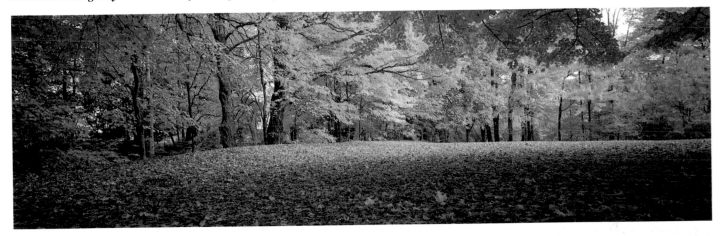

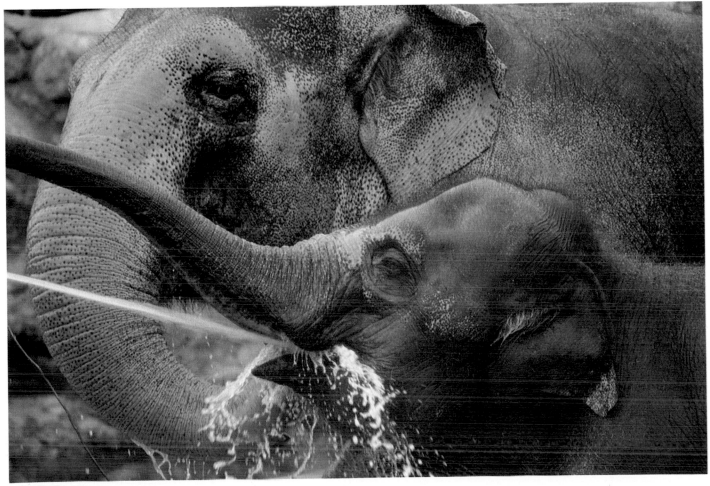

Get a feeling for size and space

In daily life we rarely feel compelled to stop and judge the size of an object unless it is far away, unfamiliar, or seen from a puzzling perspective. But in a photographic composition, which presents a flat version of reality, one of the first things we look for is a guideline to help us establish the size and proportion of the objects in a scene.

In the photograph at far right, the remains of the temple act as a backdrop to the statue head, which looms large because of its proximity to the photographer.

On the other hand, the enormous size of the rocky projection at right becomes clear only when we recognize the tiny figures as climbers. When human figures are juxtaposed with massive shapes, either natural or man-made, the effect is often breathtaking.

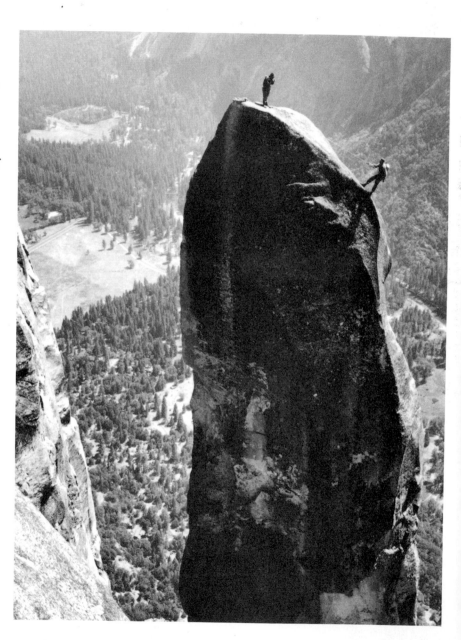

When the difference in scale between two elements in a scene is vast, the photographer often has to find ways to emphasize the easily overlooked, smaller element. In this case, the angle of the picture serves to accentuate the two rock climbers, and the sun lighting them from behind silhouettes their figures.

The stone head in the picture at right looms large because world-famous photographer Brian Brake positioned himself directly in front of it. By using a wide-angle lens, however, he has placed distance between the head and the temple, creating an unexpected difference in scale. The fog and the bluish light add to the mysterious atmosphere.

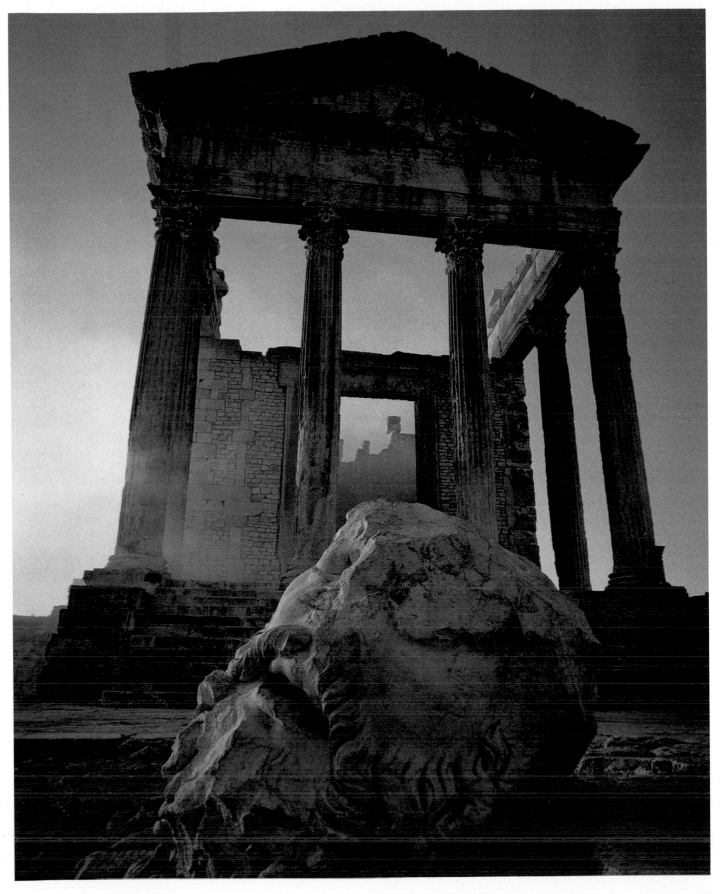

Shape...
Line...
Pattern...
Texture...
Scale...
Form

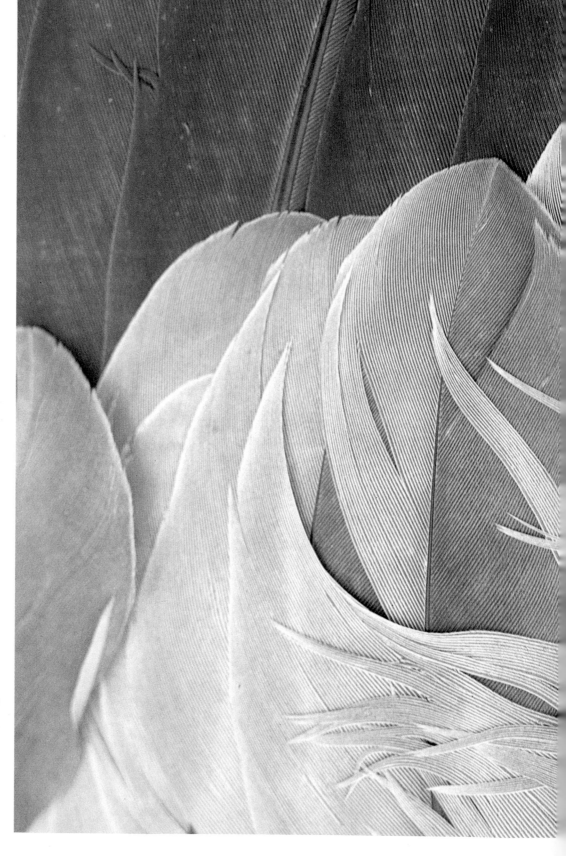

All of the visual elements we have discussed contribute to this striking close-up of a bird's plumage. We immediately recognize the familiar shape of feathers, see their repetition as a pattern, and can almost feel their soft texture as revealed by the lines of their finely branched structure and slightly cupped form. A disruption in this uniformity creates the main visual interest—the irregular, flamelike points cutting diagonally across the photograph.

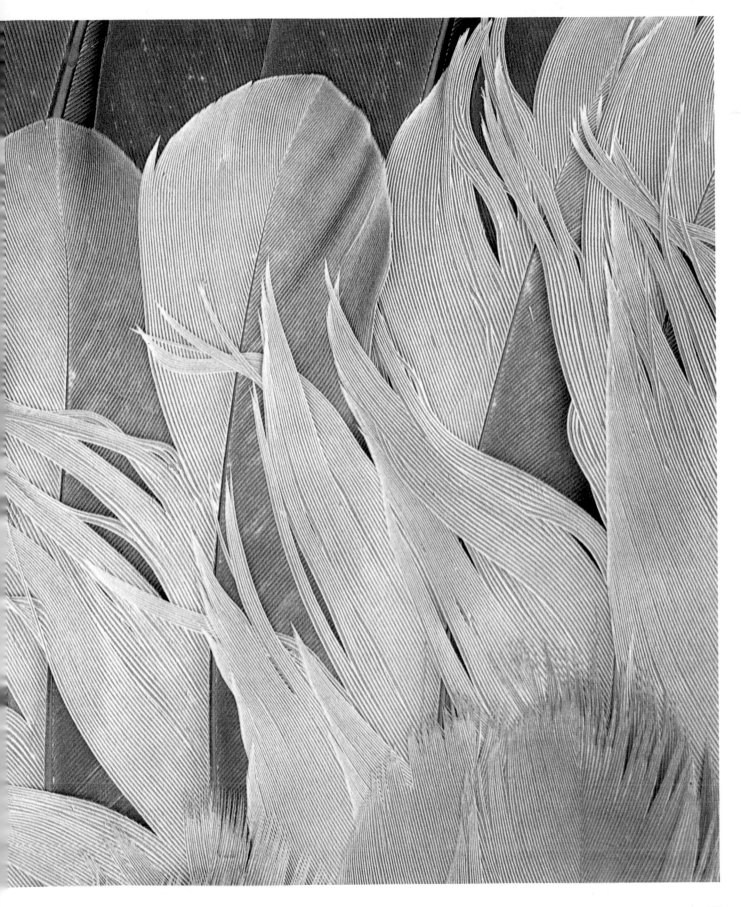

Arrange and compose pictures

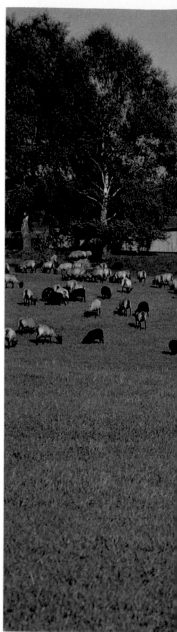

When isolated and highlighted, each of the visual elements—shape, line, pattern, and texture—can become the subject of an exceptional photograph, as we've seen in the pictures presented here. However, most photographs depend on many or all of these elements in varying proportions.

As a photographer, you want to use these elements knowledgeably to structure your picture in a meaningful way—one that conveys a mood or shares an insight with the viewer. This presents a problem: Unlike a painter, you cannot pick and choose freely, eliminating one object, shifting the position of another, or changing the color of a third. Still, you have a great deal more flexibility in creating the arrangement than you may think. You can move closer or farther away, shift to one side or another, raise or lower the camera, tilt it upwards or downwards, or turn it vertically or horizontally. And, as you'll see in Part II, you can change emphasis dramatically by choice of shutter speed, aperture, lens, film, filter, and lighting.

How you use these options to organize a picture will depend on what you want to say and the visual connections you want to make. There are no hard-and-fast rules for composition. But there are some general guidelines that a photographer should consider, including balance, angle of view, and framing, all of which are discussed on the following pages.

Your goal is to create a photograph that will effectively convey your subject, theme, or idea. Composition is a deliberate effort. You need to analyze all of the elements in a scene,

then arrange them for the effect that you want to achieve. Sometimes just one element will be sufficient to carry your idea. Simplification can produce powerful images, such as the shot below of a lighthouse at sunset or the picture of feet at right. Other times you may need several elements to tell your story. You may want a balanced, harmonious picture, or you may choose to convey a feeling of precariousness or stridency.

Often the main subject of your photograph will dominate and be supported by other elements and details. The viewer's eye is first drawn to your main image and then led around the frame. The dominance need not come from sheer physical size. In the Ernst Haas picture of the field, the two brightly clad women, while no larger than other shapes in the photograph, capture our interest because of their position and their colorful clothing.

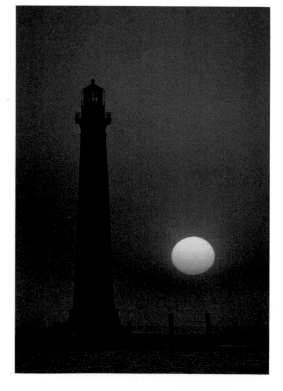

A lighthouse and the sun against a darkening red sky are all the elements needed to convey the mood of an ocean sunset. At the same time, the long linear shape of the light tower contrasts nicely with the sun's roundness.

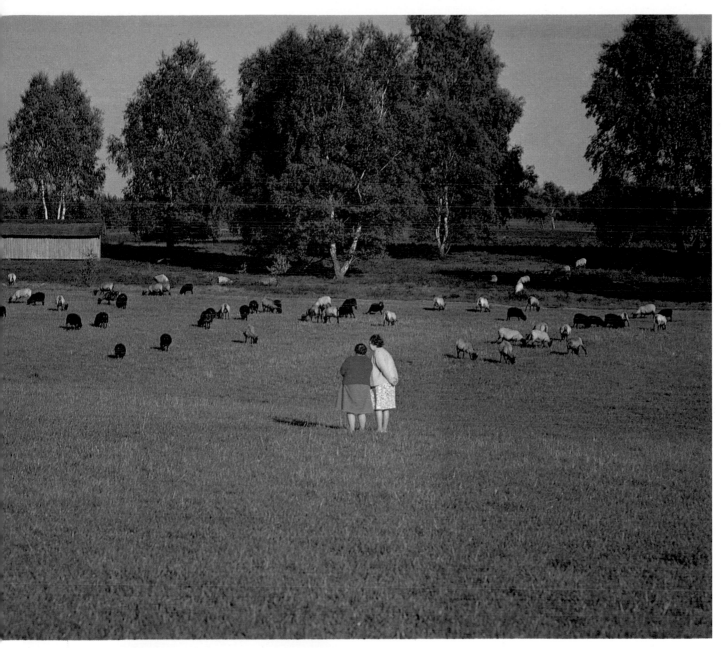

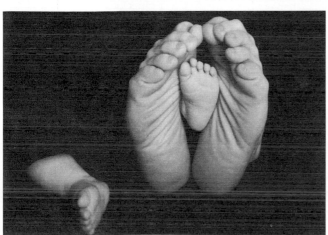

As a composition, the playful contrast of adult and infant feet at left owes its strong visual impact to the fact that the feet are isolated against a dark background. Had the photographer tried to simplify the image by photographing only the main grouping, the entire character of the picture would have been radically altered. Instead of imparting a playful quality, it would have become a cool, symmetrical puzzler that would leave the viewer wondering about the missing foot.

To compose the idyllic scene above, master color photographer Ernst Haas selected a vantage point that allowed him to emphasize its quiet, pastoral quality. He is able to keep all the elements small and in harmonious balance without sacrificing the unexpected visual delight of the chatting women.

...to create balance...and imbalance

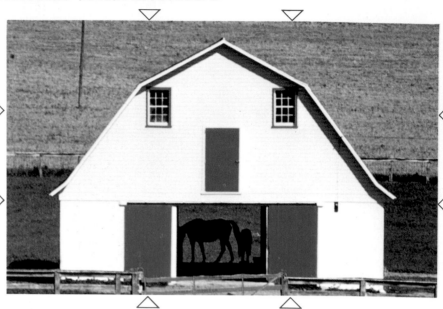

Logically, it would seem that the most harmonious and appealing image would be symmetric—the main subject in the center of a picture and other elements divided around it evenly. But such strict compositions usually strike us as static, because they lack the two central characteristics that most often excite a viewer's curiosity—tension and movement. The sense of balance inherent in a successful photograph usually comes from a less-obvious source: the visual weight given to various elements within the picture. This kind of balance is frequently achieved by contrast—bright primary colors balanced by more muted hues; intricately detailed objects by spacious empty areas; or dark masses by lighter surroundings, as seen in the mist-shrouded locomotive at far right.

Often these contrasts immediately suggest an arrangement for achieving the best balance and highlighting the central point of attention. One trusted formula for emphasizing the main point of interest—the rule of thirds—has been used by painters for centuries. This "rule" presents numerous interesting possibilities. As you look through the viewfinder, imagine lines dividing the image into thirds, both horizontally and vertically. Subjects placed near one of the four intersections formed by the lines gain immediate off-center emphasis. Alternatively, elements situated at diagonally opposed intersections seem balanced. Or, when elements are located at three of the junctures, they can form a dynamic triangular composition. In still other shots, the imaginary lines divide a scene into a pleasing two-thirds/one-third proportion.

Almost perfect symmetry is the most striking feature of the above shot of a barn with surprisingly human features. But it is the asymmetrical position of the horses that intrigues the eye. Yet the rule of thirds is clearly evident here, since the façade divides easily into thirds and the windows and bright red doors gain emphasis from their location near the junctures of the imaginary dividing lines.

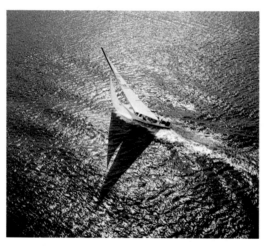

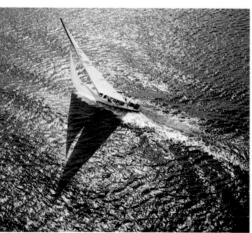

Although luminously backlighted by the sun, a sailboat is only mildly interesting when placed close to the center of the picture, as in the photograph to the left above. But it gains an added sense of drama and better conveys the boat's movement when the photograph is cropped in line with the rule of thirds—in this case, by locating the center of interest one-third down from the top and one-third in from the side.

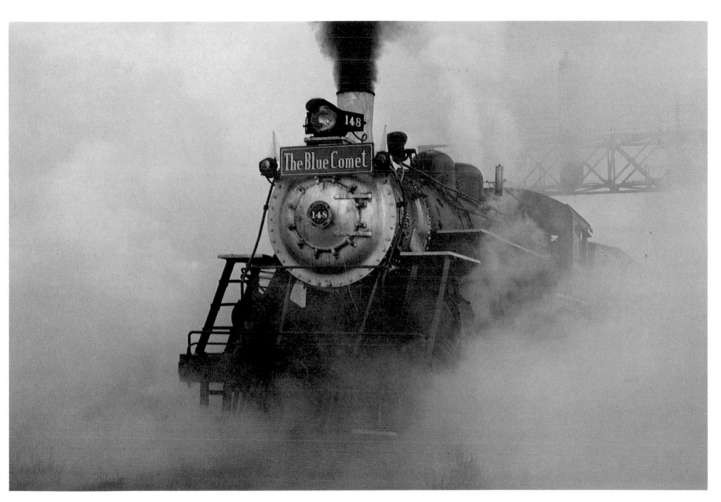

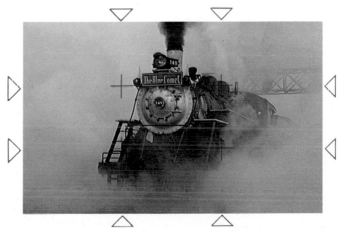

An old steam locomotive looming out of the mist like a ghostly spectre also conforms to the rule of thirds. As shown by the grid-marked version of the picture, nearly all of the train's bulk is confined to the lower and the right two-thirds of the image area.

Choose the best viewpoint

You can alter the viewpoint of your pictures—as well as their mood and impact—simply by changing your camera angle. The same scene can appear radically different depending on whether you shoot it from above, below, or at eye level. Climb a few stairs or find an upper-story window for downward shots, or squat down or even lie on the floor to angle your camera upward.

A normal eye-level angle, since it is the way we usually look at the world, conveys realism—the everyday appearance of a scene. When people or objects are shot from below, however, they appear to tower over the viewer and are infused with power and dominance. Shot from above, subjects become diminished, but the organization of elements in the picture often becomes clearer, as in the photograph of a small town at lower right.

In open landscapes, the moods evoked by shifts in angle can be dramatic. When a scene is shot from a low angle, the horizon in the picture moves downward, revealing an expanse of sky and emphasizing the spaciousness of the landscape. From a high angle, the horizon is near the top of the scene and the land seems to stretch away endlessly.

For the photographer at a more experimental stage, the question is when to use such radical points of view. Both high and low angles can include more of a subject than a straight-on, eye-level shot, and both can reveal patterns and textures that we do not normally perceive. Both angles can also be used to simplify a composition. By shooting upward, you can isolate a subject against the sky or a plain wall. By shooting downward, you may be able to eliminate a cluttered background.

The straight-on, eye-level camera angle used below is an appropriate choice for emphasizing the stark realism of a shadowy nighttime street. The documentary quality of the photograph is further established by the use of black-and-white film.

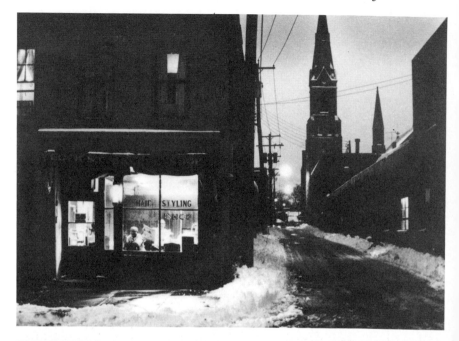

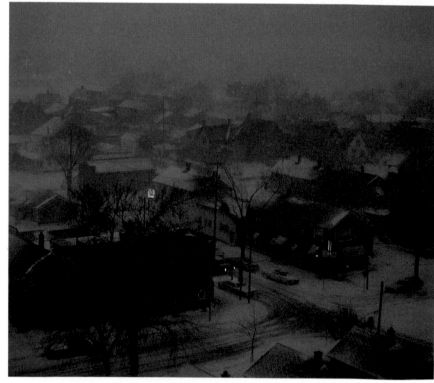

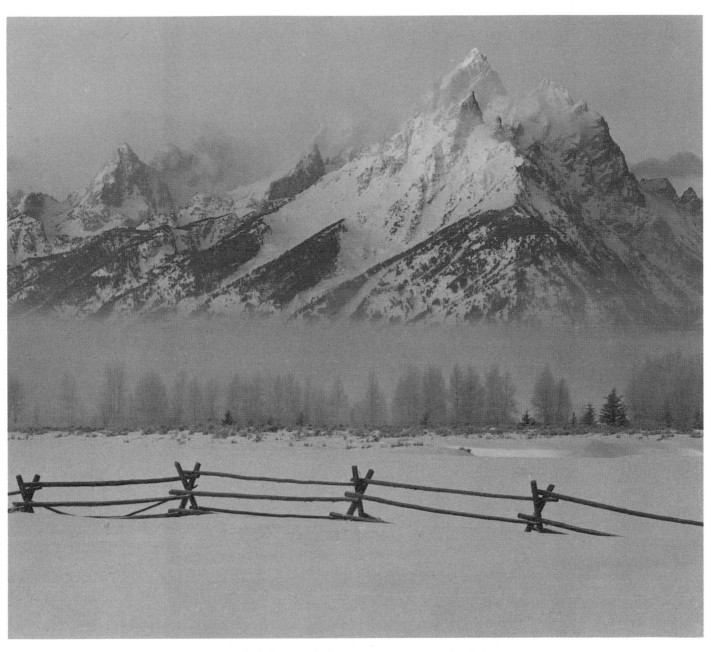

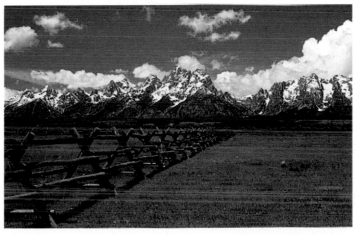

The small-town scene at left, illuminated by the lights from a corner tavern, is very different from the small-town scene above. The rooftop view reduces the town to a sleepy community of doll houses, a charming scale model devoid of the harsher qualities suggested in the bleak street scene.

Changing both the angle and the kind of lens used can radically alter the perspective of a photograph, as these two shots of the same chain of mountains illustrate. In the wintry scene above, taken from a relatively low angle, the photographer used a telephoto lens (see page 105) to bring the distant mountains to the fore. At left, by pointing the camera downward and using a wide-angle lens (see page 106), the photographer greatly diminished the peaks and emphasized the long lines of the rail fence.

35

...the most effective angles

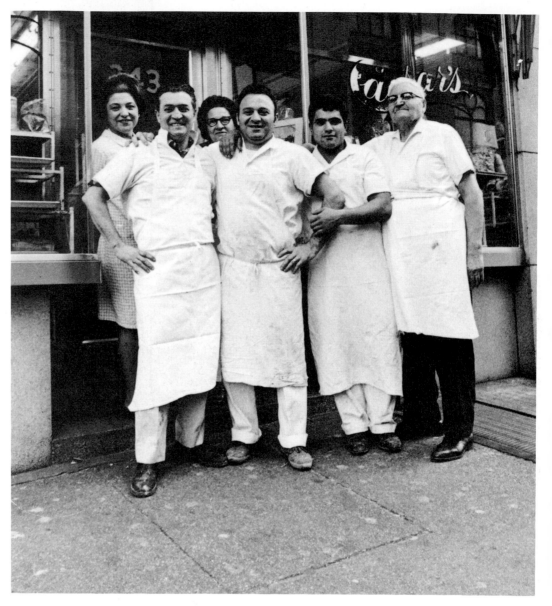

What would the picture at right communicate if it had been shot at eye level? Probably not much. It would have been a quite ordinary snapshot of a group of people. By lowering the camera and shooting upward, however, the photographer effectively expresses the pride these individuals take in their bakery shop and their profession.

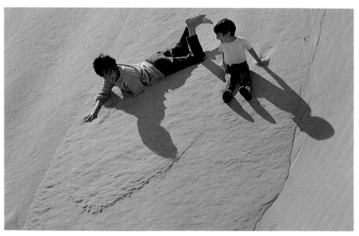

In this exuberant scene, two children are dwarfed against the steep slopes of a sand dune by the use of a high camera angle. By exaggerating the steepness of the dune, the high angle makes the boys' position even more precarious than it is.

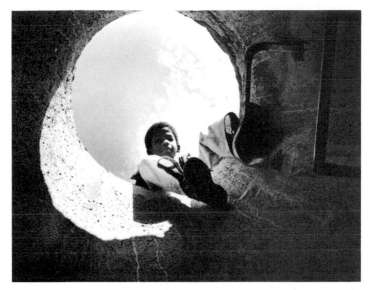

An unusual and dramatic perspective can be the result of pointing a lens almost straight up, as in this photograph of a boy isolated against the sky. The dark, tunnel-like structure he is sitting on forms an effective natural frame.

To exaggerate the joyful expressions of a mother and her playful, nose-pinching son, the photographer shot the animated scene below from a low angle. A normal or high angle would have missed their expressions entirely.

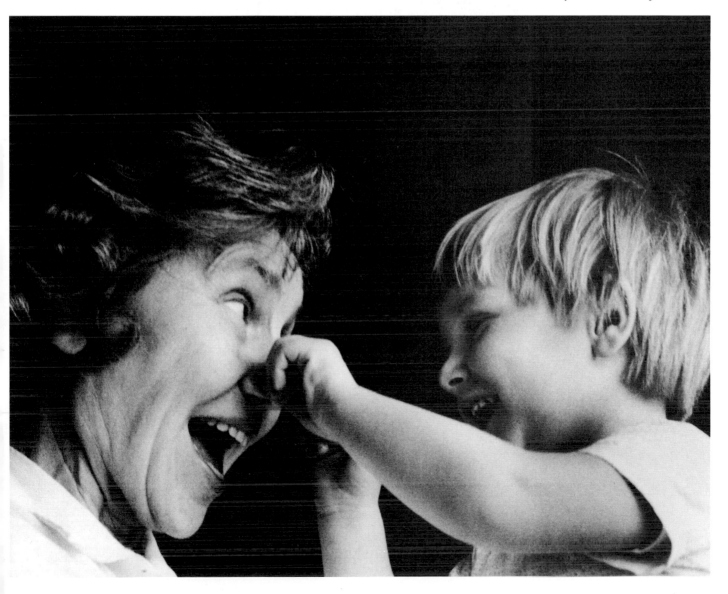

Unify by framing and cropping

To draw the viewer's attention to a picture's main subject, photographers sometimes rely on a simple compositional device known as framing. Positioned around the subject, a tree, a doorway, a window, or even a gap in a fence can create a frame within the picture's frame. Framing is not only a highly effective means of directing the eye, it also serves to obscure unattractive foregrounds or other distracting details. At the same time, a frame can convey a sense of depth and identify the photograph's setting.

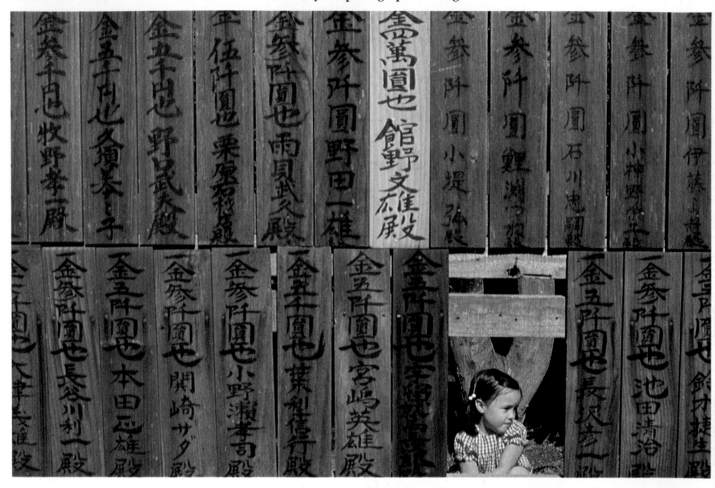

An unexpected break in the strong rhythmic pattern created by a fence forms an attention-attracting frame for a little girl, even though her position in the picture is unusually low. The Oriental ideograms help to establish the setting.

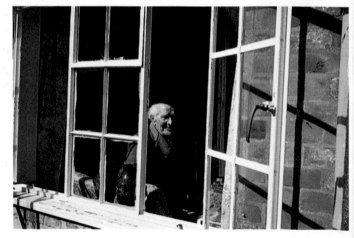

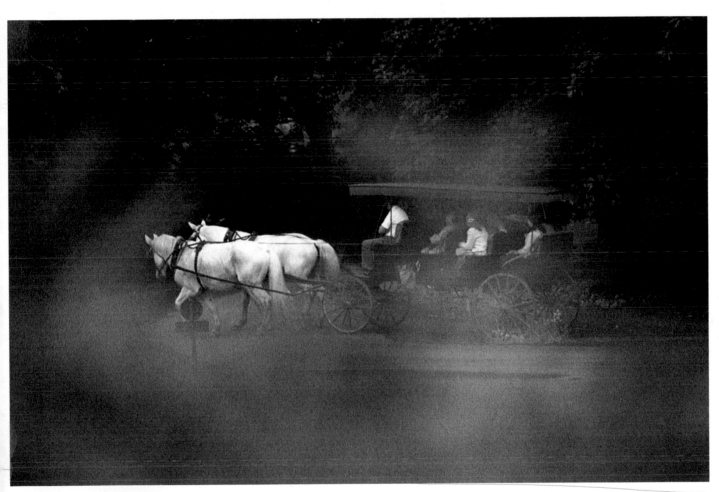

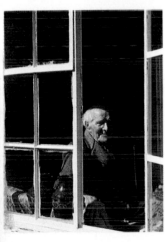

Two versions of the same picture show how framing can be used to create dramatically different images. By revealing more of the exterior of the building, the scene at far left depicts an elderly man sunning himself by the window. Nothing in the picture tempts us to speculate further. When the top, left, and right of the image are cropped, however, our attention is immediately directed to the man's expression and we become more personally involved with the photograph. This kind of cropping can be done in the darkroom (see page 280).

Above, out-of-focus foliage provides a strong frame for these costumed passengers in a horse-drawn buggy and heightens the scene's period charm by infusing it with a dreamlike quality. Soft-focus frames are created by selective focusing (see page 94) or by applying a thin coating of petroleum jelly around the edges of a filter.

Study the language of light

Light is the photographer's medium, just as oils are the medium of a painter. An artist must learn the properties of paint to bring ideas to life on canvas. Similarly, a photographer must understand the characteristics of light in order to create an effective photograph. Light creates the hues we see in a color photograph and the tones we see in a black-and-white one. Even the most subtle variations of light—its quantity and quality, its color, its source and direction—can greatly affect the emphasis and mood of a picture.

The many technical options that are available to you for controlling light are outlined in Part II of this book. It is important first, though, to learn how to observe light and take advantage of its myriad possibilities for creating effective photographs.

As you'll see on the next few pages, the most prevalent source of light—the sun—offers innumerable opportunities for the alert photographer. In just one day the sun's light can change from soft, misty luminescence to blinding midday brilliance to the oblique rosy rays of sunset. And as night falls, the sun creates the cool, almost black-and-white moonlight of evening. Sunlight also changes —often dramatically—with the seasons.

There are a number of other light sources as well, ranging from ordinary incandescent bulbs and fluorescent tubes to the mercury vapor lamps of sports arenas or the neon signs that light up city streets.

With a working knowledge of light, you can take full advantage of the enormously varied kinds of illumination you will encounter. You may choose to shift your point of view, for example, to obtain a particular effect, whether it be to highlight a subject or silhouette it. As you become more experienced with your camera, you will more fully recognize the many possible ways to put light to work for you.

Light is responsible for the striking qualities of the shot at right of a stream cascading down a rocky palisade. The agitated water reflects light diffusely and the rainbow at the foot of the fall is the result of light being diffracted by moisture in the air.

In the photograph at left of two kimono-clad Japanese girls hovering over a traditional bamboo and paper lantern, the golden glow of firelight isolates the subjects against a dark background and creates an atmosphere of warm intimacy.

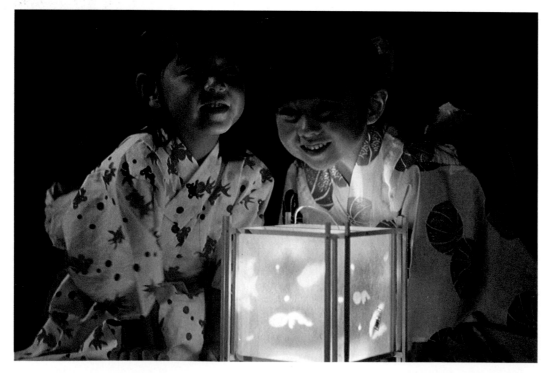

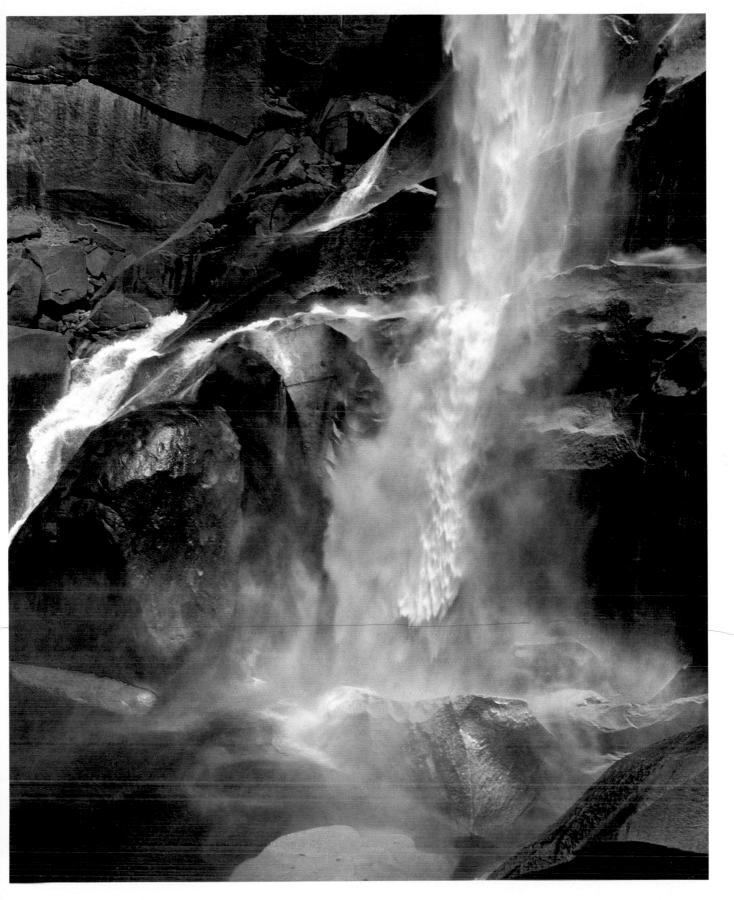

See light as the source of all color

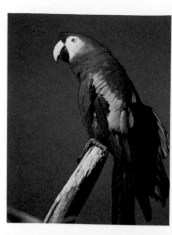

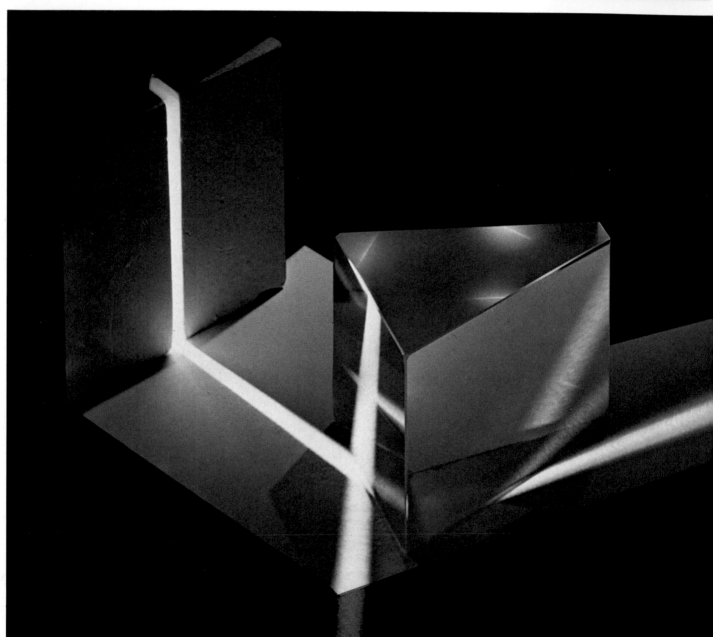

Light is the source of color. Pure white light is composed of all the visible colors. This can be easily demonstrated by passing a beam of light through a prism, as shown below. The colors, each of a different wavelength, fan apart to form a rainbow spectrum ranging from violet to red. When light hits a surface, some colors are usually absorbed while the others are reflected. The colors that we and our cameras see are those that the surface reflects. Thus, in the variegated plumage of the macaw, the red feathers reflect red and absorb all other hues. Similarly, the yellow feathers reflect only yellow wavelengths and the blue feathers only blue ones. An object appears white when its surface reflects all colors and black when its surface absorbs them.

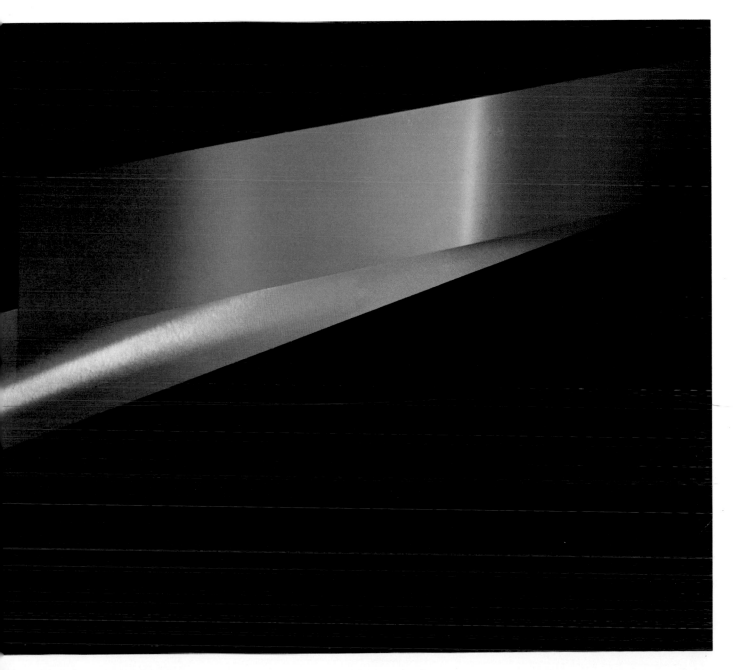

Sense the mood of colors

Whether it is warm or cool, bright or subdued, gay or somber, color sets the mood of a photograph. We respond excitedly to reds and oranges and are soothed by shades of blue. All too often, however, we take the colors in a scene for granted—as a given over which we have no control. This is a mistake. Just as with other elements in a picture, it is possible to manipulate the effect of color in your photographs by judicious choices of subject, vantage point, and, most importantly, the kind of light you employ.

As the spectrum and the macaw on the preceding pages show, what we and our cameras perceive as color is light bouncing off an object. As a result, color depends entirely on the light in which we see it. You may have noticed that a garment first seen under the fluorescent lights of a department store seems to change color when later examined by daylight or under an incandescent bulb at home. And in instances such as George Silk's picture of an early morning sky, we see the obvious effects of changing light.

But usually when we look at an object in different lights, our brain automatically makes the necessary adjustments. If we know a building is white by day, we tend to see it as white even when it is rose-tinged at sundown or faintly blue under a mercury vapor light at night. Only by training our eyes to see such differences, as the camera does, can we compensate for them.

Good color photographs are rarely accidents. By carefully selecting your camera angle and by choosing the proper light, you can bring some colors to the fore and eliminate or subdue the effect of others. Usually, the photographs that please us most are those in which one color or group of closely related hues predominates. This may take the form of a bright, primary-colored object against more neutral shades or softer hues that permeate the entire scene, like the blues in the moonlit fishing scene at right.

In each of these exceptional outdoor scenes, the well-known photographer George Silk uses one prevalent color to create a mood. At right, a flock of geese flies upward against a reddened sky that conveys the warm brightness of dawn.

Below, cool blues, interrupted only by the luminescent moon and the fisherman's figure, carry the message of nighttime serenity. In both images, the sky and water seem almost to merge, creating a nearly solid-colored background.

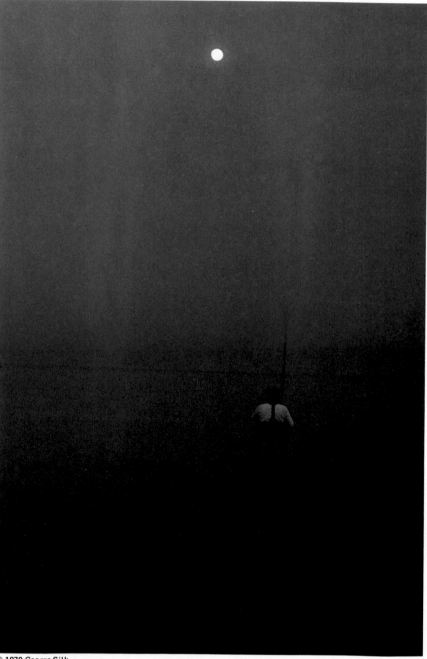

© 1979 George Silk

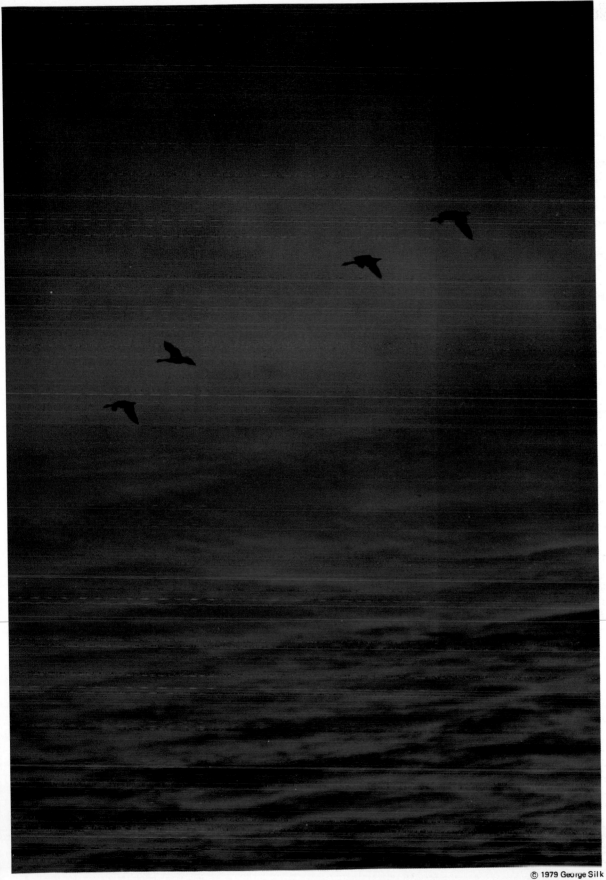

...the beauty of black and white

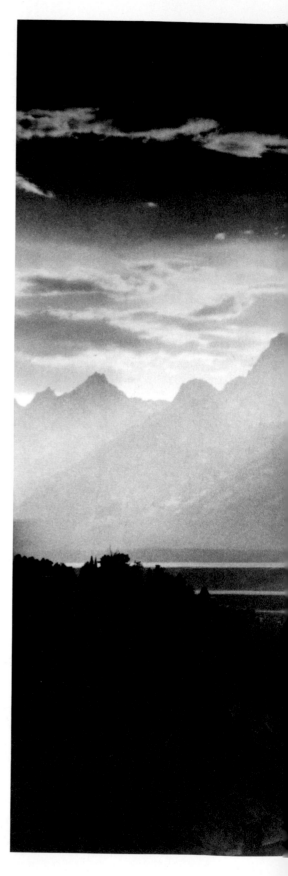

In a black-and-white photograph, the colors produced by light are recorded in terms of their intensity, or brightness, and in the final print we see them as black, white, or shades of grey. As a result, black-and-white photography is a medium as different from color photography as etching or drawing is from painting. To use black-and-white photography effectively, you need to develop an eye for its special qualities.

A black-and-white photograph, by its very nature, is an interpretation of reality rather than an exact rendering. This characteristic is perhaps the greatest asset of black-and-white film, for it is able to reduce an image to pure tonal intensities and affords the photographer great flexibility in interpretation. Frequently, qualities that do not depend on color can be better portrayed in black and white—for example, highlights and shadows, contrasts between lightness and darkness, and certain shapes, textures, and patterns. The lines and planes that we use to judge perspective can also be made more evident in black and white.

For these reasons, scenes that might appear quite ordinary in a color photograph can become strikingly graphic when translated into a play of light and dark tones. The Grand Tetons in Wyoming are photographed by tourists literally thousands of times every year. Yet seldom has the majesty and vastness of the range been better conveyed than in master photographer Minor White's black-and-white shot at right.

Much of the drama of Minor White's breathtaking shot of sunlight breaking through clouds over the Grand Tetons can be attributed to the sheer intensity of light and the striking tonal contrasts. In the foreground, the valley floor and river are reduced to almost pure black and white, while the distant mountains assume subtle gradations of grey.

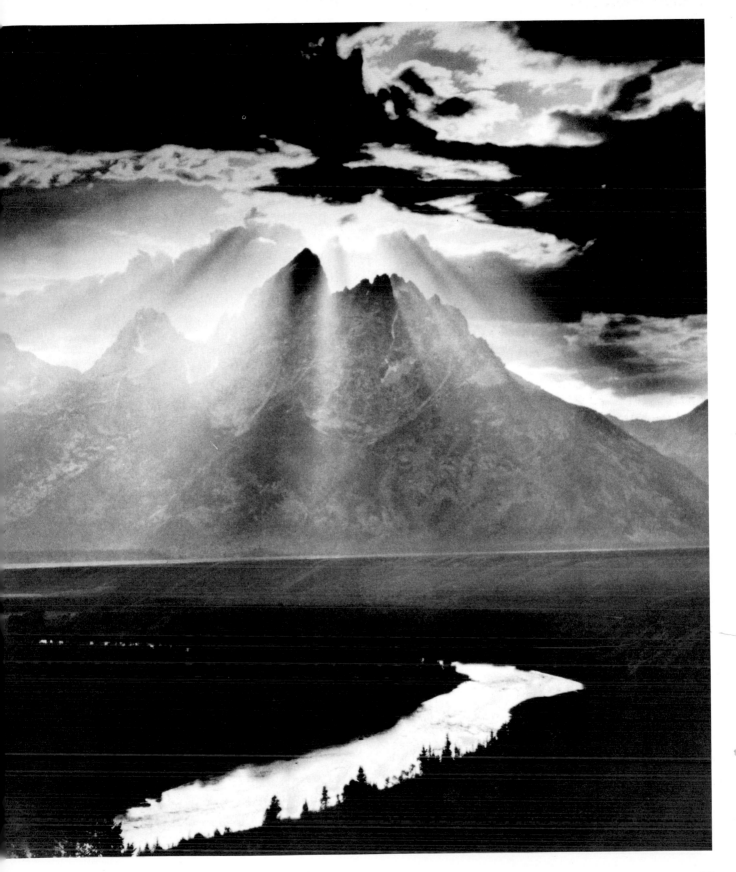

...the intensity of tonal values

In a low-key photograph, such as the shot below of an old brick building, nearly every tone in the picture is dark, from the medium grey corrugated siding on the enclosed stairway to the solid black shadow it casts. Only the sign is white. The resulting mood is bleak, dreary, and decidedly somber.

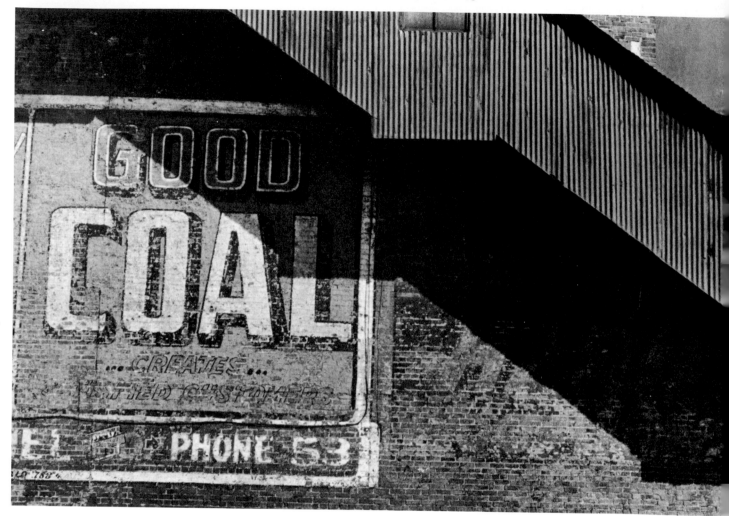

To work in black and white, you need to learn, above all else, to evaluate colors in terms of their intensity—to observe the strength of light, which often determines the range of contrast between brightness and darkness. In brilliant light, you will find a great latitude of tones, and the resulting image will be contrasty, tending to startle the eye. In dimmer illumination, the range narrows and the gradations become more subtle. Highly effective photographs are possible with either extreme, as well as with the tones in between.

As the pictures on these pages illustrate, the range of tones can also affect the mood of a photograph. If lighter tones predominate, the result is a "high-key" picture, which usually conveys a feeling of freshness or dreamy softness. If darker tones are emphasized, the effect of the resulting "low-key" photograph will generally be more somber and brooding.

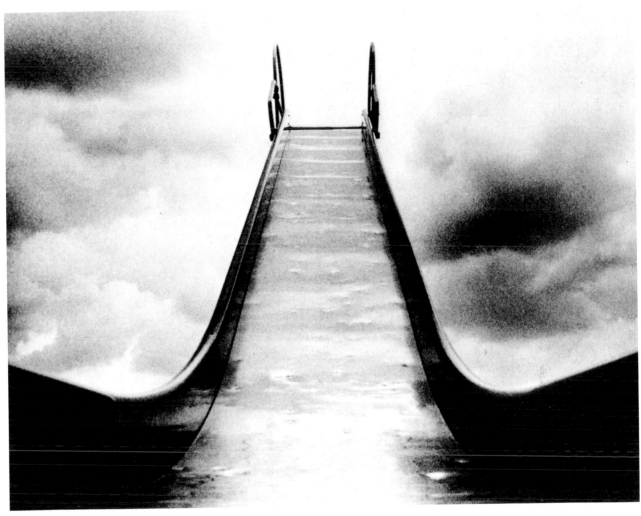

Although this photograph displays too many grey values to be considered a true high-key image, the surreal effect of a gleaming playground slide soaring heavenward is greatly enhanced by the predominance of lighter tones.

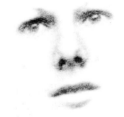

This shot of a woman's face is an excellent example of high-key photography. Every detail in the image, except for the eyes, nose, and mouth, has been reduced to pure white. As a result, the picture has an almost ethereal quality.

Investigate the direction of light

In the photograph at right of a woman and children at a fountain, master photographer Ernst Haas has come in close to capture their gleeful, spontaneous expressions. The low sun behind the subjects causes rim lighting, which highlights the texture of their hair and adds sparkle to the photograph.

As you begin to experiment with light, you'll soon become aware that the direction of the main source of light can greatly affect your photograph. There are three principal ways a subject can be lighted: from the front, from the back, or from the side.

Frontlighting, in which the sun is behind you when you take a picture, provides even illumination and usually results in colors that look natural to us. But since all shadows are cast behind the subject, the image tends to be flat, lacking the shadings that indicate volume and depth. This is an advantage only when you want to emphasize patterns by reducing forms to two-dimensional shapes.

The illusion of three-dimensionality is far more convincingly achieved when the subject is lighted from one side. And, indeed, for most photographs, whether they be portraits, street scenes, or landscapes, sidelighting is the most effective kind of illumination. As the picture of the little girl and her dog at lower right shows, the play of light and shade softens and rounds the subject, yet at the same time reveals details clearly. Sidelighting, especially if it rakes across a surface at a low angle, can also be used to emphasize textures.

Illumination from behind a subject, or backlighting, is tricky to use, but the results can be dramatic. If the light is strong, the subject turns into a silhouette, like the flying daredevil at upper right. If it is weak and balanced by reflections or other light from the front or side, the effect may be rim lighting —a slightly darker than normal subject ringed by a halo of light. The hair of the women in Ernst Haas's fountain scene at far right is an outstanding example of this effect.

Lighting from above, which is most evident at midday when the sun is directly overhead, has only limited use. The shadows it creates are almost always unflattering to both people and scenes.

With light streaming diffusely through the haze and smoke behind him, this backlighted aeronautical daredevil and his biplane are almost completely silhouetted. This reduction to simple forms emphasizes the man's dangerously precarious position on the top wing.

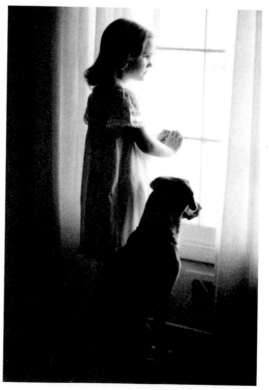

Sidelighting is often used to enhance the roundness of forms, as is demonstrated in this shot of a pensive young girl and her dog. When the light hitting a subject is as strong as it is here, the photographer must take precautions to avoid having shaded areas turn completely black (see page 92).

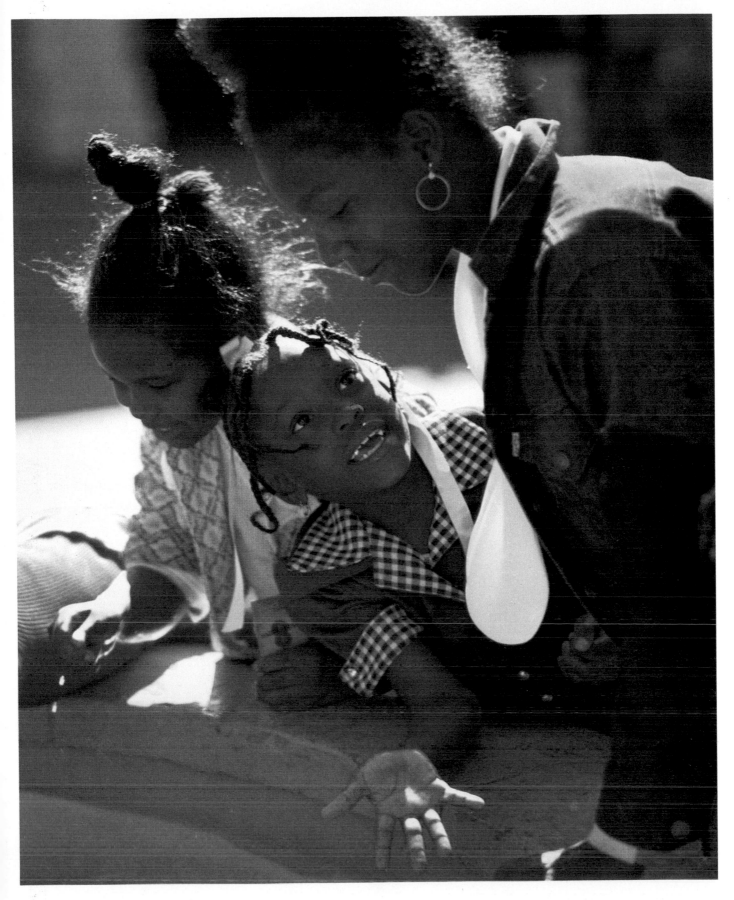

...soft and reflected

Some directional light mixed with a more prevalent diffused light can be highly effective in certain situations. The faint sidelighting on the face of this wide-eyed youngster combines with the overall indirect illumination to play up the rounded form of his face.

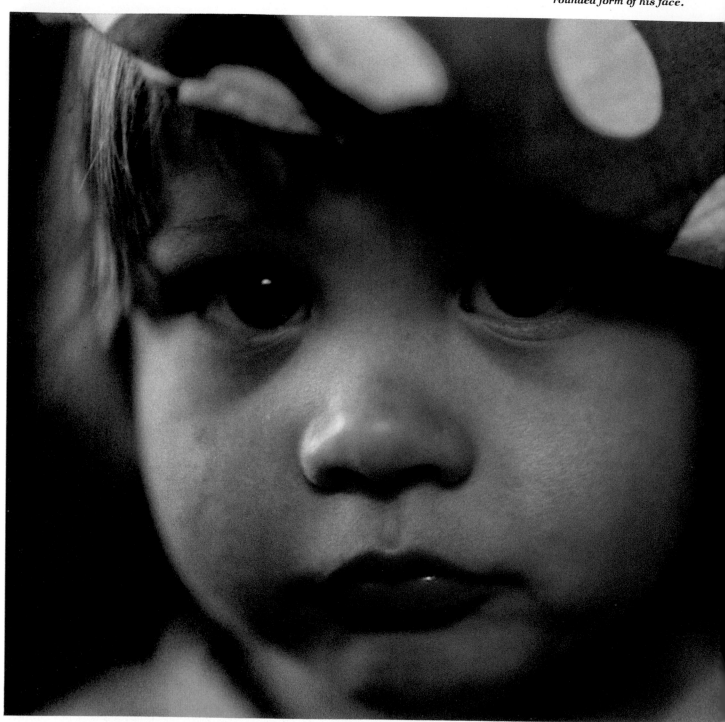

To explore light and use it effectively in your pictures, you must develop an eye for its various possibilities in a wide variety of settings. As the photographs here show, the soft, diffused light created by overcast skies or shaded areas diminishes contrast, accentuates the solidity of forms, and creates more subtly graded colors. It is a form of illumination that is especially flattering to people, for it eliminates harsh shadows and softens facial features.

As it changes throughout the day from dawn to dusk, and throughout the year from season to season, sunlight alters the mood and atmosphere of a scene. And, as we will see on the following pages, these changes follow the predictable cycles of time itself. If you make the effort to study these cycles and tackle the various challenges they present, you will be rewarded by the discovery of many new opportunities for creative picturetaking.

The happy, almost winsome expression of this woman feeding pigeons would have been consumed by shadows if the skies had been bright and clear. In the soft light of an overcast day, however, detail is preserved. Often, diffused light requires longer exposure times than directional light (see page 92), and in this case, it proved to be an advantage—the birds' blurred wings, indicating their frenzied flapping, would have been lost otherwise.

On a bright, sunny day, the canopy of a grove of trees provided a shady setting for this scene of a little girl gleefully watching an elderly woman blow bubbles. In diffused light, colors like the blue in the woman's dress glow with a richness and vividness generally lost in harsh, direct light.

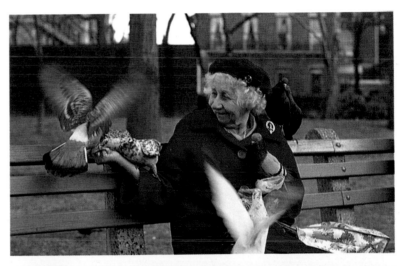

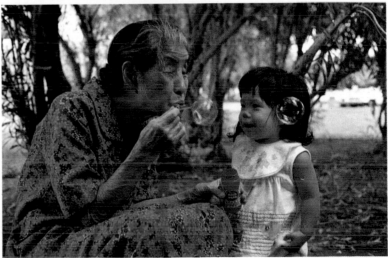

...day and night

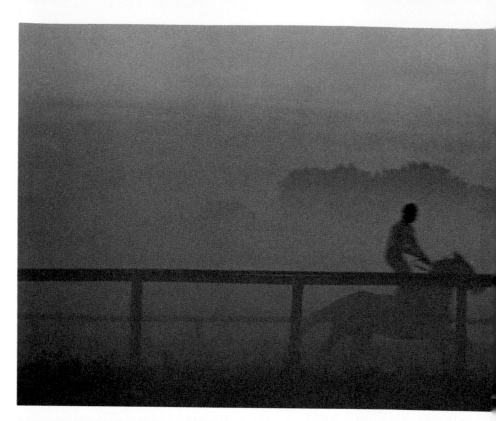

At night, the shadowy shapes
of natural settings are usually
out of the camera's reach. The
best time to take nocturnal
shots, like George Silk's
sailboat on the moonlit Pacific
below, is late in the evening,
before the sky blackens. At
that hour, shapes, like the
trees and the sailboat here,
are dramatically silhouetted
against the lighter sky
and water.

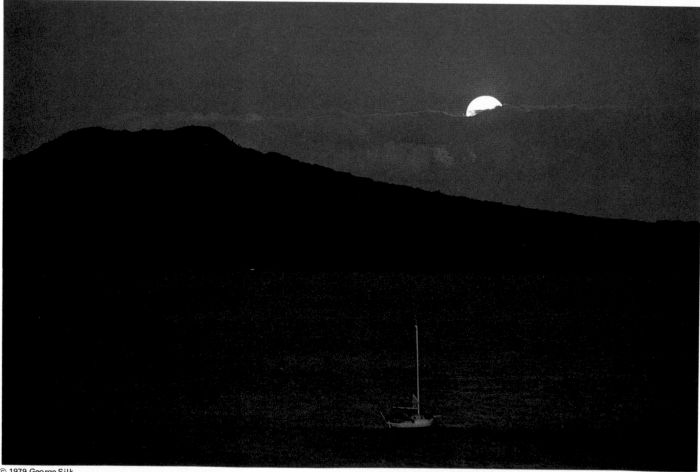

Just before sunrise, the first glow of light creates a world of pearly pastels, an effect that is often heightened by morning mist, as in the shot at left of an early morning ride. Distant forms are barely discernible, and even closer ones, like the rider, become soft-edged silhouettes. As soon as the sun breaks over the horizon, the light will change considerably, infusing the landscape with a warm, golden glow.

In late afternoon, as the sun drops toward the horizon, its rays angle obliquely across a scene. At this time of day, sunlight can be used to sidelight a subject, like the cat shown below, or to reveal the texture of a landscape, as it does with the sand dunes. Shadows lengthen, and the color of light becomes increasingly warm—first yellowish, then golden, then deepening to ruddy hues at sunset and a violet blue at twilight.

...spring and fall

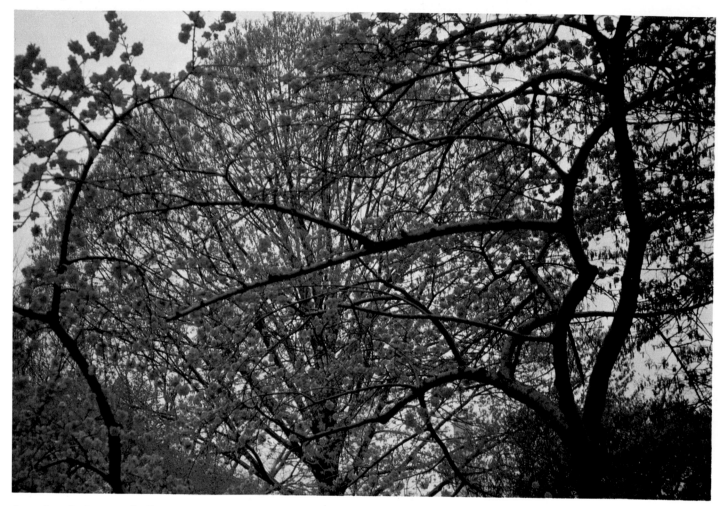

In spring, the days gradually lengthen, and, as the sun climbs higher, its rays are no longer harshly oblique. In quality, the light assumes a sparkling clarity that complements the fresh, pale greenness of new foliage and the fragile pastels and whites of new buds. It is a season of delicately beautiful landscapes, like this grove of dogwoods captured by Ernst Haas.

Autumn, like spring, usually discloses nature at its loveliest, but for quite different reasons. Days shorten, and as the sun lowers in the southern sky, it loses the blindingly intense brilliance of summer light. Frequently, autumn light will also be crisp and clear, but with a faint red hue that echoes the vivid red and golden amber shades of the fading foliage. The resulting landscapes can be fiery—or mellow, as Ernst Haas's autumn scene here shows.

...winter and summer

Winter light, in most parts of the world, is as stark and severe as the bare tree branches that pattern the winter landscape. Harshly angled by a low sun or reduced to a dull grey by leaden skies, it is a light that emphasizes shapes and textures. At the same time, it reveals surprisingly delicate hues amidst the long shadows it casts. Snow, although it can create exposure problems (see page 238), can be especially helpful in simplifying and unifying a scene, as in the shot below of a ptarmigan.

Summer light is intense, direct, and generally unflattering for much of the day. Colors are rich, but reflected glare often obscures them. Experienced photographers usually look for shady settings at midday or take advantage of the cool morning hours and the lingering evening twilight. Sometimes, however, a stark, high-noon shot can be effective, like this southwestern scene of an Indian horsewoman tending her flock.

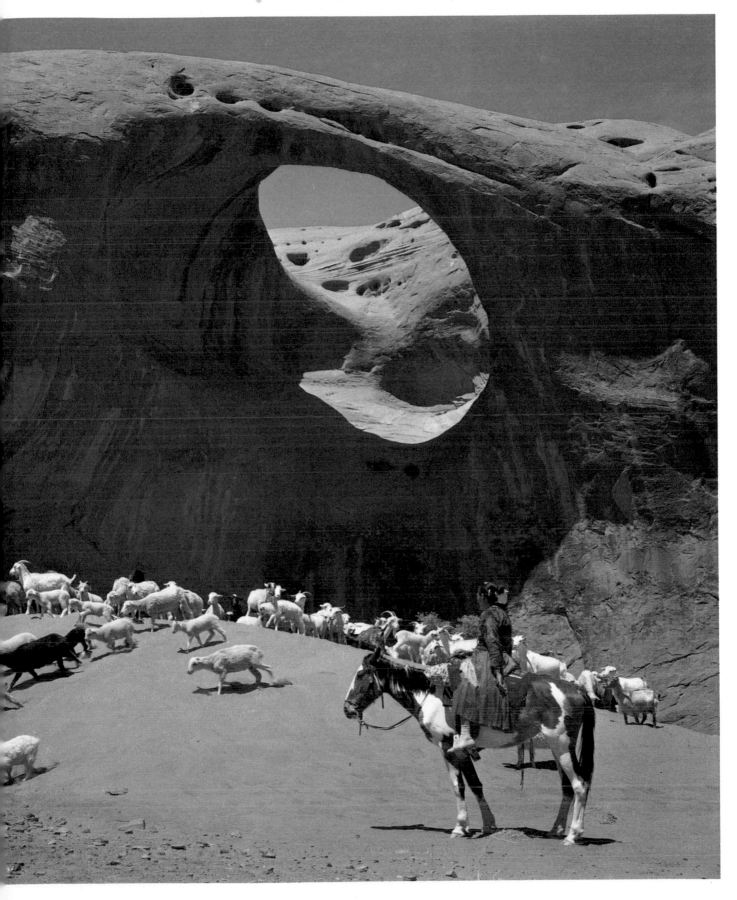

*Born in Kansas and raised in Minnesota, Gordon
Parks began photographing for LIFE Magazine in
1948. He was a staff photographer for nearly two
decades and still contributes to the magazine.
Over the years his style and subjects have ranged
from high-fashion photography to hard-edged
photojournalism to evocative portraits. In
addition to his international reputation as a
photographer, Mr. Parks is an accomplished poet,
author, filmmaker, and composer.*

The personal style of Gordon Parks

"Harlem Gangleader,"
New York City, 1949

I experience, as everyone does, the pleasure
and pain that come with living. But my
utmost joy comes from the freedom to
express my experiences through
photography—to capture my feelings, the
images of my fellow humans, and the nature
of their conditions. I turned to photography
not only as a way to make a living, but to
pursue my desire to be somebody, so that I
might have a voice that people would have
reason to listen to.

One day in 1937, while I was a railroad
dining car waiter working between St. Paul,
Chicago, and Seattle, I wandered into the
Chicago Art Institute. My reactions to the
paintings there were similar to those I had to
the Farm Security Administration
photographs—those memorable documents
of Dorothea Lange, Russell Lee, Walker Evans,
John Vachon, Arthur Rothstein, John Collier,
Jack Delano, Carl Mydans, and others. At a
movie that same day I saw a newsreel of
Japanese planes bombing the U.S.S. Panay.
The cameraman, Norman Ally, stayed at his
post to the end, shooting the final belch of
steam and smoke that rose when the ship
sank beneath the Yangtze River. The grim
directness of his film brought me face to face
with the real horror of war. Fascinated, I sat
through another show, deciding then and
there to become a photographer.

Flavio of the Favella,
Rio de Janeiro, 1961

"The Learning Tree," Kansas, 1963

*The dreams of young boys have
always been important to me,
perhaps because as a child in
Kansas I often allowed myself
the luxury of a lazy daydream
about adventurous cowboys
and the good life. All children
have dreams, whether they're
teenagers in Harlem forced to
live in an adult's world of
harshness and violence or a
small boy in the slums of Rio
who captured the hearts of
LIFE's readers.*

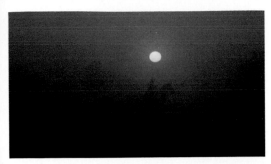

California cowboys, 1954

Back in Seattle I went camera hunting. Abe Cohen's pawnshop had better cameras on its dusty shelves, but the one that suited my taste was a Voightlander Brilliant. I liked its fancy name, and when Abe told me it cost only $12.50 I bought it without bothering to inspect it. I was mildly surprised when he said I would have to buy film for it; somehow that particular necessity had not entered my mind. We spent the next half hour trying to load it.

That afternoon I shot scenes along the waterfront—buildings, people, signs, whatever struck my eye—confident that my efforts would be masterpieces. At a wharf, trying to photograph seagulls in flight, I fell headfirst into Puget Sound and splashed about, hollering for help, until two firemen fished me out with a long pole. I was dripping wet and shivering, but I held on to my Voightlander Brilliant. Undaunted, I dried myself off, bought two more rolls of film, and took pictures until the sun went down.

Eastman Kodak in Minneapolis developed those rolls, and when I picked up my contact prints, a clerk complimented my first efforts. "Keep it up and we'll give you an exhibition," he said. Realizing that I wasn't taking him seriously, he added, "I mean it. You've got a good eye." Still cautious, I thanked him, saying that I would hold him to his word. In the coming weeks I photographed skiers, clouds, women, children, old bearded men, sand dunes, ocean fronts—just about anything I found in front of my camera. Six weeks later Eastman Kodak kept its word: My photographs were exhibited in the window of their downtown store. For me, that's the way it started.

Because of the frustrations of my own early life, I try to share, through my work, the problems of other people around me—regardless of their color or race. I feel a responsibility to point up the plight of those less fortunate than myself—to communicate the abuse of the underprivileged and the insensitivity of those who administer the abuse. Silent watching is not enough, however. I realized long ago that condemnation would have to give way to commitment and that photography was a splendid way to put commitment into practice. My heart would help my eye select the subject of each photograph.

When a *LIFE* magazine editor asked me why black people were burning the ghettos, I loaded my camera with film and pointed it at the impoverished black families suffering through the brutally hot summers and the terrible winters. Their plight was evidence enough for anyone who seriously wanted to understand the problem. Yet, when I photograph these people, ensnared in misfortune, my problem is inevitably one of reporting objectively, without allowing my subjective feelings to take over.

My choice of photography for self-expression was not accidental. When I bought my first camera I was aware of its power to communicate my feelings. The problem was to learn to do it simply, so that I could be understood in China as well as in Missouri, and to release the esthetic and emotional impulses trapped inside me. But photography is different for different people, and rightfully so. To some, just the pleasure of catching the image of something that interests them is enough. Thankfully, all painters and poets are not inspired by adversity and all music isn't composed by those who sing only sorrowful songs. Otherwise few mornings would be worth waking to. I try to strike a balance—to affirm the good and condemn the bad.

Child, Paris, 1950

Joseph Welch, Boston, 1954

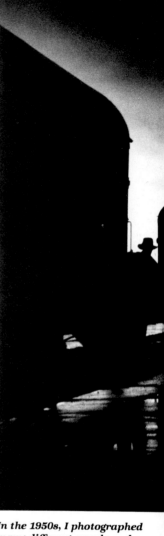

In the 1950s, I photographed many different people and places for LIFE—from a Parisian child at her window to miners in the Yukon to Joseph Welch, the Boston lawyer who defended the Army against Senator Joseph McCarthy's HUAC hearings. This honest man helped defeat McCarthy when he asked him, "Have you no sense of decency, sir?"

One of my assignments took me home to Fort Scott, Kansas, to do an essay on my childhood. It was a nostalgic trip, one that started me on an autobiographical journey that was to end in 1963 with the publication of The Learning Tree.

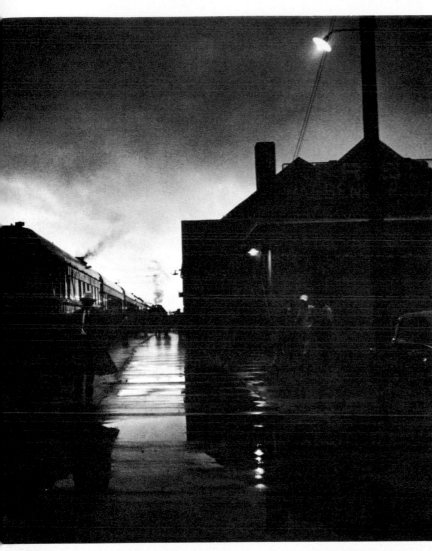

Railroad station, Fort Scott, Kansas, 1950

Uranium miners, Blind River, Yukon, 1955

Child, Chicago, 1953

Paris, for instance, holds a very special significance for me. I love its ancient buildings, its towers and spires, its cathedrals. The ornate bridges along the Seine are beautiful, and underneath them pass barges and boats on the dark, silky water. So many perfected dreams float in the city's pale air: dreams of Proust, Chopin, Liszt, Wagner, Delacroix; dreams that survived the Huns, the Hundred Years' War, the black death, and the Prussians. I sit sometimes at the *Cafe des deux Magots* on the left bank, drinking good red wine and photographing from where Villon, Balzac, or Baudelaire perhaps sat. Other days, from high above the city on Montmartre, I turn my camera to where the classical Paris of Molière sprawls in the soft light of an evening sky; to Notre Dame, where Napoleon was crowned Emperor. Paris is a photographic feast.

Fashion model, Paris, 1949

Paris rooftops, 1964

Reclining model, London, 1951

My photography continued to expand in new directions, and although I never lost my concern for children, especially poor children, I found myself drawn to the romantic world of Paris, where I was assigned for two years. I photographed fashions and Parisian society, and in 1964 I did a Paris essay for LIFE to commemorate the publication of Hemingway's Moveable Feast. Two of the pictures on this page are from that story.

Cafe window, Paris, 1964

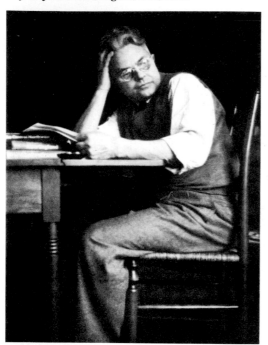

Many people ask me about "American Gothic," my photograph of the black cleaning woman and her broom and mop. Fired by the racial insults I experienced in Washington, D.C., when I first worked there with Roy Stryker in 1942, I found that using my camera against intolerance was not as easy as I thought it should be. To photograph a bigot who refused to serve me in a cafe or to let me enter a theater because I was black wasn't enough. Many bigots have the good fortune to look intelligent. Roy, sensing my frustration, urged me to talk with the black charwoman who cleaned the office on our floor.

This was a strange suggestion, but after Roy had gone for the evening I searched her out and introduced myself. She was a tall, spindly woman with friendly features. Her

The Brooklyn Bridge, 1958

hair was swept back from graying temples, and a sharp intelligence shone in her eyes behind steel-rimmed glasses. Our conversation started awkwardly, since neither of us knew why we were talking together. At first it was a meaningless exchange of words. Then, as if a dam had broken, she began to tell me her life story. It was a pitiful one—her father was lynched and her husband murdered, both by whites—and it was full of the poverty and hardship so familiar to many American blacks.

I finally asked her to pose for me. When she consented, I positioned her before the American flag, Grant Wood style: a broom in one hand, a mop in the other, eyes staring straight into my camera. Stryker took one look at the blowup the following morning and was speechless.

"Well, how do you like it?" I asked eagerly.

He smiled finally. "Keep working with her. Let's see what happens."

I photographed her at home, at work, at church, and just about everywhere she went. "You're learning," Stryker admitted one evening when I laid the photographs before him. "You're showing that you can involve yourself with other people. This woman has done you a great service. I hope you understand this." I did understand.

Since then, I have tried to show—picture by picture, word by word—things as they are: the darkness and the light, the cheerful faces and the disgruntled ones. And what I have photographed is, in large part, what I have come to know about our universe and the people who inhabit it. What I have not photographed is what I have yet to learn.

Gordon Parks
New York City
1979

Facade of Notre Dame Cathedral, Paris, 1963

Austrian-born Ernst Haas is an acknowledged master of color photography whose ability to record action in its many moods has gained him worldwide recognition. In 1947 he produced a black-and-white exhibit on the returning prisoners of war in Vienna; two years later he joined Magnum in Paris, and in 1950 he came to the United States. He is a frequent lecturer on photography and is the author of The Creation *and* Himalayan Pilgrimage.

The personal style of Ernst Haas

For me, photography *is* joy, yet joy is not identical with happiness. In life, as in photography, joy is a most contagious force, one that can heighten all your senses— seeing, listening, smelling, tasting, touching. Joy makes you open and vulnerable, but it will also heal your disappointments. It is silent but shining; it is gaiety with a little gravity. It is more a smile than a laugh.

Joy is an inspirational force that intensifies existence. It is able to guide your heart, your eyes, and your hand when you release the camera shutter. The subject is unimportant; what you have framed speaks because you have photographed it.

A photographic image creates a story that was never intended to be told. It is a lie telling the truth, a yes and no at the same time, an is and an is not. Call it a poetic moment in which "as if" creates new life. Take the pigeon, who, in the hand of a stony saint, seems to be having a peaceful discussion with an old friend. In the split second of a photograph, one can relate the unrelated. When a little girl feeds pigeons at San Marco in Venice, her fear turns into joy. Every thriller is based on this human paradox, the joy of fear. Neither positive nor negative, joy can go in many directions at once.

Piazza San Marco, Venice, 1975

Shopping center, central Florida, 1971

Macy's Thanksgiving Day Parade, New York City, 1976

Paris, 1973

Once you have mastered a few basics, taking pictures becomes easy. But to see pictures—to really see, so that your vision convinces—is the more difficult and more important achievement. The joy of seeing with a camera is that you will see the special message of scenes that others may pass by.

To have this photographic vision, you must be alert. Everything is boring if you are bored. The frame of a camera's viewfinder is like a window onto the world that we carry with us wherever we go. It is this frame that becomes our discipline in seeing.

Photographing well, then, is only a step to seeing and enjoying more without a camera. Through photography you will learn to judge lines, shapes, and most important, colors, and to see their harmony or discord, their rhythm, and their beauty. The juxtaposition of objects in a picture should create an image that conveys your feelings as well as your thinking about the scene. Like the row of grocery carts and their benevolent sun, or the Michelin rescue sign posted over a definitely unrescued car, a scene can be amusing and still tell us something about ourselves and the way we live.

Father and daughter, Cologne, West Germany, 1973

Farewell, Munich, West Germany, 1973

Photography is a universal medium, a language that needs no translation. If art is aristocratic, photography is its democratic voice. It is a medium for all people, perhaps because it so effectively conveys the subtleties and complexities of people's feelings for each other. In a railroad station scene in Munich, Germany, for example, the camera juxtaposes those who don't want to go with one who, in her thoughts, seems to have already arrived at her destination. And the joyous but reluctant father–daughter embrace speaks of the age-old love game of resisting what both sides want.

I delight in photographing people; they make the pictures we relate to most. They can make us happy or mad or mournful. Most of all, they say, "Look, here's someone who feels the way I do."

There are secrets to capturing people on film. First you must learn to observe and anticipate. People's expressions and movements are fleeting. Only the well-prepared photographer comes away with the one image that best speaks of a person or group. Don't torture yourself with too much equipment. It will tire you and cripple your concentration.

You must learn to be unobtrusive and not to interrupt or influence people's actions. Don't dress too colorfully, either. You want to see without being seen. Try to become invisible. If people do notice you, let them know that you feel compassionate toward them, and chances are they will let you photograph them. Smile, and you will get a smile in return.

Sharpen your instincts. Learn when to work from a distance and when to get closer, when to talk and when to be quiet, and when *not* to photograph. Most important, learn when to quit. Only practice can teach you these things.

I never really wanted to be a photographer. It was a compromise that slowly grew out of a boyhood desire to combine two goals: explorer and painter. I wanted to travel, see, and experience, but was overwhelmed with too many constantly changing impressions. What better profession could there be than that of a photographer, who is almost a painter in a hurry?

My inspiration and influences came much more from all the arts than from photography magazines alone. There are two photographers I really admired. One was Henri Cartier-Bresson. He became a friend and made me aware of the hidden geometrical structure in a picture as well as of that certain decisive moment when form and content seem to melt into each other. The second photographer was Edward Weston, who in his work taught me how to create a still life filled with a pulsating energy.

But soon I was forced to use all these formulas for a new dimension, which was the world of color. Black-and-white photography is a subtraction, a reduction of color to tones of black, white, and grey. It is a form I respect, and I have never quite understood why it should compete with color photography in strength or merit. But with the possibility to express a world of color *through* color, I had to search for a composition in which a color photograph became much more than just a colored black-and-white picture. In this new world of color I was without great influences and much more dependent on what painters, old and modern, had to teach. This fascination goes back almost twenty-five years.

Monarch butterflies, Monterey, California, 1971

Since I began using a camera, pure documentation was never enough for me. I have always felt that every picture should have the pulse of life and be imbued with what is, what has been, and what will be.

The first color film, KODACHROME, was, compared with today's films, a very slow one, and it forced me, by its sheer insensitivity, to use very slow shutter speeds when I was photographing movement that took place in shaded areas. This led slowly to an experiment in which, by stretching the moment and panning the camera parallel to the moving subject, I arrived at a visual solution that expressed motion in a more dynamic language.

As a photographer, I think of my pictures as pieces of a great mosaic. As I work, I think of this mosaic and see its empty spots. That way I know what's missing, what my mosaic needs.

When you photograph something, don't accept it as the end result; there's always a next step. But repeat something only if you can improve on it. Otherwise, you must move on. A photographer must change to show change, and it is as much the photographer's challenge to show change as it is to preserve what is. A picture must be a question as well as an answer.

Ernst Haas
New York City
1979

Wild mustang, Nevada, 1960

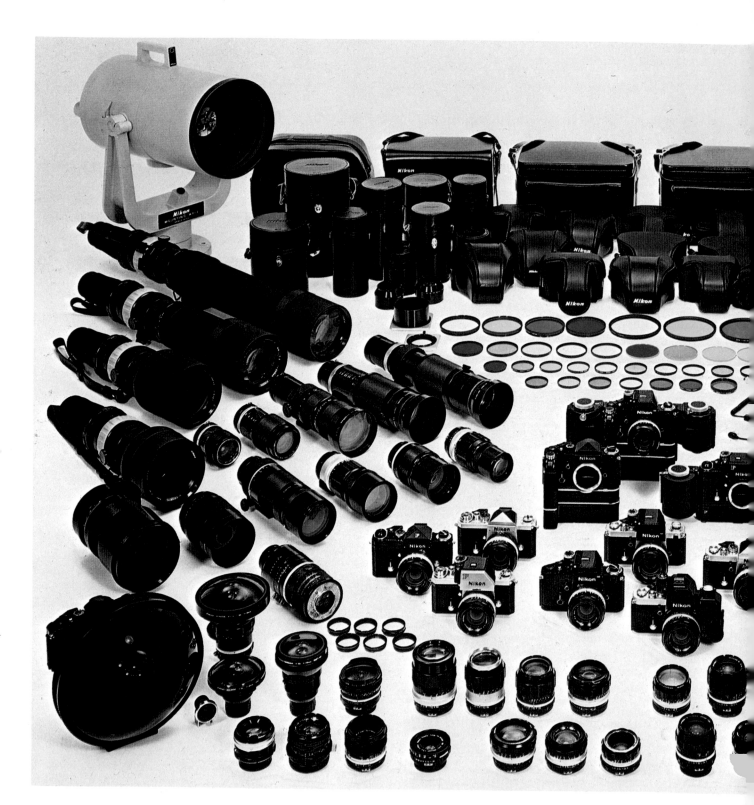

The
Tools

Cameras

Film

Lenses

Filters

Flash

Accessories

**The Photographer's
Most Common
Problems**

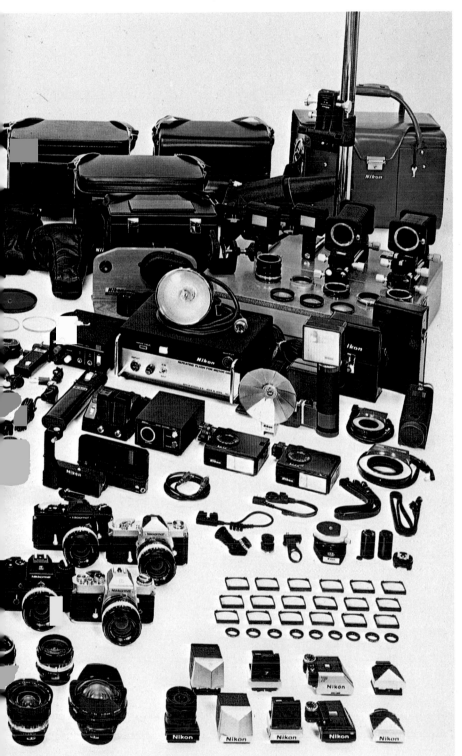

*The family of 35 mm camera
equipment is large. Cameras
come in a variety of models,
and most manufacturers also
offer a wide array of accessory
equipment—lenses, filters,
cases, flash attachments, and
other devices. In some
instances, equipment from one
manufacturer's line can be
used with cameras from
another maker, although you
may need to invest in
adapters. Before you buy a
camera or other photographic
equipment from any
manufacturer, read the tips on
buying a camera on page 81.*

Cameras

Types of Cameras

During the last quarter century, the 35 mm camera has become the most popular choice of both professional and serious amateur photographers. Its versatility coupled with its ability to capture many high-quality images on a compact roll of film recommend it for a variety of uses. Developed in the 1920s by the E. Leitz Optical Company of Germany, the 35 mm camera today comes in models ranging from simple, vest-pocket cameras to complex instruments that can be used with a wide array of auxiliary equipment, such as the system shown on the preceding page. Basically, however, there are two types of 35 mm cameras: the rangefinder and the single-lens reflex (SLR) models.

The simplest, smallest, and usually least expensive 35 mm cameras are the rangefinders, often called compacts. The chief distinguishing characteristic of these cameras is that the viewfinder optics, used for framing and focusing, are separate from the lens. For most pictures, the image you see through the viewfinder is the image being recorded on film. When you move in for a close-up, however, the rangefinder lens and viewfinder do not see the same area. This is called parallax. Although most rangefinders have parallax marks to guide you in this situation, extra caution is needed to avoid inadvertently cropping any part of your subject. Also, since this viewfinder cannot show the effect of changing lenses, most rangefinder cameras are designed with a permanently mounted lens. This lens has a relatively wide field of view, which makes it good for all-purpose picturetaking—especially landscapes and group portraits.

The single-lens reflex camera, on the other hand, solves these problems by incorporating a mirror and prism that allow you to view a subject through the same lens that takes the picture. Although this addition makes the camera heavier, more complicated, and as a result, more expensive, it dramatically increases the camera's potential. In a close-up, for example, you'll be able to see exactly what you are shooting. With an SLR, you can use auxiliary wide-angle lenses to encompass large scenes and telephoto lenses to bring distant objects near. Most SLR cameras accept a myriad of accessories for any number of specialized applications, and with each lens or filter, the viewfinder will show you exactly what will be recorded on film.

Both rangefinders and SLRs are available in automatic as well as manual models. Nearly all modern 35 mm cameras have a built-in light meter. This device measures the intensity of the light in a scene and indicates when the two exposure variables—the shutter speed and the aperture opening (see page 90)—have been adjusted properly for that light and for the film you are using. On a manually operated camera, you must adjust both controls. On most automatics, however, you set only one and the camera's miniaturized circuitry calculates the other and sets it for you. On the models known as shutter-priority automatics, you set only the shutter speed; on aperture-priority automatics, you adjust only the aperture. On some completely programmed automatics, you have your choice—the camera can set either control. Many automatics also have an override feature that permits you to switch to manual operation. This gives you the freedom to deviate from the meter reading to achieve a special effect or to compensate for an unusual lighting situation—for example, to avoid having a backlighted subject recorded as a dark silhouette.

A high percentage of recently introduced rangefinders are automatics with a manual override, a feature that does not add a lot to their cost. For SLR automatics, which can nearly always be switched to manual mode, the price may be substantially higher, but it depends very much on what other features the camera offers.

The camera that started the 35 mm boom—the first Leica camera, introduced in 1924—is shown in the foreground above. Behind it is one of the most recent automatic single-lens reflex cameras. At right are shown two current 35 mm models. In the foreground is an automatic single-lens reflex camera. Behind it is a rangefinder, also automatic in operation.

Buying a Camera

When you buy a camera, here are some things to keep in mind:

▶ Do you want the compactness and convenience of a rangefinder or the greater picturetaking potential of a single-lens reflex? Both use the same films and can give virtually identical results in normal situations. If you shoot only a few rolls a year on vacations and at family gatherings, an inexpensive rangefinder may suit your needs. If you want to experiment with lenses, you should have an SLR.

▶ Do you want an automatic or manually operated model? Automatics leave you free to concentrate on the subject and composition, while manuals give you more control.

▶ Research what models are available. Talk to other photographers; read photo magazines; send for manufacturer's test reports and brochures. Additional features usually cost more. Decide whether you need a top shutter speed of 1/1000 second instead of 1/500 or a maximum lens aperture of f/1.4 instead of f/2 (see pages 82 and 83).

▶ If you are getting an SLR, you'll probably want to add lenses and other accessories eventually. Although you may find some good "bargain" prices, the model in question may be phased out and may be incompatible with new gear.

▶ When you've narrowed the field to a few models, take ample time to check out the cameras themselves. Are the controls easy for you to operate? How about with gloves on? Is the viewfinder sufficiently bright for easy focusing? Is the light meter display clearly discernible?

Cameras

A Camera's Lens

The lens is by far the most important element in a camera. Its function is to collect and bend light rays onto film, so that you will get a sharp, correctly colored image of whatever you photograph. If you've ever looked through an ordinary magnifying glass, you've probably noticed that colors viewed through the lens tend to separate, giving the magnified objects rainbowlike edges. The same thing happens in a camera's lens. By bending and redirecting the light, the many glass elements in the lens, which are precisely assembled at specified distances and orientations, correct both the distortions in shape and the aberrations in color. In addition, the metal tube that holds the collection of glass elements is itself a complexly engineered product, with controls that allow you to adjust the amount of light passing through the lens and to focus.

The control that enables you to adjust the amount of light reaching the film is the **aperture ring.** Its location varies from camera to camera. On the lens shown at far right, the aperture ring is the control closest to the camera body. On some cameras, it is the most distant ring. Whatever its position, the aperture ring controls an adjustable diaphragm—a series of overlapping metal blades that together operate much like the iris of the eye. The size of the opening created as the blades open and close determines the amount of light passing

The 35 mm camera above was cut in half to expose the intricate workings of the lens and camera body. The lower view and the picture of the camera at the top of this page show the markings on the outer ring of a lens. Both indicate the lens's focal length and maximum aperture; the lens on the cutaway camera has a serial number as well.

through. The diaphragm can be opened to let in all the light the lens collects or it can be closed down to let only a tiny dot of light through. And, of course, it can be adjusted for any amount of light in between.

The size of this opening, or aperture, is usually indicated in f-numbers—typically 1.4, 2, 2.8, 4, 5.6, 8, 11, and 16. The larger the number, the smaller the opening. On most lenses for 35 mm cameras the smallest aperture is $f/16$. The largest aperture varies, but on most current models it is at least $f/2.8$ for the camera's normal lens. On more expensive models, it is often $f/2$ or even wider. The difference between f-numbers, commonly called f-stops, may seem minor, but $f/2$ actually admits twice as much light as $f/2.8$—a great advantage when you are shooting in dim light. The other f-stops have a similar relationship. As you adjust the aperture from a high number to the next lower one—from $f/11$ to $f/8$, for example— you double the amount of light. Conversely, when you go from lower to higher—from $f/8$ to $f/11$—you decrease the light by half. This is true for all but a few odd maximum apertures, most notably $f/1.8$ and $f/3.5$.

F-numbers are arrived at by a formula based on the ratio of the size of the opening to the lens's focal length. The focal length of a lens is an optical measurement that determines the degree of magnification and the area of view. The lens on most compact rangefinders has a focal length between 35 and 45 mm, whereas SLR normal lenses have a focal length between 50 and 55 mm.

Lenses with a focal length longer than 55 mm are telephoto lenses. A subject photographed with a telephoto appears to be closer to the camera than it actually was. In addition, less of the total scene is recorded than would be captured with a normal lens. Lenses with a focal length shorter than 45 mm are wide-angle lenses. They include more of a scene than a normal lens would.

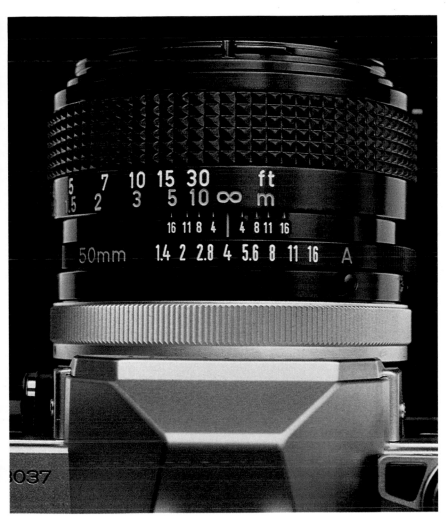

An overhead view of a normal lens on a 35 mm camera shows, from top to bottom, the focusing ring (with distances indicated in both feet and meters), the depth-of-field scale, and the aperture ring.

As a result, subjects appear to be farther away from the camera than they actually were. (See pages 104 to 107 for more information on telephoto and wide-angle lenses.)

Both the focal length and the maximum aperture of a lens are engraved on the ring around the front of the lens. The lens in the picture at left above, for example, has a focal length of 50 mm and a maximum aperture of 1.4. Note that the aperture is usually written as a ratio. Here it is 1:1.4.

The other control on the lens is the *focusing ring,* which moves the glass elements in the lens closer together or farther apart to sharpen the image of your subject. On the lens shown at left, it is the ring closest to the front of the lens. The numbers inscribed on the focusing ring make up a simple scale that indicates the subject-to-camera distance in both feet and meters when you have focused the lens sharply. Most normal lenses can focus from as close as two or three feet to as far away as the eye can see, which is usually called infinity and marked ∞. When you rotate this ring until your subject appears in focus through the viewfinder, the number at the center of the lens, opposite a stationary slash or dot, is the distance to your subject.

Surrounding this center mark on most SLRs is a series of lines with numbers (or colors) corresponding to the *f*-stops. This is the depth-of-field scale, which shows how the zone of sharpness in a scene changes when you change the aperture. The scale indicates the amount of picture area in focus at a particular *f*-stop and subject-to-camera distance. In general, when you focus on a subject using a small aperture, such as *f*/11 or *f*/16, much of the area in front and in back of your subject will also be sharp; with a large aperture, on the other hand, such as *f*/2.8 or *f*/2, very little more than your subject may be in focus. How to read this very useful scale is explained in detail on page 94.

Cameras

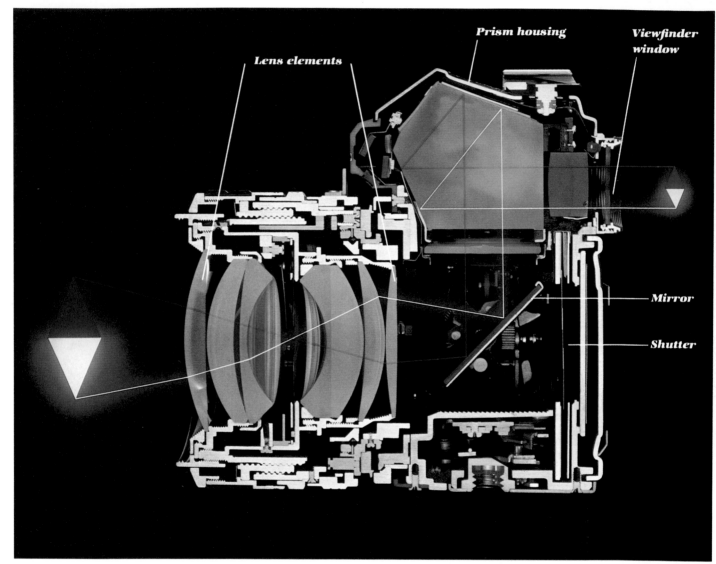

Prism housing **Viewfinder window** **Lens elements** **Mirror** **Shutter**

The combination of an angled mirror in the camera body and a prism housing on top of the camera allows you to see through the lens of a single-lens reflex camera. The red and white lines in the cutaway view here indicate the path of the light from the lens to the window of the viewfinder. During exposure, however, the mirror flips up, permitting light to pass directly through the shutter and onto the film.

Inside a Camera

When you look in the *viewfinder* of a single-lens reflex camera, you are actually seeing through the lens. The cutaway section at left shows how an image is transported through the lens to both your eye and the film. Following the red and white lines, you will see that as the light rays collected by the lens enter the camera body, they are reflected upward by an angled mirror into a prism housing on top of the camera. The image coming through the lens, however, is reversed, with the white line on top and red on bottom. To correct this and to direct the image into the viewfinder, the rays are reflected back and forth within the prism and then through the viewfinder. As a result, the scene you see is exactly the one that will be captured on film.

When you press the shutter button to take a picture, the angled mirror, which is hinged at the top, flips upward to permit the light to pass into the camera. Simultaneously, the *shutter,* a pair of curtains just in front of the film, opens to let the light hit the film. The shutter remains open for a precise amount of time, which is determined when you set the shutter speed. At 1/250 second, for example, the exposure time will be far shorter than if your shutter speed is set at 1/8 second. As soon as the shutter closes, the mirror drops back into its normal viewing position. Because the mirror rises to allow the image to pass through to the shutter and then to the film, the viewfinder goes black momentarily when you take a shot.

Most modern SLRs have a built-in *exposure meter* that reads the light reflected by a subject and helps you to determine the correct aperture and shutter speed. One or more photocells located in the light path measure the intensity of the light and relay the information to a device visible in the

So that all parts of the film image receive the same amount of light, the SLR focal-plane shutter has one curtain (top) that covers the shutter opening before exposure. When the shutter is released, the curtain is rapidly pulled downward (second picture). A second curtain (bottom three pictures) completes the exposure by springing up from the bottom.

viewfinder—usually a centering needle or a series of light-emitting diodes (LEDs). When the needle is centered or the middle light is bright, you have set the aperture and shutter speed in a combination that will give you a correctly exposed image (see page 90).

A rangefinder camera works quite differently from an SLR. Although there is a mechanical link between the lens's focusing ring and the viewfinder, it is optically separate from the lens. When you look through the viewfinder, you see two images coming from a pair of windows on the front of the camera. To focus, you simply turn the focusing ring until the two images coincide. Except in the case of very close subjects, the area shown by the viewfinder is almost the same as the one being taken in by the lens. Unlike most SLRs however, a rangefinder cannot show you what is happening when you focus selectively to sharpen one part of the image, leaving the rest blurred.

Most rangefinders differ from SLRs in two other ways. Instead of a curtain-type shutter, rangefinders have metal leaves that are located in the lens and look somewhat like the aperture diaphragm. This is an advantage, since it allows you to use flash with a greater number of shutter speeds. Also, although the meter display in the viewfinder is much the same as in an SLR, the photocells for a rangefinder's exposure meter are located on the outside of the camera, either on the ring around the front of the lens or on the camera body near the viewfinder.

To move the film out of the magazine, across the picture area, and onto the take-up spool, both types of cameras have similar *film transport mechanisms,* as we will see in the section on loading the camera (see page 89).

Cameras

Outside a Camera

The exteriors of most 35 mm cameras have an impressive number of dials, levers, rings, and other controls. But they are all easy to use once you understand their functions. Two of the most basic controls, the focusing and aperture rings, are on the lens; their functions were detailed on pages 82 and 83. The other basic control, for shutter speed, allows you to choose the amount of time that the shutter will remain open. On the automatic single-lens reflex camera shown here, the **shutter-speed dial** is a ring around the lens mount. On other cameras, it may be a dial on top of the camera body. Shutter speeds are usually marked as 1000, 500, 250, 125, 60, 30, 15, 8, 4, 2, 1, and B. Most represent fractions of a second—1000 stands for 1/1000 second, 500 for 1/500 second, and so on down to 2 for 1/2 second. The number 1 represents a full second. If you set the dial on B, the shutter remains open as long as you hold down the shutter release button.

Another important control is the **shutter release button** itself, which you press to take a picture. It is usually located on the top of the camera, about a quarter of the way in from the right, where you can push it easily with your right index finger. Most shutter release buttons are threaded to accept cable releases, an accessory that enables you to trigger the shutter from a distance (see page 146). Many cameras also have another shutter release, the **self-timer** lever, which permits you to delay the exposure for eight to ten seconds and thus include yourself in the photograph. On the camera shown here, the self-timer is located on the camera front; on some other models, it is located on the top.

Most cameras have a device called the **film-advance lever,** located on the righthand side of the top of the camera. When you move the lever, an unexposed frame of the film moves forward out of the magazine, into position for the next picture. At the same time, the number of pictures, or frames, that

have been exposed on the roll is indicated on a **film-frame counter** adjacent to the lever. On the left side of the camera top is the **rewind knob,** used for winding the film back into its magazine. Often you must pull this knob upward before you can release the fold-out crank used to rewind the film. The rewind knob will not work until the advance lever has been disengaged. On this camera, the **rewind release** is a lever on the front, but it is often a small button on the bottom.

Most modern cameras also have two controls for their built-in exposure meters. One lets you adjust the meter for the sensitivity of your film. On the camera shown here, this **film-speed dial** is the large knob to the right of the prism. On other cameras it is located around the rewind knob or on the lens mount. You should set this dial to match the ASA speed of the film you use (ASA speeds are explained on page 100). The other control is simply a switch for turning the meter on or off. Here, it is on the top between the rewind knob and the prism. On this model, you can also choose between automatic or manual operation of the camera. The locations of this switch and of the exposure mode selector vary greatly.

To synchronize an electronic flash unit with the shutter, most cameras have two places for connecting flashes: a **hot-shoe** outlet for mounting a flash directly on top of the prism, and another outlet for a cord on the front of the camera. By fitting the flash unit into the shoe you establish the electrical connection between flash and camera (see page 138). SLR cameras often have two other controls on the camera's front or top: a **depth-of-field preview button** that lets you view the scene through the actual aperture size to see the area of sharpness in the picture, and a **lens release button** that permits you to unlock and remove the camera's lens. The back and bottom of a camera are described on the next page.

This advanced single-lens reflex camera, which can be operated either automatically or manually, has about as many controls and other devices as you are likely to encounter on any 35 mm camera. The position of some, like the film advance lever and the rewind knob, are the same on all cameras, but the location of others varies greatly from model to model. Some cameras combine functions—for example, on many cameras, turning the film advance lever slightly switches on the light meter. The best guide to a particular model is the instruction book that comes with it.

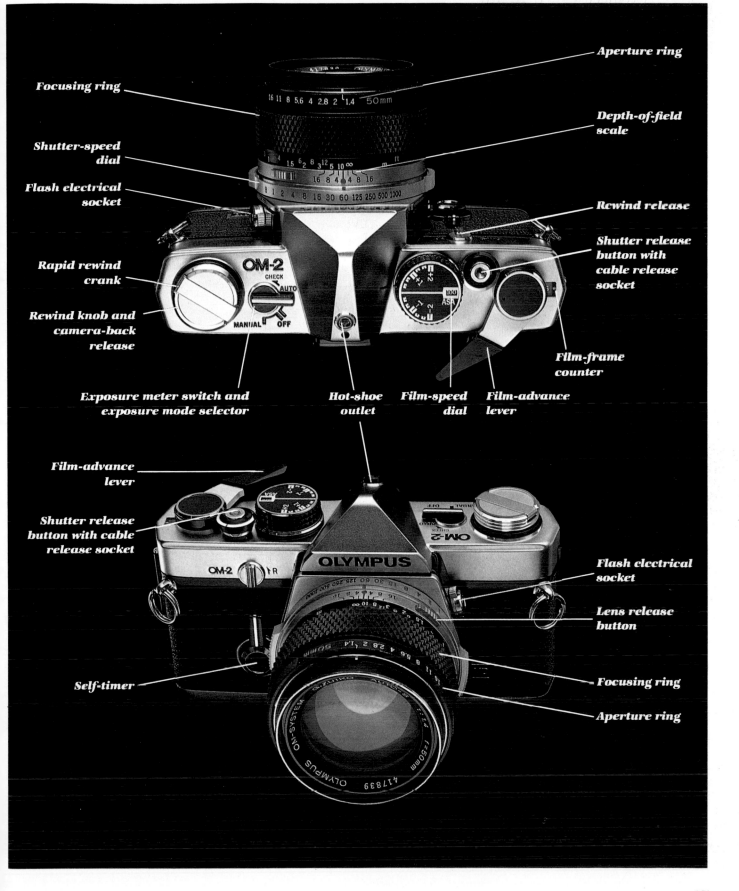

Aperture ring

Focusing ring

Depth-of-field scale

Shutter-speed dial

Flash electrical socket

Rewind release

Shutter release button with cable release socket

Rapid rewind crank

Rewind knob and camera-back release

Exposure meter switch and exposure mode selector

Hot-shoe outlet

Film-speed dial

Film-advance lever

Film-frame counter

Film-advance lever

Shutter release button with cable release socket

Flash electrical socket

Lens release button

Self-timer

Focusing ring

Aperture ring

Cameras

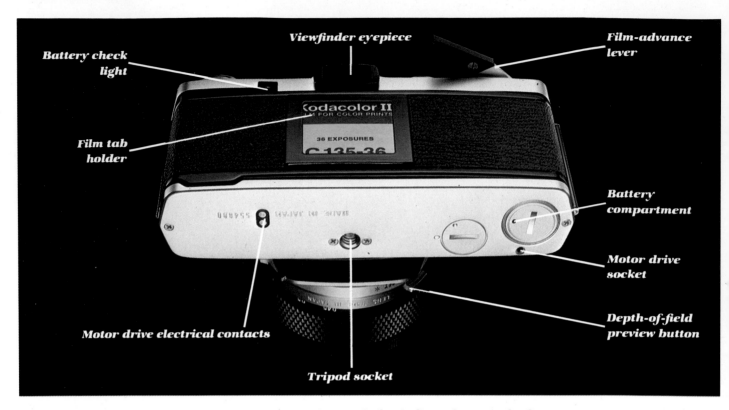

- Viewfinder eyepiece
- Film-advance lever
- Battery check light
- Film tab holder
- Battery compartment
- Motor drive socket
- Motor drive electrical contacts
- Depth-of-field preview button
- Tripod socket

Outside a Camera

Although the back and bottom of a 35 mm camera have far fewer elements than do the front and top, it is equally important to understand their functions. The most significant feature on the back is the *viewfinder eyepiece*, which you look through when you compose and focus a picture. On a single-lens reflex camera such as the one shown here, the viewfinder eyepiece is located behind the prism in the center. On most rangefinders, the viewing window is positioned more toward the left. If you wear glasses and have trouble seeing through the viewfinder with them on, you may wish to investigate the possibility of getting a corrective lens for your camera's eyepiece.

Also on the back of the camera shown here are the *battery check light,* which lights

up when pushed to indicate the strength of the battery that powers your exposure meter, and the *film tab holder,* a metal frame designed to hold one end of a film box, a handy way of remembering the kind of film you are currently using. A film tab holder also can be purchased as a separate accessory. The mechanism for opening the back of the camera varies from one model to another. On this model, the back springs open when you pull up the rewind knob. On others, a small *release tab* on the lower left corner of the camera back unlocks it.

On the bottom of nearly all modern 35 mm cameras is a *battery compartment* for the battery used to power the exposure meter. The lid covering it can usually be unscrewed with a coin. You should replace the battery at least once a year; leaving it in any longer may cause corrosion. All cameras also have a *tripod socket,* which is used not only for mounting the camera on a tripod, but also for attaching a motor drive or an automatic winder, devices described on page 146. The camera bottom may also have electrical contacts for attaching either of these units and another screw-out lid covering the opening where they connect with the camera's film drive.

This view shows the back and bottom of the same single-lens reflex camera that appears on the preceding page. From this angle, you can see the depth-of-field preview button on the lens, which was not visible in the earlier pictures.

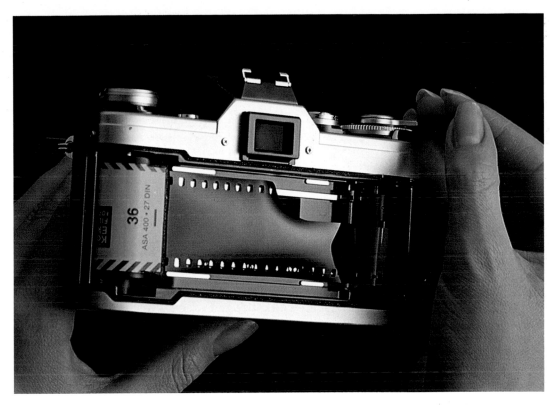

Loading a Camera

Loading film in a 35 mm camera is relatively easy; after doing it a few times, you'll find that it becomes almost automatic. Although some steps may differ for individual cameras, the procedure here is the most common.

▶ Set the camera's film-speed dial to the ASA number indicated on the film box or instruction sheet.

▶ Take the film magazine (or cartridge, as it is often called) out of its packaging and open the back of the camera.

▶ Pull up the rewind knob and insert the magazine in the left side of the camera. Make sure that the spool end coming out of the magazine is pointed downward and that the leader strip—the narrow strip of film sticking out of the magazine—is pointed toward the take-up spool on the right.

▶ Secure the magazine in place by pushing down the rewind knob. Turn the knob slightly until you feel it drop into place.

▶ Pull a slight amount of film out of the magazine and thread the leader strip over the sprockets onto the take-up spool. These spools vary, so follow your camera's instruction manual.

▶ Using the film-advance lever, move the film forward one frame, as shown above, to make sure the take-up spool has a good grip on the film. It's a good idea to advance the film one or two more frames until both sets of perforations are engaged by the sprockets next to the take-up spool.

▶ Close the back of the camera. Then, to take up any slack in the film, gently turn the rewind knob clockwise until you feel a slight tension. Advance the film and press the shutter release two or three times until the number 1 appears in the film-frame counter on the top of the camera. To make sure that the film is moving smoothly through the camera, check the rewind knob as you advance. It should be turning in a counterclockwise direction.

▶ To take out the film after you finish the roll, activate the rewind release, which is either a lever on the front or a button on the bottom of the camera. Fold out the crank on the rewind knob and turn it slowly clockwise to reel the film back into the magazine. Open the back and remove the magazine.

When you're loading your camera with film, be sure the top and bottom perforations are aligned on the take-up spool and that they catch firmly on the sprockets.

Cameras

 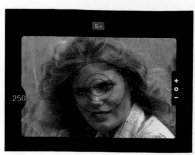

Setting the Exposure

Films differ greatly in their sensitivity to light. Some require a lot of light to record an acceptable image, while others need much less, as we will see later in the section on film (see pages 96 to 101). If your film receives the proper amount of light, the final image will be balanced in both color and tone. But, as the series of pictures on the facing page demonstrates, if the film gets too much light, the image will be light-toned and washed out; and if it gets too little light, the image will be dark and muddy. To avoid overexposure or underexposure, it is very important to understand how to use the two controls on your camera that adjust the amount of light reaching the film—the shutter speed and the aperture.

Exposing film to light has often been compared to filling a bucket with water from a faucet. You can turn the tap wide open and fill the bucket quickly, or you can open it only a little and let the water trickle slowly into the bucket until it is full. The two variables are how much you open the faucet and how long you leave it on. The two exposure controls on the camera work in much the same way. Like the valve in the faucet, the aperture controls the size of the opening in the lens that admits light, while the shutter speed determines the length of time that the shutter will stay open to let light pass through.

The exposure meter in your camera reads the total quantity of light that the film receives from both settings. For a typically well-lighted scene, your film may be properly exposed with a combination of a large aperture and a fast shutter speed, such as $f/2.8$ and 1/1000 second—the equivalent of filling a bucket quickly—or with a small aperture and a slow shutter speed, such as $f/22$ and 1/15 second—the equivalent of filling it slowly. Since a wide aperture such as $f/2.8$ severely limits the zone of sharpness

in a picture (see pages 94 and 95) and a slow shutter speed such as 1/15 second may make it virtually impossible to keep the camera steady in your hand, you will usually want a combination of a relatively small aperture and a moderately fast shutter speed. A setting of $f/8$ and 1/125, for example, would give you fewer worries about blurring the image by misfocusing or movement. Of course, you won't always be able to use such an ideal combination in even a well-lighted scene. But a one-stop change in either aperture or shutter speed—to $f/5.6$ or 1/60 second, for example—will not greatly decrease the zone of sharpness nor increase the likelihood of camera movement. For different lighting conditions or for special effects, you'll need to learn to adjust the exposure accordingly, as we'll discuss on the following pages.

The mechanics of setting an exposure vary according to the camera. On manually operated models, or on an automatic in the manual mode, you must set both the aperture and the shutter speed until the light meter indicator in the viewfinder shows proper exposure (see pictures above). Which you set first usually depends on your preference or on the effect you want to achieve. With a brightly lighted scene and slow-speed film, ASA 25 to 32, the $f/8$ and 1/125 second setting mentioned above would make a good starting point. And for most films, the exposure table listed on the instruction sheet is a good guide for initial settings.

With automatic cameras, the type of camera again dictates how you set the exposure. On shutter-priority automatics, you set only the shutter speed and the camera automatically adjusts the aperture. On an aperture-priority automatic just the opposite is true: You set only the aperture. With a few completely programmed automatics, the camera is designed to set either control or both within a safe range for normal pictures.

The effect of one-stop changes in aperture is clearly illustrated by the series of pictures at right. The shutter speed for all of the pictures was the same but the aperture ranges from f/1.4 (top left) to f/16 (lower right). The camera's meter indicated a proper exposure of f/5.6. The setting on the camera and the actual aperture opening are shown beneath each shot. One-stop changes in shutter speed would have resulted in similar changes in exposure.

With the most common viewfinder exposure indicator (left), you adjust the controls until a needle is centered in a gate. The plus and minus signs indicate over- or underexposure. As an aid, this finder also shows the shutter speed—the middle number at bottom. The light-emitting diode (LED) indicator (middle) works similarly, with small dots that light up to tell you if you are over-, under-, or properly exposed. Both shutter speed and aperture are indicated in this viewfinder. The needle in the aperture-priority automatic (right) shows you the shutter speed the camera has selected. In manual mode, this needle is matched with another one.

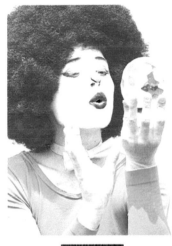
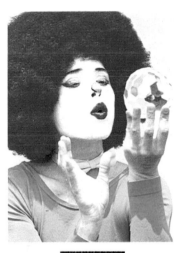

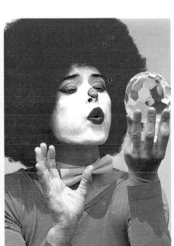
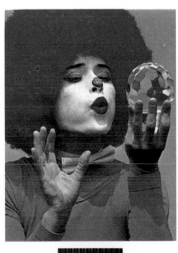
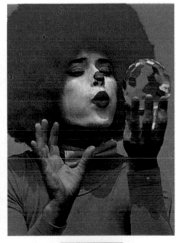

Cameras

Setting the Exposure

Not all scenes are brightly lighted, and changes in light call for changes in exposure settings. The softer, diffused light provided by open shade or overcast skies, for example, usually requires two stops more exposure (a two-step change in either aperture or shutter speed or one in both) than does a bright scene, and indoor photography may require several stops more. If the light is even and not too dim, your camera's light meter will help you select the proper setting. Keep in mind, though, that a light meter is only a mechanical device designed to take an average reading of the light in a scene. In some situations, this reading will not be an accurate guide to achieving the results you want.

When a scene includes a strong, direct light source, it is crucial that your reading take into account more than just the dominant light. To record as much as possible of the bright and dark elements in a contrasty scene, take a reading of both and then choose an exposure midway between. Or, take a reading off an 18 percent photographic grey card, which represents an average middle tone. To be on the safe side in tricky lighting situations, you should bracket—that is, take extra pictures that give you one-half or one stop more and less exposure than indicated.

A sidelighted subject or one against a bright background such as the sky or a sunlit wall may require one extra stop of exposure for flesh tones to look normal. A backlighted subject is likely to require two more, and a subject against a dark background may need one less. The best solution in all cases is to move close to take a reading of the subject. Then, set your camera for that reading and resume your original picturetaking position. The same approach may be necessary when the lighting is uneven or when the element you wish to emphasize is small.

In altering exposures, remember that a one-stop change in shutter speed is the equivalent of one *f*-stop change in aperture. Thus, if you want to increase the exposure of a scene by one stop, you can either open the aperture one *f*-stop—say, from *f*/16 to *f*/11— or switch to a slower shutter speed—from 1/250 to 1/125 second, for example. In either case you are doubling the amount of light reaching the film. On automatic cameras, switch to the manual mode to make any changes beyond what your meter recommends. If your automatic does not have a manual override, you can get the equivalent of a one-stop increase in exposure by temporarily turning the ASA film-speed dial to the setting closest to one-half of the film's normal ASA rating.

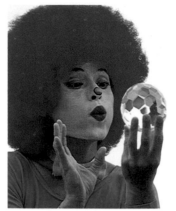
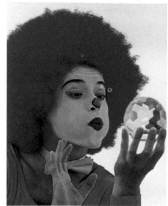

Your meter will tell you that the flattering light of an overcast day (top left) or of open shade (top right) requires two stops extra exposure. You also have to increase your meter's reading by one stop for sidelighting (bottom left) and by two stops for backlighting (bottom right).

Extreme situations call for extreme exposure combinations. The dimly lighted interior above required a wide aperture and a slow shutter speed, whereas the speeding Grand Prix car at left needed a fast shutter speed to stop the action, which required a wide aperture.

Cameras

Focusing

Proper focusing is one of the two fundamental steps in taking a good picture, the other being setting the correct exposure. The focusing device in the viewfinder differs from camera to camera. On rangefinder cameras, you have to match two images—either by superimposing a faint image on a bright, dominant one, or by lining up a scene that is split into top and bottom parts. The latter focusing device is usually called a split-image finder. On single-lens reflex cameras, the entire viewing surface is a screen that becomes sharp or fuzzy as you turn the focusing ring. In addition, most SLR viewfinders have a circular center area, commonly referred to as a microprism, that is a highly refined focusing aid capable of showing very slight differences between sharp and less sharp images. On some viewfinders this microprism may be supplemented or replaced by a central split-image finder, such as the one shown at right.

Understanding Depth of Field

Whatever the type, most focusing controls are easy to operate. To use them to greatest advantage, however, it is important to know that when you focus on a subject, the depth of field—the zone in acceptably sharp focus in front and in back of the subject—varies enormously depending on the size of the aperture, the subject's distance from the camera, and the focal length of the lens. With a working knowledge of how to control depth of field, you can heighten the effect of any picture. As the series of photographs at right shows, a limited depth of field results in a blurry background and foreground, whereas a greater depth of field results in overall sharpness.

Aperture is the most important consideration in determining depth of field. The smaller the aperture, the greater the depth of field. At $f/16$, for example, most normal lenses focused on a subject sixteen feet away will show everything in focus from eight feet in front of the camera to infinity. At $f/2$, only the subject will be sharp; both the foreground and the background will be blurred. Midway

between, at $f/5.6$, sharpness will extend from about three feet in front of the subject to about six feet behind.

The effect of subject distance on depth of field is a bit trickier, but in general, the closer your subject, the shallower the depth of field. Even at $f/16$, if you focus three feet away with most normal lenses, the depth of field will be a foot at most. And at $f/2$, your subject's eyes may be in focus while the nose and ears are blurred. As you back away from a subject, the depth of field increases rapidly. With $f/16$ at six feet, the zone of sharpness would extend from a foot in front of the subject to about three feet behind. And at about sixteen feet at $f/16$, when the depth of field extends to infinity, most normal lenses give their maximum range of sharpness. Focusing any farther away only reduces foreground sharpness. Although this point of diminishing return varies from lens to lens, it is important to be aware of it—especially when you want to get the greatest possible range of sharpness in both foreground and background, as, for example, in a landscape.

The focal length of the lens plays a role in depth of field, too. The shorter the focal length, the more depth of field you'll get at the same aperture. Thus a wide-angle lens gives more depth of field at $f/11$, say, than a normal lens, and a normal lens gives more depth of field than a telephoto lens.

To help you determine the depth of field, many cameras have a simple depth-of-field scale inscribed on the lens barrel next to the focusing ring. As the picture at lower right shows, the scale usually has two lines for each aperture between $f/4$ and $f/16$, and, as you turn the focusing ring, the distances on the ring falling between those lines are in acceptable focus. The lens shown here, for example, is focused on ten feet, but since it is set at $f/11$, the depth of field actually extends from seven feet to twenty feet. Once you've experimented with this scale a few times and feel comfortable using it, you'll find it a very handy aid.

In the out-of-focus and in-focus examples of an SLR viewfinder above, the center circle is a split-image finder, while the ring surrounding it is a microprism. The entire surface of the viewing screen, however, also serves as a focusing aid.

The aperture ring on the lens below shows it is set on f/11, and the focusing ring indicates the subject is ten feet away. The pair of lines for that aperture on the depth-of-field scale (the middle ring) shows that everything from about seven feet to twenty feet away will be sharp.

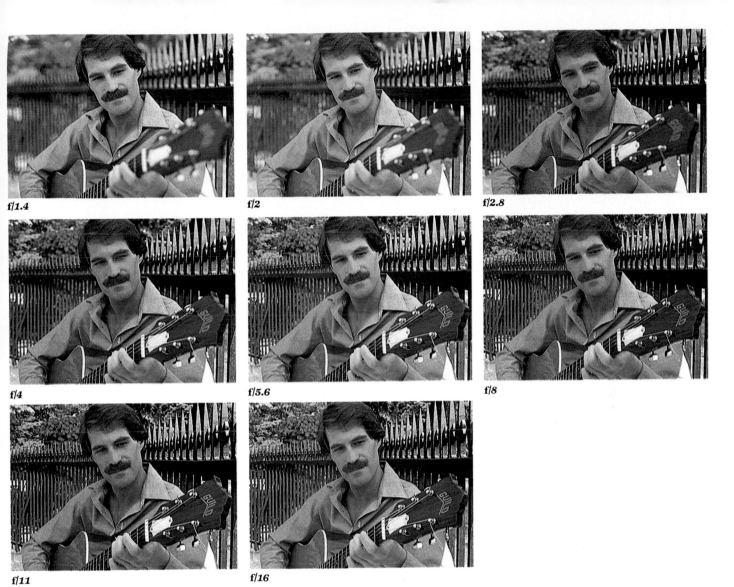

f/1.4

f/2

f/2.8

f/4

f/5.6

f/8

f/11

f/16

To show the effect of depth of field, a photographer remained focused on the subject to take all of the pictures above. For each one, though, he changed the aperture one stop at a time, from f/1.4 to f/16. The shutter speed was changed proportionately to obtain equivalent exposures.

With a single-lens reflex camera, since you focus through the lens, you can actually see the depth of field. However, there is a catch. Modern SLRs, in order to maximize viewfinder brightness, are designed to stay open to their maximum aperture until you click the shutter. As a result, when you look through the viewfinder, you will normally see only the zone of sharpness for that maximum opening, not for the smaller one that you may be planning to use. To compensate for this, many SLRs provide a depth-of-field preview button. When you press it, the aperture closes down to the *f*-stop you have set. Although the viewfinder will become noticeably darker, you can see the actual zone of sharpness at your selected aperture.

In experimenting with depth of field, keep in mind that changes in aperture require compensatory changes in shutter speed for

equivalent exposures. If your camera's meter indicates a correct exposure of *f*/5.6 at 1/125 second, but you decide to open up two stops to *f*/2.8 in order to blur a distracting background, you must reduce the exposure time two stops by adjusting the shutter speed from 1/125 to 1/500 second. At times you will have to compromise on depth of field. If you are trying to freeze the motion of a racing cyclist on an overcast day, for example, you can't expect great depth of field—the fast shutter speed required to stop action calls for a large aperture with minimal depth of field. In a case such as this, film speed also becomes a factor in depth of field. A more light-sensitive, high-speed film will permit you to use the smaller apertures that give a wider area of sharpness.

Film

A hundred years ago, most photographs were made individually on large, cumbersome glass plates. The photographer planning to take twenty or thirty pictures had to lug about a considerable burden. In addition, each plate had to be coated with a wet, light-sensitive emulsion just before exposure and developed immediately afterward. By comparison, today's 35 mm film is truly amazing—a long, flexible strip of lightweight film only 1 3/8 inches (35 mm) wide, able to capture up to thirty-six images on a single roll, and packaged in a light-tight metal spool known as a magazine, cassette, or cartridge.

Although far more convenient, 35 mm film works on the same basic principle as a glass plate. Its flexible plastic base is coated with a light-sensitive emulsion consisting of fine particles of silver halide and other compounds. When light strikes the film, it causes a change in the chemical structure of the particles, creating an invisible record—or latent image—of the subject that is later made visible by chemical action during processing. Black-and-white film has only one layer of emulsion; all light reaching it, whatever its color, is reproduced as black, white, or shades of grey. Color film has several layers that respond to the three primary colors in the light spectrum—blue, green, and red.

After processing, the image recorded on black-and-white film is a negative, which then must be printed onto light-sensitive paper to produce the positive image that we call a photograph. Depending on the type, color film will produce either negative images, for making prints, or positive transparent images—slides—which can be projected onto a screen or looked at in a hand viewer. You can make prints from slides in a color darkroom (see page 269), as can a photo finisher, who can also produce slides from negative film.

Each of these three general categories—black-and white negative, color negative, and color slide—includes several different types of film. On the pages that follow, we discuss their characteristics and their suitability for various conditions and picturetaking situations. It's wise to experiment with several different films. Once you have found

There are three kinds of 35 mm film from which to choose. The dark strip in the center here is color slide film. To the right of it are color negative film and a contact print made from it. To the left are black-and-white negative film and strips of black-and-white contact prints. At the far right is the the bottom panel from a box of film, which indicates the type and color balance of the film, the ASA speed, the number of exposures, and the date by which you should process film.

a particular film you like, however, the best way to become really familiar with its characteristics is to use it almost exclusively for a long time. You will soon develop an eye for its potential in different situations, and that familiarity will give you a great creative edge.

Whatever type of film you use, certain precautions should always be observed. First, expose and process film before the expiration date printed on the box. After that date, color and speed are unpredictable. Store film in a cool, dry place. Keep it away from direct sunlight, heaters, or radiators and out of automobile glove compartments. In damp climates, put your film in a sealed plastic bag along with moisture-absorbing silica gel crystals. Although refrigeration is recommended for some professional films, most others survive well in normal room temperatures. When advancing and rewinding film, use smooth, steady movements. In extremely dry atmospheres, rapid movement can create static electricity, which may produce streaks on your pictures; in frigid weather, film can become brittle and break. Airport security X-ray baggage scanners can also damage unprocessed film if the film gets a massive dose from a poorly adjusted machine or from repeated exposures at different stopovers. The lead-foil pouches sold at photo stores offer some protection, and the cumulative effects of X rays can be lessened by rearranging the film each time it is scanned. Better still, arrive early and ask for a visual inspection of your film, or mail your exposed film home or to a laboratory in prepaid envelopes. If you develop your film yourself (see Part IV, The Process), always handle it in complete darkness once you've removed it from its light-tight magazine.

Film

Types of Film

Different light sources emit different colors of light. Our eyes adjust quickly to the difference between the yellowish hues of incandescent light bulbs indoors and the more bluish color of sunlight outdoors. Film, however, is not as adaptable. Even with black-and-white film, artificial and natural light render colors with different intensity. But because black-and-white film records all colors as tones of grey, the differences are acceptable to our eyes.

With color film, however, even subtle gradations of color must be reproduced accurately if the image is to look correct to the eye. To achieve this, color film is adjusted, or "balanced," for a particular light source. Because the color can be altered somewhat in the printing process, color negative film is usually balanced for only one source—daylight. This includes direct and reflected sunlight, as well as the "instant sunshine" provided by electronic flash and blue flashbulbs. But color slide film, which turns directly into a final image when processed, cannot be corrected so easily. Thus, while some slide films are balanced for daylight, others are balanced for two types of artificial light sources.

Some special color slide films, marked photolamp or Type A, are designed to be

When daylight film is used in the outdoor light for which it is designed, the result (far left) seems correct to our eye. But when tungsten film is used outdoors (below), the image has a blue cast, giving skin an unusual pallor. Indoors under incandescent light, tungsten film gives the color balance that we expect (below right). When daylight film is used instead (far right), the picture looks too amber in tone, although flesh tones don't suffer dramatically. To avoid using film improperly, always be sure to read the instruction sheet that accompanies every roll (right).

Daylight film outdoors

Tungsten film outdoors

used with studio floodlights with a color temperature specified at 3400 K. More often, however, you are likely to encounter the slide film marked tungsten, or Type B. It is balanced for incandescent lights with a color temperature of 3200 K, which is slightly brighter in intensity and cooler in hue than normal room lighting. You can use Type B or tungsten film quite successfully in a scene that is illuminated by ordinary household incandescent bulbs.

To compensate for the shortage of blue in yellow-red incandescent light, tungsten film is especially sensitive to the blue end of the spectrum. As a result, if you use tungsten film outdoors in the more even mix of colors provided by sunlight, your slides will have a pronounced bluish cast. Conversely, if you shoot daylight-balanced film indoors under household incandescent bulbs, it will record the scene as more golden in tone than you perceive it. The four shots of the boy below show the effects of using tungsten and daylight film in both types of light. As a rule, you should match your slide film to the prevalent light source in any scene you are photographing. If you happen to have the wrong film in your camera, filters (see pages 120 to 123) can be used to help correct the color balance.

Tungsten film indoors

Daylight film indoors

Film

Characteristics of Film

In addition to its color balance, film has many other characteristics that can significantly affect your pictures. Most notably, all film has a specific degree of sensitivity to light. This sensitivity, or speed, is denoted by an ASA number—an abbreviation for the American Standards Association, the originator of the rating system. The ASA speed is clearly indicated on the film box and instruction sheet, as well as on the film magazine itself. Along with the ASA number you will often find a comparable DIN number—a system used in parts of Europe.

The most commonly used ASA numbers range from 25 to 400. The higher the number, the more sensitive the film is to light. For convenience, the ASA numbers are usually classified into three categories: slow speed (ASA 25 to 32), medium speed (ASA 64 to 125), and high speed (ASA 160 to 400). A doubling of the number indicates a doubling of the sensitivity of the film. Thus, a film with an ASA 400 rating needs only half as much light for proper exposure as a film rated ASA 200. Conversely, an ASA 100 film is half as fast, or sensitive, as an ASA 200 film, and it requires twice as much light for proper exposure. Not all film is rated in uniformly doubling multiples, but any such doubling or halving of ASA numbers is the equivalent of a one-stop change in either aperture or shutter speed on your camera, since both of those controls also work by doubling or halving the light.

Since high-speed film requires less light for proper exposure than slower film, it allows you to take pictures in low light both indoors and outdoors, pictures that might otherwise be impossible. Further, because less light is needed, you can use smaller apertures and faster shutter speeds, which give you the benefit of a greater depth of field or good action-stopping ability.

Medium-speed film (ASA 64 to 125) is intended for more common photographic conditions—daylight and a relatively stationary subject. It is a good all-around film that allows adequate flexibility in choice of shutter speed and aperture combinations.

Slow-speed film (ASA 25 to 32) is the best choice whenever adequate light is available—for example, bright scenes such as a sandy beach or snowy ski slope on a clear, sunny day. The chief advantage of slow-speed film is its exceptional clarity, sharpness, and tonal contrast. If you have adequate light, it is an excellent choice for portraits, landscapes, still lifes, or any shot in which you want to reveal fine detail or textural nuances.

The unavoidable loss of sharpness as you move from slow- to high-speed films can be explained in terms of the silver and dye particles in the film's emulsion. The faster a film is, the larger these particles must be. In higher-speed films, the particles tend to form irregularly distributed clumps that give a photo a sandlike or granular appearance. This quality, known as graininess, is most pronounced in extreme enlargements.

A film's definition, or ability to render a sharp, clear image, also varies with the chemical composition and thickness of the emulsion and the film's plastic base and backing. All of these affect the tendency of light to scatter in the emulsion. When light scatters, the boundaries between light and dark detail blur. As a general rule, this blur is least likely to occur with slow-speed film. Thus, when you are after the utmost definition in a picture, a fine-grained, slow-speed film is highly recommended. More often, however, you will probably opt for the convenience of medium- and high-speed films. Given modern advances in film technology, today's high-speed films provide very satisfactory results in terms of both clarity and brightness.

In setting your camera, keep in mind that black-and-white and color negative films have a fairly wide exposure latitude. That is, if underexposed or overexposed by a stop or even two stops, the resulting negative will often still yield an acceptable print. The

High-speed black-and-white film allows you to capture action in dim light, as the nighttime baseball scene at right shows. As a trade-off, however, prints made from such a film are usually grainier than those made from a slower speed film, as the portrait below was. Slow- and medium-speed films, ASA 32 to 125, help reveal textures and render details sharply.

High-speed color film, ASA 400, is especially beneficial for low-light scenes, as it permits you to use either a smaller aperture for greater depth of field or a faster shutter speed to stop action more easily

exposure for color slide film is far more crucial. As the series of pictures on page 91 shows, a one-stop change can make a noticeable difference. Because of this, you should bracket important color slide shots in uncertain lighting conditions by shooting at one-half and a full stop both over and under the recommended exposure.

All film is designed to be exposed within a range of shutter speeds. These "reciprocity characteristics" vary from film to film and are usually noted on the film's instruction sheet. But in general, if you use a very long exposure—a second or more—in very dim light, you exceed the film's acceptable range, and its sensitivity decreases. With black-and-white film, you can compensate by increasing aperture size or using an even longer exposure. With color film, however, there may also be a strong shift in color when you stray outside the film's limits. Thus, it's best to avoid extremely long exposures, except for special effects.

In extreme conditions—very dim light, for example, or a combination of low light and a moving subject—high-speed black-and-white and some color slide films can be specially processed, or "pushed," for extra speed, either commercially or at home. See the film instruction sheet or ask your photo dealer for information. When you are shooting a roll that will be push-processed, you should set a higher ASA number on your camera. If you plan to increase the sensitivity of ASA 160 film by one stop, set 320 on the ASA dial. If you plan to push-process ASA 400 film one stop, set 800 on the dial; for one-and-a-half stops, set 1250; and for two stops, 1600. Some black-and-white films can be pushed even more, but you should expect a perceptible loss in image quality. (See page 256 for more information on push-processing.)

Finally, if your pictures consistently look washed out and overexposed or dark and underexposed, run a meter test. Bracket a normal exposure two full *f*-stops more and less than your meter recommends, using half-stop increments. If your results indicate that you need more exposure, compensate by setting a lower ASA speed; for less exposure, set a higher ASA speed. For each full stop of exposure you need, double or halve the ASA speed accordingly.

Lenses

In addition to giving a natural-looking perspective akin to our own vision, the 50 mm normal lens usually has a wide maximum aperture, which makes it handy for low-light situations.

These beach-goers are using some of the longest telephoto lenses available to the single-lens reflex user, but master photographer Ernst Haas chose the most useful, the normal lens, to take this shot.

One of the great advantages of single-lens reflex cameras is their capacity to accept a wide variety of lenses. Subjects can be dramatized or subdued, depending on the choice of an accessory lens. The chief difference between the various lenses is focal length—the effective distance between the lens and the film when the lens is focused on infinity. (We say "effective" distance because it is not always the actual distance with today's optically sophisticated compound lens.) Focal length is measured in millimeters, and the standard lens on most SLRs is about 50 mm. This focal length on a 35 mm camera comes closest to our own eyes in the angle of view, in the relative size of objects, and even in the zones of sharpness it provides. As a result, it is the most adaptable of all lenses, providing a natural perspective for images ranging from portraits to landscapes.

As we will see on the following pages, there are two other basic types of lenses: telephoto lenses, which have longer focal lengths and bring distant subjects closer; and wide-angle lenses, which have shorter focal lengths and encompass more of a scene. Zoom lenses range over several focal lengths, and certain other specialized lenses are designed for taking close-ups and for correcting perspective distortions.

Learn to use the lens your camera is equipped with and fully explore its potential before you purchase accessory lenses. When you are ready for an additional lens, keep in mind that lens quality varies and that there is no need to pay for more lens than you need. For example, if you will be shooting in broad daylight only, it doesn't make sense to pay a premium for a maximum aperture one stop wider. Also be aware that lens mounts differ. You can get adapters, but any time you buy a lens not designed for your camera's mount, test it first. Finally, lenses are delicate instruments that must be handled with great care. Keep front and back lens caps on all detached lenses. When you change lenses, do it in the shade and carefully read your camera's instruction booklet as to the proper method. Be sure, too, to keep your lenses dust- and fingerprint-free.

Lenses

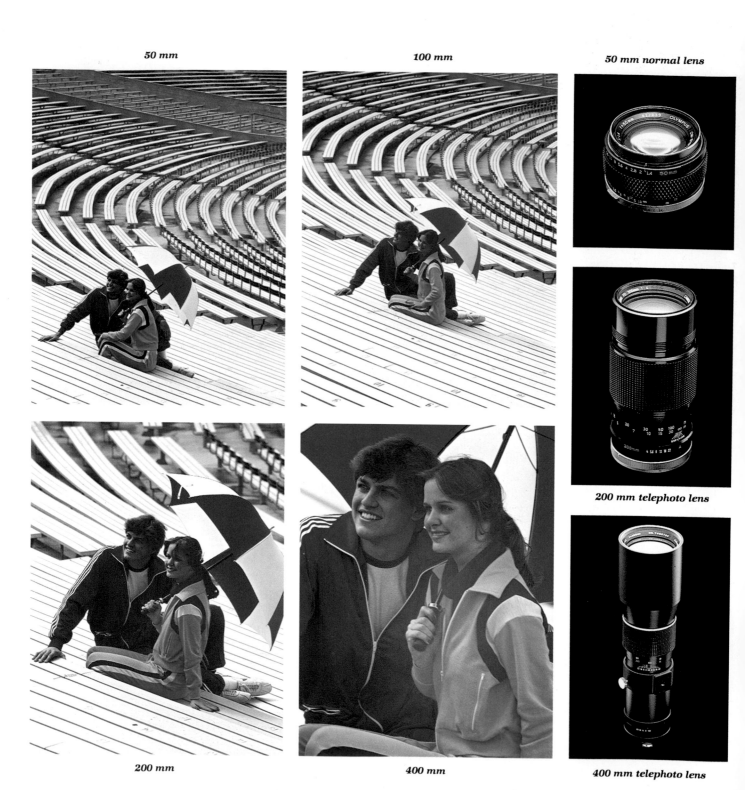

50 mm

100 mm

50 mm normal lens

200 mm

400 mm

200 mm telephoto lens

400 mm telephoto lens

Telephoto Lenses

Telephoto lenses, which have a focal length longer than that of a normal lens, enlarge a subject in the same way that a telescope does. The longer the focal length of the lens, the greater the degree of magnification. As the lens lengthens, some other interesting things happen that affect your image. The lens's angle of view becomes narrower, for example, and the depth of field becomes shallower. There is also a change in perspective. All of these effects can be highly advantageous, depending on the picture you are taking. The narrow angle of view enables you to isolate a detail or eliminate a cluttered foreground. Although it makes more careful focusing necessary, the shallow depth of field is great for blurring distracting foregrounds and backgrounds. And the perspective change can make distant elements in a landscape appear closer together or let you get a tight close-up of a face without distortion.

By far the most useful of the long lenses is a medium telephoto—any lens with a focal length between 75 and 135 mm. Most are available with fairly large maximum apertures, such as $f/2$ or $f/2.8$. Because they minimize facial distortion and allow a comfortable distance between photographer and subject, while still providing a full-frame image, medium telephotos are ideally suited to portraits. In addition, they are great for

many situations in which you have to keep a moderate distance away from your subject—when you are taking a candid street shot, for example, or photographing architectural detail on most buildings.

Strong telephoto lenses—those with focal lengths of 180 mm or longer—have much more specialized uses. Most notably, they are used by serious sports and wildlife photographers. Both these types of photography rely on the powerful magnification of a strong telephoto, even though these lenses are effective only in brightly lighted situations. They usually have a relatively small maximum aperture, often $f/4$ or smaller, and since they tend to accentuate the effect of camera movement a great deal, a fast shutter speed is necessary. To prevent such image-blurring movement, the rule of thumb is to use the shutter speed closest to the reciprocal of the lens's focal length. For a 200 mm lens, for example, this would be 1/250 second. Alternatively, you can use a tripod or other means to steady the camera. Because their depth of field is very shallow, strong telephoto lenses also require careful focusing.

Telephotos of 500 mm or longer are bulky, heavy, and awkward to use and nearly always require a tripod. The mirror telephoto lens greatly reduces these problems. Following a principle used in the design of observatory telescopes, this lens has two curved mirrors that bounce the light rays back and forth—in effect, "folding" them to pack a longer focal length in a shorter lens barrel. Although the lens is larger in diameter than a regular long lens, it is far more compact and lightweight. The price of this convenience, however, is an unchangeable aperture, usually around $f/8$ for a 500 mm lens. Further, with this lens there is a tendency for bright points of light to become doughnut-shaped rings in the final image.

To obtain greater magnification with most lenses, you can also use tele-extenders—relatively inexpensive tubelike attachments that fit between the lens and the camera either to double or triple the focal length of the lens. Tele-extenders reduce the effective aperture of the lens and usually cannot match the sharpness achieved with a real telephoto, but they may be useful in certain situations.

100 mm medium telephoto lens

Taken from the same vantage point, these photographs compare the effects of a normal 50 mm lens (upper left) with a moderate 100 mm telephoto lens (upper right), a stronger 200 mm telephoto (lower left), a powerful 400 mm lens (lower right), and a 500 mm mirror telephoto lens (far right). Since the focal length of each lens was twice the previous one, with the exception of the 500 mm lens, the magnification of the subjects doubles with each image. Also note the decreasing depth of field with the longer lenses, especially apparent in the bleachers.

500 mm mirror telephoto lens

500 mm

Lenses

Wide-Angle Lenses

When you wish to encompass more of a scene than would be possible with your normal lens, a wide-angle lens is appropriate. With its shorter focal length and wider angle of view, the wide-angle lens achieves an effect opposite to that of a telephoto. Instead of enlarging and isolating an object, the wide-angle diminishes it and takes in more of its surroundings. At the same time, a wide-angle lens greatly increases the depth of field, so much so that you don't need to be concerned about sharpness unless your subject is very close to the camera. For certain pictures, all of these characteristics can be very advantageous— for example, when you want to emphasize the panoramic sweep of a landscape, when you wish to include more of a scene in your photo but have a wall at your back, or when you want to maximize depth of field.

Wide-angle lenses also alter the perspective of a scene—elements appear to be more distant from one another than your eyes perceive. This change in perspective can cause distortion if your subject is too close to the lens or at an angle to it. An object or a person may appear longer, taller, wider, or more bulbous than is actually the case. Such effects are not always undesirable— distortion can enhance an image or ruin it, depending entirely on how it is used. Be especially careful, however, when using a wide-angle to take close-ups of people.

A moderate wide-angle lens, one with a focal length of 28 or 35 mm, is the most useful. These lenses generally have a fairly large maximum aperture, $f/2$ or $f/2.8$, making them especially helpful when shooting indoors with low lighting. Ultra-wide-angle lenses, 18 to 24 mm, are indispensable when the effect you're after is expansiveness or when you wish to create a deliberately dramatic distortion. Extremely wide-angle lenses, known as fisheyes, take in almost 180 degrees, more than the unaided eye can see.

35 mm wide-angle lens

The scene shown on the preceding page—taken from the same vantage point—is used to illustrate the effects of a normal lens (below center) versus a 35 mm moderate wide-angle lens (below), a 20 mm ultra-wide-angle lens (below right), and a 7.5 mm fisheye lens (right), which takes in a hemispheric 180 degrees. In all the pictures, the depth of field is virtually limitless.

35 mm

7.5 mm

7.5 mm fisheye lens

20 mm ultra-wide-angle lens

50 mm

20 mm

Lenses

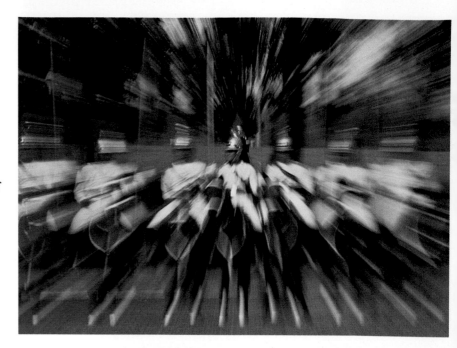

Zoom Lenses

Rather than being limited to just one focal length, a zoom lens has movable optical elements that make possible a whole range of focal lengths. In addition to the standard focusing and aperture controls, zoom lenses have a third ring for adjusting focal length. As you turn this ring, the image of your subject becomes larger or smaller. Zoom lenses are available in a variety of focal-length ranges. The telephoto range offers focal lengths from 70 or 80 mm up to 200 mm or more. Another group hovers around the normal 50 mm focal length, with choices roughly between 35 and 85 mm. More recently introduced is a collection of wide-angle zooms, ranging from about 24 mm to just short of normal.

Early zoom lenses were difficult to manage and often gave unsatisfactory results. Today, however, zooms are both easy to use and of more-than-acceptable optical quality. They offer tremendous advantages: Not only are you able to adjust the closeness of an image without changing lenses or your position, but you also have access to a wide range of nonstandard focal lengths. All you need to do is slowly turn the focal-length control until you reach the desired image size. And usually, once you have focused, a subject will remain sharp as you change focal lengths.

There are certain drawbacks to these high-quality zoom lenses, however. They are expensive and rather large compared with most lenses in the same range. And, more important photographically, they have a relatively small maximum aperture, usually $f/3.5$ or less. This limits their peak effectiveness to brightly lighted scenes. On the other hand, considering the total cost and the effort of carrying two, three, or more separate lenses to cover the same optical range, the price and size of a zoom lens seem quite reasonable. Thus, if you usually shoot outdoors—or indoors with a flash—a zoom lens makes good sense, but if your picture-taking is mostly limited to situations with low available light, your best bet would be to stick to single-focal-length lenses.

35 mm

The unusual effect in the picture at left was achieved by "racking" the zoom lens—that is, changing its focal length—during a relatively long exposure.

35 to 105 mm zoom lens

70 to 210 mm zoom lens

Wide-angle zoom lenses, which can range in focal length from 20 mm through 35 mm (far left below) and on up to normal, are one of the most recent major advances in optics. For most photographers, however, the handiest zoom lens ranges on either side of the normal 50 mm lens, covering focal lengths between 35 mm and 100 mm (left below). A zoom lens that runs between 80 and 200 mm (below) is especially useful for sports, nature, and candid photography.

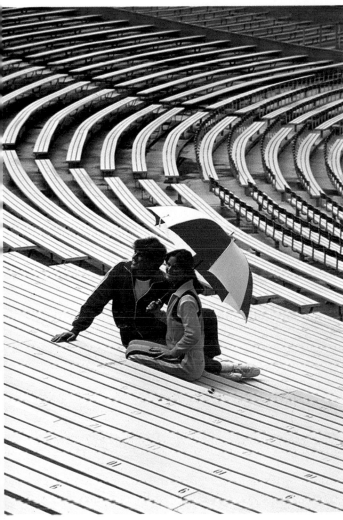

100 mm

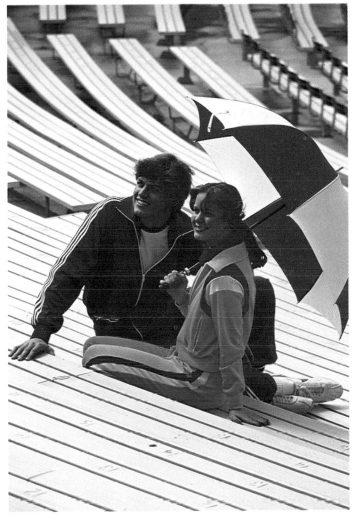

200 mm

Lenses

Special-Purpose Lenses

Nearly all photographers have had occasion to lament the limitations of their standard lenses. Two situations in particular are frustrating: when you want to move in for a tight close-up and you find that your lens won't focus that close; and when you take a picture of a building and discover that its sides converge so much at the top that it looks more like a pyramid than a rectangular structure. There are special lenses designed to handle these problems. Both are expensive, but if you encounter either situation frequently, the lens may be well worth the investment.

The problem of sloping building sides, also known as keystoning, occurs primarily because you lean back and tilt the camera upward when you take a picture of a tall building. This distortion is most noticeable with wide-angle lenses. The perspective control lens is a special wide-angle lens with a front that can be shifted—up and down or side to side, depending on how it is mounted—so that you can take your picture while keeping the camera level. Since the camera's film plane is then parallel to the structure instead of angled, distortion is minimal. To get the equivalent shot with an ordinary wide-angle lens, you might have to climb a very high ladder or shoot from an adjacent structure. This shift feature can also be used to create the opposite effect—an exaggerated distortion. The chief limitation of a perspective control lens is that the aperture has to be operated manually. The typical focal lengths for PC lenses are 35 and 28 mm.

The lens that lets you focus closely on a small subject, such as the flowers shown here, is usually known as a macro lens. Strictly speaking, this lens should be called a close-focusing lens, since the term *macro* implies making an image life-size or larger on film. When used alone, these lenses have an upward limit of reproducing something about half life-size. For most close-up subjects—flowers, insects, coins, stamps, or documents—this enlargement is usually more than enough. And, with the addition of extension tubes or bellows between the camera and the lens, the range of the macro lens can be extended even further to reproduce subjects at two, three, or more times larger than life.

Although some telephoto and zoom macro lenses have recently appeared on the market, most are lenses with a normal focal length, and a few are wide-angle lenses. All of them, however, are tricky to focus, because the depth of field becomes very shallow as you move closer to a subject. To keep your subject sharp, you must keep it in a plane parallel to the film plane. And, if your subject has much depth at all—like a flower or an insect, for example—you must decide which part of it you want to be in focus. Such selective focusing isn't necessarily undesirable, since a soft blurring of the foreground or background can make the central aspect of a subject stand out and appear three-dimensional.

For the photographer who only occasionally takes close-ups, there are alternatives to the macro lens. Extension tubes and bellows increase the magnifying power of the macro lens and can be used with your regular lenses for focusing on objects much closer than the lenses alone would permit. Although they reduce the effective aperture of the lens, they can give very good results if properly used (see page 191). Another possibility would be the simple, filterlike, supplementary close-up attachments that screw onto the front of your regular lenses. These are not as effective as extension tubes, however.

55 mm macro lens

The macro lens allows you to focus very closely on a small subject and get a near life-size image without distortion. The first picture at right above was taken with a 50 mm lens at its closest focusing distance; the second only inches from the flower using a macro lens.

35 mm perspective control lens

A 35 mm wide-angle lens is useful in architectural photography, but it often creates a distortion of converging lines. In the picture at right, the pillars lean together and the arch seems to be falling away. By using a perspective control wide-angle lens and shifting the lens front up (far right), the photographer has made the arch appear normal.

50 mm

Macro

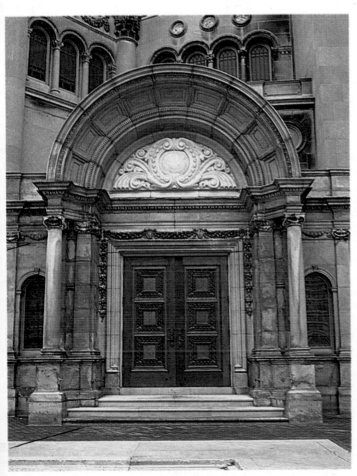

35 mm

35 mm PC

Filters

If you've ever looked at a professional's photographs and wondered why they looked so much more realistic, intriguing, or dramatic than your own, the answer may well be filters. As the sampling here shows, a wide array of these simple attachments is available, and each can make a unique contribution to your pictures.

#0

#1A

#29

#11

#50

#80A

#80B

#82A

#25

#58

#22

#47

CC30M

CC50R

ND 0.40

#81A

#85

#85B

#8

#15

Filters

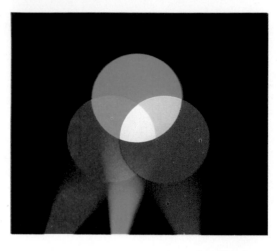

How Filters Work

Because the human eye and film do not respond the same way to all colors, filters are most often used to adjust the color of light from a scene, so that the shades reproduced on film correspond to those we see with our eyes. A color filter permits light of its own color to pass through and, to varying degrees, absorbs or blocks the light of other colors. The extent to which this occurs depends on the intensity of the filter color as well as its position in the spectrum. In general, closely related hues are permitted to pass through, while complementary colors are stopped. Thus, a yellow filter absorbs blue, but lets most orange through. Only the light that gets through, of course, is recorded on film.

Nearly all filters, because they reduce the light entering the camera, require a larger aperture or a slower shutter speed than you would use without a filter. The change, although now frequently given in *f*-stops, is traditionally specified as a filter factor—a number that indicates how much you must multiply your exposure. A filter factor of 2, for example, tells you that you must double the amount of light—the equivalent of a one-stop change. A factor of 4 requires four times as much light—the same as a two-stop increase. Filter factors for some common filters are given in the table on page 124. A through-the-lens exposure meter, or any other meter that reads light passing through the filter, may not give a correct reading when a colored filter is on the lens. Therefore, before attaching the filter, take a meter reading and adjust for the filter factor.

The size of a common glass disk screw-in filter is usually expressed as a number representing its diameter in millimeters. When you purchase a filter, be sure it is the same size as the diameter (not the focal length) of your lens. You can also purchase adapters that allow you to attach various filters of the same size to different-sized lenses. For occasional use, another alternative is to buy inexpensive gelatin filters that fit into a holder in the front of the lens.

You can buy glass-mounted filters that screw directly into lenses (right). Different lenses, however, may require different-size filters. Rather than buy a complete set of filters for each lens you own, you can buy all your filters in the same diameter and use adapter rings, like the one shown at far right. Many filters are sold in series especially designed for this purpose.

To create the picture below, a small light source suspended by string from the ceiling was swung in an ever-changing arc while the photographer made a long exposure behind a piece of textured glass. The multicolored effect was produced by changing color filters for different periods during the exposure.

Filters

UV and Skylight Filters

The two most popular basic filters are the colorless ultraviolet (UV) or haze filter and the faintly amber-tinted skylight filter. Both are designed primarily for use with color films. However, since they have little effect on black-and-white photographs and do not require any change in exposure, many photographers simply leave one of them on the camera at all times to protect the lens's vulnerable front glass element. A scratched filter is far less expensive to replace than a lens.

The UV filter absorbs ultraviolet radiation—wavelengths shorter than the blue-violet end of the visible spectrum. Although we can't see ultraviolet radiation, the sun's rays are filled with it, and film records it along with visible light. Most often, it shows up in the background of distant shots as a bluish haze—much thicker than normal atmospheric haze—created by UV radiation reflecting off particles suspended in the atmosphere. When a UV filter is used to block out this ultraviolet radiation, the scene recorded on film looks more like the scene we actually see. The UV filter does not, as is often believed, permit you to penetrate visible haze. Because it is colorless, the UV filter makes an excellent base for certain special techniques, such as diffusion and vignetting, discussed on page 133.

The skylight filter also reduces the effects of ultraviolet radiation, but in addition, its slight amber tint reduces the bluishness of light in open shade and on overcast days. Unlike UV radiation, this coloration is actually visible as a bluish reflection on light-colored objects. We rarely notice this tint when simply looking at a scene, but a color photograph usually enhances it. In portraits especially, it can make skin tones look slightly pallid. A skylight filter does not affect other colors noticeably.

No skylight filter

Skylight filter

Although its effects are not very strong, the skylight filter helps reduce the slightly bluish quality of light in open shade and on an overcast day. Notice the lighter blue of the man's shirt in the bottom picture above, which was taken with a skylight filter. The top picture was taken unfiltered.

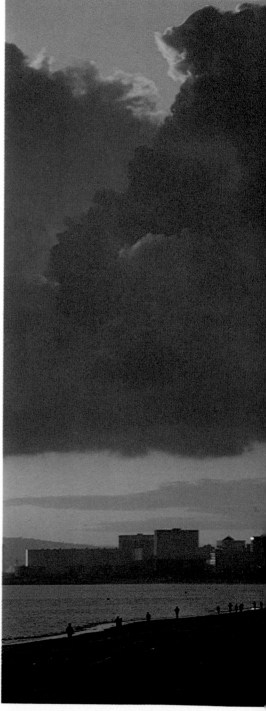

No UV fi

The UV or haze filter has an even less noticeable effect. It prevents a picture from having more atmospheric haze than our eyes see. The shot at left below was taken without the filter and the one at right with it.

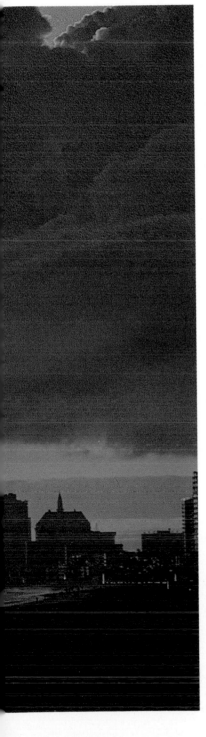

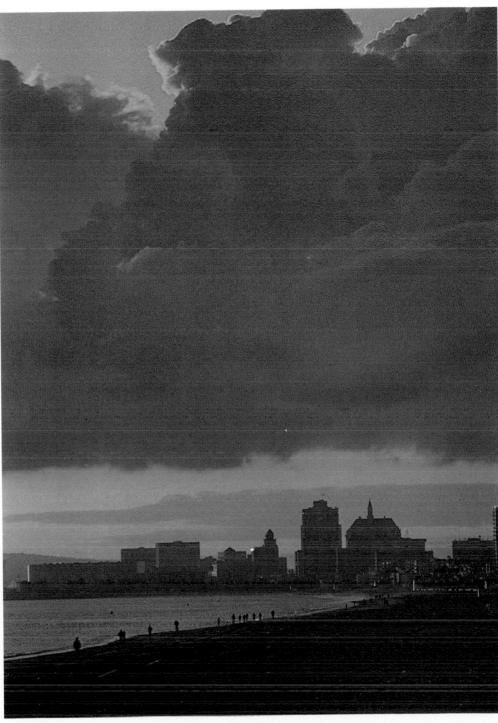

UV filter

Filters

Polarizing Filters

For both black-and-white and color work, one of the most versatile aids you can own is a polarizing filter. Such a filter has multiple uses: It can reduce reflections, darken a blue sky, penetrate atmospheric haze, and add richness to colors.

Light reflected from nonmetallic surfaces, such as glass and water, becomes polarized—that is, it vibrates in only one plane. The polarizing filter, which rotates in its holder, is a screen with crystals aligned in parallel rows. As you turn the filter, it blocks light traveling in that plane. From the correct camera angle, this permits you to tone down the glare from water or to eliminate reflections in glass panes. To penetrate haze and darken the sky, the filter works by blocking the polarized light reflected by tiny particles in the air. Since this light is the source of the haze and of much of the sky's brightness, its elimination results in a deeper blue sky and diminished haze. The polarizing filter also enriches the color of many other surfaces, ranging from foliage to skin, by eliminating reflections that lighten their tone. A polarizing screen usually has a filter factor of 2.5, which means you have to increase your exposure by one-and-one-third *f*-stops.

No polarizing filter

The way to darken blue skies in a color photograph is with a polarizing filter. The difference the filter can make is dramatically illustrated in the comparison shots at right.

Polarizing filter

The polarizing filter also helps reduce reflections. In the picture at right below, notice how the water has deepened in color and the reflections from the sky and rock are removed.

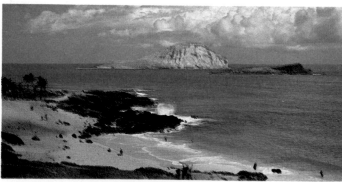

No polarizing filter

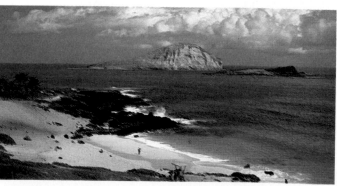

Polarizing filter

With a frontlighted subject (top two pictures), a polarizing filter intensifies colors, tones down skin reflections, and darkens the sky slightly. A polarizing filter is most effective with a sidelighted subject (bottom two pictures) because the photographer is at a right angle to the sun. It can be used at half or full power, depending on how much you want to darken the sky and accentuate hues.

To use a polarizing filter most effectively, keep in mind the following points:

▶ For maximum effect, the handle or mark on the filter's rotating ring should point toward the main light source—whether it be the sun or a lamp.

▶ To eliminate reflections, the angle from which your camera views the reflection should equal the angle between the light source and the reflecting surface. In practice, this is usually an angle between 30 and 40 degrees above or to the side of the reflecting surface.

▶ To photograph the sky at its deepest blue, make sure that the sun is at a 90 degree angle to an imaginary line between you and your subject. In the morning when the sun is in the east, for example, the northern and southern skies will deepen the most.

▶ With a single-lens reflex, you can monitor the effect of a filter through the viewfinder as you turn the filter and as you change camera angle. With a rangefinder, on the other hand, you must hold the filter to your eye, turn it until you get the effect you want, and then mount it on the camera with the handle or mark pointing in the same direction.

▶ Reflections from metallic surfaces cannot be eliminated with a polarizing screen. This includes mirrors, which have a metal-leaf backing.

No polarizing filter

Polarizing filter

No polarizing filter

Polarizing filter

Filters

Color Correcting Filters

Ideally, the color film you use in a given situation should always be balanced for the type of illumination available. But there is another alternative: Color film can also be used successfully with other light sources if you use filters to adjust for the color of the light. The cost, as with most filters, will be an increase in the exposure required. This correction is crucial with slide film, since it is processed directly into a final image after shooting. In most cases, the images from color negative film can be partially corrected during printing.

The chief color correction filters are special yellow- and blue-tinted filters known as color conversion filters. All together, there are about eighteen commonly available color conversion filters in the series 80 (darker blue) and 85 (darker yellowish orange) for major adjustments, and in series 82 (lighter blue) and 81 (paler yellow) for more minor changes. Most photographers, however, generally need only two of these filters—No. 85B and No. 80A.

As illustrated by the picture sequences at right, these filters are sufficient to handle the two situations you are most likely to encounter. The first is finding yourself outdoors on a sunny day with a half-exposed roll of tungsten-balanced film in your camera. Since tungsten film produces a bluish image if used in daylight, the filter that corrects for this—No. 85B—is yellowish orange in color. It filters out the excess blues and heightens yellow-red hues. This same filter should be used when shooting tungsten film with an electronic flash, since the flash simulates daylight.

The second situation is just the reverse—being caught indoors in incandescent light with daylight-balanced film. Uncorrected, the scene will appear unnaturally golden. The solution is a blue-colored filter, No. 80A, which absorbs some of the overly abundant yellows and reds and enhances the scarce blues. This filter requires a two-stop increase in exposure, however. Therefore, if you anticipate shooting a roll of film half indoors and half outdoors, your best bet is to select a high-speed tungsten film, ASA 160, which you can use unfiltered indoors where the light is dimmer. When you go out into the brighter sunlight, the exposure increase required by the No. 85B filter, only two-thirds of a stop, shouldn't give you any trouble.

If you do much work with photolamps and the film balanced for them, there are four filters you might want to consider. With a blue No. 80B filter, you can use daylight-balanced film under photolamps, while a yellowish orange No. 85 will allow you to use photolamp-balanced film outdoors. This change is very similar to the change between tungsten light and daylight shown at right, since there is a relatively small difference between tungsten illumination rated at 3200 K and photolamp light at 3400 K. There are, however, filters to adjust for this slight difference. A faint yellow No. 81A filter corrects photolamp light for tungsten film, and a pale blue No. 82A adjusts tungsten light for photolamp film. Exposure increases for these filters are given in the table on page 122.

The other color conversion filters are rarely needed. But if you shoot indoors under normal room lighting with tungsten film and find that the results are usually too amber, then try a pale blue No. 82B or 82C filter. Similarly, if you feel your photos shot on cloudy, rainy, or hazy days are too coolly blue—even with a skylight filter—then experiment with a light yellow No. 81 or 81A filter. In both cases, the adjustment is likely to result in a final image that corresponds more closely to the way your eye perceives the scene.

When daylight film is shot outdoors on a sunny day, the result (top) looks much the way we see it. With tungsten-balanced film (middle), however, there is a pronounced bluish cast. When a No. 85B yellow-orange filter is used with the tungsten film (bottom), the color balance is almost the same as with daylight film. The filter required a two-thirds-stop increase in exposure.

Daylight film outdoors

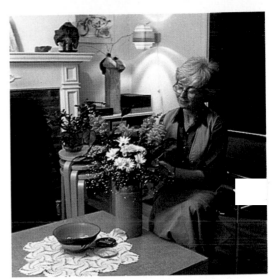

Tungsten film indoors

Using tungsten-balanced film with incandescent light indoors (top) gives a natural-looking image. When daylight-balanced film is used instead (middle), the result is too amber in tone. But with a blue No. 80A filter (bottom), a picture taken on daylight film is virtually indistinguishable from the image on tungsten film. The correction, however, required a large exposure increase—two stops.

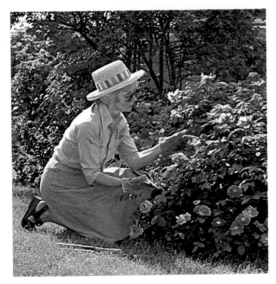

Tungsten film outdoors

Daylight film indoors

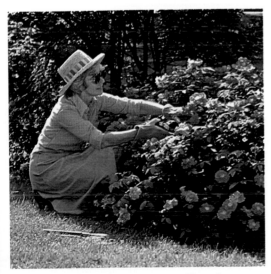

Tungsten film outdoors—filtered

Daylight film indoors—filtered

Filters

Color Correcting Filters

This table will help you determine the appropriate filters and exposure changes for different film and light-source combinations. If your camera's meter has an external photocell, you can adjust the exposure by setting the lower ASA speed shown here. If you have a through-the-lens meter, you can set the lower ASA and adjust your camera until it indicates a proper exposure before putting on the filter and shooting. Alternatively, you can first meter the scene without a filter at the film's normal ASA. Then, when you put on the filter, increase the indicated exposure by the *f*-stop change indicated here.

For the other most common type of illumination, fluorescent lighting, color conversion filters are helpful. Fluorescent tubes are too deficient in red to fit into the spectrum of colors for which film is balanced, and a strong addition of red and yellow is needed to make the image appear natural in tone.

The most widely used kind of fluorescent light, cool white, can usually be adjusted with two commonly available screw-in filters—FLD (fluorescent daylight) for daylight film and FLT or FLB (fluorescent tungsten) for tungsten film. Both filters require a one-stop increase in exposure. For other types of fluorescents you can use color compensating (CC) filters. These are made in graduated densities for the three primary colors—red, blue, and green—and for the three complementary colors—cyan, yellow, and magenta. Some suggested combinations for different kinds of fluorescent light are shown in the lower table at right. You can also use the inexpensive gelatins in preparing filter packs for unusual occasions.

Color conversion filters have many other purposes, related either to correcting the color of light or to adding an overall hue to a scene (see pages 126 and 127). In using them, keep in mind that each primary color blocks the two other primaries— a red filter, for example, blocks blue and green. Each of the complementary colors blocks one of the primaries: A cyan filter blocks red, a magenta filter blocks green, and a yellow filter blocks blue. The extent to which they block the colors depends on their density, which is indicated by their number. Thus, a CC30M (magenta) filter blocks 30 percent of the green in the scene. This filter might be useful if you are shooting through a green-tinted, plate-glass window. A CC30R, which blocks 30 percent of the blues and greens, may be helpful in underwater photography.

Conversion Filters and Exposure Changes for Color Films

Film color balance	Film speed	Daylight speed or f-stop change 5500 K	Photolamp speed or f-stop change 3400 K	Tungsten speed or f-stop change 3200 K
Daylight film	Filter type ▶	No filter	No. 80B	No. 80A
	25	25	8 or + 1⅔ stops	6 or + 2 stops
	64	64	20 or + 1⅔ stops	16 or + 2 stops
	100	100	32 or + 1⅔ stops	25 or + 2 stops
	200	200	64 or + 1⅔ stops	50 or + 2 stops
	400	400	125 or + 1⅔ stops	100 or + 2 stops
Tungsten film	Filter type ▶	No. 85B	No. 81A	No filter
	160	100 or + ⅔ stop	125 or + ⅓ stop	160
Film for photolamps	Filter type ▶	No. 85	No filter	No. 82A
	40	25 or + ⅔ stop	40	32 or + ⅓ stop

Filters and Exposure Change for Fluorescent Light

Fluorescent lamp	Daylight film	Tungsten film
Daylight	40M + 30Y + 1 stop	No. 85B + 30M + 10Y + 1⅔ stops
White	20C + 30M + 1 stop	40M + 40Y + 1 stop
Warm white	40C + 40M + 1⅓ stops	30M + 20Y + 1 stop
Warm white deluxe	60C + 30M + 1⅔ stops	10Y + ⅓ stop
Cool white	30M + ⅔ stop	50M + 60Y + 1⅓ stops
Cool white deluxe	30C + 20M + 1 stop	10M + 30Y + ⅔ stop

These three pictures were taken in the same cool white fluorescent light but with two different types of film. Tungsten-balanced film (above) gives a cool blue-green cast. Daylight-balanced film (above left) provides a warmer green cast. The most natural looking shot (left) was taken with color correction filters and daylight film.

Filters

Filters for Black-and-White Film

Because black-and-white film records colors as different shades of grey, the appearance of a black-and-white picture can be altered either subtly or significantly with color filters. Nearly all widely used black-and-white films are panchromatic—that is, they will record all the colors in the visible spectrum. But they do not reproduce each of these colors with the same relative brightness as we perceive them. Most notably, black-and-white films are less sensitive to yellow and more sensitive to blue than is the human eye. In addition, they are fairly sensitive to ultraviolet radiation, which we can't see. The most noticeable result of this disparity is that the sky appears much lighter in tone than we actually see it. The filter that is most helpful in correcting this imbalance is the light yellow No. 8, which darkens blues and lightens yellows to make the scene appear more natural. The next handiest corrective filter is the yellowish green No. 11. Outdoors, it darkens the sky and, in addition, gives foliage and flesh tones a more natural appearance. Indoors, it absorbs some of the excess reds in amber-hued incandescent light that tend to make reddish colors appear too light in tone.

Both of these filters transmit their own color and related hues to make the corresponding tones in a scene darker on the negative and thus lighter in a print. Further, they block other colors, so that these shades are lighter on the negative and darker in the final print. Other color filters can be used in a similar fashion to heighten the contrast between elements in a scene. This is useful when two elements of equal brightness might be recorded as almost identical greys. Unfiltered, red tulips will tend to merge with green leaves, but with a green filter, the tulips will appear dark against light foliage. If a red filter is used instead, the flowers will be light against dark leaves. These filters also can be used to create dramatic effects—especially with the sky. As you go from light yellow through orange to deep red filters, the sky becomes progressively darker, with spectacular delineation of clouds. The same sequence also greatly enhances textures ranging from bark to fabrics.

Filter Recommendations for Black-and-White Films in Daylight

Subject	Effect desired	Suggested filter
Blue sky	Natural	No. 8 yellow
	Darkened	No. 15 deep yellow
	Spectacular	No. 25 red
	Almost black	No. 29 deep red
	Night effect	No. 25 red, plus polarizing screen
Marine scenes when sky is blue	Natural	No. 8 yellow
	Water dark	No. 15 deep yellow
Sunsets	Natural	None or No. 8 yellow
	Increased brilliance	No. 15 deep yellow or No. 25 red
Distant landscapes	Addition of haze for atmospheric effects	No. 47 blue
	Very slight addition of haze	None
	Natural	No. 8 yellow
	Haze reduction	No. 15 deep yellow
	Greater haze reduction	No. 25 red or No. 29 deep red
Nearby foliage	Natural	No. 8 yellow or No. 11 yellow-green
	Light	No. 58 green
Outdoor portraits against sky	Natural	No. 11 yellow-green No. 8 yellow or polarizing screen
Flowers—blossoms and foliage	Natural	No. 8 yellow or No. 11 yellow-green
Red, "bronze," orange, and similar colors	Lighter to show detail	No. 25 red
Dark blue, purple, and similar colors	Lighter to show detail	None or No. 47 blue
Foliage plants	Lighter to show detail	No. 58 green
Architectural stone, wood, fabrics, sand, snow, etc., when sunlit and under blue sky	Natural	No. 8 yellow
	Enhanced texture rendering	No. 15 deep yellow or No. 25 red

Filter Factors for General Picturetaking with Black-and-White Films

Filter number	Color of filter	Daylight		Tungsten light	
		Filter factor	Open the lens by (f-stops)	Filter factor	Open the lens by (f-stops)
3	Light yellow	1.5	⅔		
4	Yellow	1.5	⅔	1.5	⅔
6	Light yellow	1.5	⅔	1.5	⅔
8	Yellow	2	1	1.5	⅔
9	Deep yellow	2	1	1.5	⅔
11	Yellow-green	4	2	4	2
12	Deep yellow	2	1	1.5	⅔
13	Dark yellow-green	5	2⅓	4	2
15	Deep yellow	2.5	1⅓	1.5	⅔
23A	Light red	6	2⅔	3	1⅔
50	Deep blue	20	4⅓	40	5⅓
25	Red	8	3	5	2⅓
58	Green	6	2⅔	6	2⅔
47	Blue	6	2⅔	12	3⅔
29	Deep red	16	4	8	3
61	Deep green	12	3⅔	12	3⅔
47B	Deep blue	8	3	16	4
Polarizing screen—grey		2.5	1⅓	2.5	1⅓

Color

Black and white unfiltered

No. 25 red filter

No. 58 green filter

When photographed in black and white, red tulips appear the same shade of grey as their green stems. With a No. 25 red filter, the flower petals become lighter but do not stand out well against the white flowers in the background. A No. 58 green filter absorbs the red light of the tulips, thus decreasing their exposure on the negative. When the negative is printed, the tulips become darker and the stems lighter, thus adding contrast to the photograph.

In the middle picture below, the photographer used a polarizing filter to darken the skies and reduce reflections on the water in the rocky beach scene at left. Adding a red filter to the polarizer (right) heightened contrasts and produced an ominous feeling.

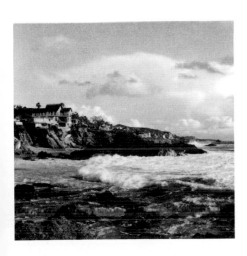

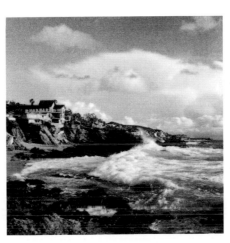

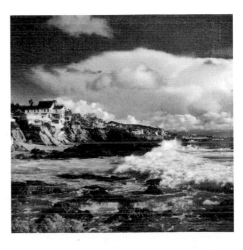

Filters

Nature is beautiful in its own right, but it's sometimes tempting to improve on nature. As the series below shows, you can create effects ranging from burning red to icy blue by adding an overall hue to the scene with any of the color filters intended for black-and-white photography (see page 124) or with the denser color compensation filters (see page 120). The technique is not limited to

Color Filters for Special Effects

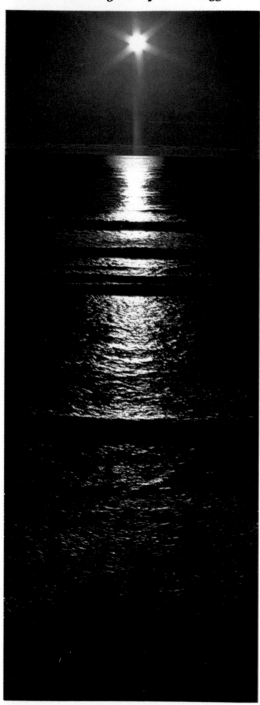

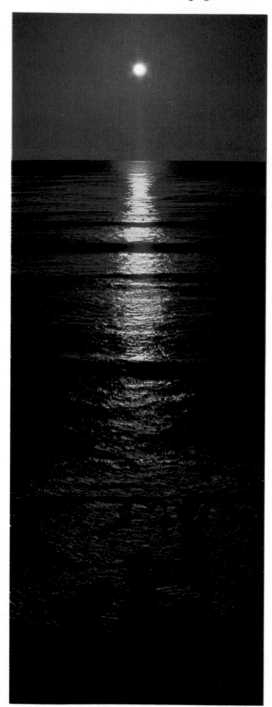

landscapes, of course. You can turn a sunny zoo scene into an arid desert setting with an orange filter, or enhance the stark shapes of buildings with many different filters. For such special effects, it is wise to use slide film, for a well-meaning processing lab may struggle to print your negative so that the tones appear more natural.

The pictures at the far left and second from right were taken without a color filter. On the other shots, the filters used were, from left to right, an orange, a deep red, and a dark blue.

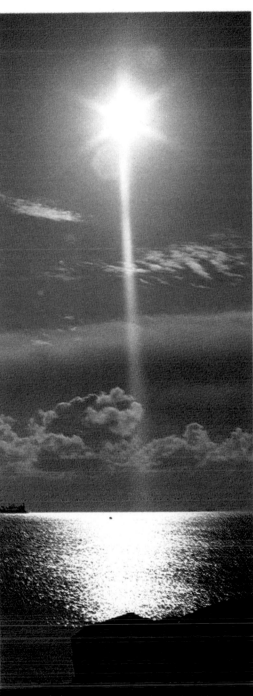

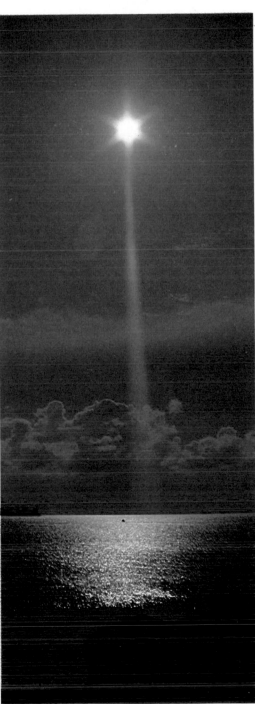

Filters

This scene of a sphinx and a pyramid, which is shown as it would normally appear immediately below, was dramatically transformed with the use of an amber-purple split-field filter. In making a dual-color filter, be careful to butt the edges evenly.

Split-field filter

Split-Field Filters

There is no need to limit yourself to just one hue when you're using color filters for special effects. Split-field filters, which divide the filter surface into two or more different colors, can help you add interest to many scenes. There are three basic types of split-field filters, all of which are available commercially. You can also make your own, however, by cutting up filter gelatins and either using them in a filter holder or taping them over a colorless UV filter, as shown in the picture at near right above.

On the first type of split-field filter, which is used mostly to emphasize the sky, only half of the filter is tinted. The second type of split-field filter is half one color and half another, to create an effect such as the one in the picture of the sphinx at right. On the third type, there is a clear circle in the center of a tinted filter to produce a color vignetting effect.

With all of these filters, the line between the different colored areas will be much softer and less distinct if you use a wide aperture and a long lens. Commercial dual-color filters are usually designed so that both halves require the same exposure increase, and if you make your own, you should try to do the same. Exposure with split-field filters is still largely experimental, however. If your camera has a meter that measures light passing through the filter, you can use it as a starting point, but it's still a good idea to bracket by several stops.

Color Polarizing Filters

Color polarizing filters are another device that allows you to change the overall hue of a scene. With the single-color type, for example, you can gradually change the color of a scene from light pink to deep scarlet. With a two-color polarizer, such as a red-blue one, you can color a scene with a tint that goes from deep red to light red through magenta, and then on to light blue and dark blue.

By rotating a two-color polarizing filter, you can change the overall tint of a scene from deep red to deep blue, with interesting color combinations in between.

Color polarizing filter

Filters

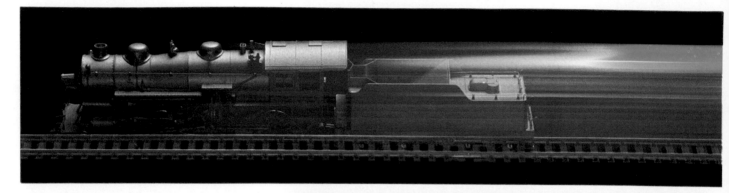

The Harris Shutter

You can get striking images with multiple exposures when you take each exposure through a different color filter, and this is easy to do with the basic techniques and exposure times for multiple exposures explained on page 240. Move the camera slightly for each new exposure so that the colors overlap, as in the picture at right. To get the right amount of light on the film, decrease exposure by one stop for each exposure. If a scene calls for a setting of 1/250 second at $f/8$, a double exposure through filters would require 1/250 at $f/11$ for each of the two exposures.

Although you can use any combination of filters, you will get the most interesting results when you use red, green, and blue filters—the three primary colors that constitute white light. When you shoot a scene such as a landscape through No. 25 deep red, No. 61 deep green, and No. 38A blue filters, most of the scene will look normal, because the original color has been restored by the primary combination. Anything in the scene that is moving, however, will be recorded with rainbowlike colors.

Putting on and taking off three filters can be cumbersome, so to get the same effect with much less bother, you can use a simple device known as the Harris shutter. The Harris shutter, pictured at right below, is three gelatin filters taped side by side, with pieces of black cardboard attached at both ends. The entire filter strip fits in a frame on the front of the lens. When you take a picture using the Harris shutter, set the camera on B for time exposure and start with one of the

pieces of black cardboard over the lens to block light. While the shutter is open, let the Harris strip drop until the cardboard piece at the other end covers the lens. The Harris shutter allows you to make multicolored time exposures of moving subjects, as the picture of the toy train at top shows. Your exposure time will depend on how fast you let the strip fall. It's wise to bracket your exposure and to use color negative film, which can be corrected to a certain degree in printing if you've made an exposure error.

Two views of a model train illustrate the effects of recording multiple exposures with three different color filters (above) and of using a Harris shutter (top).

Harris shutter

Neutral Density Filters

Density	Number of f-stops to decrease exposure
0.10	$\frac{1}{3}$
0.20	$\frac{2}{3}$
0.30	1
0.40	$1\frac{1}{3}$
0.50	$1\frac{2}{3}$
0.60	2
0.70	$2\frac{1}{3}$
0.80	$2\frac{2}{3}$
0.90	3
1.00	$3\frac{1}{3}$

Neutral Density Filters

Neutral density (ND) filters are greyish filters that reduce the amount of light entering the lens. Since they do not change the hues or relative intensities of the colors in a scene, they can be used with any black-and-white or color film without altering the appearance of what you see. They are invaluable in situations that require you to reduce exposure. If you go on vacation and want to be able to shoot in varied conditions on the same roll of film, for example, you can put high-speed film in your camera and use it without filters for most lighting. When you want to shoot a very bright scene—a sunny beach, say—you can put on an ND filter and still use the high-speed film.

Neutral density filters are also very useful for achieving certain special effects. If you want to use a large aperture, such as $f/2$, to blur out a background but find that you don't have a shutter speed that's fast enough, an ND filter will let you take the picture. Neutral density filters can be used to prevent overexposure of the film during a time exposure. And, as the picture at right demonstrates, they also let you use slow shutter speeds to get blurred motion photographs on bright days. As the chart above shows, ND filters are graded by their density, and the gradations translate into f-stop reductions. Using an ND 0.10 filter, for example, means you should increase your exposure setting by one-third stop. The three handiest gradations of filters are 0.30, 0.60, and 0.90, as they represent full f-stops—1, 2, and 3, respectively. To increase the effect of neutral density filters, add two or more together. You can also use a polarizing filter as the equivalent of an ND 0.40 filter.

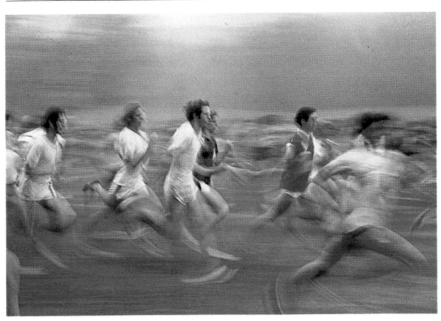

By cutting down the light reaching the film, a neutral density filter allows you to use slower shutter speeds in bright light without overexposing the final image.

Neutral density filter

Filters

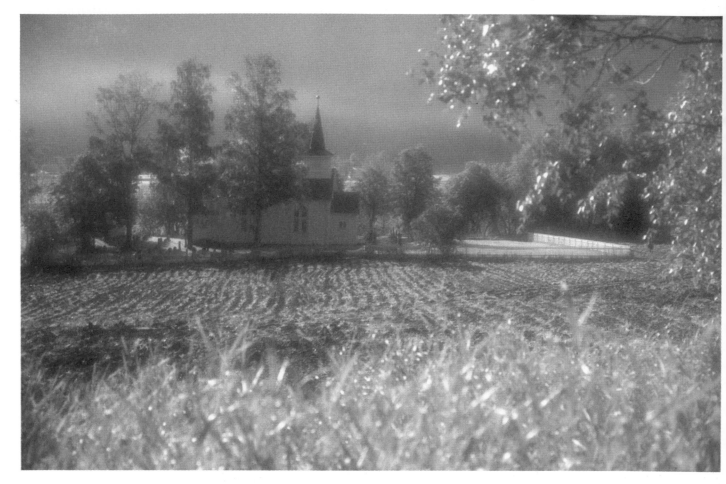

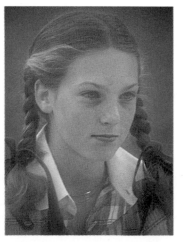

Whether you smear petroleum jelly on a colorless filter or stretch a piece of nylon hose over the lens, homemade diffusers and vignetting filters are fine for the photographer who only occasionally takes a soft-focus picture (left and right

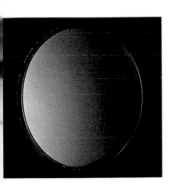

Diffusion filter

Most diffusion filters such as the one above have a fine pebbly surface that causes the light to reflect slightly and spread, creating a soft-focus effect, as in the picture at left.

Starburst filter

Starburst, or cross-screen, filters (above) contain a fine metal mesh that turns points of light into four-pointed stars—or eight-pointed ones if two filters are placed at an angle to one another.

A diffraction grating lens (below) has thousands of tiny ridges in its surface that act as prisms, breaking strong light into bands of spectral colors.

Lens Attachments for Special Effects

There are a great many other filters and filterlike attachments that can be used to produce striking results on film. Perhaps the best known of these are diffusion filters, which produce an overall misty, soft-focus effect, and vignetting filters, which produce a similar effect around the edge of the picture but leave the center sharp. As the pictures below left show, you can obtain a similar type of diffusion by stretching a piece of nylon hose over the lens or by smearing a thin coat of petroleum jelly on a colorless UV filter. The effects vary quite a bit, so it is best to experiment. A wide aperture and backlighting enhance diffusion.

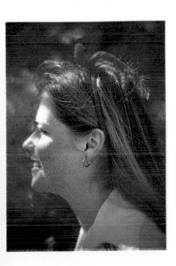

Two other common lens attachments shown here work by bending or breaking up light rays. The starburst filter is a screen that causes bright pinpoint lights or reflections to look as if they are emitting long, pointed rays. A diffraction grating attachment breaks a light source into a prismatic rainbow of hues in a pattern across the picture. If your camera's meter reads light passing through the filter, you don't need to make any exposure adjustments for these attachments.

Diffraction grating lens

Filters

Lens Attachments for Special Effects

Another popular group of screw-on filterlike attachments features multiple-image lenses. They have prismlike surfaces that cause images to repeat in parallel, concentric, radial, and other patterns. They require no exposure adjustments and usually work best with subjects isolated against a simple background. An exception is the cluttered junkyard below, which is effective because of its strong lines and interesting shapes and colors.

Multiple-image lens

Multiple-image lenses such as this one produce one main image surrounded by slightly fainter repetitions. In the picture at right, the effect was enhanced by using multicolor filters at the same time.

Repeating lens

A parallel repeating multiple-image lens, such as the one above, was used for the auto junkyard shot below. The lens can also be turned to make images that repeat horizontally or at an angle.

Accessories

Flash

Even though ultrafast films and lenses make taking pictures easy in many kinds of lighting, most photographers find a flash an invaluable aid. By providing more light—and light that you can control—a flash overcomes many of the limitations of shooting in available light. It lets you use fine-grained, slow-speed film and auxiliary lenses with smaller maximum apertures. With flash, you can also gain greater depth of field, stop action, and take pictures in near or total darkness. Although flash bulbs are still practical for some photographs, they have been almost completely eclipsed by electronic flash units, which are more convenient to use and cost less per flash.

An electronic flash unit has a flash tube powered by a battery-fed capacitor. The capacitor stores energy from the battery and releases it to the tube for a very brief instant to create the flash, which often lasts less than 1/1500 second. Most inexpensive flash units are powered by conventional batteries, which have to be replaced when their energy is exhausted. More costly units use nicad (nickel–cadmium) batteries, which can be recharged many times. The only disadvantages of nicad batteries are that a fully charged pack will be drained before conventional batteries and that nicad cells do not usually recycle (fill) the capacitor as fast as a fresh set of regular batteries. This means you have to wait a moment between pictures—a problem when you want to take pictures in rapid-fire succession. For most photographers, however, the nicad rechargeable models are still more useful than the simple battery models. Nicad units are available with greater power output, more automation, and extra features, such as "zoom" heads that change the lighted area to match different lenses, and tilting heads that let you bounce the light easily. Some also have attachments such as diffusers and cords for bouncing the light.

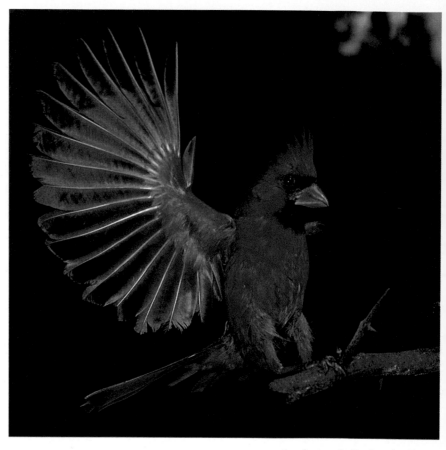

An electronic flash unit allows you to stop action within a fraction of a second. Here a bird is captured, with wings outstretched, just as it lands securely on a branch.

To meet a variety of lighting needs, the commonly available electronic flashes range from units smaller than a cigarette pack to larger, more powerful and sophisticated units.

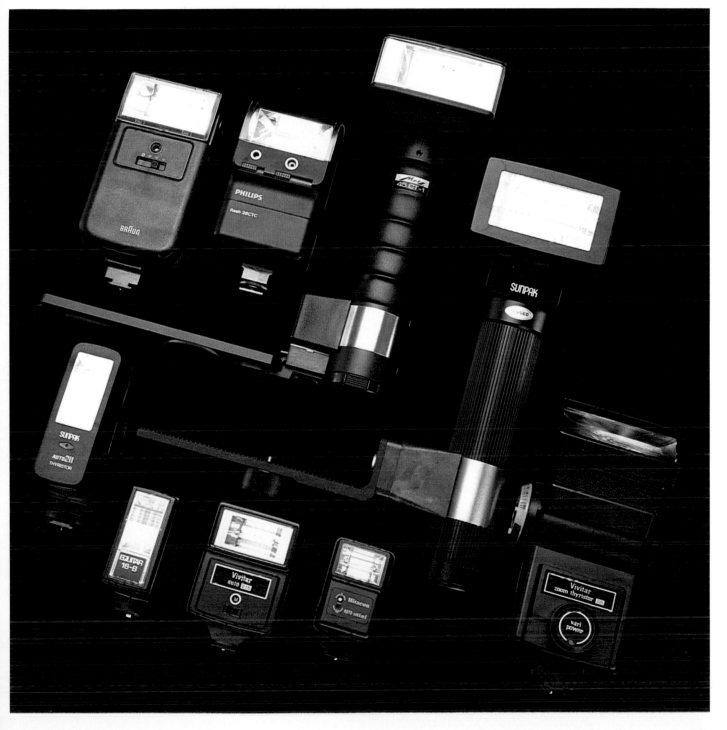

Accessories

Synchronizing Flash

Because the duration of a flash is shorter than the fastest shutter speed, the length of flash—rather than the camera's shutter speed—determines the exposure time. Theoretically, this would mean that any shutter speed could be used with a flash. On rangefinder cameras with leaf-type shutters, this is generally true. But because of the mechanical limitations of the focal plane shutters used on single-lens reflexes, it is usually necessary to use a shutter speed of 1/60 second or longer.

It is imperative that a flash be synchronized with the shutter—that is, that the light appear at exactly the right moment, when the shutter is open. Most modern cameras are already synchronized for electronic flash. Inserting a flash unit into the hot shoe or plugging in the flash cord automatically sets the synchronization. Older cameras have either a pair of flash-cord sockets—for bulb and electronic units—or a hot shoe that can be adjusted for the type of flash. The socket or setting for electronic flash is usually marked with an X, which indicates that the flash will go off almost instantaneously as the shutter opens. The synchronization for flash bulbs, labelled M or FP, causes a momentary delay before the shutter opens, to let the bulb reach its peak of brightness. Your instruction manual should give you full details about setting synchronization for your particular camera and flash unit.

Since the duration of the flash determines the exposure time, your shutter speed will remain a constant, and you only have to adjust the lens's aperture when you are shooting with a flash. On the simpler, manually operated units, this is usually done with the aid of guide numbers. As a subject retreats from the flash, the intensity of the light hitting that subject decreases. As a result, flash exposure is determined by the distance between the flash and the subject. The guide number, which is determined by the power of the flash and the speed of film, is divided by the subject-to-flash distance in feet. The resulting number is the *f*-number you need to set on the aperture ring. Most flash units have a simple rotating calculator dial like the one shown in the picture above to help you determine the *f*-stop quickly. To find the subject-to-flash distance when the flash is mounted on the camera, focus the lens on the subject and then use the distance indicated on the lens's distance scale. Otherwise, it is best to measure the distance.

The calculator dial on manually operated flash units is a simple rotary scale. Set the dial on the bottom to your film's ASA speed, then find the f-stop you will need opposite your subject-to-flash distance at top.

If you do not use the hot shoe on your camera, you must establish the electrical connection by plugging the flash cord into both the camera and the flash unit.

The hot shoe on top of the camera is convenient to use, but not always the best place to put your flash, since it gives flat, even light with little modeling.

The guide numbers for some electronic flash units are overly optimistic about the unit's strength, so it's usually a good idea to run your own guide number test. One of the best ways to do this is to load your camera with a medium-speed (ASA 64 or so) color slide film, attach the flash, and mount the camera on a tripod in a normal-sized room. Have a person sit exactly ten feet from the camera.

Take your first flash picture using the aperture setting recommended by the flash unit's calculator dial for your combination of film speed and the ten-foot distance. Then bracket the recommended aperture at one-half stop increments, taking two or three shots at smaller apertures and the same number at larger ones. If the recommended aperture is $f/4$, your smaller apertures would be midway between $f/4$ and $f/5.6$; then $f/5.6$; and then midway between $f/5.6$ and $f/8$. Similarly, your larger openings would be midway between $f/4$ and $f/2.8$; $f/2.8$; and midway between $f/2.8$ and $f/2$. As in the example here, it is very helpful to have your subject hold cards showing the aperture setting for each shot.

After the roll is processed, compare the other slides with the one taken at the recommended exposure. If one of them looks better, tape a reminder to your flash unit to adjust the exposure. One easy way to make this change is to reset the film speed dial on the calculator to compensate. If you want to get a full stop more exposure, set half of your film's ASA number—80 for an ASA 160 film, for example. If you want one-half stop more, set a number that is 25 percent lower—150 for an ASA 200 film. To decrease exposure, double the film's ASA for a full stop, and set a number 50 percent higher for one-half stop.

f/4

f/2.8 — f/4

f/4 — f/5.6

f/2.8

f/5.6

With a simple exposure test such as the one shown here, you can check the power output of your flash unit and, if necessary, adjust your guide numbers to help you correct exposure. The test is also useful for checking the effect of various diffusion and bouncing techniques (see page 142).

Accessories

Automatic Electronic Flash

Some electronic flash units have automatic exposure control, which eliminates the need to work with guide numbers. On the front of these units are light-sensitive cells that are pointed toward the subject. When the flash goes off, the cell almost instantaneously measures the light reflected from the subject and adjusts the duration of the flash. It gives a shorter flash for a close or bright subject and a longer one for a distant or dark subject.

The calculator dial on an automatic flash unit works in much the same way as on a manual unit. After you have set the ASA speed at the bottom, however, it allows you to choose a range of f-stops, which appear between the arrows at top.

Added benefits of an automatic electronic flash are that its recycling time is faster and that you get more flashes per battery because, unlike manual models, which give the same amount of light with every flash, the flash doesn't have to use its full capacity to light a close subject. When you set your film's ASA on an automatic flash, the unit's dial lets you choose from among several *f*-stops, each with a somewhat different distance range. Your choice depends on the camera-to-subject distance, the depth of field you want, and how much of the scene behind your subject you want to light up.

The customary place to attach an electronic flash is on the camera's hot shoe, so called because it transmits the electrical signal that causes the flash to fire. This location is a convenient one for a flash, as it doesn't require a connecting cord. But when a flash is aimed directly at your subject from the camera position, the lighting can be flat and even, eliminating shadows and textures that give roundness and solidity to a subject. Most subjects look more three-dimensional—the effect is called modeling—and will produce more flattering portraits when the light comes from the side and above the camera. Such a lighting angle also makes your subject more comfortable and eliminates the problem of "red eyes"—red spots in your subject's eyes that are reflections of the flash.

There are several styles of brackets that attach to a camera and hold the flash to one side and at various heights above the lens. The pictures on these pages show some of the brackets you can use. To gain even more distance between the camera and the flash, hold the flash up in your hand, off to one side. If this proves awkward, you may need to place the flash on a stand.

When an automatic flash unit is fired, a photosensitive cell on the front of the unit reads light reflected off subjects and regulates the duration of the flash, depending on the brightness of the subject and the distance between flash and subject.

Flash attachments can be mounted directly on the camera's hot shoe (far left below), but the light they give may flatten some subjects. Using a bracket (center) or hand-holding the flash (below right) to change the angle of the lighting will help you achieve a more three-dimensional effect.

Accessories

Diffusing and Bouncing Flash

Light at an angle from a direct flash can be harsh and bright, causing great contrast between highlights and shadow areas. Even from the side, a flash can be too strong; it may wash out details and color in highlight areas, particularly at close range. There are several techniques for softening light that will lower contrast. The most popular is known as diffusion. Many flash units have accessory diffusers, but you can also diffuse the light from a flash by taping one or more layers of white tissue or matte acetate over the head of the flash. Since this reduces the light reaching the subject, you have to increase your exposure. As a rough guide, add one-half *f*-stop per layer of material, but for greatest accuracy, it's best to run an exposure test (see page 139).

Another alternative to direct flash is to bounce the flash off a nearby wall or the ceiling. The surface should be neutral-colored, preferably white, or else your subject will pick up a reflected tint. Some flash units have a tilting head that can be angled up toward the ceiling, and for other units you can buy special angling brackets. You can also simply hold the flash in your hand and point it at the surface. Bouncing a flash also requires an increase in exposure. The general rule is to add two *f*-stops, but the results will vary depending on the brightness and distance of the reflecting surface. It's best to experiment until you get the feel for certain settings, and even then it's safest to bracket. If you do a lot of your photography in one room, run an exposure test there. Some automatic flash units have to be used in the manual mode for bounce, but ones with tilting heads work on automatic, provided the sensor on the front is pointed at the subject.

Another way to bounce flash is to use a photographic umbrella or other commercial reflector, equipment that gives you good control. You can aim the umbrella or reflector where you want and adjust the light very carefully. These units differ in their reflective qualities, but most come with full instructions. You can make your own reflector by attaching a large sheet of white cardboard to a lamp stand, but be sure to run an exposure test with it.

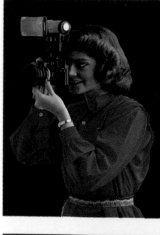
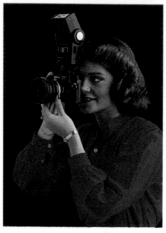
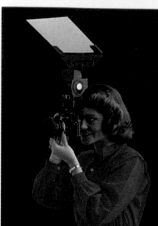

Using a diffuser (top left and right) softens light without cutting too much of its brightness. The result of bouncing a flash off the ceiling or walls depends very much on how light the surface is and how close you are to it. Some units have movable flash heads (above) that can be tilted upward to bounce the flash off the ceiling. When you use a white-card reflector (above right), the result will be more predictable and usually brighter than if you bounce the flash off the ceiling. A photographic umbrella (right) gives a very pleasing soft light that can be aimed at the subject, somewhat like a parabolic reflector.

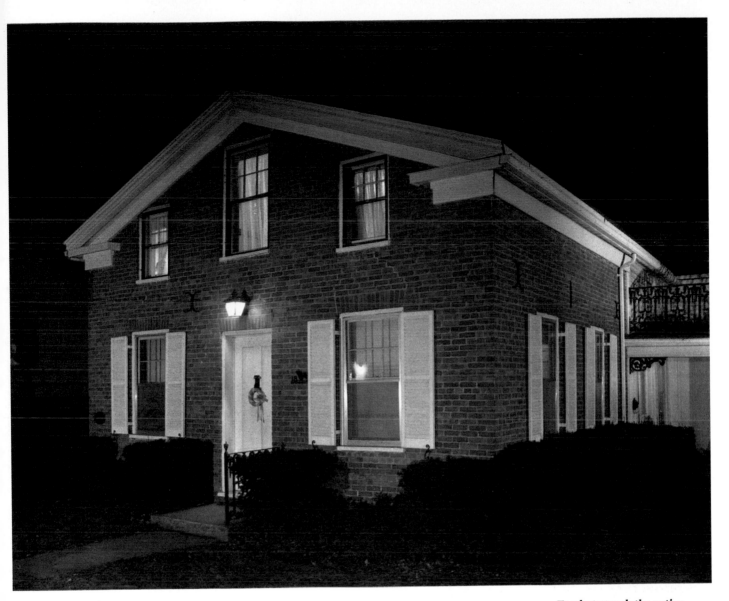

Open Flash

If you want to use a flash to light a subject that is so far from your camera that a cord would be impractical, or if you want the light to come from an unusual angle, there is a simple technique you can use known as open flash. Mount your camera on a tripod, set the shutter speed on B for a time exposure—using a cable release with a lock to keep it open—and then walk over and fire the flash independently before closing the shutter. The scene should be dimly lighted, or the picture may be overexposed by ambient lighting. As with other flash shots, the aperture you set will depend on the subject-to-flash distance, but if you plan to side- or backlight the subject with flash, you may have to increase your exposure by one or two stops.

Open flash can also be used to light a subject too large for one flash alone. With the camera on a tripod and the shutter open, fire the flash several times, each time illuminating a different portion of the subject. Try to maintain the same distance from the subject for all the flashes and use that distance for determining your f-stop. Also avoid overlapping flashes, since that would cause uneven exposure. Determine how much a single flash will cover and plan the sequence in which you will light your subject. This technique, known as painting with light, was used to photograph the house above but is not limited to exteriors. It works very well in dimly lighted interiors as well (see page 218).

To photograph the entire façade of this house at night, the photographer "painted" it with light—firing a single flash unit several times in different spots while the camera was set for a time exposure.

Accessories

Multiple Flash

Studio photographers know that a careful balance of light from several sources gives the greatest amount of modeling and dimension to any subject. The easiest way to get this kind of multiple lighting is to use two or three electronic flashes. To make sure they fire simultaneously, you can use cords connected with Y-shaped terminals, but this is messy and may limit the position of the flashes. It's much easier to attach "slave" photocells to all units except for the one that is connected to the camera. When the unit attached to the camera is fired by the shutter, the slave photocells "see" the flash and fire their units in the same instant.

The multiple-flash arrangement shown in the overhead shot at right places the main light about 45 degrees to the side of the camera, aimed downward at about a 20-degree angle. The fill light used to brighten the shadows created by the main light is close to the camera and near lens level to avoid more shadows. Fill light is the most convenient to connect to the camera. With the main flash closer to the camera, this set-up gives you a 3:1 lighting ratio. The main flash gives two units of light to the principal features of the subject, while the fill light provides one unit overall. Therefore, the principal features receive a total of three units, while the shadows receive one. If both flashes are equally powerful, use the f-number relationships to position the flashes. For instance, just as an $f/8$ aperture transmits twice as much light as $f/11$, you can set the main flash eight feet from the subject and the fill light at eleven feet. Any equivalent combination will also work. A lighting ratio of 3:1 is usually considered pleasing, but you can easily vary it. Moving the main light closer to the subject will give you greater contrast between highlighted and shadowed areas; moving it back will lessen the difference. You may also use a third flash if you want, to backlight the subject, as here, or to brighten the background so that the subject stands out from it. If all of the flash units have the same output, set your aperture as if the main light were being used alone. If they differ in power, you will have to experiment and bracket exposures for best results.

This overhead shot shows a typical multiple-flash setup that can help you achieve studiolike lighting control. You can use two, three, or even more flashes.

During the day, sometimes the best position for a subject will cause shadows. A flash unit is very handy for controlling these shadows, as the pictures below, taken in sidelighting and backlighting, show.

Sidelighting without flash

Sidelighting with fill-in flash

Flash Outdoors

Strangely enough, one of the best places to use flash is outdoors in bright sunshine. As the series of shots below shows, an electronic flash, which matches sunlight in color balance, is ideal for filling in the harsh shadows created by the sun on front- and sidelighted subjects and for making back-lighted subjects and ones in shade stand out.

When using flash as fill-in light outdoors with the leaf-type shutter on most rangefinder cameras, you are usually safe if you set the aperture recommended by your flash's guide number and then use the camera's meter to determine the correct shutter speed for the sunlight. Theoretically, this combination would result in both light sources being of equal intensity on the final picture. Without reflective surfaces, however, some of the flash's light is lost outdoors, making its effect about a stop or two weaker than for the indoors situations that the guide numbers are designed for. Thus the flash acts as fill-in light only, lightening shadow areas somewhat but maintaining pleasant contrasts and softer lighting on your subject's face.

Single-lens reflex cameras are another story. Since they have focal-plane shutters, you have a limit on your shutter speed. The fastest you can use on most cameras is 1/60 second, although a few permit 1/125 second. After you have set this shutter speed on your camera, set the aperture indicated by your camera's meter. You then have to move back and forth to get a subject-to-flash distance that supposedly requires the same settings you've already chosen for the camera (see above) to ensure that the flash will be weaker than the sunlight. Rather than moving, you can reduce the output of your flash by using one or more layers of diffusing materials, such as facial tissue, estimating a half-stop change for each layer. You can also stand at the best subject-to-flash distance and select a lens that will frame the scene and give you good composition.

You can also use your electronic flash outdoors at night, if you remember that with so few reflective surfaces, you have to increase your exposure a stop or so. Night or day, if you shoot outdoors in cold weather, keep the flash unit warm under your coat, because the cold can drastically diminish the power of its batteries.

You can use flash outdoors at night to capture sharp, bright images of subjects that are normally wary of a photographer.

Backlighting without flash *Backlighting with fill-in flash*

Accessories

There is a wide variety of photographic accessories. Some you may want to consider are shown here and on the following pages.

For many photographers, a **tripod** is indispensable. It holds the camera steady when you're using slow shutter speeds or when you have a long telephoto lens attached. It assures that there will be a minimum of camera movement to blur a picture. To determine whether a certain tripod is steady enough for your purposes, extend it fully and place your hand on the camera-mounting surface. Rest some weight on that hand and try to move your hand in a circular fashion. If the tripod doesn't wobble or shift, it's steady enough for your camera. Make sure that the legs extend and contract easily and that the tripod raises to the height you want. Check to see that all adjustments lock securely. If you're going to photograph small subjects at ground level, be sure that the tripod center column reverses so that the camera can be mounted close to the ground. Make absolutely sure that the camera-mounting system, usually a plate with a screw that inserts into the bottom of the camera, is strong enough to hold a camera with a long telephoto lens. Last, test the tripod with your own camera to make sure that you can move all the camera's controls while it is mounted on the tripod.

Cable releases, which screw into the camera's shutter button, provide an extra bit of steadiness when the camera is on a tripod by removing your hand from the shutter release. Most good cable releases have a lock to keep the shutter open for time exposures.

Remote releases free the photographer from the camera. The most common ones include old-fashioned air bulb releases and devices with photoelectric cells. Both can trigger a camera from many yards. More expensive units can fire the shutter by radio signals from miles away. Remote releases are most often used with wildlife, but they can also be handy in a home studio. Many late-model SLRs can be fitted with an automatic film advance device—an

automatic winder or **motor drive.** Both incorporate a battery-driven electric motor that releases the shutter, advances the film, and cocks the shutter for the next exposure. Motor drives advance the film faster (three to five frames per second and faster) than auto winders and are usually a bit more rugged. Ideal for sports photography, informal portraits, and candid work, where scenes and subjects change rapidly, automatic film-advance mechanisms allow you to keep your eye to the viewfinder and concentrate on capturing the decisive moment without taking time to advance the film manually.

Camera manufacturers offer so-called **ready cases** that are designed to protect the camera from knocks, jolts, and moisture. Usually they are rigid and bulky, but the protection they afford more than makes up for loss of convenience. Soft cases are easier to handle but give less protection.

If you intend to use the ready case for storing the camera, but not for carrying it, you'll need a **neck strap.** Carrying straps come in all materials, widths, and color schemes, and some photographers adapt guitar straps or army surplus harnesses. A wide strap doesn't slip off your shoulder as easily as a thin one, and the increased surface area means less pressure on your neck or shoulder during long days with a camera.

For active photographers who don't want to have their cameras constantly swinging like a pendulum, there are special sports **harnesses** that make the camera ready and accessible but keep it flat against the chest when not in use. You can also find **film canisters** that connect to your camera strap—which is preferable to putting film in your pockets but probably more of a nuisance than stuffing film into a gadget bag. It's possible to achieve the same effect by taping the packaging cans to the camera strap.

All **gadget bags** serve the same purpose—to carry your gear safely and to make it easily accessible. Some photographers prefer

Tripods (top) range in size from small tabletop models to tall studio stands. Be sure to get a sturdy one—even though it may weigh more. A wide carrying strap (above) distributes the weight of heavier single-lens reflex cameras more evenly than a narrow one. Use a cable release (right top) to remove your hand from the camera to prevent camera movement. Film canisters attached to your carrying strap (right center) keep your film easily accessible, and a sports harness will hold your camera to your chest, ready for instant action (right bottom).

*Gadget bags are available in
an enormous variety of styles.
Your choice depends on your
needs and preference.*

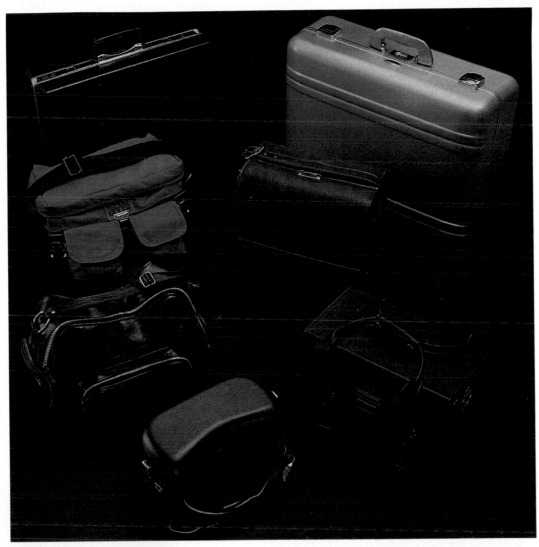

handsome leather bags with compartments
for everything. Others use aluminum
suitcases, and still others adapt backpacks,
army surplus bags, and briefcases. Examine
your own needs—the amount of equipment
you own, the amount of protection it needs,
whether you take long trips or short outings,
and even your self-image. To be
inconspicuous, don't carry a bag that looks
like the typical gadget bag. If you send photo
equipment unguarded into the bowels of
airplanes, get the best protection you can
find. Better yet, get a bag that stows away
under an airplane seat and keep your
gear with you. There are also lead-proof film
containers for frequent air travelers.

Accessories

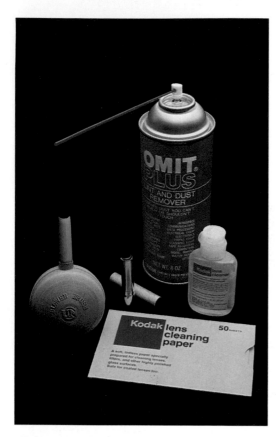

All you need to clean your camera and lenses is a soft camel's-hair brush, lens tissue, lens cleaning fluid, and either an air bulb or a container of compressed air. Be sure to get photographic lens tissue and cleaning fluid. The ones sold for eyeglasses are not suitable for camera lenses.

Cleaning supplies: Both the lens and the body of your camera need periodic cleaning. The lens needs cleaning on the front and back glass elements, and to do it all you need are a soft brush (preferably camel's-hair), lens-cleaning tissue, and lens-cleaning fluid. Make sure that the tissue and cleaning fluid are not the kind for eyeglasses. And be careful when cleaning lenses! First, brush off all movable particles. Then place a sparing amount of fluid on the lens surface or on a piece of lens-cleaning tissue and wipe the glass gently until clean. A final, gentle polish with dry tissue will help remove any lint. Rub hard and there's a possibility of scratching the surface with grit and dirt. Putting a UV or skylight filter on your lens will help protect the front element from dirt and scratches.

It's also simple to clean out a camera body— in the front where the lens is mounted and in the back where film is loaded. All you need is your soft brush and a rubber air bulb or can of compressed air. (If you use the latter, follow the instructions on the can. If misused, a compressed air container can spray propellant inside the camera, causing damage.) Look first for any visible dirt or dust, remembering that cleaning must be as gentle as possible to avoid knocking delicate mechanisms out of adjustment. When your brush, bulb, or air bottle has removed everything visible, give an overall shot of air with the camera opened upside-down to remove any unseen particles. Clean the mirror as you cleaned the lens, and if possible do it with even more care. The mirror is precise and adjusted exactly— knocking it out of line can result in an expensive repair bill. Finally, the viewfinder window gets dirty easily. Give it the same treatment as the lens. Clean cameras work better and spend less time in the repair shop. They also give better pictures.

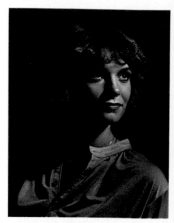

One photolamp

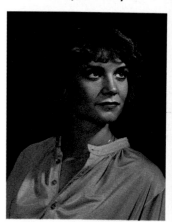

Two photolamps

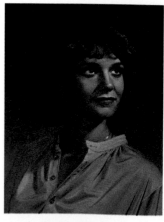

Three photolamps

The Home Studio

Many photographers prefer the controlled setting of a studio for certain subjects—mainly people. A studio needn't be complicated. In fact, it can be entirely portable and still fit many applications. The main ingredients are light, background, and enough space to work in freedom.

For lighting, you'll need several light sources that can be moved around. Multiple flash (see page 144) is adaptable to the home studio, but photolamps are also popular. The chief advantage of the photolamps over flash is that you can see the effect of the lighting as you're arranging the shot. There's also no delay for recycling, and photolamps may be less expensive than flash. The disadvantage is that photolamps require films with special color balance (see page 98) or color correcting filters (see page 120). They are also hot and may make a subject uncomfortable during a long shooting session. Flash, on the other hand, is color balanced for daylight film, and quite cool. Whatever type of light you use, mount it on a steady support. Regular photographic light stands are widely available, and you can also attach both photolamps and flash units to clamps that can, in turn, be attached to almost anything.

For a background, a wall painted in a neutral color with matte finish is adequate, but a portable, changeable background is more flexible. Photo dealers sell tall, portable supports for a long roll of special studio background paper that can be pulled down to the floor for the background and out toward the camera as a foreground. Since there are no joints or separations in the material, it is called "seamless" or "no-seam" paper. It comes in rolls of standard widths and is available in many colors and textures for different subjects or effects. You can construct your own stand for seamless paper using two uprights with a pipe between them for the roll.

Almost any room can be converted into a temporary studio with a little imagination. Except for still lifes, however, space is important. Try to pick a room with a fairly high ceiling and some depth. This will give you enough room to use a variety of lighting positions and equipment, such as moderate telephoto lenses.

With a tripod, background paper, and photolamps, it is easy to set up a home studio in large rooms. Packed away, all this equipment takes up very little space. The effects of using one, two, and three photolamps are shown in the series at left.

The Photographer's Most Common Problems—

Mechanical problems

Technique problems

Every photographer—beginner or expert—is at times disappointed with the way pictures turn out. Sometimes it's just a matter of better timing or a steadier hand on the photographer's part. At other times a faulty camera may be to blame. In any case, it's helpful to recognize the disappointing elements of your pictures and learn to correct them. In the examples and advice given here, you'll find over a dozen of the problems photographers most often encounter—and what you can do to solve them. The first list covers possible mechanical problems; the second concerns problems of technique.

▶ **Film jam:** If the film refuses to advance or rewind, take the camera to a dealer who is able to extract the film without ruining the pictures you have already taken. The dealer should also be able to determine whether the problem lies with the camera, your loading technique, or with that particular roll of film.

▶ **Battery failure:** If the exposure meter starts to act erratically or quits completely, chances are that the battery is dead. Replace it and check to see whether the exposure meter functions correctly.

▶ **Pictures consistently too dark or too light:** If your prints or slides always turn out underexposed (too dark) or overexposed (too light), make sure that you have set the correct ASA number on the camera's film-speed dial. Another cause of improperly exposed photos is a malfunctioning meter or shutter, for which you'll want to have the camera examined by a repair person. If your flash pictures are too light or too dark, make the exposure test detailed on page 139 to determine a new, correct flash guide number for the film you use.

▶ **Flash failure:** If the flash fails to fire when you press the shutter release, check the connecting cord (if you use one) for a tight connection at both ends. If the connection seems good, and the flash does fire manually (most units have a button to fire the flash), replace the connecting cord. If this doesn't solve the problem, have the flash unit and/or camera inspected by a technician.

▶ **Blurred pictures:** A dirty lens can cause an overall blur in your pictures, as can unintentional camera motion. Keep the lens clean (see page 148) and hold the camera steady, with your feet solidly planted and arms firmly braced against your body. Make sure the shutter speed is fast enough to prevent camera movement—generally 1/30 second or faster, except with telephoto lenses (see page 105). Use a tripod for slow shutter speeds. When a moving subject is blurred and the rest of the scene is sharp, the shutter speed was too slow to freeze the action (see page 176). If part of the scene is sharp, but the main subject is blurred, you may have focused incorrectly (see page 94).

▶ **Unattractive foregrounds and backgrounds:** In the heat of an exciting moment of picturetaking, it's easy to overlook distracting elements that surround the subject. Use a discriminating eye to look at the scene before you press the shutter release. If something's not quite right, change your position or move the offending object.

▶ **Poor composition:** For every "rule" of good composition there is a picture to disprove it. Yet there are several guidelines for composition, framing, and angle of view that can help you add interest or emphasis to your photographs. For instance, place subjects away from the center of the picture to avoid a static, dull result. When you're taking pictures of people, be sure to change position and explore several possible angles before taking the picture. Avoid having a tree or telephone pole appear to be growing out of a person's head.

and How to Solve Them

Millions of photographs are processed each year, and at one time or another everyone shares some of the most frequent photographers' problems.

Little League uniforms are nice but without the cherubic faces of the players, this picture doesn't quite tell the whole story. If your pictures sometimes "miss the mark," read these pages to find out how you can remedy some of the problems most common to photographers.

▶ **Cropping part of the subject:** *If you find that you consistently crop off some part of your subject—be it someone's head or the last person in a group shot—you need to practice aiming the camera. Carefully establish the locations of your subjects within the rectangular viewfinder frame. You should be able to see all sides of the frame at one time. Placing the top or center of your subjects near the focusing ring should put them well within the picture frame. Once your confidence and pictures improve, begin experimenting a little with different compositions.*

▶ **Sharp contrasts:** *Your camera's meter is easily fooled by strong contrasts between bright and shadow areas. If your pictures look washed out in the lighter areas or too dark in the shadows, try taking close readings from the most important parts of the subject and then using a compromise exposure. If you have one, an 18 percent photographic grey card (see page 265) is also handy for taking an accurate meter reading.*

▶ **Dark shadows in indoor flash pictures:** *Bounced, diffused, and multiple flash (see pages 142 to 144) will help eliminate deep shadows on your subject. It also helps to turn on room lights so that the rest of the scene won't appear to be a dark void. The difference in color balance on your subject will be negligible because the flash will overpower the tungsten or fluorescent light.*

▶ **Partially exposed flash pictures:** *If less than the full frame is exposed in your flash pictures, check to make sure that you're using the correct shutter speed and synchronization setting for flash.*

▶ **Glare spots in flash pictures:** *Shiny surfaces will reflect light from a flash back to the camera. Be sure to take flash pictures at an angle to reflecting surfaces.*

▶ **"Red eyes" in flash pictures:** *Flash can create red reflections in a person's eyes. To lessen or eliminate this effect, hold the flash away from the camera (a good idea anyway) and turn on all the lights in the room to make the subject's pupils contract.*

▶ **Bluish or reddish-orange pictures:** *If you use film that is not balanced for the color of light in the scene, the color balance of the resulting pictures will be either bluish (for tungsten film used in daylight) or reddish-orange (for daylight film used in tungsten light). See pages 120 to 123.*

▶ **Unusual color balance:** *If the film was outdated or exposed to extreme heat or humidity, the color balance and film speed may shift to give unpredictable results.*

▶ **Light streaks or spots on processed film:** *Unexpected light spots or streaks (fogging) may be the result of opening the camera when the film is withdrawn from the magazine. A light leak in the camera may also cause fogging, as can handling film in extremely bright light.*

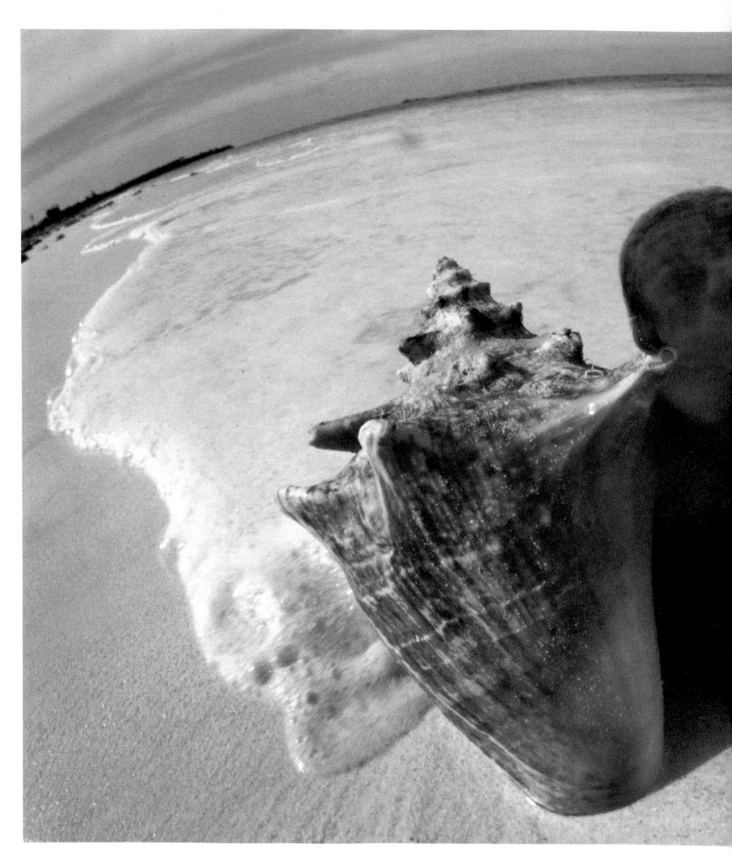

© 1979 Goorgo Silk

Part III

The Image

Photographing People

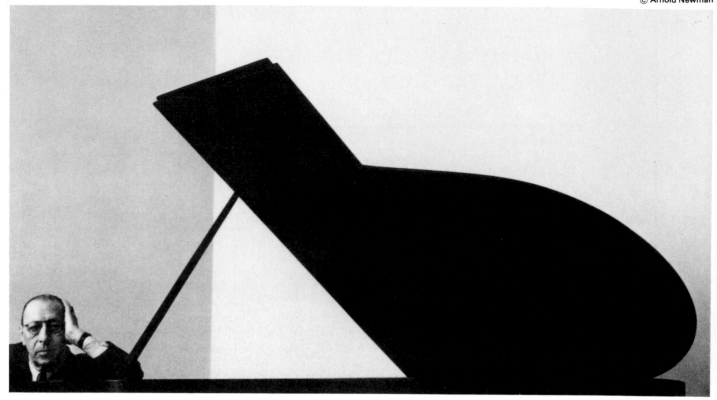

Portrait photographer Arnold Newman is renowned for his images of eminent artists in settings that suggest their work. In this picture of composer Igor Stravinsky, the piano is a powerful graphic image as well as a symbol of Stravinsky's art.

Our mental images of people are kaleidoscopic. We remember them by the way they look, how they walk and talk, and what they mean to us. Usually these impressions are gathered piecemeal over a period of time as we get to know a person. A portrait, however, telescopes time, so that a single, static image must act as a metaphor for movement, character, and soul. It is a tremendous challenge for the photographer.

To create a successful portrait, you must learn to isolate those characteristics that reveal a subject's distinctiveness. Sometimes the decisive element will be a fleeting facial expression. Other times it will be the way a subject dresses or the pose a person strikes. Most often, several elements come together momentarily to provide a visual distillation of personality. Renowned portrait photographer Yousuf Karsh expressed it well when he said, "There is a brief moment when all that there is in a man's mind and soul and spirit may be reflected through his eyes, his hands, his attitude. This is the moment to record. This is the elusive 'moment of truth.'"

The background, setting, and props you select can play a significant role in the message you communicate. For example, you may want to photograph a child among playthings or old friends engaged in a game of chess. In the portraits by Arnold Newman above, the lines of Martha Graham's ballet barre and the shape of Igor Stravinsky's piano not only suggest the subjects' professions, they also produce striking compositions. Simple backgrounds—such as the sky, a plain wall, or seamless photographic paper (see page 149)—focus attention on the subject. You can eliminate distracting backgrounds by shooting at close range, so that your subject fills the camera's frame, or by adjusting the depth of field so that only your subject is sharply focused.

When posing a subject, keep in mind that you want the person to relax as much as possible. Most people are self-conscious in front of a camera, and you may need to reduce the tension with light, casual conversation. If the person is seated, suggest that he or she lean slightly forward, a position that feels and looks more natural.

The direction the subject faces can also affect the mood of a portrait. Photographed straight on, people generally appear stiff and a bit

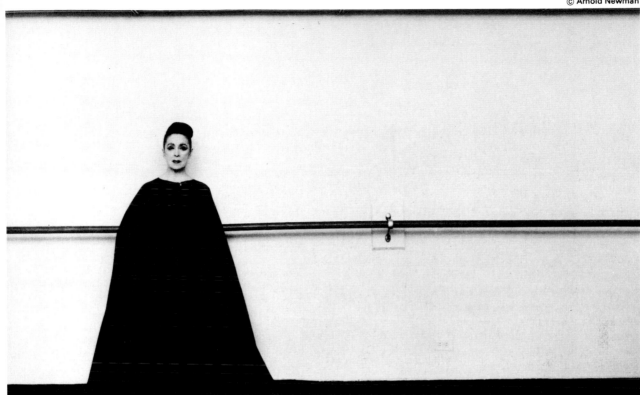

Newman's portrait of Martha Graham, one of the prime movers of modern dance, uses a ballet barre to tell us something about his subject. Like Stravinsky's piano, this stark, bold background heightens the visual impact of the photograph.

formal—especially if their expression is a serious one. Turned slightly to the side, for a three-quarters view, a subject usually looks more relaxed. Profiles, although frequently unflattering to the shape of the nose and chin, are nearly always dramatic.

A normal eye-level angle is best for most portraits; unusually high or low camera angles can result in unflattering facial distortion. Too high an angle—often a problem in photographing children and seated subjects—makes the head loom like a dome over the face and reduces the body by foreshortening. Too low an angle in a close-up results in an overly prominent nose, mouth, and chin.

At times, however, you will want to use a slightly low or high angle to create a certain effect. In a full-length portrait, for example, an eye-level shot makes a subject look shorter. A picture taken from a squatting position more accurately indicates height, and an even lower angle can make the subject seem taller. Even a high angle, which is generally unflattering, can be used to add drama or to eliminate a distracting background.

The most important element in a portrait is lighting. Depending on its angle, intensity, and diffuseness, light can emphasize certain features and soften or even completely obscure others. Light aimed directly at the subject tends to flatten facial and bodily contours and wash out details. For most portraits, light coming from an angle slightly above and to the side of the camera is preferable. This sidelighting brings out textures in the subject's skin, hair, and clothing that can be character-revealing. More importantly, it produces shadows, which give a rounded, three-dimensional appearance to a subject.

Too bright a light may create harsh shadows on one side of the subject's face. To compensate, use a reflector or a less powerful diffused light to fill in the shadows produced by the main light. Just moving your subject closer to a light-colored wall or having someone hold up a large sheet of white paper may provide all the extra reflection you need. In general, however, the best way to lower the contrast between highlights and shadows is to avoid using intense, direct light. Most portraitists favor soft, indirect light that illuminates the subject more evenly.

155

People

Tools

Although pleasing and effective portraits can be made with a normal lens, the single-lens reflex owner will find a medium telephoto lens a valuable aid. A telephoto lens with a focal length between 75 and 135 mm and a large maximum aperture, $f/2.8$ or larger, will enable you to work in dim indoor light and to limit the depth of field when you wish to blur a distracting background. The medium telephoto, often called a portrait lens, is especially well suited to portrait work. Normal and wide-angle lenses tend to distort facial features at the close distances required for tight head shots. A medium telephoto, on the other hand, allows you to maintain a comfortable distance from the subject and yet achieve a flattering, detailed likeness. For large group portraits, or to show subjects in their surroundings, a normal or wide-angle lens may be the only choice, even though distortion can present a problem.

Because proper lighting is essential to a successful portrait, a reflector should be considered basic equipment. A large white card mounted on a simple stand is easy to rig up, as is crinkled aluminum foil pasted on cardboard (the foil will give you a brighter reflection). An electronic flash is also a form of supplemental lighting. Outdoors, it can be used to fill in strong shadows caused by the sun or to brighten a backlighted subject. Indoors, it can be bounced off walls, ceilings, reflectors, or umbrellas as a subtle supplement to light from a window. It can also serve as the main source of illumination.

Your choice of film will depend primarily on lighting conditions. A high-speed film, between ASA 200 and 400, may be necessary indoors, in dim light outdoors, or with restless subjects, such as children or pets. But when conditions permit, a slow- or medium-speed film, ASA 25 to 125, is preferable. Such films result in a sharper, more detailed, and less grainy image.

Striking images by two eminent photographers clearly demonstrate the interpretive potential of the lens in portraiture. For his eerie shot of opera singer George London made up for the role of Méphistophélès (right),

Gordon Parks used a medium telephoto lens to get a tight head shot free of distortion. Henri Cartier-Bresson, however, found a normal lens more advantageous for showing artist Henri Matisse in his bird-filled room.

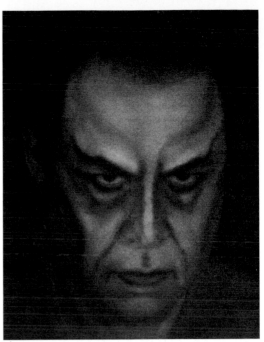

Certain other equipment, although less essential, can be extremely useful for the portrait photographer. A tripod ensures a stationary camera during longer exposures. A skylight filter will warm the bluish hue common to outdoor portraits taken in open shade, and a diffusion filter will soften an image, minimizing wrinkles, freckles, and other blemishes. A vignetting lens attachment is useful for isolating a subject. Finally, an automatic winder or motor drive, which advances the film automatically, can help capture the quickly changing expressions of a subject's face—particularly the more relaxed, less self-conscious expression that inevitably crosses someone's face once the shutter has clicked.

People

Outdoor Portraits

Taking portraits outdoors has some great advantages. The light is far brighter than indoors, of course, and the number of potential settings is enormous. Gardens, parks, beaches, mountains, and a variety of other natural backdrops offer exciting portrait possibilities. You still need to exercise good judgment, however, in choosing lighting and in selecting a background that will complement rather than compete with your subject.

Evenly diffused light is the best all-around illumination for photographing people— outdoors or indoors. The filtered, hazy light of a misty morning; a cloudy, overcast day; or a shaded setting all produce soft, flattering shadows. Usually subjects feel more comfortable in this type of lighting than they do in harsh, direct sunlight. At the same time, diffused light allows you to use a wider aperture with medium-speed films and thus narrow the depth of field (see page 94). As a result, only the subject is in focus; the background appears as an impressionistic montage of soft, blurred shapes. The picture of the boy at upper right is an example of this effect.

Although soft illumination is easiest to work with, bright, direct sunlight can also be used for portraits if you pose your subjects with the sun coming from an angle slightly to the side of, and slightly above, the camera. This solves the problem of squinting, but correcting the deep shadows created by direct sunlight is more of a problem. You can use a natural reflector, like water, as in the shot here of a child swimming. With color film, however, this technique is not always ideal, as you must choose the reflector carefully. A blue wall used as a reflector can give subjects an icy complexion, for example, while foliage will add a green tint.

One alternative is to set up your own reflectors. Although few people think of using flash on a bright, sunny day, it can be used to soften shadows. A flash will also help you achieve a more balanced picture when your subject is either backlighted by the sun or posed against a bright background. By taking a light reading from your subject's face and using a flash exposure, you can properly expose the face without washing out the background.

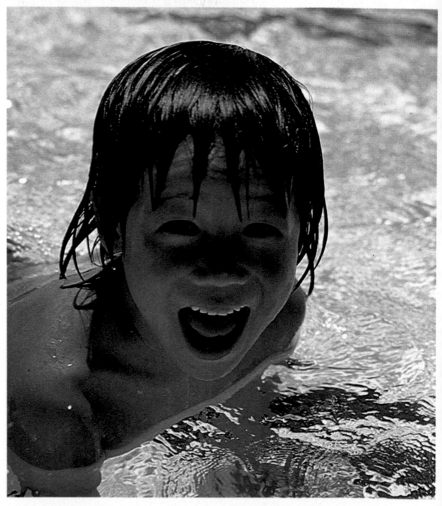

Two portraits of the same young boy in somber and ebullient moods illustrate the effects of different kinds of outdoor illumination. In the picture at left, the diffused light of a shaded area results in a shadowless, smooth face. Below, the harshness of bright, overhead sunlight is offset in good part by the reflection from the water.

158

A shaft of light singles out this girl on a rock from the surrounding shadows. Her face is further set aglow by light reflected off the book she is reading.

A haze-shrouded German port provides a scenic yet undistracting background for this portrait of a young couple.

People

Indoor Portraits

Portraits taken indoors, like the ones shown here, present their own special problems. During the day, the best source of light is the natural illumination provided by windows and doors. On bright, clear days, the best light for a portrait is diffused light. Openings that are not receiving direct sunlight, like a window with a northern exposure or a doorway shaded by a porch, are ideal. On an overcast day, any opening will provide even illumination.

If you pose a subject by a window, the bright outdoor light may fool your camera's light meter. To get a good exposure, move close and take a reading from your subject's face. If the window is to be part of the portrait, remember that a bright window will be washed out and overexposed if you expose correctly for your subject.

When shooting indoors, even soft light may be too directional, creating shadows that you may want to fill in. If you are shooting in color, add fill light that is compatible in color balance with the main illumination. Use a reflector with window light or bounce a flash off a white or neutral-colored ceiling or nearby wall. For black-and-white film, any light source is acceptable.

At night indoors, any kind of artificial light can be used for a portrait. If necessary, the existing light can easily be adjusted—for example, by moving a lamp to brighten the scene. Or, you can rig up a photolamp (see page 149) and bounce its light off walls, ceilings, or reflectors to soften shadows.

Again, if you are shooting in color, use the film that is compatible with the predominant light source. With ordinary household bulbs or other incandescent spots and floodlights, use tungsten film if possible. Daylight film will render subjects more warmly, which may not be objectionable. Prints from daylight-balanced color negative film may be partially corrected to tone down the warmer colors and present a more natural appearance. With electronic flash, use daylight film—other light sources in the scene will be overpowered by the flash and will not present a problem.

Since most artificial lighting in the home is far less intense than sunlight, you will usually need to use fast film with a rating of ASA 400, and you may want to push-process color slide or black-and-white negative film (see page 256) to a higher speed if you are working in available light. If the scene is so dim that a slow shutter speed is required, you may also need to use a tripod and a cable release to prevent blurring the image during exposure.

Natural light pouring through a beachhouse window illuminates this candid portrait of writer E. B. White. Jill Krementz's photograph of the author of **Charlotte's Web** *has been compared to an Andrew Wyeth painting in its lines and sparseness.*

Diffused, almost completely nondirectional lighting enhances the deliberately soft and dreamlike quality of this indoor portrait of a young woman. Diffusion filters, which produce this effect, are described on page 133.

People

Children

Taking pictures of children is as tricky as it is rewarding, especially for the novice photographer. Children will rarely stay in one place or hold an expression long enough for you to establish the perfect lighting, background, and camera angle. Their attention span is short, their mood shifts are sudden, and their activity level is high. There are, however, many things you can do to overcome these difficulties. First, to free yourself from continually having to set and reset the camera, you can preadjust it. A small aperture, such as $f/8$, $f/11$, or $f/16$, will give you a wider zone of sharpness, so that even an active child will remain in focus. At the same time, preset your camera to a relatively fast shutter speed, 1/250 or 1/500 second. This will permit you to capture fleeting expressions or freeze a child's leap in midair. The exact setting will depend on lighting conditions, but a fast film, ASA 400 or pushed higher, will also help. If you need extra lighting indoors, an electronic flash will give you a sharp image and a good depth of field. Bounce or diffuse the flash to eliminate its harsh effects.

Some children are delightfully candid in front of a camera. But more often, they are self-conscious, bored, or simply glum if made to pose. One solution is to photograph children when they are occupied—playing with a new or unfamiliar toy, for example, or in the midst of a birthday party. Another solution is to engage them in a lively conversation or, even better, have someone else talk to them so you can concentrate on taking the pictures.

There are two essential things to remember when photographing children. First, they are small, so you must move in close to capture their facial expressions. If you can't get close enough without "cramping their style," stand back and use a medium telephoto lens (see page 105). Second, children are short, so you should kneel or squat down to their level to get a good likeness.

By positioning the two youngsters above close together and moving in for a tight head shot, the photographer achieved an intimate, informal picture that captures their subtle, wistful expressions.

A small boy engaged in an endeavor too sophisticated for his years results in a droll and rather whimsical portrait. Restless youngsters will rarely cooperate long enough for you to arrange a pose like this.

The joy of children is spontaneous and often unpredictable. An alert eye and quick reflexes were needed to capture the clowning antics of the Canadian Eskimo youngsters at right.

People

Elderly

No kind of portrait work requires more sensitivity to the nuances of facial expression than photographing older people. Their faces reflect in subtle and often complex ways the joys and sorrows they have experienced over the years, as well as their changing attitudes and expectations at this stage of life.

One of your chief concerns in photographing elderly subjects will be lighting. You may want to capture the texture of their skin—the wrinkles, lines, and age spots that can reveal so much of their character. Harsh, direct light from the side creates shadows that emphasize facial lines. If you want to stress skin texture without overemphasizing it, use a soft light from the side as your main source of illumination and fill in shadows with a more diffused light. The picture of the Indian woman at right exemplifies this sidelighting technique. Diffused light will sometimes require additional illumination. Sunlight coming through a filmy, translucent curtain, for example, can be supplemented with flash bounced off the ceiling.

Soft, diffused, nondirectional light—such as that created by overcast skies, shaded settings, or a bounced flash indoors—will also result in a flattering portrait. Facial features and head shape will be gently emphasized. A diffusing attachment (see page 133) or a neutral filter smeared with a light coating of petroleum jelly can also be used to reduce skin texture, although the effect is not usually realistic. If a person's skin is extremely pale, it may take on a bluish tinge when you shoot with color film in the shade. Correct this by using a filter tinted with warm color, such as a skylight filter.

Although full frontal views are generally more flattering to older people, three-quarter and profile views often result in more distinctive photographs, such as Arnold Newman's portrait of artist Grandma Moses at far right.

The beautiful close-up of an American Indian woman above captures both the weathered texture of her skin and the warm directness of her eyes.

In portrait photographer Arnold Newman's carefully planned picture of the American painter Grandma Moses, details of her house—a lacy plant, frilly curtains, a hooked rug, a teapot—serve as clues to her character and life-style.

People

Figure Studies

A good photograph of a nude is a study in subtleties—in the color and texture of skin, the shapes and lines created by the arrangement of the body, and the forms revealed by shadows and highlights. The body becomes an artistic medium—one that the photographer uses to celebrate the sheer beauty of form or to suggest an idea, such as innocence, vulnerability, or even motion. In the age before moving pictures, Eadweard Muybridge made this study of a nude woman's movements by rigging up three rows of eight cameras that were tripped automatically by a timeclock device.

Muybridge's photographs captured the grace and fluidity of the human body in motion. Most figure photography, however, focuses on a single, static form. When the subject's face is revealed, the expression must be treated as sensitively as in a portrait. When the face is obscured, the nude becomes an interesting yet impersonal form. Many of the world's greatest photographers, including Edward Weston and Irving Penn, have photographed nudes this way. In their classic studies of the human torso, the body becomes an anonymous and abstract design.

Lighting can also reduce the human body to abstract forms. Bright light coming from the direction of the camera flattens features and washes out skin texture. From the side, that same intense light highlights skin texture and creates deep shadows that emphasize contours. These effects can be controlled by filling in shadows with a reflector or by using weaker lighting. Strong light coming from behind the subject, whether directly or bounced off a backdrop, produces a striking silhouette, which can also be filled in from the front.

Again, as with all portraits, soft, diffused light is usually the best all-around form of illumination for figure photography. If it is completely even and nondirectional, it will soften contours and make the skin look smoother without sacrificing nuances of color or tone. Diffused light coming from one direction, as, for example, through a window, is even more effective. It is gentle, yet it brings out contours. In addition, the shadows it creates can easily be controlled with a reflector or fill-in lighting.

In posing the model for figure photography, keep in mind that a model who is relaxed without being too casual will give you a more natural looking image than one who assumes a stiff, artificial pose. Often, it helps to ask your model to perform some imaginary act, like reaching up to take a book off a shelf. Some posing techniques can be used to downplay figure faults or to achieve certain effects. For example, the neck appears longer when the head is thrown back. Legs look better when seen from the side, or when the model is sitting or kneeling. When the model lies down, the stomach flattens. Similarly, the breasts lift and the upper arms look thinner when the model reaches upward, as in the pictures on pages 168 and 169.

Once you have posed and determined the lighting for your model, experiment by taking several pictures. You may find, for example, that a short, standing model appears taller when shot at knee level or below. Moving closer may allow you to capture a striking detail. From certain angles, a telephoto lens will foreshorten the body and thicken the limbs, while a wide-angle lens will attenuate the body. By opening the aperture, you can keep one part of the body sharply focused while the rest is gently blurred.

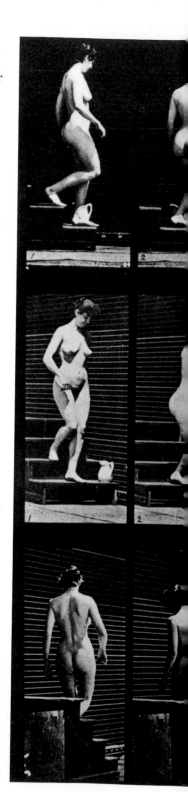

In 1878 Eadweard Muybridge settled a very famous bet by proving that all four of a running horse's hooves are in the air at one time. His success led him to study motion at the University of Pennsylvania, where he recorded the movement of hundreds of different subjects, including this woman on stairs.

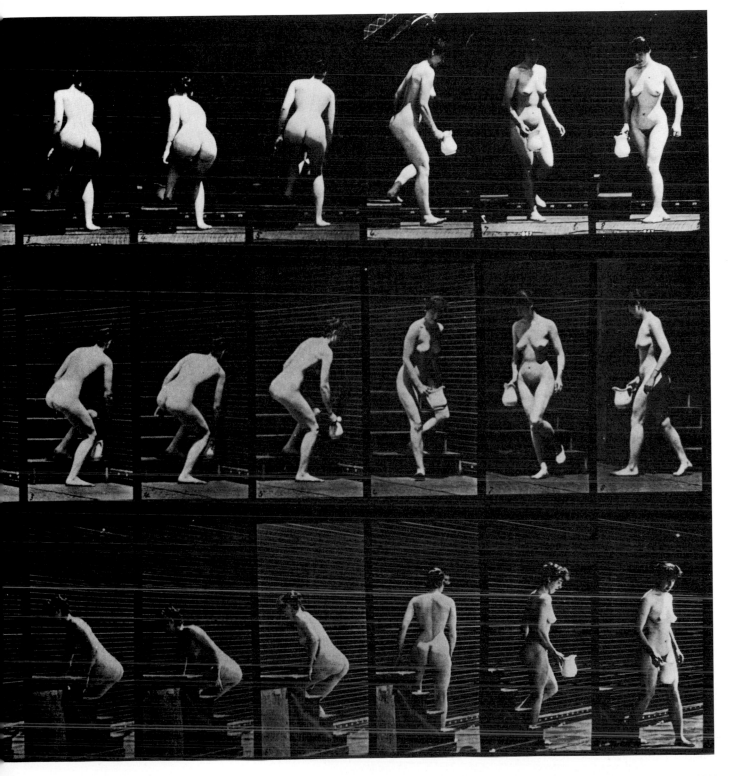

People

Figure Studies

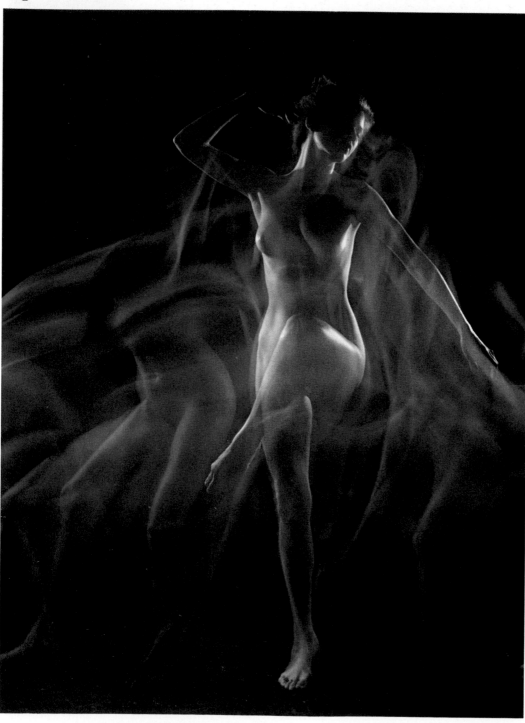

Graceful motion is the theme of the figure study at left. The multiple images of a dancer were taken as a time exposure, and the photographer fired an electronic flash during the long exposure to highlight the central image (see page 242).

In the figure study at right, lighting from the back and side silhouettes the model and emphasizes her gentle contours, while softer frontal light enhances the smoothness of the skin. The play of light and dark encourages us to view the torso as an abstract object, an effect heightened by the use of black-and-white film.

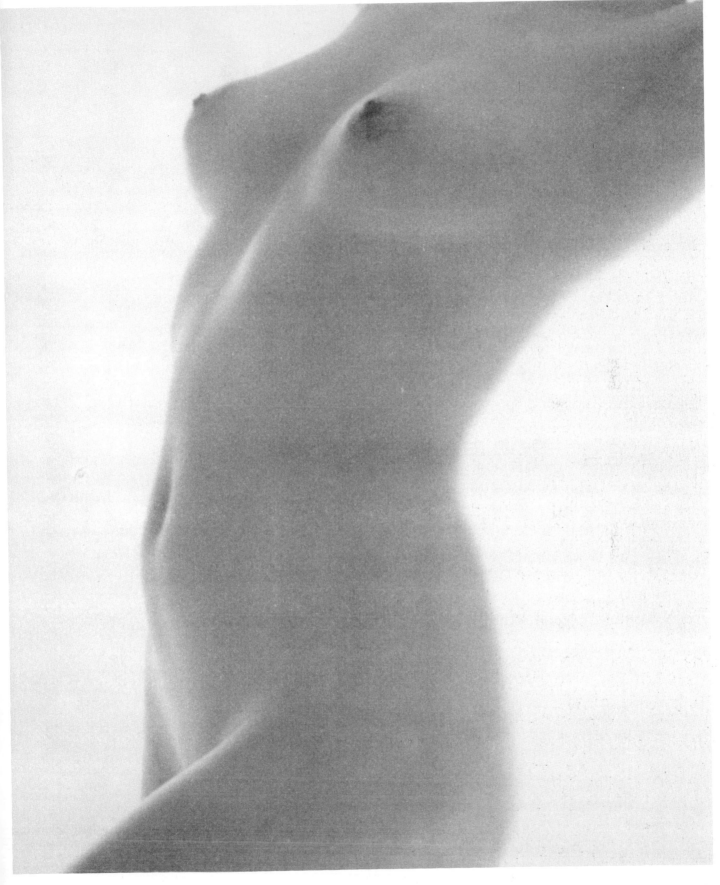

People

Candids

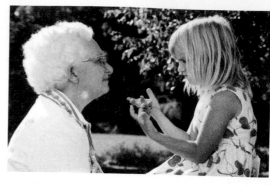

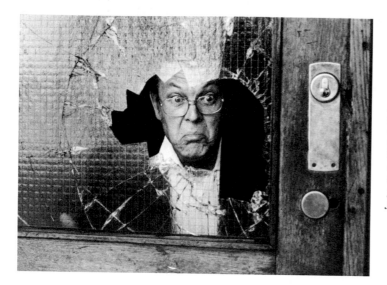

It's difficult to tell whether the man at left is reacting to his damaged window, the photographer, or both. His look of utter surprise, however, makes the candid particularly expressive, and the broken pane and door serve well as framing devices.

The compactness and sophistication of the 35 mm camera make it the ideal instrument for taking candid shots of people—unposed, slice-of-life photos that capture people being themselves. Some photographers have gone to great lengths to conceal their cameras when in pursuit of candid shots. For example, the early photojournalist Erich Salomon, a pioneer in candid photography, hid a camera in a hollowed-out book to take pictures inside a Monte Carlo gambling casino. Usually, such extreme measures aren't necessary to get good candid shots. There are many moments when your subjects will be completely unaware of you and your camera. If you are able to remove yourself from the scene by using a telephoto lens, you are even more likely to go unobserved.

The key to successful candid photography is maintaining a low profile, even when it is impossible to avoid notice initially. As soon as people begin to take you and your camera for granted, they will leave you to your own pursuits. If you shoot rapidly and frequently, at least one or two of your pictures are bound to be good, and you are likely to get several shots of people interacting. As in the series of a woman and her grandchild above, you can arrange your photos in sequence to tell a story.

A sense of timing is essential to the successful candid photographer. You can catch the fleeting gesture or telling expression only if you are prepared and vigilant. Not only must your camera be loaded and the right lens mounted, but the shutter speed, aperture, and distance should be selected as much in advance as possible.

Outdoors during the day, you can take a light reading and preset a fast shutter speed (such as 1/125 or 1/250 second) that will stop most normal action. Similarly, you can preselect a small aperture (such as $f/8, f/11$, or even $f/16$) that will give you a wide depth of field. Everything you snap within the given range of that depth of field will be sharp. Provided the lighting conditions remain constant, you can continue to shoot many pictures within that range without changing the setting.

Indoors, and in dim light, you won't have such latitude, even with high-speed film. But you can preadjust the camera's aperture and shutter speed for the prevailing light, so that you only have to focus and shoot. By keeping the same distance from your subjects, you can sometimes also avoid refocusing. If the light is so low that you must use a slow shutter speed, one that won't freeze motion (such as 1/30 second), learn to look for momentary lulls in the action. A person talking, for example, will often pause in midgesture to make a point, and, if you are alert, you can capture the moment.

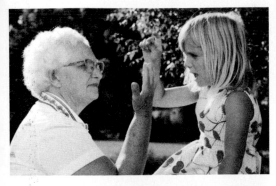

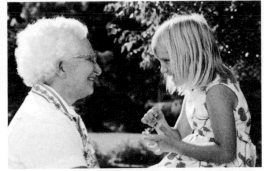

These candids of a girl and her grandmother provide a fine example of a story-telling sequence. In the first three shots, the child talks with animation and the pair appear to be just getting to know each other.

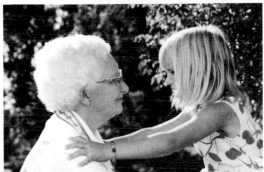

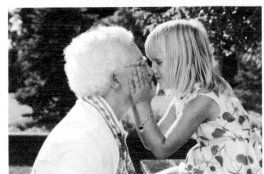

In these two pictures, the relationship becomes increasingly intimate as the girl first reaches out to touch her grandmother and then rubs noses.

Tools: A medium-length telephoto lens with a focal length between 75 and 135 mm is the first choice of many candid photographers with SLRs. Ideally, it should be a fast lens, with a maximum aperture of $f/2.8$ or wider, so that you can work in dim light. Although they do not have such large apertures, zoom lenses that cover all the focal lengths in the medium telephoto range and even longer telephoto lenses are advantageous for shooting in bright light. If you take a lot of candid shots, an automatic camera that selects the aperture or shutter speed for you may be best. A camera with a black body, which is less noticeable than one with chrome, may also be worth the few dollars extra. Most rangefinder cameras cannot accept a telephoto lens, but many candid photographers prefer them because of their generally smaller size and quieter mechanism.

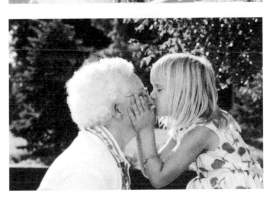

Full rapport is finally established with a kiss.

For all but the brightest scenes, high-speed film, rated at ASA 400 or pushed even higher, will give you the greatest flexibility by allowing smaller apertures and faster shutter speeds. Flashes, tripods, and most other accessories usually hinder the candid photographer. But two devices that may help are an angled mirror attachment, which screws onto the front of your lens and permits you to take pictures at right angles, and a motor drive, a device that advances the film to the next frame automatically.

People

Special Events

Celebrations vary from family to family and from country to country, but the desire to record special occasions seems almost universal. Gatherings of family and friends generally provide opportunities for taking good pictures—images that in later years help us to relive the events.

A good starting point for photographing special events is to review the preceding section on candid photography. Friends and relatives are much more likely to be relaxed around your clicking shutter than are strangers. Your main objective will probably be to get some shots that capture the essence of the occasion—pictures that convey the mood, emotions, and events of the day. Both of the photographs on these pages are expressive yet uncluttered because they were taken just as the event was beginning. Once the birthday cake has been cut or the holiday dinner has gotten underway, it is difficult to get such clean images. Similarly, the best time to photograph a tree scene during the holiday season will usually be before the presents are unwrapped.

Tools: Any 35 mm camera can be used for photographing special events. If you have an SLR, you may find it helpful to purchase a wide-angle lens with a focal length of 35 mm or less. This will enable you to photograph a large group gathered in a room. Since you will usually be shooting indoors, any lens should have a large maximum aperture, $f/2.8$ or wider. For the same reason, you will probably want to use a high-speed film, ASA 400 or pushed higher. If you need supplemental lighting, a flash is handier in congested rooms than are photolamps or other spots and floods. Bouncing the flash off the ceiling or a wall will usually give you good, even illumination. Be careful, however, about mixing flash with incandescent lights, since the latter produce warmer colors. If you want to include yourself in a scene, you'll need a tripod or some other firm support and a camera with a self-timer.

For this shot of several generations gathered for a holiday feast, the photographer overcame the problems of shooting a large group in a confined and dimly lighted indoor space by using supplemental lighting to the right of the camera and a wide-angle lens. The slight distortions in the foreground figures caused by the lens are too insignificant to diminish the photograph's appeal.

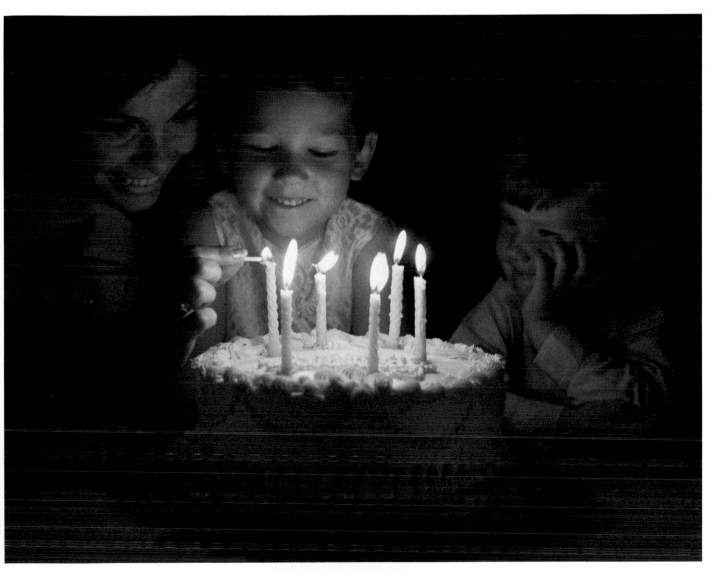

In a picture that effectively expresses the joy of a birthday, a child watches with happy anticipation while the last candle on her cake is lit. Using the candles as the only source of light lends a cozy, intimate quality to the scene.

People

Weddings

Weddings are colorful, visually exciting events—occasions that are ideal for taking good pictures. If the wedding is large, a professional photographer may have been hired to cover the main event. However, as a friend or relative of the couple, you can capture the behind-the-scenes story by taking informal pictures both at home and at the reception.

In addition, if the bride and groom can be pried away from well-wishers for a few minutes, you may want to take some shots that express their mood on this special occasion and reflect their personality as a couple. Keep the setting simple and scenic as in the photographs here, and try photographing the couple away from the other members of the wedding party. Since you are not likely to have much time, you should scout a location in advance and plan the kind of shots you want to take. To give life to the scene, you might suggest some action for the couple; in the picture here, the groom is pictured running toward his bride. Such variations on the usually static and often stilted wedding photograph provide a refreshing change and are welcome additions to a wedding album.

Weddings also offer good opportunities for group portraits. When photographing many people together, you will find balanced lighting essential. Outdoors, if the skies are overcast, you won't have any problem. But if it is a bright, clear day, try to assemble your group in a shaded area so that everyone will be evenly illuminated as well as spared from squinting. Indoors, if you are using a flash, arrange the group so that all the faces are roughly the same distance from the flash. Ideally, a group portrait should be a balanced composition. Instead of simply lining people up, try a triangular or circular configuration that blends their shapes harmoniously and balances bright colors. A sloped setting, like the side of a hill or church steps, naturally lends itself to group

In the photographs on these pages, the outdoors provides a refreshing and lovely setting for a bride and groom dressed in their full nuptial regalia. Less formal wedding shots like these help you convey the magic and mood of the occasion.

portraiture. But if such a setting is not available, consider taking a shot from a high angle—perhaps a second-story window or a balcony—so that everyone's face is clearly visible.

Another alternative is to fall back on the more traditional staging: taller individuals in back and shorter and seated people in front. If the group recedes from you, a medium telephoto lens will make those faces in back seem closer and thus more in proportion with faces in the foreground. A wide-angle lens, on the other hand, will enable you to photograph a group spread out horizontally. The rest of the equipment you will need for photographing a wedding is basically the same as for candid shots (see page 170) or other special events (see page 172), although you should expect to use a lot more film.

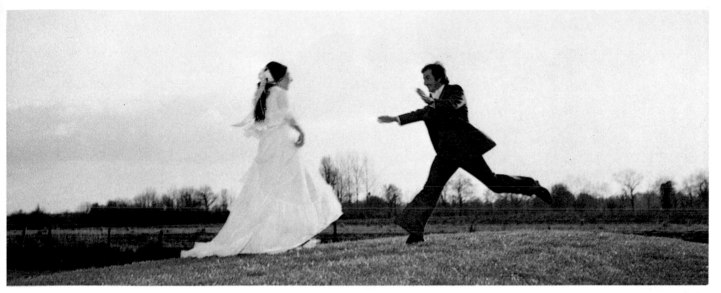

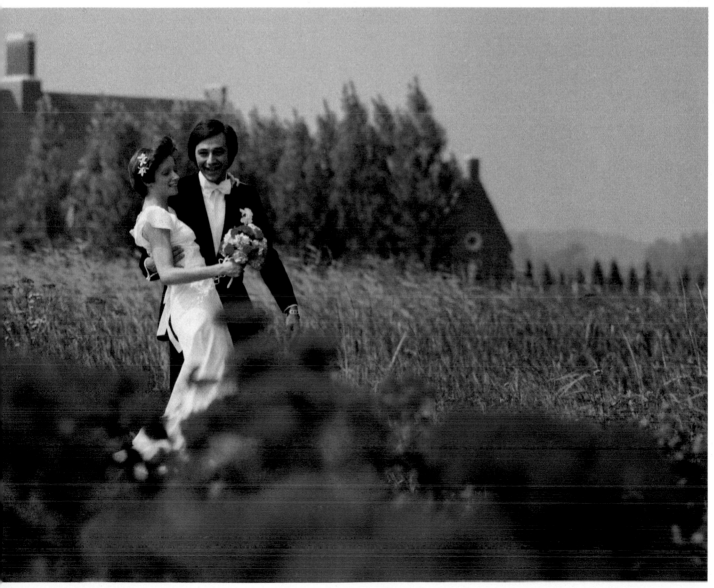

Photographing Action

Freezing Movement

One of the greatest challenges in photography is to convey via a still image the dynamic movement in our ever-changing world. As we will see on the following pages, a feeling of motion and a sense of the thrust of an action can often be suggested by techniques that blur either the subject or the background. Other peak moments are best expressed by freezing action, as in the pictures of the boy on a skateboard and the jumping horses.

With the fast shutter speeds on today's 35 mm cameras, stopping action is not much of a technical problem—especially in bright daylight or with an electronic flash. A setting of 1/1000 second will produce a sharp image of most rapidly moving objects, provided you have focused correctly. A sense of timing is invaluable to the action photographer. Although only a fraction of a second is required for the brain to signal the finger to push the button and then for the button to actuate the shutter, this time is crucial. If you wait until you see the event to take the shot, it will usually be over by the time the shutter clicks. You must be ready to push the button an instant before the action reaches a peak. Follow the movement through your viewfinder, keeping in mind that at very fast shutter speeds camera motion won't affect the picture.

Sometimes your subjects will appear to be suspended in midaction, and often they actually are pausing momentarily. The boy on the skateboard, for example, has reached the limit of his upward thrust and inertia is holding him there for a split second before gravity begins to pull him back down. If you plan for these moments, you can use an even slower shutter speed, such as 1/125 or 1/250, to stop most of the action—a great advantage if you are working in light that requires a wide aperture.

Two other techniques permit you to freeze action yet still use a slower shutter speed in less-than-perfect lighting. The first involves the direction of an action relative to the camera. If a subject is crossing your camera's field of vision at a right angle to the axis of the lens, the subject will appear to be moving faster than if he or she is moving toward you or away from you. As a result, the action will be harder to freeze. Thus, to photograph a

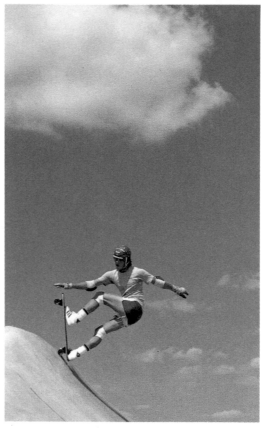

runner approaching you head on, you can use a slower shutter speed than would be required if you were shooting from the side. Certain locations, like the bend in a racetrack or a speedway, will permit you to take head-on pictures safely.

The apparent speed of a subject also decreases as you move farther away from the action. To freeze a cyclist passing twenty feet away, you can use a much slower shutter speed than would be needed to photograph a cyclist five feet away.

Tools: To stop action with shutter speeds of 1/500 or 1/1000 second, you will usually need a lens with a large maximum aperture, $f/2.8$ or wider. High-speed film, ASA 400 or pushed even higher, will make better use of the available light during the extremely short period the shutter is open. An automatic winder, which can take several shots a second, will increase your chances of capturing the exact moment desired. Indoors, when the action is fairly close, an electronic flash with a fast recycling time is often necessary.

An agile skateboarder braking to stop his ascent at left is a striking example of action frozen at its peak. Such moments of suspended motion occur in many activities when a person abruptly reverses direction. If you are prepared, this pause permits you to use a slower shutter speed and stop the action.

With ingenuity and imagination, a photographer has captured the surging drama of a steeplechase by placing his camera directly in front of the brush. He used a remote release to protect himself and to avoid frightening the horses, and an ultra-wide-angle lens to heighten the feeling of movement.

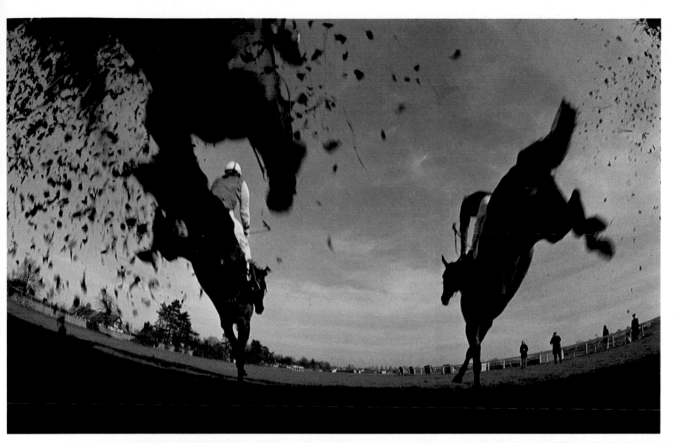

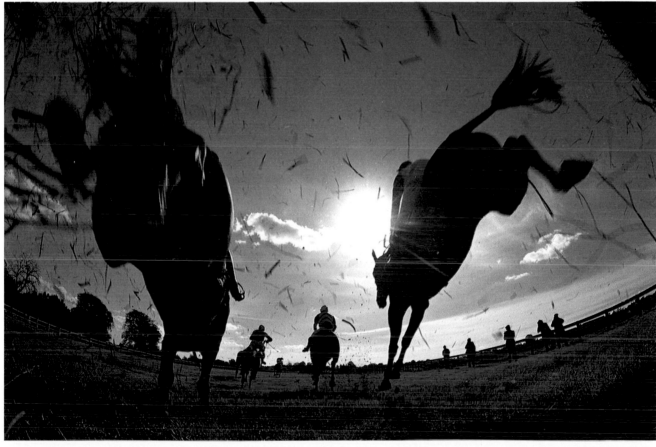

Action

Blurring Movement

In the early days of photography, subjects were cautioned to remain perfectly still so that the photographer could get a sharp image. Today, however, blurring is used deliberately to convey motion. Blurred pictures appeal to us immediately, because they recreate the images our eyes see when we look at fast-moving objects—like the blades of a fan or the spokes of a wheel.

To convey action adequately, you will usually want to blur the subject while keeping most of the background sharp or at least recognizable. The shutter speed you select will depend in good part on how fast your subject is moving. A speeding car may blur at a relatively fast shutter speed of 1/125 second. But for most subjects in motion, like the African dancers in the photograph at right, 1/30 second will usually blur some details and keep others sharp. The slower the shutter speed, the more blur you will get. At 1/8 second and less, most or all of a moving subject will be blurred, as in the shot of the ice skater at far right. At these slow shutter speeds, it is essential to keep the camera steady to keep the background sharp. Below 1/30 second, a tripod is usually necessary. In planning a shot, keep in mind that the closer you are to your subjects, the more likely they are to blur. The same is true of subjects moving across your field of vision rather than approaching you head on. Also remember that the fastest-moving parts of a subject will be the most blurred, like the arms and right leg of the ice skater shown here.

Tools: Other than a tripod for long exposures, no special equipment is required to blur a moving subject. When working at slow shutter speeds, which let in a lot of light, you may need relatively slow-speed film, such as ASA 32 or 25, especially in bright daylight. You can also cut down on the light reaching medium- or high-speed film with neutral density and polarizing filters (see pages 131 and 118).

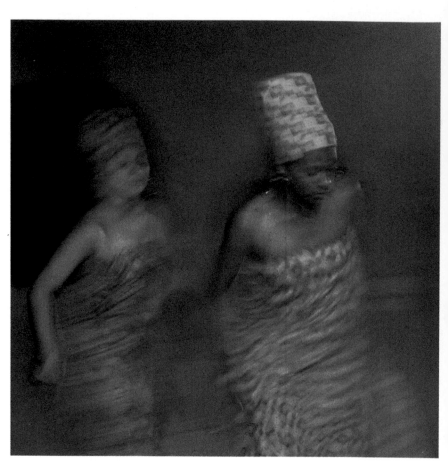

Blurring conveys the idea of rhythmic action far more eloquently than does a sharply defined photograph. In this picture of African dancers, the energy of the performers' movements is readily sensed.

Blurring in a photograph makes action rather than detail the essence of the shot. In this picture of an ice skater, the facial features and most other background details are obscured. As a result, the image is a study in pure motion.

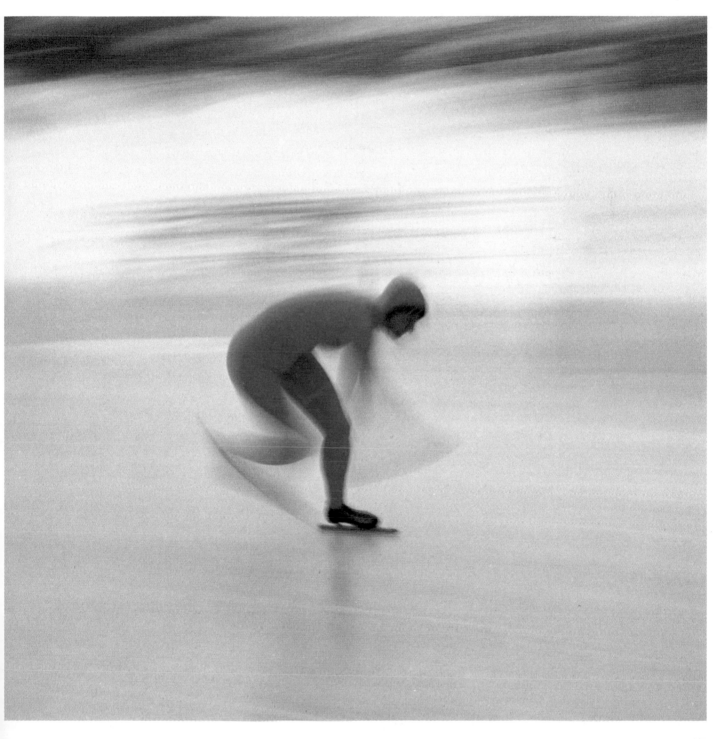

Action

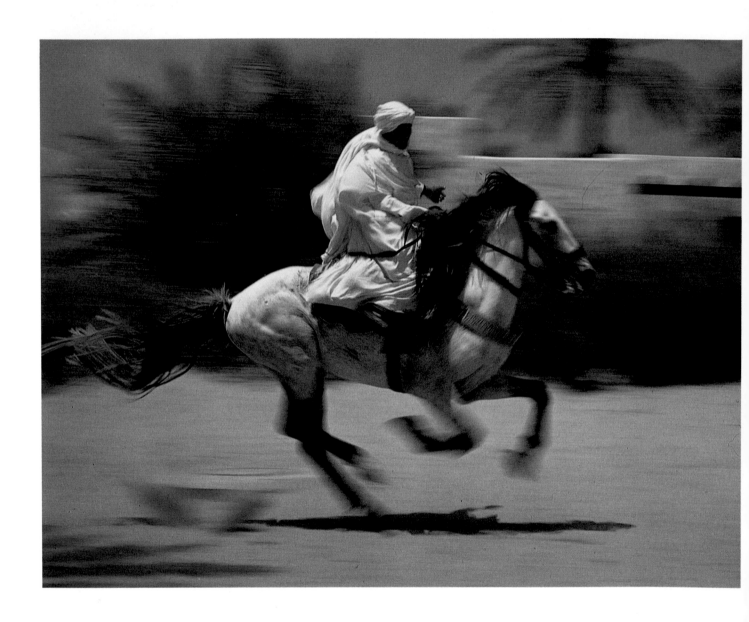

Panning

A relatively sharp subject against a blurred background also effectively conveys the impression of speed. To produce this effect, you must follow the subject with your camera during the exposure, a technique called panning. As the photographs of the horseman and the racing car here show, panning focuses attention on the subject, not the surroundings. It is one of the trickiest techniques in photography, and the results are not always predictable. The camera movement must be smooth and the subject must be held in the same location in the viewfinder as long as the shutter is open.

When panning, prefocus on the spot directly in front of you where your subject will be when you start the exposure. Then stand firmly with the camera to your eye and slightly twist the upper part of your body in the direction from which the subject will come. Begin following the subject as soon as it appears in the viewfinder. When your subject reaches the spot you have selected, release the shutter and continue following it in one smooth movement. With practice, you will be able to release the shutter smoothly and avoid jarring the camera.

Practice is essential. If you are photographing repeating action, such as a child on a swing or a race car going round and round a track, follow the action several times without releasing the shutter just to get the rhythm of the motion.

Panning requires a relatively slow shutter speed, so it is particularly well suited to dim light conditions. The exact speed will depend on the situation and the subject, variables that you will learn to accommodate as you gain experience. In general, however, it is very difficult to obtain this effect at 1/125 second or faster. At the other limit, it is virtually impossible to avoid some vertical camera movement with speeds less than 1/15 second. As a basic rule of thumb, the slower the subject is moving, the longer the exposure you will need.

Tools: At slow shutter speeds, a tripod with a panning head lessens the possibility of jarring the camera vertically. Longer exposures may also require slow film—ASA 32 or 25—or filters to reduce light. Although most people may not be aware of it, the viewfinder on an SLR blacks out the instant you push the shutter release. If you find this inconvenient, consider using an auxiliary viewfinder in order to follow the action.

A good panning shot does not necessarily have to show a perfectly sharp subject against a totally blurred background. In the picture at left of an Arabian horseman, the movement of the animal's legs and the recognizable setting of a stucco house and palm trees are important elements.

Contrasting colors and varied light and dark tones produce a pronounced streaking that heightens the feeling of movement in the panned shot at right of a racing car. The trackside barrier provided the photographer a natural line to follow with his camera.

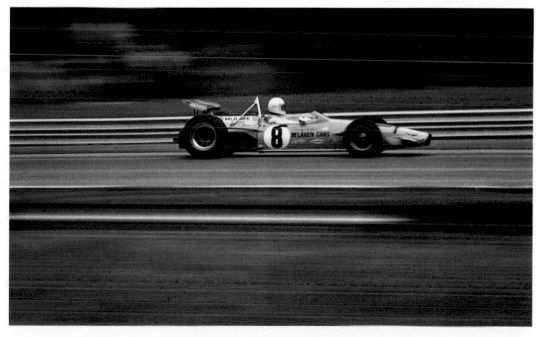

Action

Outdoor Sports

The great abundance of natural light outdoors makes it the ideal location for capturing action—a pole vaulter arching over the bar, a horse clearing a fence, or a peak moment in a soccer game. As in candid photography, the key to getting good action shots is in presetting your camera. Many sports photographers rely on the combination of a fast shutter speed and a small aperture, frequently 1/500 second and f/16 plus fast film, ASA 400, to freeze action and to obtain the greatest possible depth of field. Generally, such a combination will give you maximum flexibility.

When the action you want to shoot is confined to one spot, however, a wider aperture may be more appropriate. This will enable you to focus selectively on the main point of interest and to blur a distracting background, as the photographer has done in the shot of the horse jumping a fence at right. Again, preset your camera and focus on the spot before the action begins. It may help to scout the playing field or arena in advance to determine the most advantageous position. For night sports, take exposure readings from the lighted field, as darker surrounding areas would cause the meter to indicate too much exposure. Since you'll be using larger apertures and slower shutter speeds at night, it may be difficult to freeze fast-moving action.

Tools: Although any camera can capture action close at hand, a telephoto lens is needed to cover action at a distance. Depending on how far away you are from the activity, the focal length of the lens can range from 85 mm upwards. Lenses over 200 mm are difficult to hand hold, so a tripod—or a unipod, which is favored by some professionals—may be necessary. A zoom lens with a range of 80 to 200 mm is also very handy. The combination of a fast shutter speed and small aperture usually requires a relatively high-speed film, ASA 200 or higher, depending on the brightness of the scene. A motor drive, which permits several rapid sequential shots of fast-changing action, is especially helpful when photographing fast-paced sports events.

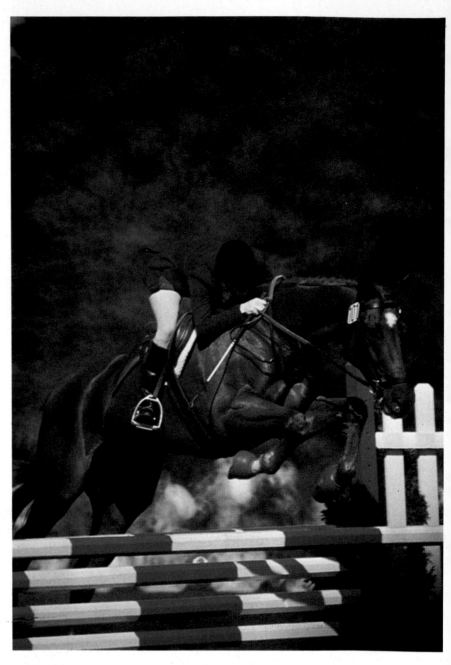

In the shot above of a horse clearing a fence, the photographer used a powerful telephoto lens with its narrower-than-normal depth of field to blur a distracting audience in the background.

The photographer's low angle in the picture at right emphasizes the height of the pole vaulter, and the blue sky provides a rich background to his arching body and red uniform.

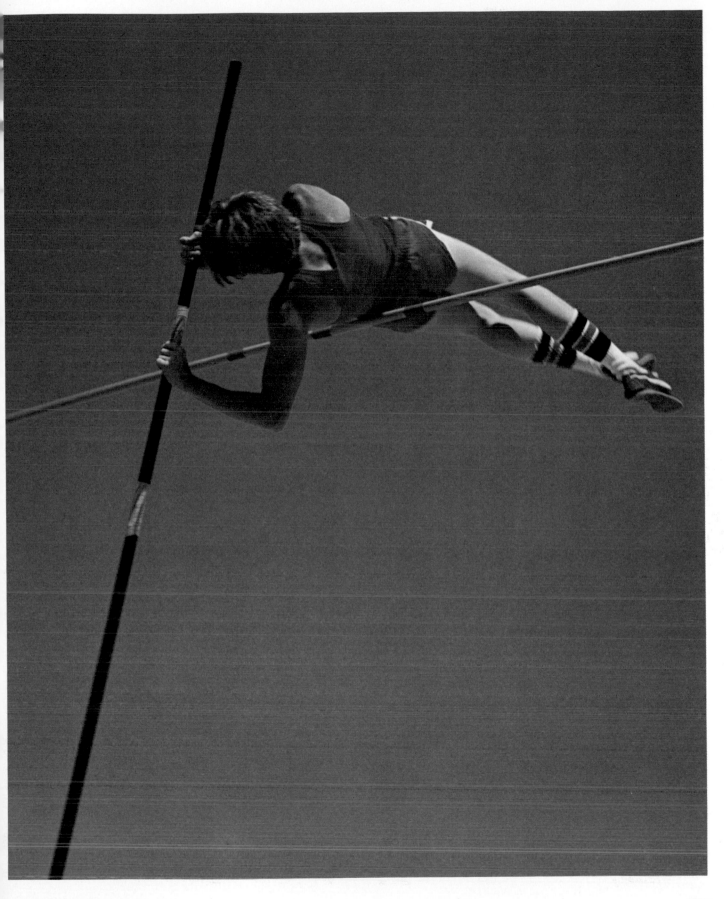

Action

Indoor Sports

Good indoor action pictures demand much from both the photographer and the equipment used. The larger apertures required in dimmer light reduce the depth of field, while slower shutter speeds make stop-action photography far more difficult. In these circumstances, timing and technique are crucial. Pick a spot, focus on it, set your exposure, and then wait for the action to drift into view. Look for locations that are likely to be the scene of peak action—the basket, the goal net, or the diving board. Be on the lookout especially for moments when the movement hesitates briefly.

Tools: Unless you are close to the action, you'll need a telephoto lens. Since relatively dim light will require a large maximum aperture, $f/2.8$ or wider, the lens should probably be a medium telephoto with a focal length between 80 and 135 mm. With their generally smaller maximum apertures, long lenses of 200 mm or more and zoom lenses are not very effective for stopping indoor action. High-speed film, ASA 400 or pushed even higher, is advisable, but be careful to match color film with the light source. If you can get close to the activity, a powerful electronic flash with a fast recycling time is a boon. For most action shots, a motor drive is also a great aid, unless you're using flash.

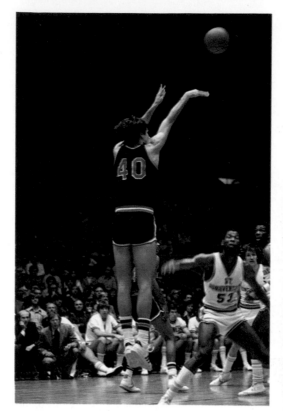

For all three of the basketball pictures on these pages, the photographers positioned themselves near the spot where peak action occurs—the hoop at the end of the court. The unusual blurring in the shot at left below was created by zooming during the exposure (see page 108).

184

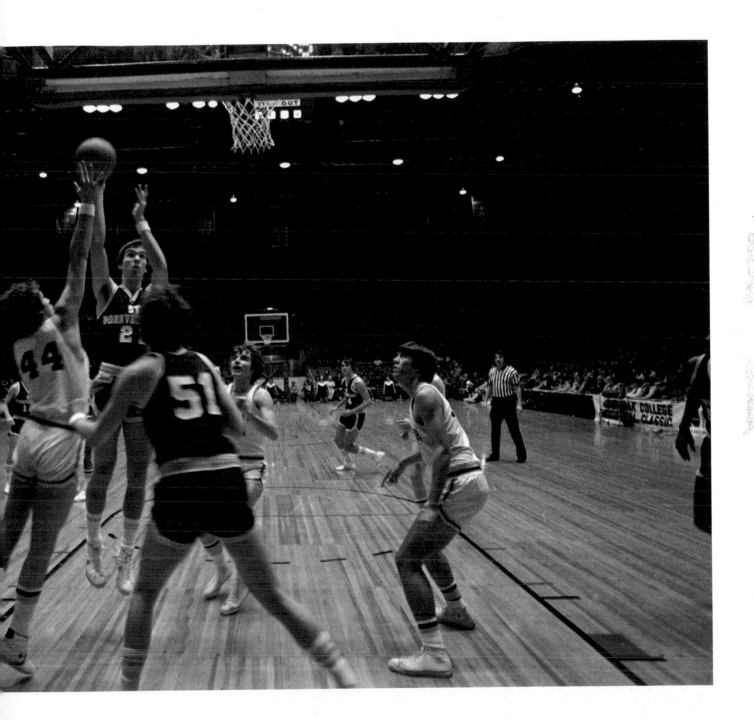

Photographing Nature

Capturing plant and animal life on film is one of the most fascinating areas of photography. Perhaps no other subject matter is as blessed with inherent grace and symmetry. The nature photographer acts as an interpreter of nature's forces—its beauty, mystery, immensity, power, and brilliance. When we respond with delight, awe, or curiosity to a photograph of the natural world, we are sharing the photographer's perception and echoing his or her response. The skilled eye of a nature photographer can isolate the spectacular in what may appear to be the merely ordinary.

Sometimes detail is paramount—a single bloom or the underside of a toadstool can be more impressive than an entire field of flowers or a tree stump covered with fungus. For such pictures you will need to move in very close and perhaps use special close-up equipment (see page 191). At other times, the larger view will be more expressive— perhaps a herd of deer grazing on a hillside or a beautifully sculpted rock formation. In such instances, you may need to use equipment that will allow you to stand at a distance from the subject (see page 105) in order to get the proper perspective or photograph a shy or skittish animal.

You needn't travel to exotic places to find interesting and appealing subjects. The flora and fauna of city parks, forest preserves, zoos, and even your own backyard can make exciting photographs. Take pictures of the geraniums in your windowsill planter or the robin splashing in your birdbath. Photographing close subjects and distant wildlife both require patience, good techniques, and practice, but the photographer who masters the necessary skills will be richly rewarded. New and unexpected aspects of nature's apparently random hand will be revealed as patterns and textures, shapes and colors. The artistic possibilities for the creative photographer are endless.

An unusually low angle reveals the fluted undersides of the mushrooms above, and backlighting gives them a golden translucence.

Action can add interest to many animal pictures. The photograph below of a snowy egret was taken just as it came up with its catch.

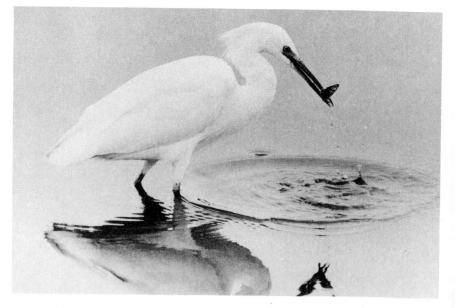

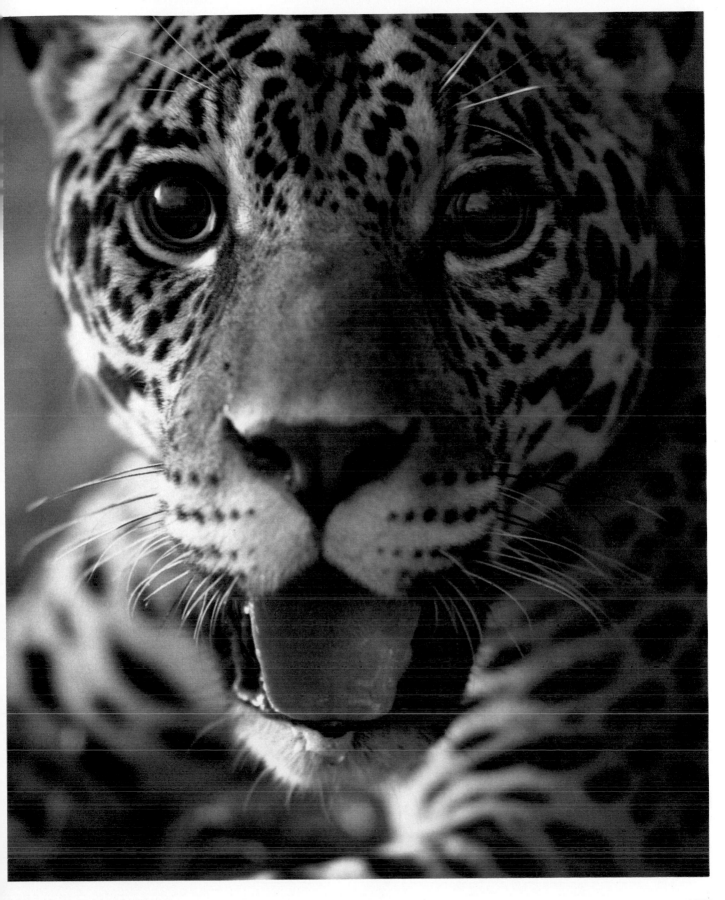

Nature

Close-Ups

Photographing the diminutive aspects of nature involves learning to handle two special conditions. First, the closer your camera gets to a subject, the shallower the depth of field becomes. The zone of sharpness can be as small as a half-inch or less. Using a small aperture alleviates the problem somewhat, but even then you must be careful to keep your subject's most important features in focus in a plane parallel to the film plane. Movement is also greatly exaggerated at close range. A faint breeze can cause a flower to flutter in and out of focus, while an insect can scurry out of view in less than a second. This problem is aggravated if you are using a slow- or medium-speed film (ASA 25 to 100) to capture fine details and a small aperture to get greater depth of field. In natural light, the combination usually requires slow shutter speeds.

Patience, planning, and a little ingenuity can help you overcome some of these difficulties. A plant can be stilled by constructing a simple windscreen with a couple of stakes and a plastic bag. Insects are most easily photographed when they pause to eat, as in the shot of wasps at right. You can also use flash to stop action.

As with a portrait, lighting can make a nature close-up magical or mundane. Follow the general guidelines about the angle of light and light at different times of the day (see pages 50 to 59), and, if necessary, use a piece of white cardboard as a reflector or rig a piece of cloth on broomsticks to serve as a diffusing canopy. You can use flash in close-ups as either the main light source or for fill. It will be softest when diffused or bounced off a reflector. When using a flash, mount it off the camera and determine flash-to-subject distance based on preferred exposure for depth of field. If you can't mount a powerful flash unit far enough away from the subject for correct exposure, cut flash output with a tissue or handkerchief.

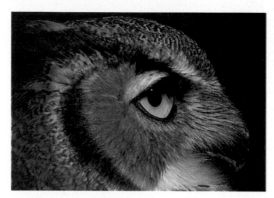

A close-up of a shy nocturnal subject, such as the photograph of an owl's eye at left, generally requires stealth and a flash.

To photograph rapidly moving insects such as those below, the best approach is to locate an area where they are active. Find a likely, photogenic flower, set up your camera, and wait for them to feed.

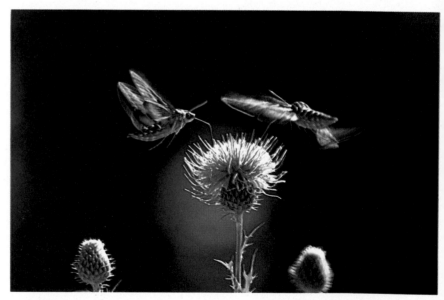

In a close-up photograph, the zone of sharpness can be as small as one-half inch, as this shot of a dewy wild pansy, with its sharply defined petals and out-of-focus stem, shows.

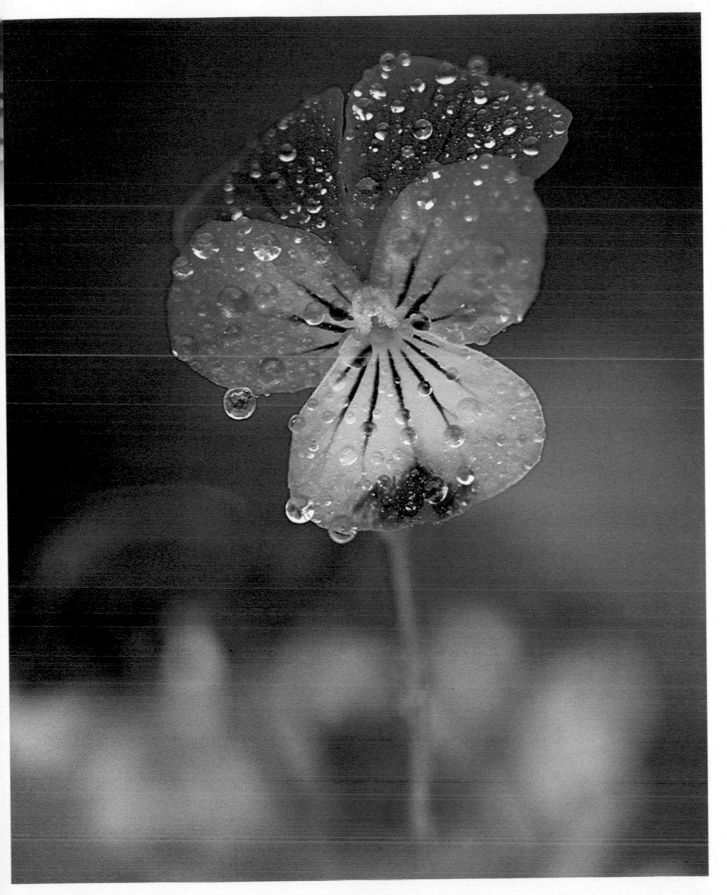

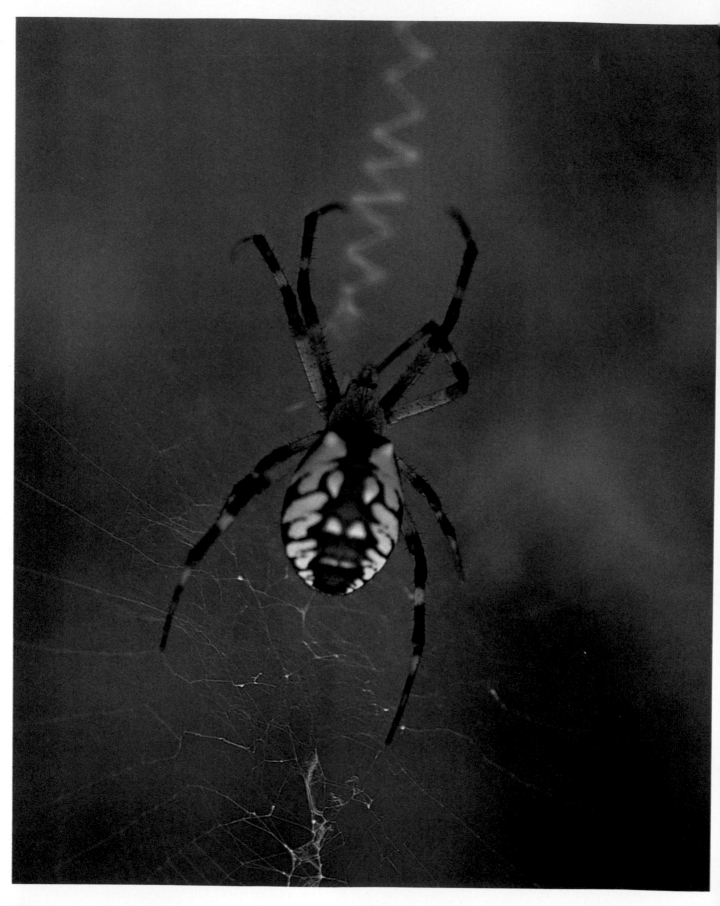

Nature

The delicate tracings of frost on these autumn leaves and grass appear almost luminescent. The photographer has used a close-focusing lens to come in close without distorting the shapes of the leaves.

The shallow depth of field in the picture above, usually a disadvantage of close-up work, here helps separate a single blossom from its same-colored background, while also making the feeding insect more distinct.

A macro lens allows you to photograph an object nearly life size. In the picture at left, a spider and its filmy web have been illuminated by an electronic flash, making each strand of the web sharp against the background.

Close-Up Tools

The best camera for close-ups is the single-lens reflex. Unlike a rangefinder, the SLR allows you to see your image through the lens and usually preview your depth of field at smaller apertures. In addition, while there is only one way to obtain close-ups with most rangefinders, the SLR offers several possibilities.

The close-up tools that can be used with either type of camera are the filterlike attachments known as close-up lenses. When screwed onto your camera's lens, they increase its magnifying power and decrease its minimum focusing distance. With an SLR, the magnification can be seen through the lens; with a rangefinder, you must measure and calculate distance and area following the lens's instruction sheet. Close-up lenses are commonly sold in sets of three, rated +1, +2, and +3 diopters, according to their degree of magnification. The greater the number, the greater the magnifying power, and the closer you can get to the subject. Close-up lenses can be combined for additional increases in magnification. They

are compact, inexpensive, and do not require exposure adjustments in a camera with a through-the-lens meter. Sharpness may be a problem, however, and you may have to use small apertures to compensate.

If you own an SLR, a better choice might be extension tubes or bellows. Both fit between the camera and its lens to permit close focusing. Extension tubes can be used singly or in combination and are lightweight and inexpensive. They are available in several lengths—the longer the tube, the closer the lens can focus on a subject. Some SLR systems also have a simple attachment that permits you to reverse any lens for very close focusing.

Bellows, although costly and cumbersome, are more flexible and permit you to get life-size or larger images. Although most bellows attachments will accept a normal camera lens, special lenses designed for the bellows may result in better images. Both extension tubes and bellows reduce the amount of light reaching the film in proportion to their length. As a result, you usually need to correct exposure according to their instruction sheets and your camera's manual.

For the more serious SLR user, a close-focusing, or macro, lens (see page 110) may be a wise investment, despite its high price tag. Specially designed to work at close distances, these lenses are unsurpassed in ease of use and optical performance. Macro lenses are available in normal to moderate telephoto focal lengths and focus smoothly from infinity to just a few inches in front of the lens. They can be used with bellows or extension tubes for greater enlargements. Many newer zoom lenses also have similar close-focusing capabilities.

Other helpful devices include a tripod and a cable release to guard against camera movement during long exposures. Ideally, the tripod should have a reversible center post for low-level subjects. Small, inexpensive electronic flash units are also useful, and many avid nature photographers use two or three for complete control over a scene. Slow- or medium-speed film (ASA 25 to 125) is best for capturing details.

Nature

Wildlife

For many of us, the mere mention of "wildlife photography" conjures up rather exotic images: stalking lions and giraffes across Africa's Serengetti Plain or capturing the rainbow plumage of exotic birds on a boat ride up the Amazon. Yet wildlife subjects abound everywhere. National parks and game preserves offer spectacular glimpses of animal life, like the herd of elk in the picture at far right. And you will probably find subjects for your camera even closer to home. Local woods and fields are filled with small mammals, birds, and snakes; marshes provide a haven for migrating or native waterfowl; and even a local park or your own backyard has its squirrel and bird populations.

Since nearly all wild creatures are both timid and fast, capturing them on film requires a combination of quick reflexes, planning, and perserverance. You can learn much about the animals in a particular area from field guides. Especially note the animals' behavior patterns—their feeding and nesting habits, the time of day they are active, their modes of defense. Thus informed, you will know where to look for animals and what reactions to expect from them. The ability to predict animal behavior is an invaluable skill for the wildlife photographer. As a general rule, most animals venture out early in the morning or late in the afternoon rather than at midday. Consider taking along food or seed to attract them to the spot you want.

When you are stalking animals, remember that many wild creatures will accept your presence if you don't appear too threatening. A powerful telephoto lens, as recommended on page 194, will help you keep your distance, but it is equally important to keep your movements to a minimum. When you do move, proceed slowly and carefully. Nothing frightens an animal faster than an abrupt action. Seek out some natural cover that still gives you good visibility. Also remember that the senses of hearing and

smell in many animals are much keener than ours. A snapping twig, a rustling bush, or a downwind whiff of you may send an animal flying. If possible, set your camera up on a tripod in a location that gives you maximum advantage—clear visibility, a safe distance from any real danger, and some natural cover to prevent your subjects from sensing your presence. It is sometimes a good idea to wrap the camera in dark cloth to muffle the sound of the shutter and prevent reflections.

Less elaborate procedures are needed to photograph the more exotic and accessible subjects at zoos. Captive animals photographed in natural-looking environs or parklike settings often appear as authentic as their counterparts in the wild. Carefully select your camera angle to exclude moats, railings, and other signs of captivity. The best kind of picture to take in a zoo is a close portrait of an animal, with the surroundings intruding as little as possible.

Like portraits of people, close-ups of animals will be most flattering when the illumination is the soft, even light of an overcast day. The low, raking light of morning or afternoon effectively emphasizes an animal's contours and the texture of its fur or feathers. In strong daylight, you should be able to use the fast shutter speeds necessary to capture a moving subject. The shallow depth of field that results from large apertures can subdue foliage interference between you and your subject or effectively separate the animal from an intentionally blurred background. Panning (see page 181) can also help you isolate a moving animal from a nondescript setting.

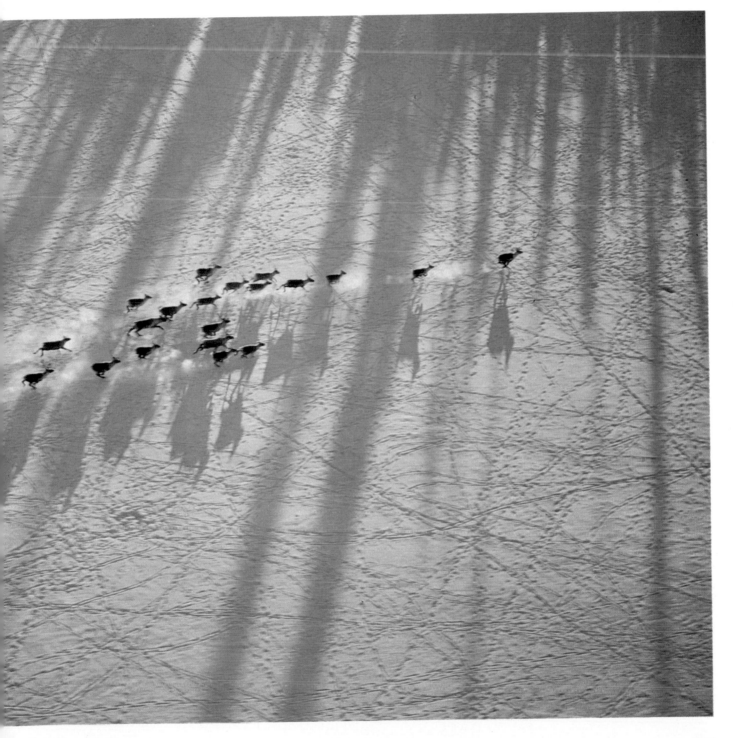

Nature

Wildlife Tools

Since wild animals instinctively keep their distance from humans—and you'll want to keep your distance from them if they are dangerous—an SLR equipped with a long telephoto lens is by far the best choice for wildlife photography. A lens with a focal length between 200 and 400 mm will pull most subjects close enough to fill the frame, yet will not be too cumbersome or difficult to use. These lenses do, however, require more care than usual. Depth of field is shallow, so careful focusing is essential to keep your subject sharp. Also, because of their magnification and the slow shutter speeds sometimes required, they can emphasize even slight camera movement.

Given these conditions, it helps to use high-speed film, ASA 200 to 400 or pushed even higher. But it is also essential to steady the camera. Depending on the circumstances, a long lens can be supported on a tree stump or the hood of a car with a folded jacket or sweater under the camera. Many nature photographers carry a small bag filled with beans or Styrofoam pellets for such shots. You should carry a tripod or a unipod, however, as basic wildlife equipment, and you might also consider a gunstock support.

If you have more than a passing interest in wildlife photography, you may want to

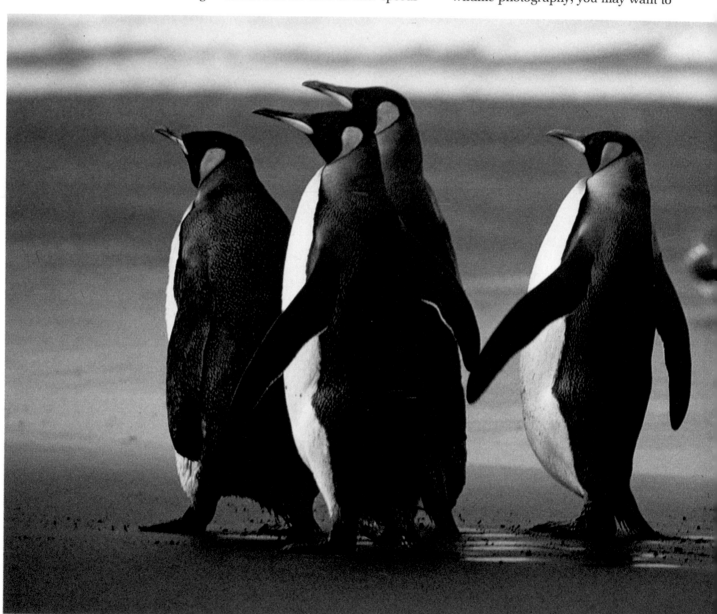

consider two other aids. The first is a blind, a small tentlike construction with a hole for your camera lens. A blind is especially useful in open areas where there are no trees or bushes for cover. You can purchase one from a hunting supply store or you can construct one using canvas and a light wooden frame. Many animals, most notably birds, quickly become accustomed to a blind and return to their normal activities in its presence.

A remote release, which allows you to trip the shutter without touching the camera, is also useful for dangerous or extremely shy subjects, or for tricky situations such as photographing a bird's nest from a nearby branch. A simple bulb-and-air-hose release allows you to take a picture up to twenty feet away. Activated by the current from a battery, a small solenoid—an electromagnetic plunger—can push the shutter button from an even greater distance. And an expensive radio-controlled release can trip the shutter from more than a mile away. You can also arrange to have your subject unwittingly trip the shutter. A simple trip cord attached to a lever that depresses the shutter button is fairly simple to rig up. A more sophisticated trip device uses photoelectric cells to actuate a solenoid. To take more than one shot of a subject with a remote release, you need an automatic winder or motor drive.

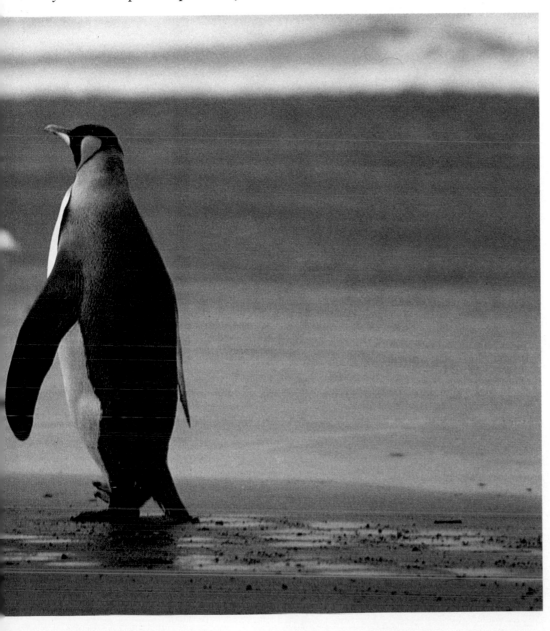

A shot of strolling penguins remarkably human in appearance illustrates the narrow depth of field on most long telephoto lenses. The birds are sharp because they are in a line parallel to the film plane. From a side angle or straight on, some of them would probably be out of focus.

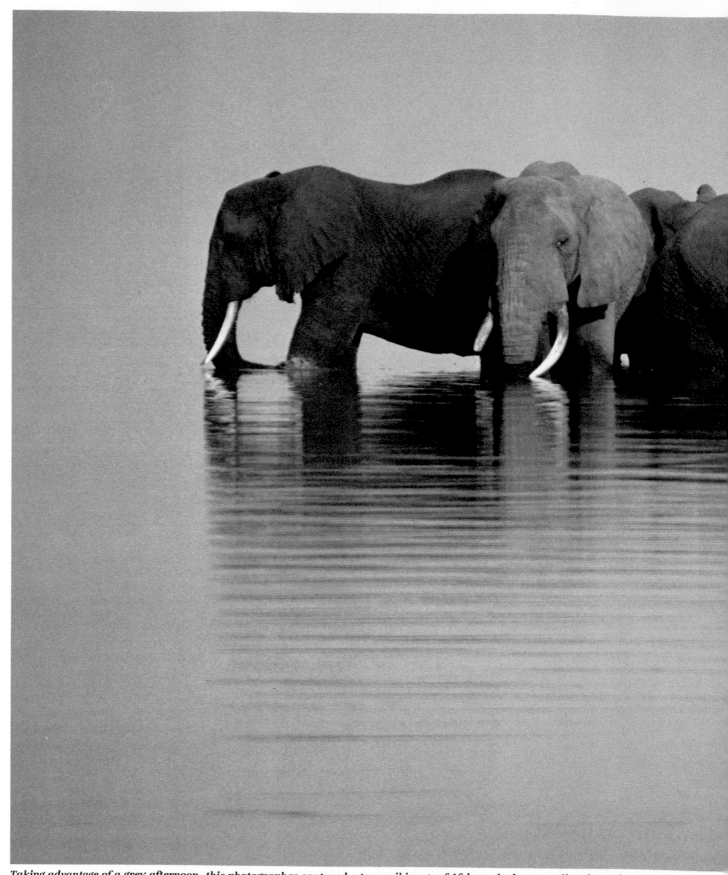

Taking advantage of a grey afternoon, this photographer captured a tranquil image of African elephants cooling themselves in Tanzania's

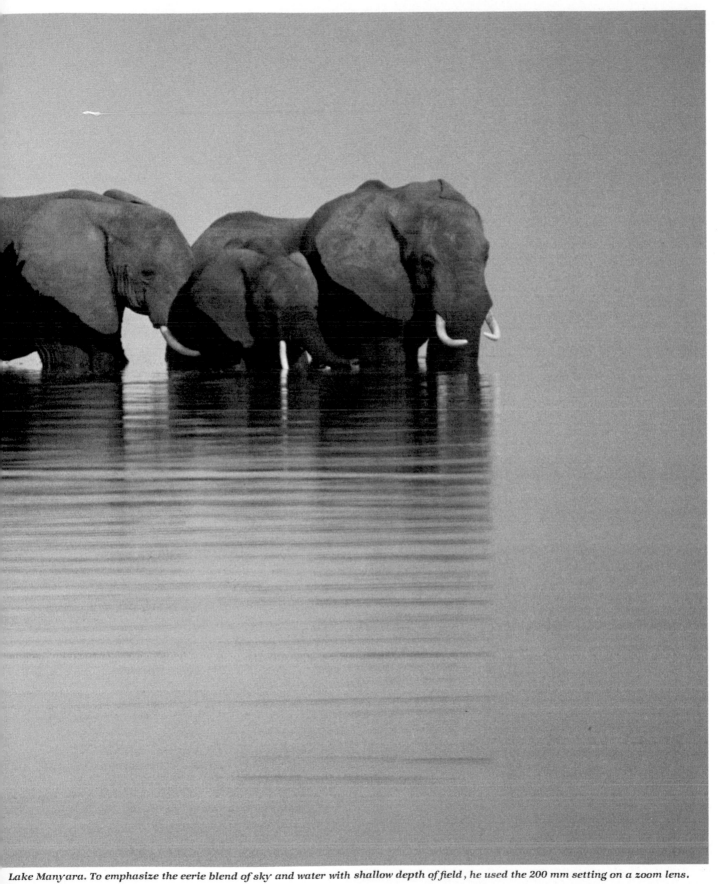

Lake Manyara. To emphasize the eerie blend of sky and water with shallow depth of field, he used the 200 mm setting on a zoom lens.

Photographing Landscapes

A good landscape evokes a sense of grandeur and timelessness, whether the setting be Manhattan's cloud-scraping skyline, a vast sweep of desert, a mountain crag, or even a vista like the one at right, perhaps more properly called a skyscape. The landscape photographer has an unparalleled opportunity to explore the interplay of color, texture, and tone in both natural formations and man-made creations.

Landscapes shot without planning and close attention to detail, however, are likely to be disappointing. The images your eyes see are not necessarily those that your camera records: A rich blue, cloud-filled sky may appear uniformly pale; an impressive mountain peak may be reduced to a hazy, distant shape; and that central rock formation you so eagerly photographed may look pretty insignificant on film. There are technical solutions to some of these problems, but many of the answers lie in the use of composition and lighting.

Beginning photographers often mistakenly assume that they have little control over the composition of a landscape. After all, how can you move a mountain a little to the left or ask a tree to step back a bit? Part of the problem is thinking of landscapes as broad vistas with elements of equal interest. Instead, if your scene includes an interesting shape or a large, distinctive element, such as a waterfall or a tower, look for ways to play

it up. A simple change of angle or lens may be all that is needed. Most effective landscapes also convey a sense of depth. Look for the vanishing ribbon of a highway or river, or a receding row of poplars that will establish perspective. Look, too, for a series of planes fading into the distance, such as successive mountain ridges dissolving into haze. Consider using foreground objects, such as rocks and trees, to establish depth and scale, or to frame a scene. Finally, give very careful consideration to the position of the horizon in your photograph. A low horizon will emphasize a spacious sky; one near the top of the picture can call attention to a looming rock or tree in the foreground.

Lighting, which sets the mood of any picture, is probably the least exploited element in landscape photography. Early and late in the day, the long, dark shadows cast by the sun emphasize the three-dimensionality of a scene. The light itself is gentle, its raking angle reveals textures, and the contrasts between bright and dark areas are subtle. The pastel colors of sunsets and sunrises in particular provide good opportunities for the landscapist working in color. The noonday sun, on the other hand, is less auspicious for picturetaking, since its harsh light and minimal shadows tend to flatten a scene.

There are exceptions, of course. Midday may be the only time when the interior of a chasm is lit or when a deep shadow is cast under a rocky overhang. The best approach, if you have the time, is to look at a scene at different times of day. Many professional landscape photographers plan their shots weeks in advance, and when they finally set up their cameras, they may wait hours for the right light. You should also keep in mind seasonal variations in light (see pages 56 to 59) and the effects of rainy, snowy, and foggy days (see pages 234 to 239). Landscape photography usually permits slower shutter speeds, which give you greater flexibility in poor light or inclement weather.

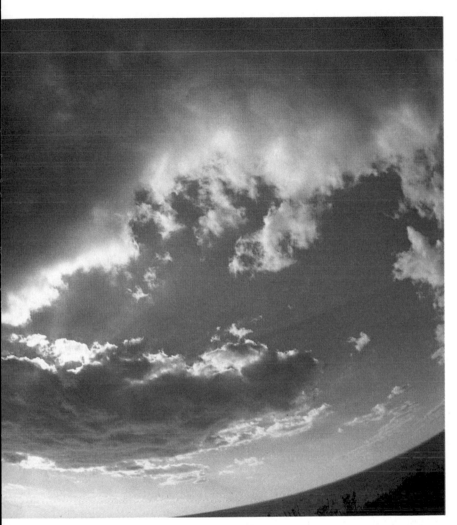

Exposing for the light in a landscape can be tricky—especially if the contrast between dark and bright is pronounced. Since film exaggerates differences barely noticed by the human eye, you can expose for the bright areas and let shaded areas become deep and shadowy. Conversely, you can expose for the darker areas and let the bright areas become intense highlights. More often, you will want to determine an intermediate exposure by taking a close-up reading of a middle tone in the scene or by metering both light and dark areas and compromising. It is often a good idea to bracket a compromise exposure with two shots that overexpose by a half and a full stop and two more that underexpose by a half and a full stop. With color slide film, many photographers prefer a slightly underexposed image; the hues thus reproduced are generally richer.

Certain conditions can create special exposure problems. Large areas of sand or snow, for example, can fool your camera's meter into recommending underexposure. The same is true when you are shooting directly into the sun. Actually, except for early or late in the day, it's best to conceal the sun behind some part of the scene or wait for a passing cloud. Solar reflections inside the lens can cause the scene to look washed out and can create those bright spots of overexposure known as lens flare.

In photographing a landscape, you will usually want to maximize the depth of field by using relatively small apertures. To keep all of a scene sharply focused, especially objects in the foreground, the depth-of-field scale on your camera's lens can be very useful. Many photographers make the mistake of always setting infinity on the center mark when shooting a landscape. If you rotate the lens's distance ring so that infinity matches the camera's aperture on the scale, you will gain in foreground sharpness without any loss in background clarity (see page 94).

The dramatic potential of the sky's vault, an element often overlooked by photographers, is explored to the fullest here. Using distortion creatively, the photographer took advantage of the unusual bowing of the horizon that occurs with an ultra-wide-angle lens when the horizon's position in a scene is either very low or very high.

The soft light of an overcast day intensifies the warm hues of a lakeside village in the Austrian Alps. Atmospheric haze softens the sheer

cliff in the background and emphasizes the church's towering steeple.

Landscapes

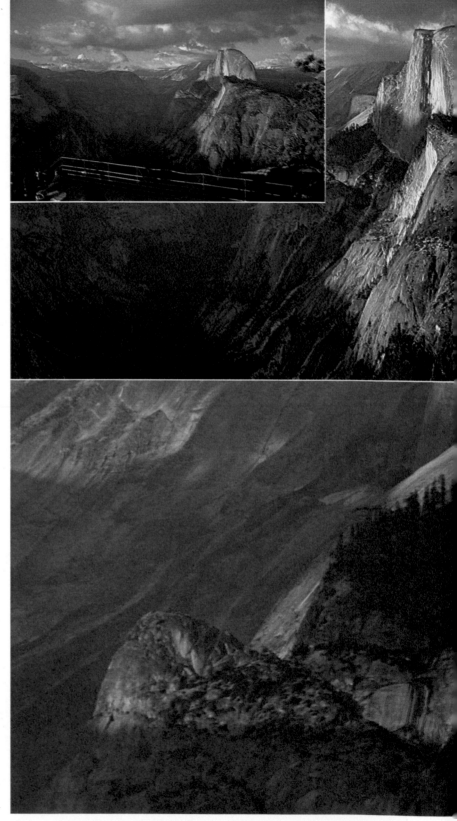

Tools

Good landscapes can be taken with the normal 50 mm lens on most SLRs and with the wider normal lens on most rangefinders. SLR users, however, will find that other optional lenses can greatly increase their flexibility—as illustrated here by three superimposed shots of the same scene taken with different lenses.

Because of its ability to encompass a broad landscape and its wider-than-normal depth of field, a wide-angle lens with a focal length between 24 and 35 mm is exceptionally well suited to landscape work. As always, you must be careful to minimize distortion of subjects close to the camera. A telephoto lens is also useful when you wish to bring a prominent feature to the fore, as in the largest picture at right, or to make widely separated elements appear closer together. A medium telephoto lens with a focal length between 85 and 135 mm is superior to a longer lens, because its depth of field is less restricted. A zoom lens that ranges from wide-angle to normal or from wide-angle to medium telephoto is another possibility.

Filters are especially handy in landscape work. An ultraviolet or haze filter can reduce atmospheric haze, which, although not always visible to your eye, can result in photographs with lackluster skies. A polarizing filter performs the same function and can also be used to eliminate reflections, define clouds, and, on color film, intensify hues, especially the blue of a northern sky. With black-and-white film, a yellow, orange, or red filter will darken the sky and highlight clouds. A yellow-green filter will lighten foliage as well, increasing the contrast between greenery and sky. (See pages 112 to 135 for more information on filters.)

Slow- or medium-speed film, ASA 25 to 125, renders detail with the greatest sharpness. If you are using small apertures as well, a tripod may be necessary to steady your camera at the slower shutter speeds required.

Three superimposed views of Half Dome in California's Yosemite National Park

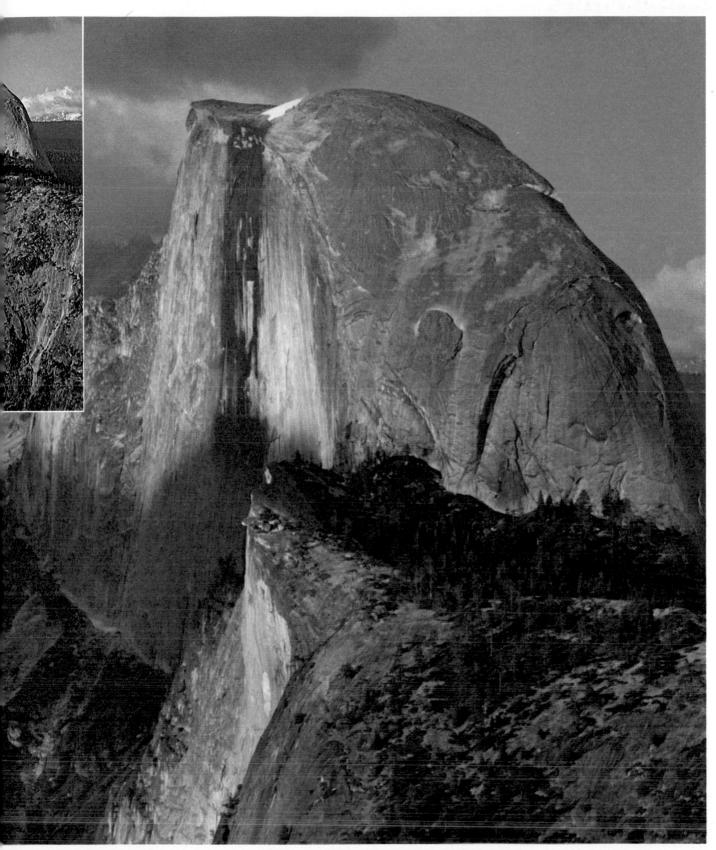

illustrate the effects of a wide-angle lens (upper left), a normal lens (middle), and a telephoto lens (lower right) on a landscape.

Landscapes
The Countryside

In the shot below of a provincial French village, a formal rectangular pond and a bed of tulips lead to a line of stone houses in the background. Note the effective use of backlighting here.

The strong diagonal line of an earthen levee cutting across the Indonesian rice paddy at left creates an irresistible visual pull. The viewer's eye is led immediately to the cluster of figures in the foreground on the right.

In the rural Vermont landscape below, a curving road and the framing bough of a tree together establish a feeling of depth, and the receding planes formed by the houses, trees, and hills further heighten this effect. Again, an overcast sky contributes to the scene's rich, vibrant color.

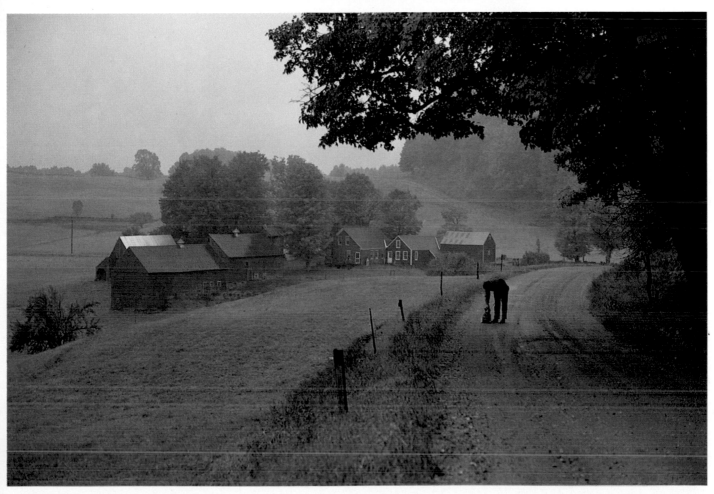

Landscapes
The City

The photographer of the
Leningrad cityscape at left
made effective use of the
natural line of the canal to
lead the viewer's eye to the
ornate, onion-domed cathedral
in the background.

The photographer has emphasized the curving façades of rowhouses in Bath, England, by using a wide-angle lens. The eighteenth-century buildings are still used as residences, as the mother and her perambulator indicate.

A volley of fireworks adds a dramatic touch to this shot of the lower Manhattan skyline. Fireworks are often best captured with long time exposures (see page 242), so that more than one burst can be recorded on the same image. Between bursts, replace the lens cap to avoid overexposing the rest of the picture.

Photographing Still Lifes

The still life has a long and venerable history. Painters have for centuries used this mode as an academic exercise, an opportunity to experiment leisurely with light, shape, texture, color, and composition. The earliest photographers found similar virtues in still lifes, and there is every reason today for the novice photographer to try them—both as learning tools and as an end in themselves.

A high percentage of the photographs we encounter every day are still lifes—shots of mouth-watering food, gleaming appliances, and other tempting products. The professionals who produce these advertising images spend hours, and often days, setting up each shot. As a result, much can be learned simply by studying the ones that you find most striking and original. Notice how these photographers use repeating shapes and lines to create patterns, subordinate less important objects to the main one, and use harmonious or clashing colors to achieve their effects.

Any object or group of objects can be the subject of a still life. Because of their intriguing shapes and inherent beauty, flowers, fruits, and vegetables, as shown here and on the following pages, have traditionally served as still-life centerpieces. Such natural items are easy to obtain; they offer endless arrangements and color combinations; and they can be used to create effects ranging from the lushly exotic to the cooly abstract.

But many other objects—both familiar and unfamiliar—are equally suitable for still lifes. Unless you want to create a deliberately jarring juxtaposition, the objects in a still life benefit from some logical thematic connection—a corkscrew with a bottle of wine, your grandfather's pocket watch with an old photograph of him, and so forth.

The meaning of an object can also change with the context. A pair of scissors will have very different connotations when paired with a bolt of cloth than it will with pencil and paper, a lock of hair, or a fresh-cut flower. And, of course, the scissors can be shown alone to emphasize the beauty of its form.

The subject of a still life need not be portable. A sink seen from a certain angle, for example, can offer a pleasing study of shape or line. But most photographers favor movable objects for still lifes simply because they want as much control as possible of composition, background, and lighting.

Nearly all professionals use studio set-ups, and it is fairly easy to do this yourself on a smaller, simpler scale with a few photolamps and suitable background material. Together with reflectors and diffusers, photolamps offer an almost infinite variety of lighting possibilities—for example, soft, even, overall light to enrich hues; backlighting to create a dramatic silhouette; strong sidelighting to heighten textures; and less angular sidelighting to stress contours. Natural lighting, especially the soft light of a window with a northern exposure, can also be used and supplemented with reflectors, flash, or daylight-balanced photolamps.

Professional seamless background paper (see page 149) provides an easy-to-use neutral setting for a still life. If you use other backgrounds—such as a wooden tabletop or a surface draped with fabric—they too should have some thematic connection with the objects. Although you have less control over light outdoors, natural settings may be more logical for some objects, such as shells on a sandy beach.

Still lifes are an excellent way to study the effects of color. When the predominant hues in a picture are blues and violets, as in this floral still life, the mood established is cool and rather detached. Yellow, oranges, and reds are warmer and more involving.

Still Lifes

Tools

Any 35 mm camera can be used for a still life, but the single-lens reflex with its through-the-lens viewfinder is more convenient. An SLR also allows you to use optional lenses. Especially helpful is a medium telephoto lens with a focal length between 75 and 135 mm. Such a lens lets you back away from your subject—out of the way of front- or sidelighting. A wide-angle lens is useful when you want to take in a large array of objects, but it may limit lighting possibilities and cause distortion.

A tripod allows you to check the composition through the viewfinder as you arrange a scene. It also permits slow shutter speeds, which may be necessary when you use small apertures for extended depth of field and slow- or medium-speed, fine-grained film for maximum image sharpness. A film rated between ASA 25 and 64 is generally preferred, although with natural light indoors you may need a slightly faster film. For longer exposures, a cable release is handy, but a self-timer can also trigger the shutter without jarring the camera.

Photolamps, reflectors, diffusers, seamless background paper, and other equipment useful for still-life work are detailed on pages 142 to 149. Most of this equipment is easily adapted to the tabletops you will probably be using for still lifes. With photolamps, be sure to use film with correct color balance or one of the filters noted on page 120. With black-and-white film, other filters can change the relative lightness and darkness of objects (see pages 124 to 125). Also helpful are an 18 percent photographic grey card for determining exposure (see page 265), a polarizing filter to tone down reflections from nonmetallic surfaces, a right-angle viewer for shots taken from directly above, and close-up equipment (see page 191). If your camera's reflection shows up in a shiny surface, such as a polished tabletop, try shielding the camera behind a large black card with a small hole for the lens.

Even perfectly formed fruits and vegetables, such as the pepper above and the apple at left, can be enhanced for the camera's eye. Their glossiness can be accentuated by a thin coat of mineral oil, their hue with gels on photolamps, and their roundness with sidelighting. A quick spray with a misting bottle will give them a just-picked freshness.

Arranging food and other items into a colorful and interesting display, as at right, allows you to experiment with shapes, colors, textures, and composition.

Photographing Architecture

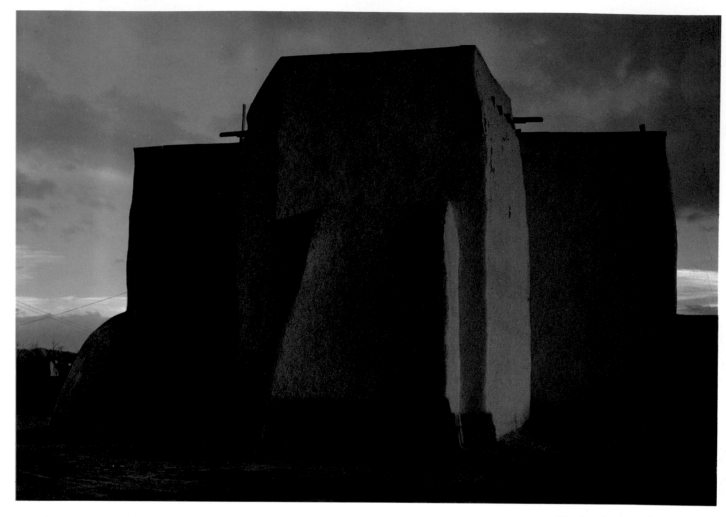

Good architects are artists as well as construction experts. They create buildings that are efficient and comfortable places to live or work, as well as aesthetically pleasing structures that reflect both classic design elements and contemporary trends. The results may be as starkly severe as the two structures shown above, or as richly ornate as the Victorian-era mansion shown overleaf.

An architect exploits on a grand scale many of the same elements central to photography—shape, line, texture, and pattern. When you photograph a building, try to remember the features that first caught your eye—the elements that you found visually exciting from the start. Perhaps it was a repeating row of arches or windows, a steeply pitched roof, or a coarsely textured concrete wall. Or it may have been a series of tiered terraces, the low lines of a sprawling ranch house, or the vertical lines of a skyscraper.

The way you choose to interpret and emphasize these features will largely determine the vantage point and camera angle you select. You may decide to shoot a structure straight on to show only the facade, from an angle to show both the front and a side, or even from the back, like the adobe church above. Likewise, you may want to squat down to get a very low-angled view of the building or climb a nearby rise to shoot downward. A low angle is especially useful for singling out a building and for enhancing its height and massiveness, while a high angle draws attention to its layout and relationship to the environment.

The lighting you select should also stress a building's unique features. If possible, study

Master photographer Ansel Adams took this picture of an adobe church in the American Southwest. Its stark, massive shape is accented by shadows caused by the sidelighting of the afternoon sun.

Ezra Stoller © 1979 ESTO

a structure at different times of the day to see how it is affected by the sun. Depending on when the sun hits the desired side of the building, the angular light of midmorning or midafternoon is the first choice of most architectural photographers. At these times of day, the sun provides good illumination while creating shadows that define structural details. If your subject has an intriguing shape, like many factories and other industrial structures, it may look best dramatically backlighted by a rising or setting sun or by a low-lying winter sun at noon. Other buildings take on a glow when washed with the warm light of dawn or dusk—from certain angles, windows may even seem to be ablaze. Some structures assume a solitary splendor when floodlit at night, and still others appear best when the soft light of overcast skies enriches their subtle colors. And, of course, fog, snow, and rain (see pages 234 to 239) all have great potential for enhancing the appearance of any edifice—especially one with majestic proportions, such as a cathedral, a castle, or a skyscraper.

In composing an architectural photograph, you should carefully consider a building's setting. A flower bed, a reflecting pond, or a driveway can lead the viewer's eye to the structure. A tree, a fountain, or a statue in the foreground can be used to frame the building or to provide a sense of scale. You can also manipulate the sky to your advantage by changing your camera's angle to increase or diminish the sky's prominence. If a building has a glass façade, you may wish to experiment with reflections in the windows: Images of neighboring buildings, clouds, or the setting sun can add great visual interest to a photograph.

Although built many years later, the Art Museum of South Texas in Corpus Christi (above) is conceptually similar to the adobe structure at left in its clean, strong shapes and lines. It also has been photographed straight on to emphasize its harsh planes and ponderous solidity.

213

Architecture

Tools

For the single-lens reflex owner, a wide-angle lens with a focal length between 35 and 24 mm, or even less, is a great asset in photographing buildings and other structures, since it permits greater flexibility when working in close quarters—a special advantage when shooting urban architecture. Keep in mind, of course, that distortion can occur with this lens.

The phenomenon known as keystoning—the convergence of a building's vertical lines as you tilt a camera upward—is especially exaggerated by a wide-angle lens. One way to overcome this difficulty is to find a vantage point—a nearby hill, if possible, or another building—that brings you more in line with the center of the building you are shooting. Another alternative is to photograph the building from a distance with a telephoto lens. To a certain extent, keystoning can also be corrected by careful printing in the darkroom. For the serious architectural photographer, however, there is a better, although more costly, solution. A perspective control lens, made with a focal length of 35 or 28 mm, lets you shift the position of the lens to straighten converging lines as shown in the two shots of an old mansion at right. The only disadvantage of this lens, which is described more fully on page 110, is that the aperture ring is usually not keyed automatically to the camera meter.

Slow- or medium-speed film, ASA 25 to 125, renders subtle architectural details more sharply than will faster films. These films, together with the smaller apertures that are often needed to attain greater depth of field, may necessitate shutter speeds slow enough to require a tripod and a cable release. In any event, a tripod is helpful in composing a scene, as it allows you to give more thought to spatial arrangements.

If a bright background or window reflections cause unreliable exposure meter readings, use an 18 percent photographic grey card (see page 265) to correct your camera's reading. You may want to adjust that reading to achieve a certain effect. One-half to one full *f*-stop more exposure will record detail on a dark structure and in shaded areas. One half stop less may prevent a bright building from looking washed out.

A polarizing filter will reduce glare from glass and intensify hues, especially the blue of the sky. With black-and-white film, yellow, orange, and red filters will darken the sky so that your subject is strikingly delineated against a shadowy background.

This shot of medieval castle ruins in Wales demonstrates the utility of a wide-angle lens in capturing a large portion of a scene. The photographer's low position also helps convey the castle's massive size.

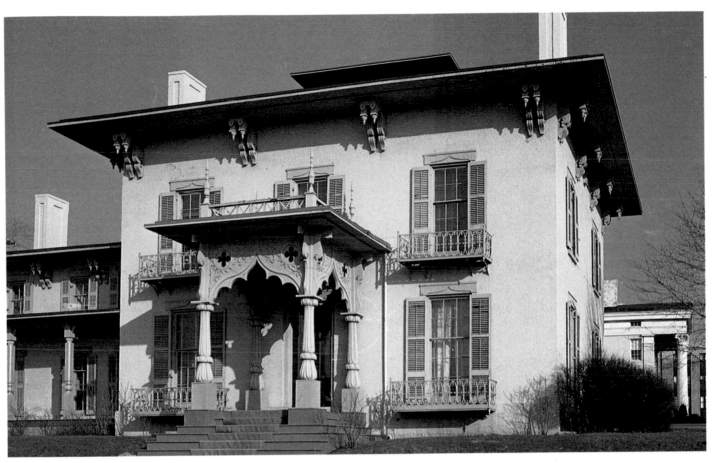

These two pictures of an ornate, nineteenth-century Gothic revival mansion taken from the same vantage point illustrate the value of a perspective control lens. In the shot at left, taken with a regular 35 mm lens, the structure's vertical lines converge toward the top. In the photograph above, a 35 mm perspective control lens was used to straighten the lines. The result is a more accurate representation of the way our eyes perceive buildings.

Architecture

Details

Details reveal a great deal about a building's style and era. As with full shots of buildings, details are usually best recorded in early to midmorning or mid- to late afternoon, when the proportions of light and shadow are most advantageous. For some subjects, however, the softer, less direct light of shade is better. This is true of the intricate ironwork and aging wood of the door pictured at far right. For contrasty subjects, determine a compromise exposure between the most brightly lighted area and the deepest shadows. With slide film, bracket if you're unsure of the results, and to improve faded color, decrease the exposure one-half to one *f*-stop.

Tools: Up to slightly above eye level, a normal lens is fine for recording details. If you have a single-lens reflex, however, you will also find a medium telephoto lens with a focal length of 75 to 135 mm useful. Such a lens will allow you to back off to get a better perspective on higher-level ornamentation— the pediments above doors and windows or a second-story balcony, for instance. Details on upper stories and along the roof line, which are best shot from neighboring buildings, may require an even stronger telephoto lens, 200 mm or more. At the other extreme, close-focusing equipment (see page 191) will help you zero in on very small details, such as stonework in relief or sections of ironwork. Slow- or medium-speed film, ASA 25 to 125, captures the intricacy of architectural detail with maximum sharpness.

An antique lion's head knocker and weathered wood combine to make the shot at right of a doorway in Oxford, England, a study in texture and subtle color.

The single column at left, supporting perfect arches, embodies the spirit and style of neoclassical architecture, a movement popular in the late eighteenth and early nineteenth centuries.

The most interesting element in the Austrian building below— the elaborate, Rococo handpainting—would not have been as clearly visible in a full photograph of the structure.

217

Architecture

Interiors

Whether your aim is to photograph striking detail such as the spiraling stained glass ceiling at far right or to convey the vaulting spaciousness of the world's largest church, as at right, photographing a building's interior presents a completely different situation. Light is generally dimmer indoors and there is less room to maneuver. Even in a space as ample as St. Peter's Basilica, you may still have trouble positioning yourself to give a true idea of the structure's shape and size. And the task becomes much more difficult, of course, in the average-sized room.

One common solution is to shoot toward a corner to show parts of two walls and the floor. You may wish to include the ceiling if it is low and you want to convey the room's cozy, intimate—or even confining— character. If this is not your objective, a room will look most airy and spacious if you stop just short of the ceiling, creating the impression that the vertical lines of the walls continue upward. To increase the feeling of height, also consider kneeling down and shooting from a low angle. If there are stairs or landings overlooking the area, or even a handy ladder, try shooting downward to give a better sense of the room's layout.

Existing light, either natural or artificial, is often sufficient to photograph an interior (see pages 226 to 228). If not, you can use an electronic flash to supplement daylight. Depending on the size of the room and the amount of light you want, you can use a single flash, a series of flashes, or photolamps as the chief source of illumination. The soft light provided by bounced or diffused flashes and photolamps is generally best for interiors.

To achieve even, overall illumination in a large area, many professional interior photographers use a technique known as painting with light. In a darkened room, set your tripod-mounted camera on B or T for a time exposure. Then walk around the room with a photolamp in a reflector, giving each surface in sequence an equal amount of light. The camera won't record you or the lamp if you keep the light in motion and pointed away from the camera. Hold the reflector away from you and toward the area you're illuminating, or you'll be silhouetted between a lighted area and the camera. Try

to spend the same amount of time lighting each area and to maintain the same distance between lamp and subject. A fairly small aperture should be used to maximize depth of field. This technique also works with a detachable flash unit (see page 143).

Tools: On an SLR, a moderate wide-angle lens, 35 to 28 mm, or even an ultrawide one, 18 to 24 mm, is very helpful in shooting interiors. A tripod and a cable release are indispensible for the slow shutter speeds required with smaller apertures and for the slow- or medium-speed film you'll want to use to achieve the sharpest images. In dim interiors where flashes and tripods aren't convenient or permitted, such as in a museum or church, a high-speed film, ASA 400, is a better choice.

Beams of light from the windows in the dome suggest a heavenly presence in the majestic interior of St. Peter's Basilica in Rome, while the visitors below give a good indication of the church's immense proportions.

When photographing stained glass, such as these panels in the spiraling ceiling of Thanks-Giving Square in Dallas, Texas, remember to expose for the light of the window, not the dim interior light, and use daylight color film. If you are shooting glass lighted from the inside at night, switch to tungsten film.

Photojournalism

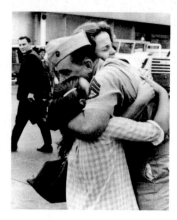

The intensity of the embrace here leaves little doubt as to the circumstances—a soldier has returned home from war.

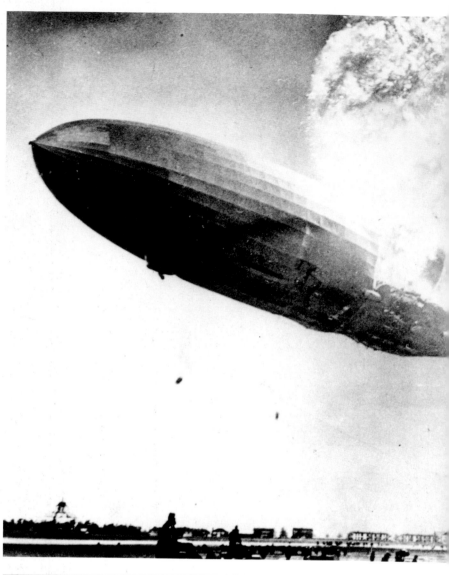

Photojournalists can be thought of as reporters armed with cameras instead of typewriters. Their pictures tell stories without words. For the most part, the techniques they use are much the same as for candid photography (see pages 170 to 171). They frequently preset their cameras for the prevalent lighting conditions, selecting a shutter speed, such as 1/125 second, that will freeze most normal activities and a relatively small aperture to attain good depth of field. At the same time, they adjust the camera's distance ring so that everything within a certain range, say five to twelve feet, will be sharp. Thus prepared, they are free to concentrate on their subjects and to anticipate and record story-telling actions.

Tools: Most photojournalists prefer a single-lens reflex with an inconspicuous black body. A medium telephoto lens, 75 to 135 mm, comes in handy when you need to keep your distance, and a wide-angle lens, 24 to 35 mm, is useful in tight spots. Even in a crowd, you can hold the camera overhead, point it at the action, and get a reasonable picture. Many photojournalists carry a zoom lens for added flexibility. An automatic winder or motor drive will help you keep pace with fast-changing events. For dim light and noncandid situations, an electronic flash may be needed. High-speed film, ASA 400, is essential.

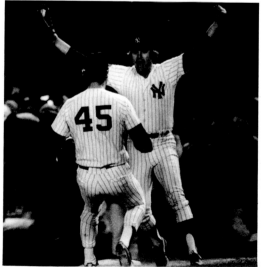

Like many sports pictures, the shot at left of a victorious baseball player was taken with a high-powered telephoto lens.

In a daring leap over a barbed wire barrier, a young East German soldier defects to West Berlin in 1961. Like many good journalistic photographs, this picture was taken at the moment of peak action.

When the zeppelin Hindenburg (left) arrived at its New Jersey mooring mast in 1937, news photographers expected to cover a routine landing. Instead, they witnessed and recorded one of the most famous news events ever. Within thirty seconds, the airship was consumed by flames.

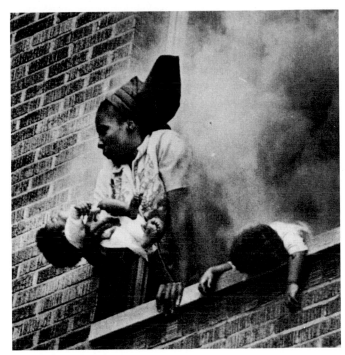

The shot at right and its companion below depict a compelling human drama. Stranded in a burning building, a mother fears for the lives of herself and her children. Her desperation turns to relief when firemen come to the rescue.

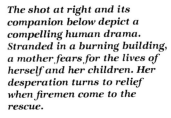

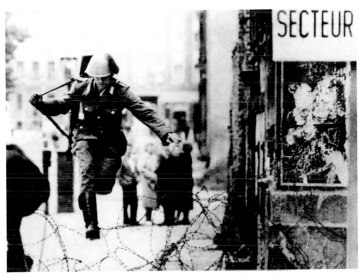

Photojournalism

The Photo Essay

In a photo essay, a series of pictures is organized to give a deeper understanding of a topic than one picture alone could ever provide. As the 1967 *Life* Magazine essay on the religious sect known as Shakers shown on these pages demonstrates, the impact of a photo essay comes from the size, position, and sequence of the pictures as well as their content. In this essay, John Loengard has photographed the Shaker people—as well as their home, handicrafts, and everyday activities—to show the serenity and simplicity of their community. The stark quality and deep shadows of the photographs also emphasize the solitary existence of the few remaining members of a dying sect.

Although *Life* Magazine made the photo essay part of American journalism, it is by no means the exclusive domain of the magazine world. Anyone can apply the same techniques and approach to any number of situations—weddings, reunions, trips, or business activities.

The organization of a photo essay can be thematic or chronological, but before you actually begin photographing, it is vital to plan the kinds of pictures you will need. You should consider shots that will serve as an opener to establish the mood or setting, others of major events or actions that can be used in a large size to carry the main theme or story, and still others that can be used in smaller size to supplement the main images or provide transitions. Finally, you should take pictures that will provide a sense of completion to use at the end of the essay.

Professional photographers often take hundreds of images on an assignment— sometimes taking many shots of the same scene using different lighting, exposures, lenses, and camera angles. You need not be so extravagant, but plan to shoot at least several rolls of film to get a large enough number from which to plan your essay. Most people select and "edit" their choices using contact sheets—proofs of an entire roll of film on a single sheet (see page 251)—or in the case of slides by sorting them on a light box. You can organize, size, and crop the pictures you have chosen on a rough pencil layout before having the images enlarged and placed in position in an album or wall display.

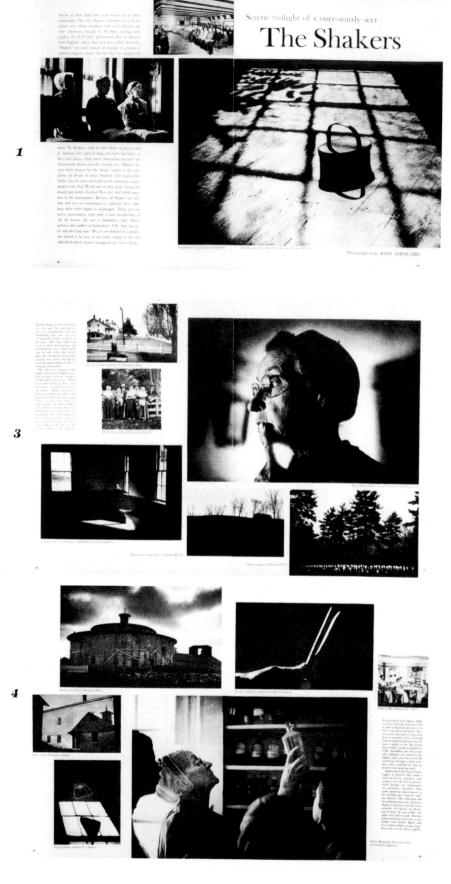

1

3

4

Neat as a toy town, the still-active Shaker village at Canterbury, N.H.

Doorway to a sisters' room

A brethren's retiring (bed) room

Segregated stairs at Pleasant Hill, Ky.

Restored Shaker parlor at Hancock, Mass. museum

Picket fence and 1850 building at Sabbathday Lake, Maine

"Mother Ann" Lee, founder and spiritual leader of the movement, believed that sex is the lord from which all earthly evil springs. To keep the mingling of the sexes to a minimum, Shaker houses even had separate doors and stairs for the brethren and sisters. Whenever a family joined the village, the husband and wife would part and so would their sons and daughters. If, somehow, a Shaker boy and girl fell in love, they were put on six months' probation. Then, if they still wished to marry, they were sent into the "world" with a sack of flour, a horse, $100 and a blessing. Brethren and sisters ate in the same dining rooms, but at separate tables, and they never touched, even during the spirited dances. This same discipline carried over into their meticulously ordered homes. Ubiquitous wooden pegs studded every wall and virtually everything hung from them: clothing, utensils, even furniture when the floor was being cleaned. And that was often, for Mother Ann lectured, "There is no dirt in heaven." Though a central ministry set down general rules, villages were self-supporting and self-governing. A village was divided into "families" of from 30 to 100 individuals each, including the children whom Shakers took in and reared. Recalls a Canterbury sister: "People think we've missed a lot by not having our own families, but I think I've loved these adopted children more than I would my own." In each village two elders and two eldresses handled family matters and gave spiritual guidance, while deacons and deaconesses dealt with the "world," what lay beyond the neat white fences and pampered crops. And every village raised its food, built its homes, made its furniture. A typical Shaker village, at Pleasant Hill, Ky., is being completely restored and, in June, will be opened to the public.

2

The dog Wiggles, cranberries and Sister Bertha in Canterbury kitchen

Though Shaker sisters still hold services, they no longer indulge in the dancing and marching that in early days provided recreation as well as a way of expressing reverence. Today television antennas sprout from their roofs and every sister has seen the movie Sound of Music at least once. The stark and spare furniture once used by Shakers is now a rarity in their living quarters. Collectors have grabbed up most of it and, anyway, the sisters prefer the comfort of soft upholstery. Yet, while embracing the good things that modern times have to offer, the sisters enjoy such old-fashioned pleasures as sorting cranberries and on a winter's afternoon they love to gather in the sewing room to gossip and giggle. "If anyone pities the Shakers for the life they lead," says one 90-year-old, "they don't know what they're talking about. I've never been bored a day in my life."

Shakers in a solemn march, palms uplifted to receive blessing

Sister singing at Sabbathday Lake sewing room

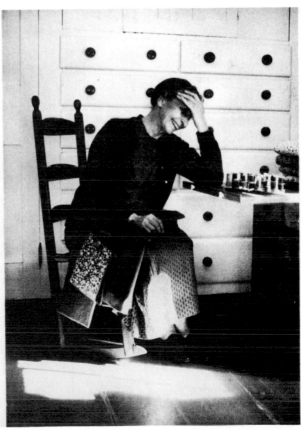

5

Photographing in Existing Light

Outdoors at Night

Some very striking photographs have been taken in less than ideal lighting conditions—outdoors at night, as in the pictures here, or indoors using only the illumination from windows or light bulbs, as discussed on the following pages. But such "existing" or "available" light, as this marginal illumination is usually called, demands much from the photographer—in planning and taking a shot as well as in judging the quality of the light. In addition to being generally dim, available light usually varies in intensity from one part of the scene to another. If no precautions are taken, certain details will be harshly highlighted while others will be deeply shadowed.

When shooting outdoors at night, one way to circumvent this contrast problem is to photograph in the early evening, up to an hour after sunset, when the lingering light provides even, overall illumination. Street scenes and nature shots benefit from twilight, but, as the pictures here show, it helps if any artificial light is evenly distributed throughout a scene.

High-speed film is essential for nocturnal photography. Black-and-white film, usually rated ASA 400, can be push-processed to ASA 800 with minimal loss of quality—and to ASA 1600 or even 3200 with a perceptible increase in graininess. Ideally, color film should be matched to the main light source. At twilight, this usually means using film balanced for daylight—either color negative film or daylight slide film. Both are available with an ASA 400 rating, and slide film can also be pushed to ASA 800. For late-night street scenes, a better choice might be tungsten slide film, which normally has a highest speed of ASA 160 and can be push-processed to 320. When an exposure lasts several seconds, however, or when there is a diversity of light sources or unusual ones (such as sodium- or mercury-vapor lamps), color negative film, which produces prints that can be corrected in printing, is best.

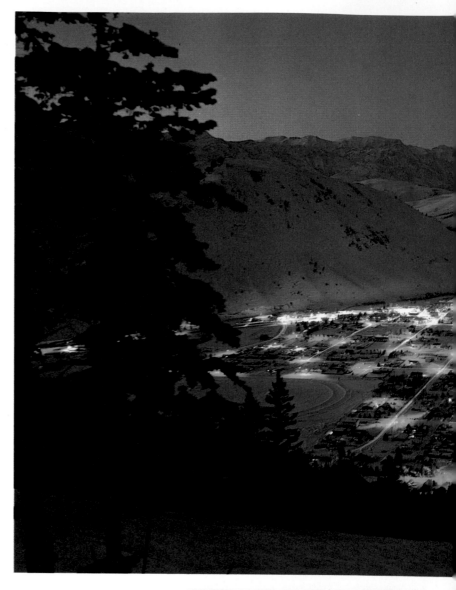

The relatively even lighting of the Indonesian street scene at right made it an ideal subject for a night picture. Since longer-than-usual exposures are often needed for such scenes, you may have to accept as inevitable some blurring of people in motion.

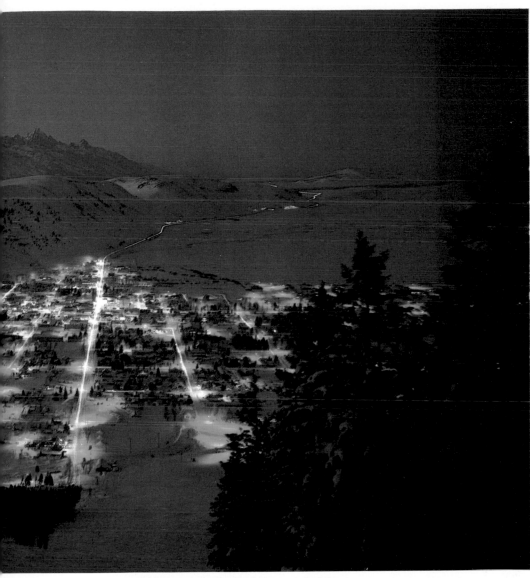

Even though the lingering light of day provided extra illumination for this shot of a town nestled in a snowy valley, a time exposure was necessary. The longer exposure had the added effect of transforming the car headlights into luminous streaks of light.

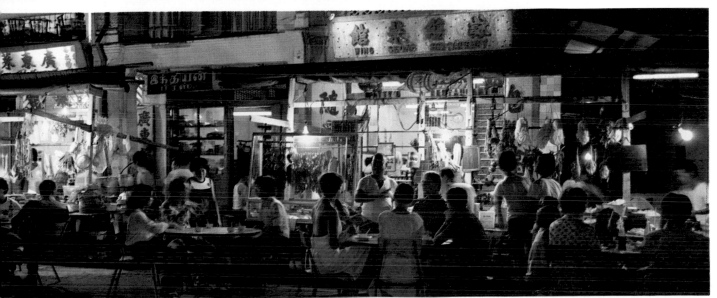

Existing Light

Shooting a subject positioned
directly in front of a window
usually results in a silhouette.
In this picture of lacemakers,
the photographer avoided this
outcome by using the reflected
light from the white tablecloth
to illuminate the women's
faces and by exposing for
the subjects.

Natural Light Indoors

Direct sunlight cascading through an open
window may be a joy to behold, but it is also
pretty tricky to photograph. This is because
the sunlight is directional and much brighter
than the room's ambient light. The best
solution is to avoid photographing sunlight at
its brightest and most severe. Even if your
goal is to show light pouring through a
window, you'll get much less contrast if you
work on days or at times of day when haze
reduces the sun's intensity but still lets it
produce distinct shadows. Otherwise, it is
usually best to keep away from direct
sunlight altogether.

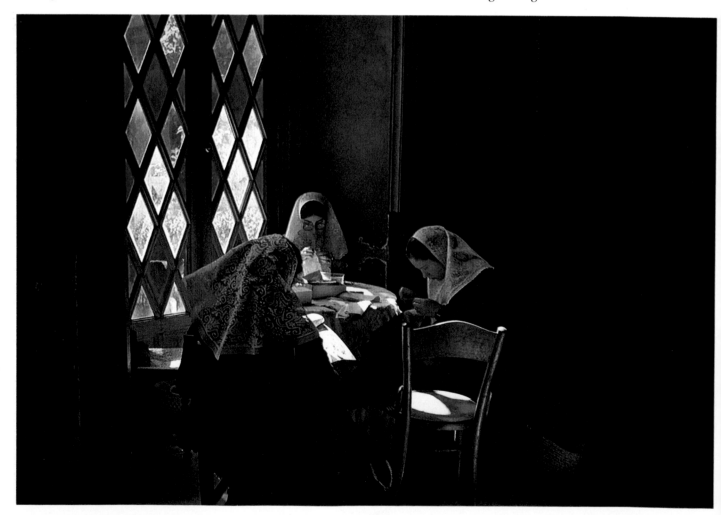

When shooting indoors, look for windows that receive reflected light from the sky—a western one in the morning, an eastern one in the afternoon, and a northern one all day. The light, although slightly directional, will be softer and less intense. Even a window with a southern exposure can be used on overcast days or when the sun is blocked by a tree or building. The amount of light can also be controlled by blinds or translucent shades and curtains. Sometimes the best place to photograph a subject is at the opposite end of the room, where the light is more uniform.

Contrast can also be reduced by secondary lighting. Use light-colored walls as reflectors to fill in details, or open a door or raise a shade to let in softer natural light from another direction. With black-and-white film, use artificial lighting to reduce contrast. If you are using color daylight film, however, improvise a simple reflector by having someone hold up a large piece of white paper or cloth. High-speed film, ASA 400, gives the greatest flexibility. Since your camera's meter is easily tricked by strong light from a window, be sure to take a close-up reading from your subject.

The streak effect of direct sunlight is not always a disadvantage. Here it dramatically lights half of a dancer's face and leaves the other half deeply shadowed. The strong, angular shadows cast in the room also create a visually intriguing design.

Existing Light

Artificial Light Indoors

Working with available artificial light indoors is a challenge. As is usually the case with existing light, the chief problem is the unevenness of the illumination, which results in images with severe contrast. Indoors at home, you can reduce this contrast by turning on all available lamps and overhead lights. If the lamps are not going to appear in the photograph, remove their shades to augment the lighting.

In public places, pose your subjects in locations where they will be evenly lighted. Or look for scenes where the main light is balanced by softer illumination from other sources. In the photograph on the facing page, general room lighting supplements the spotlights. Whenever you are working with existing light, be sure to take a close-up reading of your subject.

With color film, especially slide film, be careful to match the film with the main light source. Most indoor artificial lighting requires tungsten film, or daylight film with a filter (see page 120), to compensate for the warmer-toned light. But daylight film can sometimes be exposed under tungsten light to produce a warmer-than-normal rendition of a scene, as in the shot of the cleric reading at upper right. And, since most fluorescent lighting found in offices, schools, and other public buildings, as well as in many kitchens, is deficient in red, subjects are rendered better by daylight film. For best results, the light should be filtered (see page 122). Daylight film is also superior for subjects lit by carbon arc spotlights. When used with artificial lighting, especially from a tungsten or fluorescent source, color negative film should also be filtered. If it is not, the color imbalance can be corrected to a degree in printing (see page 264).

When shooting indoors in relatively dim light, consider having slide film push-processed. The highest-speed indoor tungsten film, normally ASA 160, will give good

Shooting a mixture of natural and incandescent light is always tricky. In the color photo at right of a studious cleric, daylight-balanced film was effectively used to reinforce the generally warm hues in the scene and to enhance its intimacy.

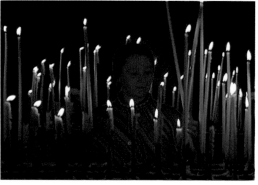

Votive candles clustered together at left provide an even and intimate light source, as well as an unusual frame for the subject. Because it contains even more red than incandescent light, candlelight will always show up on film as warmer than expected.

results when pushed to ASA 320. And high-speed daylight film, which changes from its ASA 400 outdoor speed to ASA 100 when filtered for tungsten light, can also be pushed one stop higher. High-speed black-and-white film, ASA 400, can, of course, also be push-processed.

Tools: For nearly all available-light pictures, a lens with a large maximum aperture, $f/2$ or wider, is preferable. Since many dimly lit scenes will require exposures longer than 1/30 second, a tripod and cable release are often necessary. If your camera's meter does not take readings in very low light, use a more sensitive auxiliary meter or follow the suggested existing-light exposures on the film instruction sheet.

The even illumination provided by spotlights and brilliant overall room lighting serves to emphasize the stark shapes and bright colors of elevator doors at the Harvard University School of Education Library in Cambridge, Massachusetts.

Photographing Underwater

Many underwater venturers, whether they explore only surface waters with a snorkel or probe deeper with scuba equipment, want to record the beautiful world of the deep on film. And, with the proper equipment—a watertight camera housing and the other apparatus described overleaf—this is much easier to do than you might think. Mostly it is a matter of learning the special characteristics of light in water.

Underwater subjects appear to be about one-fourth closer to you than they really are. They appear magnified to both your eye and the camera. Accordingly, you should set your focusing scale for this apparent distance, not the real distance. With a single-lens reflex in a housing that permits you to see through the viewfinder, this is no problem. And, if you know the actual distance (say, four feet), you can compute the apparent distance by multiplying the actual amount by three-fourths and using that number (in this instance, three feet) to set your scale.

The amount of light underwater is also severely reduced. Water reflects and absorbs light rays, and even the clearest lake has thousands of tiny particles that limit your visibility. A good rule of thumb is to photograph subjects no farther away than a quarter of the total distance you can see. Thus, if your visibility is sixty feet, wait until you are within fifteen feet of your subject to shoot. In general, the closer you are, the better. Since more light enters the water when the sun is overhead and when the surface is calm, the best time to shoot is between 10 A.M. and 2 P.M. on bright, windless days.

Setting exposure for underwater conditions depends on the kind of camera and housing you use. Some housings permit you to operate your camera in the usual way; less expensive housings may require you to set the exposure above the surface. The typical exposure adjustments needed for various underwater depths are given in the chart at right. The data are based on average lighting conditions between 10 A.M. and 2 P.M. on a bright, sunny day with slight winds and an underwater visibility of fifty feet. Since it is difficult to steady a camera underwater, try to use the fastest shutter speed lighting permits—1/60 and 1/125 second are common.

Underwater Exposure Settings

Depth of subject	Number of f-stops to increase lens opening over normal above-water exposure
Just under surface	$1\frac{1}{2}$
6 feet	2
20 feet	$2\frac{1}{2}$
30 feet	3
50 feet	4

Given the rapidly decreasing level of illumination underwater, flash is a useful aid below the first few feet of surface water. This is especially true for color photographs, since light waves from the red end of the spectrum are absorbed most quickly. Reds nearly disappear at ten feet, and oranges and yellows are not far behind. Without flash, you will find yourself in a totally blue-green world.

To calculate flash exposure, divide the above-water guide number by three when using the actual distance and by four when using the apparent distance. If you have focused with a rangefinder or a ground glass, the distance indicated on the camera's scale is the apparent distance. For best color, stay within five feet of the subject with electronic flash and blue flashbulbs. Beyond this, even the light from the flash will become blue-green. With its warmer light, a clear flashbulb has a greater range.

Underwater, it is best to work as close to your subject as possible. Although it may result in some distortion, as in the shot of the fish at lower right, proximity is the only way to get sharp images with accurate colors. The general blueness of the background in the upper picture indicates the absence of reds in the light at this depth.

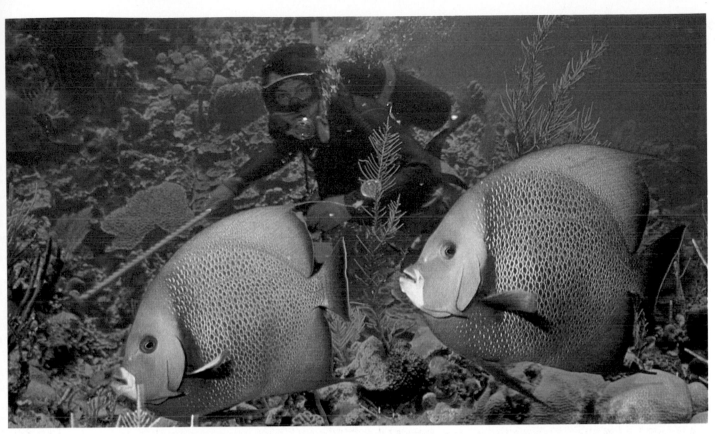

Underwater

Tools

Serious underwater photographers usually own special waterproof 35 mm cameras, but any camera with a watertight housing can be used below the surface. Such housings are made of metal or plastic with glass ports and are often designed to accommodate specific brands of cameras. The best housings offer external controls connected directly to the camera's, but even on some better housings the use of the camera's viewfinder is limited or impossible. If this is the case, you need to use an auxiliary frame viewfinder mounted on top of the housing. Because of the parallax problem, you'll also need a special wire framing device that projects out in front of the lens for close-ups. In general, metal housings are preferable to plastic: They are more durable, require less ballast, and are less prone to such problems as reflections and condensation on the lens. Special underwater flash units and housings for some regular flash units are also available.

Because of low light levels underwater, a lens with a large maximum aperture, $f/2.8$ or wider, is necessary. A wide-angle lens, 35, 24, or 21 mm, will give you a greater depth of field and let you move closer to your subject. Further, since the effective focal length of a lens is lengthened underwater, a 35 mm lens has an angle of view equivalent to a normal 50 mm lens. High-speed film, ASA 400 or pushed even higher, is recommended, and color film should be balanced for daylight. Although it can't be push-processed, color negative film, with its greater exposure latitude, is advantageous. To adjust for the shift toward blue-green hues underwater, a color correction 30 red filter can be used with natural light down to thirty feet. With natural light at depths over thirty feet, however, the filter is useless because the light has lost all its red. The filter requires additional exposure of about two-thirds of a stop. Be sure to use rolls of thirty-six exposures, so you won't have to surface very often to put in new film.

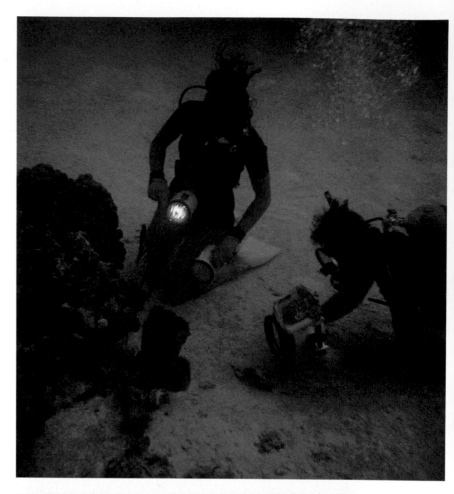

For tight close-ups such as this one of a sea anemone, you need a flash and one of the types of close-up equipment described on page 191. A wire framing device projecting in front of the lens may also be necessary.

For safety and for greater flexibility in lighting a scene, it is best to work in pairs underwater, as in the picture at left. The couple's camera housing and lighting are typical of better aquatic photographic equipment.

Wrecks make interesting underwater subjects, but they are generally larger and more difficult to light than sea life. Often it is best to concentrate on a single object or detail, such as the propeller below.

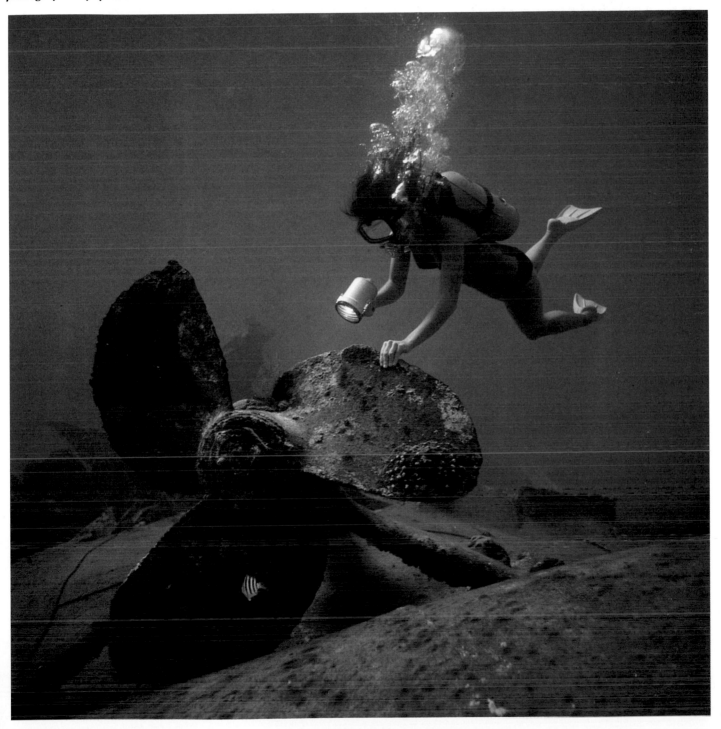

Photographing in Inclement Weather

Rain and Lightning

Rain, snow, fog, and other inclement conditions can literally add atmosphere to a photograph—especially to a landscape or an architectural shot. If you are willing to brave the elements, you will be amply rewarded. Many ordinary scenes are magically transformed by a change in the weather. And with just a few basic techniques, you can learn to capitalize on nature's "bad" days.

Whether it comes in a drizzle or a full-scale downpour, rainfall imparts a gleaming, glassy appearance to hard surfaces such as walls, streets, and cars and adds a more subtle sheen to grass and foliage. Like a coat of varnish on wood, the wetness enhances the richness of the colors; bright hues especially stand out in the dim light created by heavily overcast skies. You don't necessarily have to get wet to take advantage of a rainy day, either. Shots taken from porches, under street canopies and overhangs, and through windows can be

very effective—a rain-blurred window may even enhance a photograph's interest. Also try taking pictures immediately after a rain. Surfaces will still be wet and shining, and often the light will be brighter. Look for reflections in puddles, mist rising from the ground, and subjects splattered with droplets. Watch the sky, too, for as a storm approaches or leaves, cloud formations can be unusually dramatic, as in the picture below.

To photograph rain itself, use a fast shutter speed, 1/125 second or less, and try to get the drops sidelighted against a dark background. A short exposure is also needed to freeze ripples in a puddle. With patience and planning, you can even photograph lightning. Mount your camera onto a tripod and aim in the general direction of the storm. Select an angle that excludes any nearby light sources. In daylight, use the smallest aperture and the slowest shutter speed the

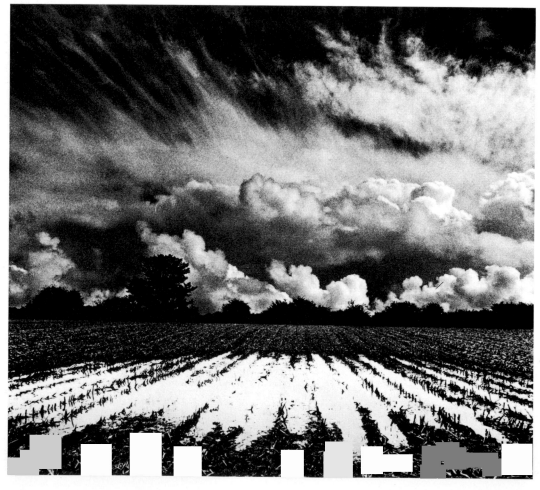

Storm clouds loom dramatically over the stubble of a harvested field in the graphic shot at left. To record such cloud formations on black-and-white film, use yellow, orange, or red filters (see page 124). With both black-and-white and color film, a polarizing filter helps to define clouds.

When shooting a scene with lightning, look for an object in the foreground with an interesting shape to add dimension to the scene. In the picture at right, a windmill is silhouetted by the flashes.

234

scene's lighting permits to capture the biggest spread of lightning. To get even slower shutter speeds, reduce the amount of light reaching the film with a neutral density or polarizing filter (see pages 131 and 118). Be prepared to snap the shutter the instant lightning appears. At night, when there is no other light in the scene, you can safely set the shutter on B or T for a time exposure (see page 242) and record several flashes of lightning on the same frame. To add interest to your picture, look for foreground objects, such as a windmill or a tree, that will be silhouetted when lightning strikes. Always keep in mind the hazards of lightning and choose a safe vantage point. Indoors, shooting through a window or a door is best. Because lightning often flashes across a large section of the sky, a normal or wide-angle lens is recommended.

Tools: For rainy, overcast days, you'll find it helpful to have a lens with a wide

maximum aperture, $f/2.8$ or larger; high-speed film, such as ASA 400; and sometimes even a tripod and a cable release. But with less formidable cloud covers, you can use smaller apertures and medium-speed film, ASA 64 to 125.

If you actually go out into the rain, it is essential to protect your camera. Keep it under your raincoat or umbrella. For additional protection, attach an umbrella to your tripod or put your camera in a plastic bag with a hole for the lens. If you have an underwater housing (see page 232), use it in the rain. You should also have a lens shade to help keep droplets off the lens and a soft, absorbent cloth handy to wipe them off if they do accumulate. Don't load or unload the camera when your hands are wet. If you live in a damp area, or are visiting one, store your camera and film in plastic bags along with packets of moisture-absorbing silica gel crystals.

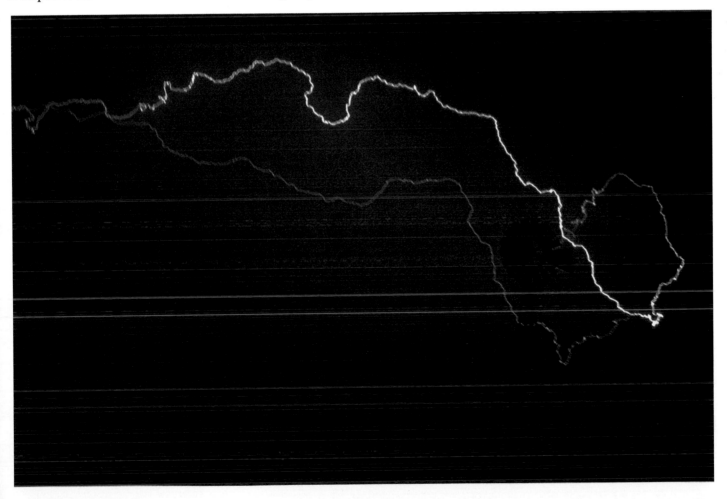

Inclement Weather

Fog

Millions of tiny water molecules are suspended in the air during a fog. Light appears even and diffused, as if seen through gauze, and hues become muted and subtle. Fog also solves the problem of background clutter: Distant shapes melt and merge into a milky white backdrop.

Fog can range from a light morning mist to pea-soup density, but whatever the conditions, your objective is to find scenes that are striking even with the inherent lack of contrast. Look for strong emphatic shapes, such as the trees and farmhouse in the picture below or the skyline in the shot at right. They should be distinctive enough to be identifiable, but relatively dark in tone to stand out against the light background. In most settings, as in the two shown here, this effect is heightened by shooting toward the sun so that the main subjects are subtly backlighted. This lighting can deceive your meter. As a rule of thumb, increase the recommended exposure by at least one stop and bracket several half stops more and less.

Tools: Since mists are most common in the reduced light of morning and evening, it is helpful to have a lens with a large maximum aperture, $f/2.8$ or wider, and to use high-speed film, ASA 400. Since the foreground assumes greater importance on a foggy day, SLR owners may wish to use a wide-angle lens; one with a 35 mm focal length is suitable for such conditions. Consider using filters as well. Color filters can add a surrealistic quality to a scene. An ultraviolet or haze filter slightly reduces the effect of fog, whereas a diffusion filter enhances it. Though less noticeably so, fog, like rain, is wet and potentially harmful to your camera and film. In heavy mists, follow the suggestions on the preceding pages for protecting your camera.

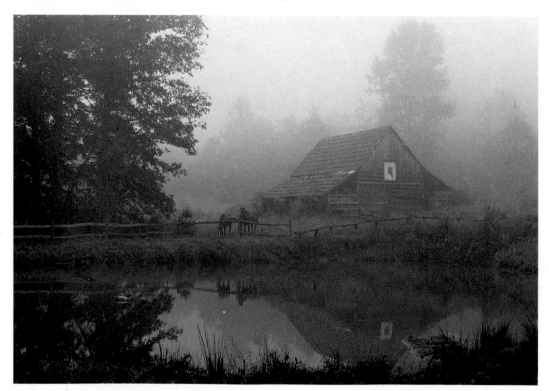

In pastoral scenes such as the one at left, the softening effect of a mist helps set the mood of the picture. The pronounced

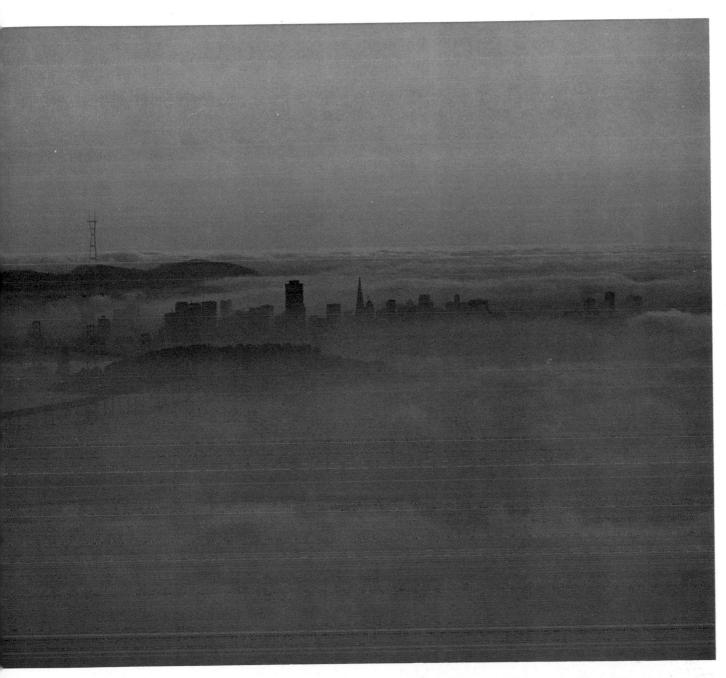

shapes of the shed and the trees, as well as their reflections in the pond, add visual interest.

Rising in silhouette out of a low-lying fog, San Francisco's skyline resembles a fairy tale image of a kingdom in the clouds. Large bodies of water, such as those that surround this peninsular city, are the best places to look for mist.

Inclement Weather

Snow and Cold

A cold, snowy day is the most challenging of all weather situations—both because of the temperature and the frozen precipitation. A snowy day can also offer some intriguing picturetaking possibilities, however. When it is actually snowing, the conditions are very much like those of fog: an overall gauziness and lack of contrast that calls for strong, pronounced dark shapes.

When the storm passes and the sun returns—the time when most photographers are tempted outdoors—the chief problem is the snow's high degree of reflectance. Like sand, snow will usually baffle your camera's light meter. The meter will take an averaged reading of an unusually bright scene. In a landscape or a portrait, the result is likely to be underexposed. The solution is to take a reading from an 18 percent grey card, the back of your hand, or anything else that approximates a normal middle tone—which, in the case of a portrait, is your subject's face. For an important shot, especially in color, you should bracket that exposure by a half, one, and two full stops in both directions.

Frigid temperatures present even more problems than the snow. As the mercury plunges, the lubricants in your camera's shutter may thicken, causing it to slow down and resulting in overexposure. Further, film can become brittle and break or generate static electricity that causes streaks and fogging. In addition, ice can form on the lens or viewfinder if you breathe on them or if snow hits them. The camera's battery may lose power on a cold day, causing the meter to give erratic readings. Most problems can be avoided by keeping the camera under your coat until you want to take a picture. Similarly, keep extra film and lenses warm in your pocket or in an insulated bag. If your camera does get cold, don't attempt to warm it up too quickly indoors. A rapid temperature rise can cause condensation to form within the lens or on the film. Instead, let it warm up slowly in a cooler place.

Tools: For snowy landscapes, use a slow- or medium-speed film, ASA 25 to 125. If your camera uses a PX-13 battery, substitute a more temperature-resistant PX-625. Invisible ultraviolet rays reflected by the snow on clear days are recorded on film as blue. A skylight filter reduces the excessive bluishness of snowscapes, but some reflected blue from the sky should be expected and even desired. If snow is actually falling while you are taking pictures, follow the suggestions on page 235 for protecting your camera from moisture.

When photographing in freezing weather, you'll find it useful to wear two pairs of gloves—thin cotton or nylon ones under heavier ones. When you take the outer layer off to operate the camera, your hands will still be protected and responsive.

In the unusual winter landscape at right, the sun breaks dramatically through storm clouds. In snow and direct sun, your camera's meter will always indicate an underexposure. You can compensate by taking a reading from a middle tone.

In the cozy rural scene below, snow serves both to simplify and to unify the image by eliminating foreground details.

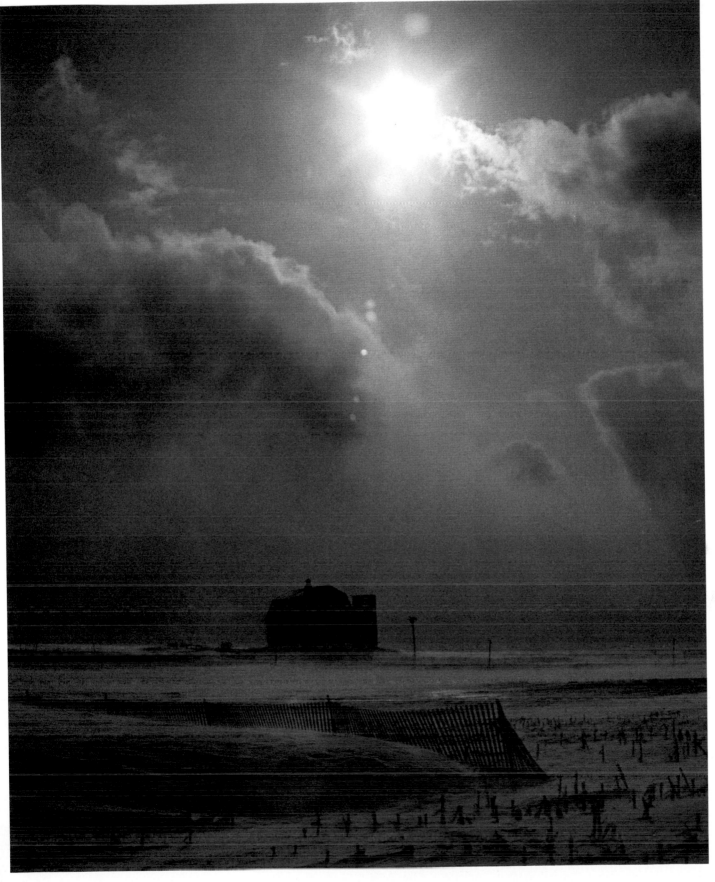

Photographing Special Effects

Multiple Exposures

Your camera is a versatile instrument, and, with just a few tricks of the trade, you can create images that will baffle and delight your viewers. Among the most notable of these special effects is multiple exposure—two or more images superimposed or juxtaposed on the same frame of film. The exact mechanics of taking a multiple exposure vary from camera to camera, so you should consult your instruction booklet. Some newer models have a control specifically for multiple exposures that enables you to release the shutter more than once without advancing the film. On many SLRs, you can do the same thing by depressing the rewind button while cocking the advance lever. These methods may cause the film to slip slightly and misregister the images, so for good results you should practice several times. On any camera with a B or T setting, you can make multiple exposures by leaving the shutter open and covering the lens between exposures. For this technique, slow-speed film and a small aperture are necessary. Dim lighting is also usually needed—although it is possible to use a flash in a darkened room.

The most common type of multiple exposure is a montage—one scene superimposed on another, as in the image at right. In planning such a picture, look for scenes or subjects that complement or contrast with each other, paying special attention to colors and light and dark tones. After taking the first shot, it's a good idea to make a rough sketch of the scene on paper so that you can position the next scene for the best effect. To prevent overexposure, you must give each shot in a montage less exposure than the subject requires. The correct reduced exposure can be calculated by multiplying your film's ASA rating by the number of shots in the montage. Set that number on your camera's ASA dial. If, for example, you were planning to superimpose three images on ASA 100 film, you would set the dial at ASA 300. You can also determine the exposure for each shot from the table that follows. The adjustments are given in f-stops, but remember that shutter speed as well as aperture can be changed, although fractions should be set on the aperture ring.

Montage Exposure Settings

Number of images in montage	Number of f-stops to decrease exposure
2	1
3	$1\frac{1}{2}$
4	2
5	$2\frac{1}{4}$
6	$2\frac{1}{2}$
7	$2\frac{3}{4}$
8	3

For emphasis, you may very well want to make one image in a montage fainter and another one stronger. The guidelines given above will serve as a good starting point. But be sure that the sum exposure of your individual shots does not exceed the correct exposure for the dominant scene.

Another type of multiple exposure involves images of subjects that do not overlap—as when you want to show three views of a person's head in the same picture. To do this, you must use a very dark background (a soft, unreflective black cloth is most common) and strong lighting on the subject—flash or photolamps are ideal. Since the film is recording only the brightly lighted subjects and not the dark background, you can use a full exposure for each shot. If you want to emphasize one image more than the others, give it a full exposure and the other less.

Tools: In general, you'll find it easiest to use slow- or medium-speed films, ASA 25 to 125. In a montage, they reduce the chances of overexposure, and in a multiple exposure with separate views, they are less likely to pick up stray light bouncing off your dark background. For careful juxtaposition of images, a tripod is essential.

You can make multiple exposures in the darkroom as well as in your camera, as we'll see in Part IV (see pages 283 to 285). In this darkroom montage by Jerry N. Uelsmann, a contemporary photographer known for his multiple exposures, he has combined several images to create a provocative dreamscape.

Special Effects

Time Exposures

In a sense, every photograph is a time exposure. When you slow your shutter to 1/8 second, however, to record a moving subject, the result can be quite striking or even dazzling. A person a few feet away strolling across your camera's field of view will be recorded as an almost unrecognizable series of streaks during a half-second exposure. Similarly, a speeding car given this same exposure will appear on film only as the bright traces of its headlights, and a pirouetting ballerina will resemble a madly spinning top. Using an even longer exposure, perhaps one of several seconds, you can create scenes with ghostly figures and other provocative images.

To avoid overexposing the image, time exposures usually require a combination of slow-speed film, a small aperture, and a relatively low level of lighting. In very dim light, even the best camera light meters are not sensitive enough to respond, so you'll have to determine the length of exposure through trial and error. When you first start taking time exposures, experiment with several different exposure times for each scene. In this way, you can become familiar with the various special effects available.

When you're using color film and accurate color rendition is important, it is usually best to keep time exposures to less than one second. With longer exposures in dim light, the film's sensitivity lessens and the color balance shifts. For many long exposures, however, correct color rendition may not be important. Lengthy time exposures on black-and-white film are not a problem. Since there are no colors to change, the film's lowered sensitivity makes it possible to take even more extended exposures. With slow- or medium-speed black-and-white film and a small aperture, for example, you may expose for several minutes to record the dimly lit interior of a building. With that long an exposure, a person walking through the scene would not register on the film.

In planning a time exposure, try to balance still and moving elements, paying special attention to the patterns that will be created by bright and light-colored moving subjects. Consider firing an electronic flash during the exposure, so that your subject will be sharp and well exposed in one spot and soft and streaked in others, like the dancer on page 168. You can also make a subject appear ghostlike or surreal by including the person for only half the exposure time. Cover your lens while the person moves out of the scene or make a multiple exposure.

Tools: Even with small apertures and ASA 25 or 32 film, you may need neutral density filters (see page 131) to cut down on the amount of light reaching the film during a long exposure. A tripod and cable release are absolutely essential, and the cable release should have a lock. A stopwatch or a watch with a large second hand is useful for timing the exposure.

Rapidly moving water becomes almost ethereal in appearance with only a very brief time exposure. For the best effect, it is important to keep a part of the scene sharp, like the well-defined pine tree in this photo of cascading falls.

These billiard balls were hit during the middle of a time exposure. As a result, their initial, stationary position is sharp, while only blurred streaks indicate their course after being struck.

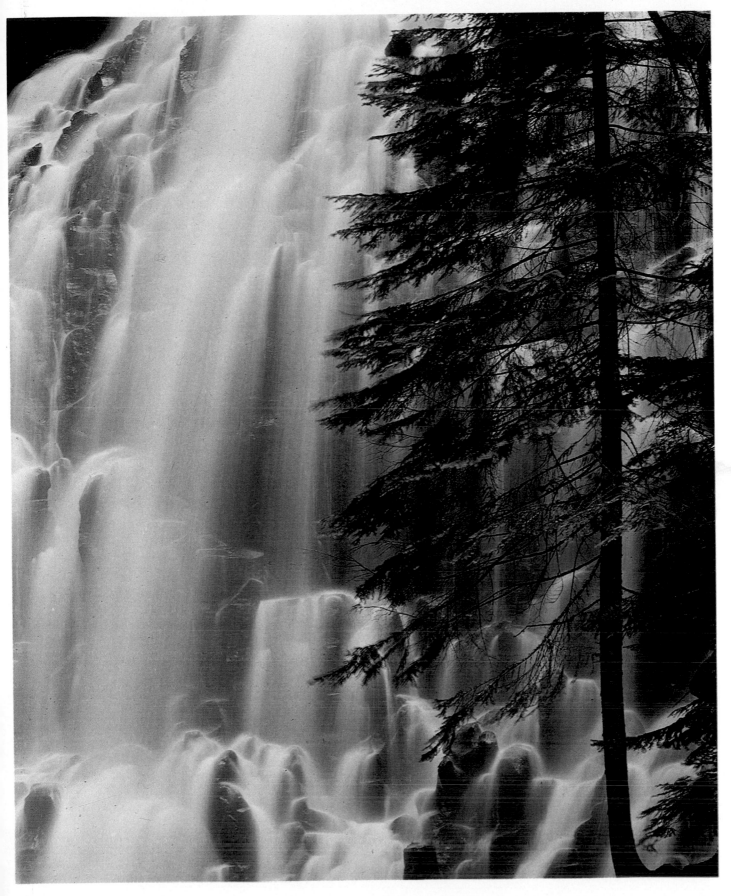

Special Effects

A carefully chosen camera angle makes the little boy appear to be almost as tall as the Taj Mahal in the picture at right.

Trick Scale

In pictures such as the one of the woman and the apple at right, the sense of scale is so altered from the expected that one subject or the other appears abnormally large or small. Such illusions require careful planning. First, you need a setting that provides as few clues as possible to the real perspective. There should be no noticeable lines converging in the distance and no receding series of planes. Many such pictures are made in the studio on seamless background paper to eliminate any clues to distance.

The other essential element is an extensive depth of field, which you'll get by using a wide-angle lens at its smallest aperture. At *f*/16 with a 35 mm lens, for example, you can get a zone of sharpness that extends from four feet to nearly infinity. And with wide-angle lenses that have shorter focal lengths, you can get even greater depth, although the likelihood of distortion increases considerably.

Once you have arranged a plain setting and established a wide depth of field, you simply need to line up your subjects to achieve the effect you want. The more unexpected the juxtaposition, the more interesting—and fun—it will be.

Tools: A single-lens reflex that accepts a wide-angle lens and allows you to preview the illusion through the lens is essential, as is a tripod to set up the scene. Since you will often need to use slow shutter speeds to compensate for the small apertures, a cable release is also helpful. For extreme contrasts between foreground and background, you may wish to use split-field close-up lenses. Half of the filterlike attachment acts as a close-up lens (see page 191), while the other half, which is usually empty, shows the normal view of the camera's lens.

In an extreme example of trick scale, a woman seems to be emerging from a bite in an apple. In actuality, she is standing far behind the apple, which is directly in front of the camera. A wide depth of field keeps everything in focus, thus aiding the illusion.

© 1979 Ryszard Horowitz

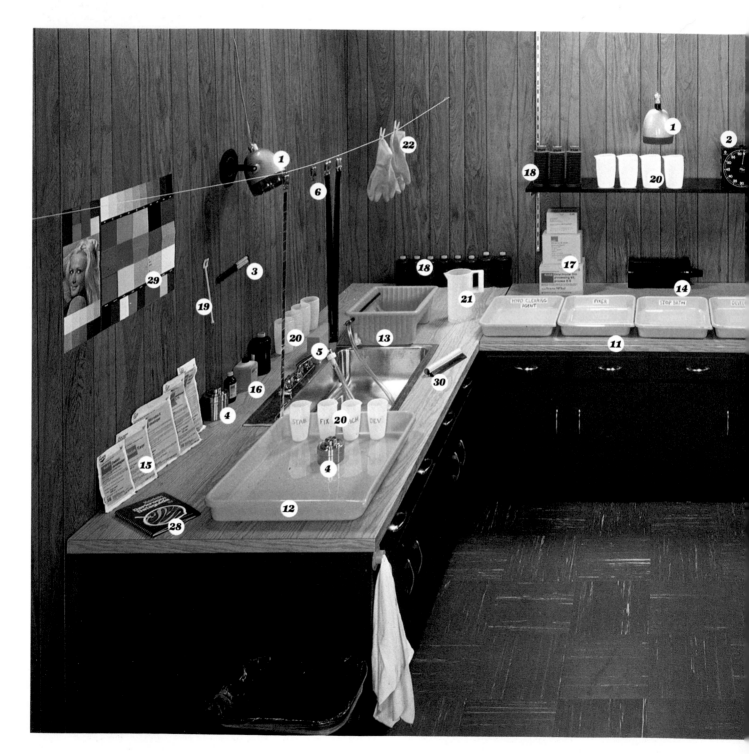

The
Process

Darkroom Principles
Processing Color Film
Making Color Prints
Processing Black-and-White Film
Making Black-and-White Prints
Basic Printing Controls
Creative Darkroom Techniques

1. Safelights
2. Darkroom timer
3. Photographic thermometers
4. Film developing tank
5. Photographic sponge
6. Film drying clips
7. Enlarger
8. Enlarging timer
9. Camel's-hair brush
10. Contact printing frame
11. Print processing trays
12. Deep print tray
13. Print washing tray
14. Color processing tube
15. Primary processing chemicals
 for black and white
16. Supplementary black-and-white chemicals
17. Processing chemicals for color
18. Chemical storage containers
19. Chemical stirring paddle
20. Darkroom graduates
21. Chemical mixing container
22. Rubber gloves
23. Color printing filters
24. Variable contrast filters for
 black-and-white printing
25. Voltage regulator
26. Grain magnifier for focusing enlarger
27. Enlarging easel
28. Darkroom reference guides
29. Color printing filtration guides
30. Rubber squeegee for drying prints
31. Black-and-white and color printing papers

Darkroom Principles

Two of the most rewarding and enjoyable aspects of photography are processing film and making prints. Since you can exercise considerable control over the final image in a darkroom, many photographers feel that creating a picture merely begins when the shutter is snapped. Developing and printmaking complete the repertoire of skills you need to produce images that express your personal viewpoint.

With some equipment and a permanent or temporary darkroom, any photographer can process black-and-white or color film (negative or transparency) and make prints. The procedures are precise but not difficult. This section provides an overview of darkroom work—processing and printing and the equipment and techniques involved—giving enough detail to help you decide whether or not to set up your own darkroom. While the instructions here will teach you the basics of both color and black-and-white work, you'll want to talk with your photo dealer before setting up shop. He or she will be able to provide more specific information, as well as sources for supplies.

When you take a black-and-white picture, light makes an invisible, latent image on the emulsion, a sensitive layer on the film coated with silver halides that react to light. With chemical processing, the silver halides turn to black metallic silver. On the negative, the brightest areas in the scene appear black, whereas very dark areas appear clear. Black-and-white photographic paper also has a layer of emulsion containing silver halides. When light is projected through the negative onto the paper, the silver halides react the same way as they did on the film. The clear parts of the negative transmit light that creates dark areas on the paper. Likewise, the nearly opaque areas transmit little or no light, which leaves the corresponding areas on the paper nearly white.

Black-and-white and color photographic material and techniques are similar, but color films and papers contain several layers of color receptors as well as silver halides. Different layers are sensitive to different colors of light—some to red, some to green, and some to blue. While one chemical reaction changes the silver halides, others create complementary colors in the reception layers. Red areas appear as cyan, green as

magenta, and blue as yellow-orange. Again, dark and light areas in the original scene are reversed in the negative, which is printed on color photographic paper through a combination of color filters. Processing makes the color information visible in the different layers of the paper, reversing the complementary colors to show the correct tonal relationships. Color transparency film also has layers to receive red, green, and blue light. Because of its different construction and processing methods, however, it duplicates the original scene after processing.

In some ways, processing and printmaking are easier in black and white. Generally, you need fewer chemicals to process film, the temperatures are not as critical, and handling black-and-white paper (not film) can be done under slightly brighter safelights. You need less equipment, and the chemicals and paper are less expensive.

Color negative

With the right equipment and a little practice, doing your own darkroom work is not only easy, but rewarding, because of the control you have over the image you are producing.

Color print

Color transparency

Black-and-white negative

Black-and-white print

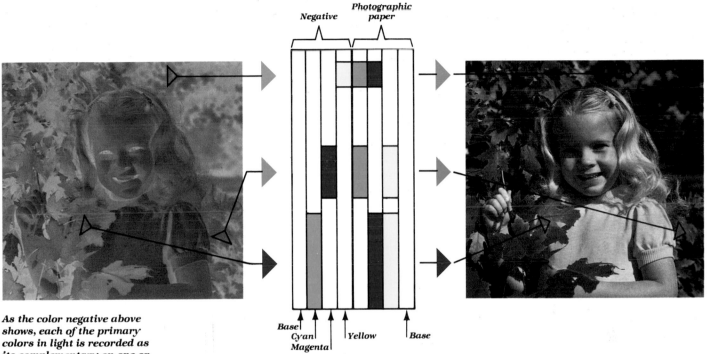

Negative | Photographic paper

Base
Cyan
Magenta
Yellow
Base

As the color negative above shows, each of the primary colors in light is recorded as its complementary on one or several of the film's layers. Blue is recorded as yellow, green as magenta, and red as cyan. Photographic paper has similarly sensitive layers. During printing, each dye layer in the negative controls the amount of complementary light that reaches the paper. Colors complementary to the light from the negative are formed in the dye layers of the paper. After processing, those colors give the same appearance as the original scene—the original primaries.

Color negative

Color paper

Color transparency

Emulsion

The cross-sections at left show, under extreme magnification, the three color layers in an exposed and processed color negative (far left), in a piece of color printing paper (middle), and in a color transparency (left). All three types of materials produce the three complementary colors— yellow, magenta, and cyan. The order of the colors on photographic paper is different from that of film to provide better definition.

Principles

Tools

For processing and printing film, you don't need an elaborate **darkroom,** but a light-tight room is necessary. You can darken any room by draping black cloth over the windows and sealing light leaks with black masking tape. Spend five minutes in the darkened room, and if you can still see a piece of white paper, look for other light leaks. Darkrooms need counter space and electrical outlets, and they should be fairly dust-free. Running water is handy but not a necessity if it is nearby. Kitchens and large bathrooms make excellent temporary facilities. For permanent darkrooms, many photographers organize basement areas or closets.

One or two **safelights** will illuminate a small darkroom without exposing (fogging) photographic paper; a larger area may need more light. Most good safelights have filters that can be changed for black-and-white printing or color negative printing. Remember to work with film in total darkness.

A **timer** makes sure that process times are accurate. Most darkroom timers can be set like an alarm clock. A second hand (or digital display) is very handy.

A **photographic thermometer** is essential. Most black-and-white developing solutions must be temperature accurate to within one degree; color processing demands a thermometer of even greater accuracy.

For processing film, you'll need a **developing tank** with a **loading reel.** Tanks come in many shapes, sizes, and materials; some process more than one roll at a time. Your photo dealer can help you assess your needs and choose the right tank. After processing a roll, you'll need a **photo sponge** or **chamois** to wipe off water drops that can cause spotting and **film clips** or spring clothespins to hang up the film for drying.

To make prints from your negatives, you need an **enlarger,** which need not be expensive or cumbersome. For 35 mm film, it should have a 50 mm lens. For color prints, you need an enlarger with a color head or one that can hold color filters. You can get an **enlarging timer** that shuts off the enlarger

light automatically when the determined exposure time has passed, but for black-and-white work, you can use a darkroom timer with a second hand. For removing dust from the negative before putting it into the enlarger, you need a **camel's-hair brush.**

An **easel** holds the photographic paper flat so that you get the sharpest projected image. Choose one that holds several sizes of paper tightly and is fairly heavy, so it remains steady when bumped or opened. You should also get a **printing frame** for making contact prints, as shown in the series at far right.

Trays are required to process black-and-white paper, and you should have at least four trays for each size paper you use. Using big trays for very small prints wastes chemicals. Use a large, deep tray for a water bath to bring smaller containers of chemicals to the required temperature. Since color processing must be done under extremely dim safelights with fairly expensive chemicals, **rotating drums, tubes, canoes,** and other vessels are often used instead of trays. They require smaller quantities of the solutions, and most let you work in room light once the exposed print is loaded into the vessel.

Processing chemicals are available from several manufacturers and in a number of

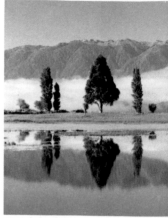

Total darkness **1 minute**

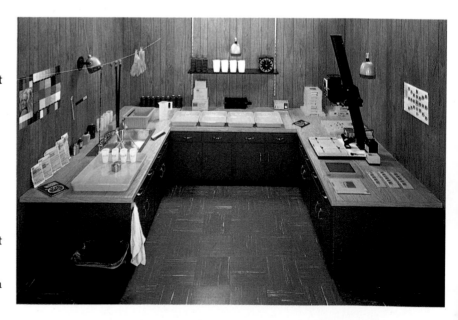

250

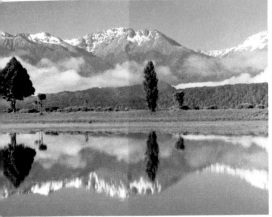

3 minutes 7 minutes

The photo at the top of this page shows the gradual overall darkening—or fogging—of paper placed too close to a safelight. Safelights must be kept at least four feet from sensitized materials.

The layouts immediately above and in the picture at left illustrate some typical permanent darkroom arrangements. Plan D shows how to adapt a large laundry room. Note that the dry areas, where you enlarge, should be kept separate from wet areas, where you process film and paper.

forms, including powders and concentrates. If you do a lot of processing, buy large, economical batches. Otherwise, buy smaller quantities to avoid spoilage from aging. You should buy **storage containers** for mixed chemicals, a **stirring paddle,** a container big enough to hold the chemicals being mixed, and a **darkroom graduate** for measuring liquids. **Rubber gloves** are also a good idea, particularly for anyone with allergies or sensitive skin.

For black-and-white film or paper you need a **developer** to bring out the image, a **stop bath** to halt development, and a **fixer** to make the image permanent. There are many developers to choose from. Some are strong, for rapid action; some are slow, for the sharpest possible image. Two other chemicals for black-and-white processing are a **wetting solution,** which will keep water spots from forming when the film is hung up to dry, and a **clearing agent** to reduce the washing time.

Chemicals for color processing are usually matched to the particular film or paper, since each process is quite specific. Several manufacturers offer kits. Depending on what you are processing, you may need a developer, a **bleach,** a fixer, a **stabilizer,** a **reversal bath,** a **conditioner,** a **bleach-fix (blix),** or a **potassium iodide wash.**

Black-and-white and color prints are made on light-sensitive **photographic paper.** Black-and-white papers, either fiber-based or resin-coated (RC), come in a variety of sizes, weights, textures, sensitivities, and tones. They also come in different contrast grades (see page 279). Start with a smooth, medium-weight, multiple-contrast paper that is cold-toned and fairly sensitive. After learning the basics, you'll want to experiment with other papers.

It's easier to choose a color photographic paper because there's less variety. There are two groups of color paper—one for negatives and one for slides. Both kinds are resin-coated and medium-weight. You'll find some choice in size and surface texture, but the rest of the decisions have been made for you. Your photo dealer can help you assemble a color printing system with the best match of equipment, chemicals, and paper.

Most photographers preview a roll of negatives by making a "contact sheet." As illustrated in the series above, the negative strips (top) and a sheet of photographic paper (second) are placed in a printing frame, emulsion sides together. Then the frame is tightly closed and exposed to light, usually from an enlarger (third). The paper is processed normally (bottom).

For color printing on an enlarger without a color head, you will need a set of filters such as the one shown at right, available from several manufacturers. They are made in different densities in the three primary and three complementary colors.

A comprehensive, quick reference guide that gives exposure times and processing information is an invaluable aid in the darkroom.

Photographic paper for black-and-white prints (top six boxes) comes in a wide variety of sensitivities, surfaces, and contrasts. For color printing (lower three packages) the choice is more limited. The 8 × 10-inch size shown here is the most popular.

Processing Color Film

The basic steps for preparing to process color negative film are shown in the series below. Start by placing the empty processing tank and premeasured quantities of the chemical solutions you will need in a water bath (top) to bring them to the recommended temperature. Then, working in total darkness, hold the film magazine in your hand with the projecting end of the spool downward and open the upper end using a hook-type can opener (second row, left). Remove the film from the magazine and clip off the tapered leader at the beginning of the film (second row, right). Holding the film by the edges, wind the film onto the tank's spiral reel following the directions for your type of tank (third row, left). When most of the film is on the reel, clip off the film's spool and finish winding the film onto the reel (third row, right). Finally, place the reel in the tank and put on the lid (bottom). You can now turn the room lights back on for processing.

Color Negative Film

Tools:
Totally dark room
Film tank and reel for 35 mm film
Thermometer accurate to
1/4° F (0.15° C)
Timer
Graduate
Chemical solutions
Water-bath tray
Clips
Negative-storage envelopes
(see page 288)
Hook-type can opener
Scissors

You can process most color negative films with a minimum of equipment, but make sure to use only the recommended chemicals: The wrong ones can ruin film. Chemicals usually come with complete instructions, which you should follow exactly, and since the life of color chemicals is rather short, mix them just before you start. They'll last a little longer if you store them in tightly closed bottles. Keep processing solutions separate from one another and in clean storage containers. When chemicals are contaminated by dirt or other chemicals, your results will suffer.

For accurate processing, the chemicals *must* be at the correct temperature. Place the bottles in a tray of running water, also at the recommended temperature. Before you use each chemical, dip your thermometer into the bottle (clean it after each immersion) to check the temperature. Since the developer is the most critical chemical and the first processing step, check it last, just before starting.

The procedure for loading film into the processing tank is shown in the series at right. Since this must be done in total darkness, it's best to try it several times in room lighting, using outdated film, before attempting it in the dark. Place everything you need in front of you. After seeing the procedure, try it with your eyes closed.

Color Film

Color Negative Film

The color negative process shown in the table at right below has seven steps—four solutions, two water washes, and drying. These take a total of about twenty-five minutes, but the number of steps and the timing will vary with the film and chemicals you use.

Start timing when you pour each solution into the tank. The time for each step includes about ten seconds at the end for draining, but tanks have different drain times. Make sure the solution has completely drained before you start the next step.

Remember: The developer temperature of this process is critical—it must be accurate to within 1/4° F. Other solutions and the wash water can be between 75° and 105° F (24° and 40.5° C). About ten minutes before you start, put the beakers of solutions and the empty processing tank in a water bath that registers 100.5° F (38° C). Make sure the water is high enough to cover the solution levels. Check the temperature of the developer frequently until it is correct. During processing, keep the tank in the water except when agitating. Again, load the film in *complete darkness.* The film also must not be exposed to light during the first two steps in processing, but most film tanks are light-tight, and you can turn on the light after loading the film. When the developer and bleach steps are complete, you can also open the tank for greater convenience.

Agitate the tank by inverting or rotating it to ensure that all areas of the film receive uniform coverage by the developer. Agitation will also remove tiny air bubbles that cling to the film and prevent complete development. Rotating the reel (if your tank is designed to be rotated) is another accepted method of agitation.

When the last step is complete, hang the film to dry for at least twenty minutes at 75° to 110° F (24° to 43.5° C) in a dust-free atmosphere with adequate circulation. Attach another clip or clothespin to the bottom of the film to prevent curling. To prevent water spots, wipe the film with a photo sponge or chamois moistened with stabilizer solution. Be gentle—when wet, the emulsion is soft enough to scratch easily.

Follow instructions to mix solutions.

▶ Use a water bath to control temperature.

The series of pictures here shows the sequence of activities involved in processing color negative film. As illustrated in the first picture above, chemicals can be purchased in a kit or separately in powdered or concentrated liquid form of various quantities. Different techniques for agitating the tank are also shown.

▶ or by rotating tank on counter.

The table below shows the times and temperatures for the C-41 process with the KODAK FLEXICOLOR Processing Kit. There are many other similar kits, and for each one you should follow the manufacturer's detailed instructions.

Processing KODACOLOR II and KODACOLOR 400 Films
Process C-41: For 1 pint (473 ml) Processing Tanks

Processing step	Minutes*	°F	°C	Agitation (seconds)		
				Initial	Rest	Agitation
1. Developer	3¼	100 ±¼	37.8 ±0.15	30	13	2
2. Bleach	6½	75-105	24-40.5	30	25	5
Remaining steps can be done in normal room light						
3. Wash	3¼	75-105	24-40.5			
4. Fixer	6½	75-105	24-40.5	30	25	5
5. Wash	3¼	75-105	24-40.5			
6. Stabilizer	1½	75-105	24-40.5	30		
7. Drying	10-20	75-110	24-43.5			

** Includes 10 second drain time in each step*

1. Add developer to loaded tank.

▶ Set developing time on timer.

▶ Agitate by rolling tank . . .

▶ by inverting tank . . .

▶ Drain developer at correct time.

2. Add bleach, set timer, and agitate.

▶ Drain bleach. You may open tank.

3. Wash film in running water.

▶ Drain wash water at correct time.

4. Add fixer, set timer, and agitate.

▶ Drain fixer at correct time.

5. Wash film under water again.

▶ Drain wash water.

6. Add stabilizer, set timer, agitate.

▶ Drain stabilizer at correct time.

7. Hang film to dry; wipe off drops.

Color Film

Color Slide Film

Tools:
Totally dark room
Film tank and reel for 35 mm film
Thermometer accurate to 1/2° F (0.3° C)
Timer
Graduate
Chemical solutions
Water-bath tray
Clips
Slide mounts
Hook-type can opener
Scissors

Some color slide films can be processed at home, and most of the advice given about negative films on the preceding pages applies to transparency film. Temperature is only slightly less critical: The first developer must be accurate to within 1/2° F (0.3° C). Another difference is that you must wait until after the fourth step, rather than the second, to work in room light.

The transparency developing process shown in the table at right below has eleven steps. In all, this process takes thirty-seven minutes. If you use a different film or processing kit, check the instructions for the appropriate times, temperatures, and sequence of steps. Once your strip of transparency film is processed and dried, you can cut apart the individual images and seal them in cardboard slip-in mounts or in more expensive plastic or glass mounts. When mounting in glass, make sure to blow away any dust from the transparency with a rubber bulb or compressed air.

A good technique to know about is **push-processing.** By adjusting the time some films spend in the first developer, you can increase the effective film speed by one or more stops. A film rated at ASA 400 can be exposed at ASA 800 and then processed with a small change in the developer time. If there wasn't enough light for a fast shutter speed or adequate depth of field, push-processing will help you capture an acceptable image. Check the instructions on the film or processing chemicals for specifics.

The chemicals for processing color transparency film, which come in concentrated liquid form, can also be purchased separately or in kits. But seven chemicals are needed, rather than the four required for processing color negatives.

As this nighttime shot of Niagara Falls shows, one of the advantages of color slide film is that it can be processed for an ASA speed higher than its normal rating. This picture was taken on ASA 400 film, exposed at ASA 800. It was then push-processed by receiving extra developing time.

Processing KODAK EKTACHROME Films
Process E-6: For 1 Pint (473 ml) Processing Tanks

Processing step	Minutes*	°F	°C	Agitation (seconds)		
				Initial	Rest	Agitation
1. **First developer**	7 †	100 ±½	37.8 ±0.3	30	15	5
2. **Wash**	1	92-102	33.5-39	30	15	5
3. **Wash**	1	92-102	33.5-39	30	15	5
4. **Reversal bath**	2	92-102	33.5-39	30	80	
Remaining steps can be done in normal room light						
5. **Color developer**	6	100 ±2	37.8 ±1.1	30	25	5
6. **Conditioner**	2	92-102	33.5-39	30	80	
7. **Bleach**	7	92-102	33.5-39	30	25	5
8. **Fixer**	4	92-102	33.5-39	30	25	5
9. **Wash (running water)**	6	92-102	33.5-39	30	25	5
10. **Stabilizer**	1	92-102	33.5-39	30	20	
11. **Drying**	10-20	75-120	24-49			

* *Includes 10 seconds for draining in each step*
† *See instructions for using solutions more than once*

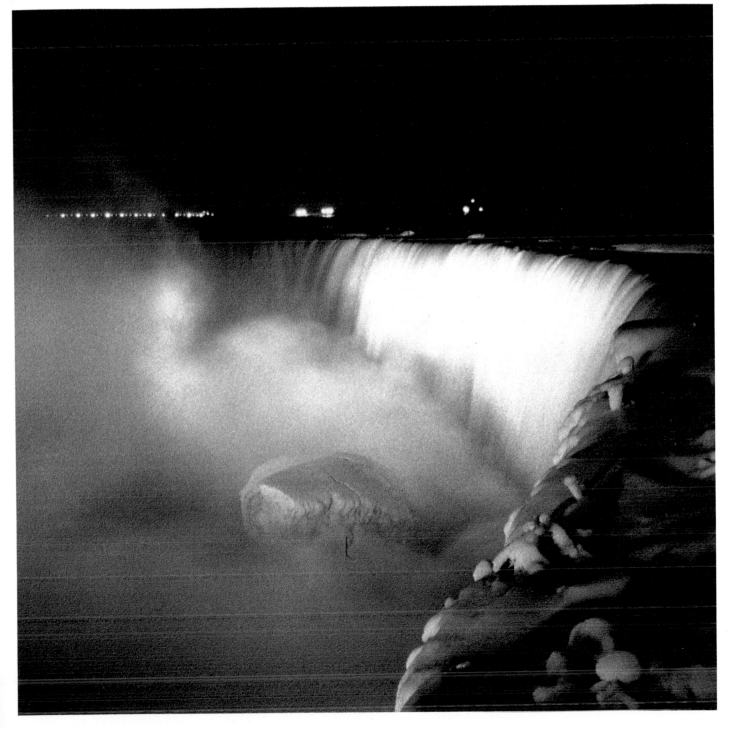

Making Color Prints

Printing from Color Negatives

Pure white light is composed of red, blue, and green light—the three additive primary colors. (Additive means that, when blended in equal amounts, white light is produced.) Color negative film has layers for recording each of these colors, but images appear in their complementary (opposite) colors. In the red-sensitive layer, red objects appear cyan (blue-green); in the green-sensitive layer, they appear magenta (blue-red); in the blue-sensitive layer, they appear yellow. These are called subtractive primary colors because, when each is added to its complementary additive, it absorbs the color to produce black or shades of grey.

Making a print from a negative with an enlarger is the reverse of taking a picture with a camera. As with film, the exposure to light makes a latent image in the silver halide and gelatin emulsion of the printing paper. Color filters in the enlarger head, which also contains the light source, negative, and lens, create a color latent image in the color-receiving layers of the paper. When the paper is treated with chemicals, a positive image appears. An image can be enlarged or reduced, respectively, by raising or lowering the enlarger head, which increases or decreases the distance between the negative and the paper. Exposure for printmaking is controlled by an adjustable aperture in the lens marked with the familiar *f*- numbers and by the length of time that the light source projects the image. As with a camera, changing from one *f*-stop to the next doubles or halves the exposure, the same effect that is accomplished by doubling or halving the exposure time.

If you look at a color negative, a built-in printing mask makes it look orange, but you can also see the colors just mentioned. In addition, light areas from the original scene are dark on the negative, and dark areas appear light. All this makes it hard to tell how the print will look, but with proper exposure and color filtration, the print will be a close match for the original scene. For a first attempt, use a negative that was exposed properly in the camera and processed and printed by a photo finisher. The prints will be a good guide for color and exposure.

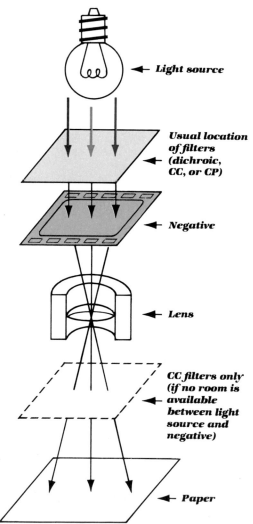

- **Light source**
- **Usual location of filters (dichroic, CC, or CP)**
- **Negative**
- **Lens**
- **CC filters only (if no room is available between light source and negative)**
- **Paper**

As the schematic diagram of an enlarger at left illustrates, almost any type of filter can be used above the lens—built-in dichroic filters, gelatin color compensating (CC) filters, or acetate color printing (CP) filters. But to avoid distortion, only the gelatin CC filter can be used below the lens.

When the visible spectrum is shown as a color wheel, as at right, each of the three additive primaries—red, green, and blue—is directly opposite its complementary—one of the three subtractive primaries, cyan, magenta, and yellow. The interaction of the additive primaries in projected light with the subtractive primaries in filters gives the control needed for color printing. The subtractive primary filters work by blocking, or "subtracting," their complementary additive primaries from the light. Note, as shown at top, that when all three additive primaries, or all three subtractive primaries, or any two complementaries, are added together, the result is white, black, or shades of grey, usually called neutral density.

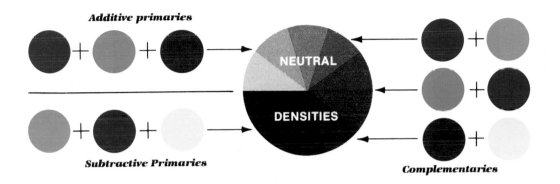

Additive primaries

NEUTRAL

Subtractive Primaries

DENSITIES

Complementaries

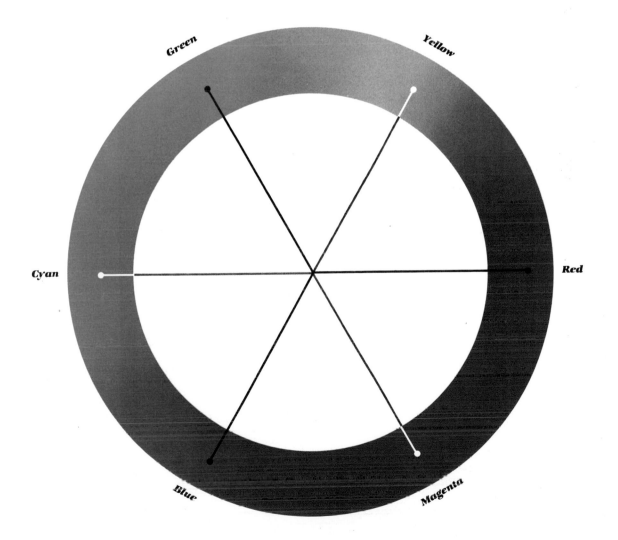

Green

Yellow

Cyan

Red

Blue

Magenta

Color Prints

Printing from Color Negatives

Tools:
Enlarger
Color printing filters
Easel
Color printing paper
Safelight with appropriate filter
(see the recommendations
for the color paper you use)
Camel's-hair brush
Timer
Voltage regulator (optional)

For color printing, you can use an enlarger equipped with a tungsten or tungsten-halogen lamp and a heat-absorbing glass in the lamphouse. Cover all light leaks in the enlarger head with aluminum foil or an opaque, noncombustible material. For 35 mm negatives, the enlarger lens should have a focal length of 50 mm. Since electrical power drops off at mealtime, when many appliances are in use, a voltage regulator can help keep the power to your lamp constant. If you don't have a regulator, ask your power company when the voltage is at peak.

Keep color paper tightly sealed and refrigerated at 50° F (10° C) or lower, to protect it from heat and humidity. Remove the package at least two hours before you begin printing to avoid condensation and to let the paper reach its normal sensitivity, but don't open it until you are ready to insert the paper in the enlarging easel.

Use safelights and filters that are correct for the paper you are using. Color paper can take just a few minutes' exposure to safelights before it starts to fog. Let your eyes get accustomed to the safelights so that you can see the paper's emulsion-coated side, which must be facing up.

The most convenient but expensive method for filtering the enlarger light is the special enlarger head with dial-in dichroic filters. To correct the color, just turn the dial. In other enlargers, the filters go between the lamp and the negative, and since they're above the lens, they can be imperfect and can even stand a little abuse. There's no practical limit to the number of filters you can use in this position, and because you can make color combinations by stacking filters, you'll need fewer than if you place the filters below the lens. In this position, the filters must be optically correct (and therefore more expensive) so they don't interfere with the precise light rays emitted by the lens. Because of this interference and reflections, only three filters can be placed below the lens, and you'll need more individual filters to create required colors because you can't combine color filters, as you can above the lens. Filters below the lens are called color compensating (CC) filters; those above the lens are color printing (CP) filters. Keep filter use in mind when you buy an enlarger.

Filters are designated by a series of letters and numbers that tell you the type, density, and color. For example, a CP20Y filter is an acetate color printing filter with a density of 0.20 (to blue light), and its color is yellow. The one filter you must always use is an ultraviolet filter, No. 2B or CP2B, to block UV radiation. Place this filter permanently above the negative carrier.

Light source can be a tungsten bulb

The series of pictures above and at right shows most of the things you will need to equip your enlarger for printing color negatives. The tables at right below list the filters required.

... or a tungsten-halogen lamp.

Heat-absorbing glass protects film.

Use 50 mm lens for 35 mm format.

Dial filtration on dichroic head.

CP filters slip in above negative.

A UV filter is essential.

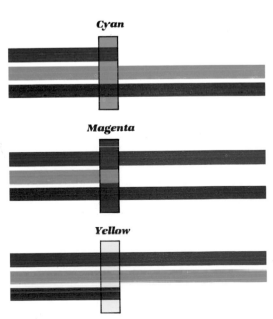

Cyan

Magenta

Yellow

Color Printing Filters

If your enlarger accepts filters above the negative, you'll need the following color printing (CP) filters:

CP2B (acetate; always used)

CP05M	CP05Y	CP05R
CP10M	CP10Y	CP80R
CP20M	CP20Y	
CP40M	CP40Y	
	CP80Y	

Color Compensating Filters

If you must place the filters below the lens, you'll need the following color compensating (CC) filters:

Gelatin No. 2B or CP2B (acetate; always used)

CC05M	CC05Y	CC05R
CC10M	CC10Y	CC10R
CC20M	CC20Y	CC20R
CC30M	CC30Y	CC30R
CC40M	CC40Y	CC40R
CC50M	CC50Y	CC50R

As the diagram at right top shows, red, green, and blue in light are called additive primary colors because when they are mixed, or "added," together, they form white light. The lower three diagrams show why cyan, magenta, and yellow pigments in filters are known as subtractive colors: Each one blocks, or "subtracts," one of the additive primaries. A cyan filter, for example, blocks the red in white light. The amount it blocks depends on the density of the filter. When added together, they block all colors in light, forming neutral density.

Color Prints

Exposing the Color Negative Print

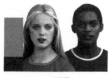

−80Y

−40Y

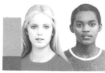

−40M −80Y

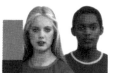

−20M −40Y

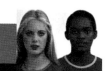

−20Y

−10Y

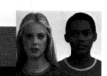

−10M −20Y

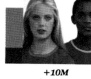

+10M −10Y

−80M −80Y

−40M −40Y

−20M −20Y

−10M −10Y

Normal

+10M +10Y

+20M +20Y

+40M +40Y

+80M +80Y

+40M −40Y

+20M −20Y

+20M

+40M

+80M

+10M

+20M +10Y

+40M +20Y

+80M +40Y

−80M−40Y

−80M

−40M−20Y

−40M

−20M−10Y

−20M

−10M

−40M+40Y

−10M+10Y

−20M+20Y

+10Y

+20Y

+10M+20Y

+40Y

+20M+40Y

+80Y

+40M+80Y

The sequence of pictures at right shows the procedure for making a test color print. Before starting, make sure you have a No. 2B or CP2B (UV) filter in the enlarger above the negative carrier. Remember that you must work under the recommended safelight when you take the paper out of the box.

1. Dust the negative with a camel's-hair brush and place it in the carrier and then in the enlarger, with the emulsion (dull) side down. Focus the negative on the easel.

2. Dial the filtration—or make the filter pack—suggested in your paper's instructions for an average negative. Because negatives vary, this is mostly guesswork, and you may have to make several test prints.

3. Using a piece of dark cardboard as a mask (with a one-quarter section cut out), place a sheet of photographic paper in the easel and expose

the upper left quarter of the paper for ten seconds at f/5.6.

4. Flip the card and expose the upper right quarter for ten seconds at f/8.

5. Expose the lower right quarter for ten seconds at f/11.

6. Expose the lower left quarter for ten seconds at f/16. Process your test print according to the directions packaged with the chemicals (see pages 266 to 267).

7. When the print is dry, decide which exposure is best. Then, examine that correctly exposed quarter to determine what color, if any, is too strong and by how much. Look especially at flesh and neutral tones. Compare your print to the examples in the display at left (called a "ringaround") and then make the filter correction indicated below the example. When you change the filtration, however, adjust the exposure to compensate, as explained on the next page.

Brush off the negative (1).

Dial the filtration (2).

Expose the top quarters (3 & 4)

. . . the bottom right (5)

. . . and the bottom left (6).

A test print (7).

Color Prints

Adjusting the Color Negative Print

Like most filters, color printing filters have different densities that transmit light in varying quantities. When you change filters to correct for color balance, you have to adjust your enlarger's exposure setting to get the same amount of light you determined to be correct for your test print. In addition, because filter surfaces lose light by reflection, you also have to adjust the exposure if you change the number of filters. Because changing exposure time adds another variable for color balance, it's wise to keep the exposure time constant and vary aperture size only for major changes.

The first table at right shows the changes in CP or CC filters you must make to correct color problems. It also gives you the new exposure times you must use to compensate for the change in filters. The new times are based on ten seconds' exposure for your test print. A second print made with these corrections should be much closer to what you want.

If you need further adjustments, refer to the second table, which indicates filter changes for making more subtle color corrections in your final print. Be sure, as a general rule, to increase your exposure time 10 percent for each filter you add and to decrease it 10 percent for each filter you take out to adjust for surface reflections of the filters. More precise adjustments can be made using the filter factors in the third table at right. Divide your exposure time by the factor for each filter you remove and multiply it by the factor for each filter you add. Dichroic filters, which are much more efficient than CP or CC filters, require fewer changes. Follow the enlarger manufacturer's suggestions.

Changes in CC or CP Filters and Exposure Time

	Amount of color variation from normal	Change in filter pack	Approximate exposure for new filter pack* (in seconds)
Too red	Slight	Add 10M and 10Y	14
	Considerable	Add 20M and 20Y	17
	Great	Add 30M and 30Y	20
Too green	Slight	Subtract 10M	8
	Considerable	Subtract 20M	7
	Great	Subtract 30M	6
Too blue	Slight	Subtract 10Y	9
	Considerable	Subtract 20Y	9
	Great	Subtract 30Y	9
Too cyan	Slight	Subtract 10M and 10Y	7
	Considerable	Subtract 20M and 20Y	6
	Great	Subtract 30M and 30Y	6
Too magenta	Slight	Add 10M	13
	Considerable	Add 20M	15
	Great	Add 30M	17
Too yellow	Slight	Add 10Y	11
	Considerable	Add 20Y	11
	Great	Add 30Y	11

** Based on an original exposure time of 10 seconds.*

Final Change in Filter Pack (if needed)

Appearance of previous print	Amount of change desired		
	Very slight	Slight	Considerable
Too red	Add 05M and 05Y	Add 10M and 10Y	Add 20M and 20Y
Too green	Subtract 05M	Subtract 10M	Subtract 20M
Too blue	Subtract 05Y	Subtract 10Y	Subtract 20Y
Too cyan	Subtract 05M and 05Y	Subtract 10M and 10Y	Subtract 20M and 20Y
Too magenta	Add 05M	Add 10M	Add 20M
Too yellow	Add 05Y	Add 10Y	Add 20Y

Factors for CC and CP Filters

Filter	Factor	Filter	Factor
05Y	1.1	05R	1.2
10Y	1.1	10R	1.3
20Y	1.1	20R	1.5
30Y	1.1	30R	1.7
40Y	1.1	40R	1.9
50Y	1.1	50R	2.2
05M	1.2	05G	1.1
10M	1.3	10G	1.2
20M	1.5	20G	1.3
30M	1.7	30G	1.4
40M	1.9	40G	1.5
50M	2.1	50G	1.7
05C	1.1	05B	1.1
10C	1.2	10B	1.3
20C	1.3	20B	1.6
30C	1.4	30B	2.0
40C	1.5	40B	2.4
50C	1.6	50B	2.9

As you raise or lower your enlarger to change the image size on the easel, the brightness of that image will also change. As the enlarger goes higher, for example, the projected image gets larger but dimmer, since the same amount of light must now cover a larger surface area. To compensate for this change in the amount of light striking the paper, you must change the exposure settings. If the distance increases, increase the exposure time or lens aperture size; if the reverse happens, decrease the exposure time or lens aperture size. Use the following formula to calculate a new exposure for a different enlarger height:

$$New\ time = Old\ time \times \frac{(New\ enlarger\ height)^2}{(Old\ enlarger\ height)^2}$$

For example, let's say the correct exposure on a 4×5-inch print is eight seconds at $f/11$, and you now want to make an 8×10-inch print from the same negative. The original distance was ten inches, and after raising the enlarger and focusing the lens to produce an 8×10-inch image, you find the new distance is twenty inches. Apply the formula:

$$New\ time = 8 \times \frac{20^2}{10^2} = 8 \times \frac{400}{100} = 32$$

The new exposure time would be thirty-two seconds. But to shorten the exposure time and keep the color balance consistent with an eight-second exposure, you instead open the aperture two stops (effectively halving the time twice), to $f/5.6$.

The Standard Negative

A standard control negative is useful when you want to change paper emulsions or enlarger lamps or to check paper processing. Select a negative that you know has been properly exposed under known conditions and that you know makes an excellent print. Since you've printed it previously, you have an accurate record of the filter pack (set of filters) required for your particular equipment and paper emulsion. When you change any one element of your printing

This "do-it-yourself" standard negative can be used to locate the best average point for your equipment. The woman's face and the 18 percent photographic grey card will help you make subtle adjustments.

process, print from your standard negative first to determine what adjustments, if any, your new set-up may require.

Your standard negative should be typical of the majority of negatives you will be printing. It should be correctly exposed and normally processed, and it should include a sensitive (i.e., neutral, such as flesh tones) area, so that any future discrepancy from it can be detected. Avoid negatives of subjects that would make pleasing prints over a wide range of color balances. If you take a picture especially to be used as a standard negative, put an 18 percent photographic grey card in the original scene for additional control. Once you have determined the exposure and filtration for your standard negative, you can catch subtle differences when you change paper or solutions. With more practice, you can spot the differences between a new negative and the standard and shorten the time it takes you to analyze and correct a print.

Color Prints

Processing the Color Negative Print

Tools:
Tube processor or rotating drum to fit the enlarging paper
Implements to mix or dilute chemicals
Storage bottles
Graduates to hold premeasured solutions
Chemicals compatible with your paper
Thermometer accurate to 1/2° F (0.3° C)
Water-bath tray
Timer
Safelights compatible with your paper
Rubber gloves

Once you have exposed your print you must process it in chemical solutions that will turn the silver halide black and cause the colors to emerge from the different layers of the paper. One of the most convenient and economical processing methods is to use the light-tight tube processor with appropriate chemicals, such as the KODAK EKTAPRINT 2 Chemicals described below. The materials investment will be small, since the chemicals, which are expensive, are held to a minimum. Time and temperature are very important, so follow instructions closely. Maintain temperature with a water bath, as described on page 253 for processing negatives. Also keep your equipment clean and the solutions uncontaminated. Especially avoid mixing any developer with the bleach-fix during processing.

The following procedures are for processing KODAK EKTACOLOR 74 RC Paper in a tube processor using the EKTAPRINT 2 Processing Kit, but they are adaptable to other kits. In using a tube processor, the first step is prewetting the paper to encourage even development and to prevent streaking. This step, however, dilutes the developer that is added next. To compensate for this, make a slightly more concentrated solution. To adapt the procedure (which uses one gallon or 3.8 liters) to the tube processor system, make the following changes in the EKTAPRINT 2 basic mixing instructions: In step 1, start with only

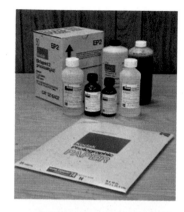

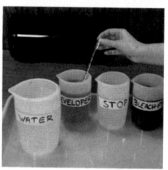

Like color negative processing chemicals, chemicals for processing color prints (top) are sold as concentrates, either separately or in kit form. Kits are best unless you do a large volume of work. For mixed solutions, a water bath (bottom) is needed to raise and maintain proper temperature—especially for the crucial developing solution.

78 fluid ounces (2.3 l) of water; in step 6, bring the total water volume up to only 102 fluid ounces (3 l).

The recommended temperature of the solutions and the wash water in this process is 91° F ±1/2° (32.8° C ±0.3°). The actual temperature depends on whether you can place the processing tube in the water bath along with the solutions, and this is determined by whether the tube is watertight. If it is, maintaining temperature will be simple. In a room of average temperature (75° F or 24° C), you can usually expect good results if the water bath is kept at 92° F (33.5° C)—a one-degree correction for heat lost as it passes through the plastic. If your tube has any opening that might let water in, however, you can't put it in the water bath. Since the tube will lose heat to the air, you will need to increase the temperature of your solutions to compensate. Run a test when you first get your tube to see how hot you need to keep your water bath in order to maintain an average developing temperature of 91° F (32.8° C) inside the tube. Repeat the following procedure as often as necessary:

1. Put a scrap sheet of paper in the tube, loading it according to instructions.

2. Go through the prewet and developer steps, using correct volumes and times, but substituting water for the developer. Have both liquids at water-bath temperature beforehand. Use 95° F (35° C) for a start.

3. Drain the tube and take the temperature of the drained "developer." Average it with the water-bath temperature. The result should be 91° F ±1/2° (32.8° C ±0.3°). If not, adjust the water-bath temperature and repeat.

With the room at 75° F (24° C) and the water bath at 95° F (35° C), the "developer" should be about 88° F (31° C). Averaging 95° F and 88° F gives 91.5° F (33.1° C), which is close

The basic steps for tube-processing EKTACOLOR 74 RC Paper in EKTAPRINT 2 Chemicals are shown here.

Insert exposed paper in tube.

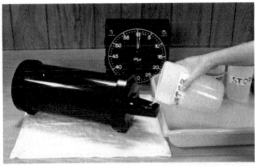

1. Turn on room light and prewet paper.

2. Add developer; time carefully and drain.

3. End development with stop bath.

4. Wash in water to remove chemicals.

5. Stabilize paper with bleach-fix.

6-9. Give print four vigorous water baths.

10. Air-dry print.

enough to the recommended temperature. The only time you may have to repeat this test series is if the room temperature is unusually low or high.

Whether you can use your tube processor in a water bath or not, the basic steps for processing EKTACOLOR RC Paper are shown in the table below and illustrated in the picture series at left. Agitation is crucial; follow the tube's instructions for the method and the chemical kit's suggestions for the time. The times given allow ten seconds between steps for draining. If your tube needs more or less drain time, allow for the difference during the process. Keep the tube on a level surface so the print develops evenly. And for the four repeated water wash steps after the bleach-fix, you can either fill, agitate, and drain the tube four times, or, as shown, you can do the same thing in a tray under normal room lighting. Do not reuse the chemicals.

Processing KODAK EKTACOLOR 74 RC Paper in Tube Processors

Processing step	Minutes
1. Prewet (water)	½
2. Developer	3½
3. Stop bath*	½
4. Wash	½
5. Bleach-fix	1
6. Wash	½
7. Wash	½
8. Wash	½
9. Wash	½
10. Drying	

* KODAK 28% acetic acid diluted 1:21 with water

When the last step is finished, remove the print from the tube and sponge the surface to remove excess moisture. Dry the print in a dust-free place, and allow for good air circulation by placing it emulsion-side up on towels or on a specially designed drying rack. You can also use a portable hair dryer to hasten drying time, provided the air temperature doesn't exceed 200° F (92° C).

Color Prints

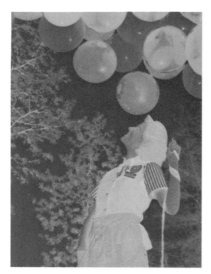

Internegative

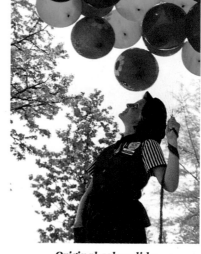

Original color slide

Print

Print

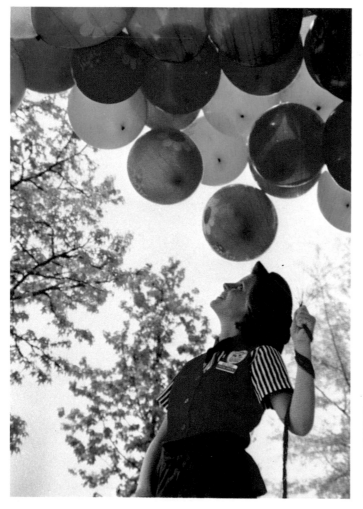

Printing from Color Slides

As the pictures at left show, there are two ways of making prints from a slide. One is to have the transparency copied onto color negative film by a processing lab. This "internegative" can then be printed as described on the previous pages. If you usually print color negatives and occasionally want a print from a slide, this method is fine. But if you shoot mostly color slides, it's easier and less expensive to print directly from the slide.

Since you are printing a positive image instead of a negative one, the chief difference between printing slides and printing negatives is that the exposure time and filtration changes are reversed. Special paper and chemicals are needed to print slides, but the equipment is almost the same as for color negatives. Especially be sure that your enlarger is equipped with a heat-absorbing glass and a No. 2B or a CP2B UV filter. Don't bother to get a safelight filter, however, since the paper must be handled in total darkness.

If your enlarger uses CC or CP filters above the negative or CC filters below the lens, you'll need these cyan filters in addition to the ones listed earlier:

CP filters	CC filters
CP05C	CC05C
CP10C	CC10C
CP20C	CC20C
CP40C	CC30C
	CC40C
	CC50C

Don't get cyan filters with the suffix "-2." They don't have the right absorbtion characteristics for most slide printing.

The procedures on the following pages are for KODAK EKTACHROME 2203 RC paper and KODAK EKTAPRINT R-1000 Chemicals. Other slide processes may differ significantly. Always follow the manufacturer's directions. The infrared cut-off filter mentioned in the paper's instructions is expensive and not necessary in the home darkroom.

If you use acetate color printing filters above the negative in your enlarger, you need only four additional cyan filters.

If you use gelatin color compensating filters beneath the lens of your enlarger, you will need six more filters—all cyan—than for printing from negatives.

You have to remove a transparency from its mount before putting it into the enlarger. Handle it carefully; fingerprints may damage the film and will show up as blemishes on the final print.

Color Prints

Exposing the Color Slide Print

Before you start making prints from slides, install a heat-absorbing glass and a UV filter in your enlarger and cover any stray light leaks around the lamp housing. In the following procedure, the exposure and filtration are for EKTACHROME 2203 RC Paper.

1. Carefully remove the slide from its mount. Dust it gently. Put it into the negative carrier and then into the enlarger with the emulsion (dull) side down. The projected image should look like the original scene. Cover any light leaks around the slide with black masking tape, or use a black paper mask.

2. Dial filtration—or insert a filter pack—of 20 cyan and 10 magenta.

3. Raise the enlarger head to make an 8 × 10-inch (20.3 × 25.4-cm) enlargement. With room lights off for better visibility, focus the image sharply on a piece of white typing paper in the easel with the lens at maximum aperture. Then stop down to $f/8$.

4. In total darkness, insert a sheet of photographic paper in the easel. Using a piece of dark cardboard as a mask, make a test print like the one at far right. Expose the entire sheet for ten seconds, then cover one-third of the paper with the cardboard and expose for ten more seconds. Finally, move the mask up to cover two-thirds of the paper and expose the remaining strip for twenty seconds. You now have a series of exposures at ten, twenty, and forty seconds.

5. Process the test print (see page 272). Once the print is thoroughly dry—it will have a bluish cast when wet—choose the best exposure time and compare the color balance with the original slide to determine which color, if any, is excessive and by how much.

6. Using the guidelines on the next page, adjust the filtration and exposure and make another print. Repeat the process until you get a print that is correct. When you do, note the filter and exposure combination. Using them, you can get good results on all similar slides from the same type of film enlarged to the same degree. These "coordinates" are also a good starting point for correcting other types of slides.

When you print from slides, you see the image projected in its original colors, making it much easier to focus, crop, and adjust the filtration.

A cardboard mask was moved across the paper to give this test print three different exposures. In slide printing, the exposures are reversed— the lightest exposure at the top was the longest one.

Color Prints

40R

40M

Adjusting the Color Slide Print

In adjusting the color balance of a print made from a slide, your chief guide is the slide itself. You should carefully compare midtone areas for discrepancies. To make noticeable changes in prints from slides, you usually have to make greater jumps in total filter density than with color negatives. On an average, you need a 0.20 density change for a slight hue adjustment. If you keep this in mind, the changes themselves are easy.

As the table at far right below shows, if a color is too pronounced, you simply subtract some of it from the filter pack—or, if that is not possible, you add a filter of the complementary color to the filter pack. It's always better to take out filters than to put more in. This avoids a density build-up that needs a long exposure, which might affect the color response of the paper. If you do not have a filter for the color that you are supposed to add or subtract, use the two colors that produce it. For example, to correct a greenish cast, remove equal amounts of cyan and yellow.

Never use more than two subtractive colors in your filter pack; all three together create a neutral grey density that blocks light and lengthens the exposure. If you do end up with all three in your pack, remove the color of the lowest density from the pack entirely and then subtract the same density value from the other two colors. For example, if your pack has 20Y, 50M, and 50C, remove 20Y, 20M, and 20C, leaving only 30M and 30C. The color balance will remain the same.

Whenever you change filters, you must also adjust the exposure to compensate for the density change and, with CC and CP filters, for the change in the number of filter surfaces. Use the filter-factor table on page 264 when you make a one-filter adjustment. If the change involves more than one filter, use the filter factors as a rough guide and make a new test print—or use the color printing computer in the *KODAK Color DATAGUIDE*. When printing slides, remember that increasing exposure makes the print lighter, while decreasing exposure makes it darker. The formula for adjusting the exposure for enlarger-height differences on page 265 also applies to slide printing.

Processing the Color Slide Print

As with prints from color negatives, the most efficient way to process prints from slides in the home darkroom is in a tube processor. Although the chemicals are different, the equipment described on page 266 is the same. For processing prints from slides, too, the average developing temperature depends on whether or not you can keep the tube processor in the water bath along with the premeasured solutions. Full details for calculating and controlling temperature are usually given in the instructions that come with the processing kit. For EKTAPRINT R-1000 Chemicals with EKTACHROME 2203 Paper, the average developing temperature should be $100°$ F $\pm 1/2°$ ($37.8°$ C ± 0.3).

As the table below shows, the process for the EKTAPRINT R-1000 Chemicals has fourteen steps, which take thirteen and one-quarter minutes, excluding drying. The time for each step includes ten seconds for draining. Some tubes have slightly longer drain times, however, so check your tube's instructions and be sure to allow enough time so that you can drain the tube completely and add the next solution on schedule. For an 8×10-inch (20.3×25.4-cm) print, you'll need 5 fluid ounces (150 ml) of water for step numbers 1, 4, 5, 7, 9, 10, 11, and 13, but only 2.4 fluid ounces (70 ml) of each chemical in steps 2, 3, 6, 8, and 12. For drying, follow the instructions given on page 267. Do not reuse solutions, and be sure to clean and dry the tube before processing another print.

Processing EKTACHROME RC Paper, Type 2203, in Tube Processors*

Processing step	Minutes
1. Prewet (water)	1
2. First developer	2
3. Stop bath	½
4. Wash	1
5. Wash	1
6. Color developer	2
7. Potassium iodide wash	½
8. Bleach-fix	3
9. Wash	½
10. Wash	½
11. Wash	½
12. Stabilizer	½
13. Rinse	¼
14. Drying	As needed

* *Nominal solution temperature of $100°$ F ($38°$ C)*

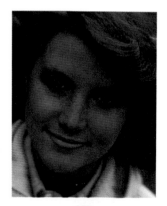

40B

20R	**1 stop overexposed**	**20Y**	**40Y**

20M	**20G**	**40G**

Normal

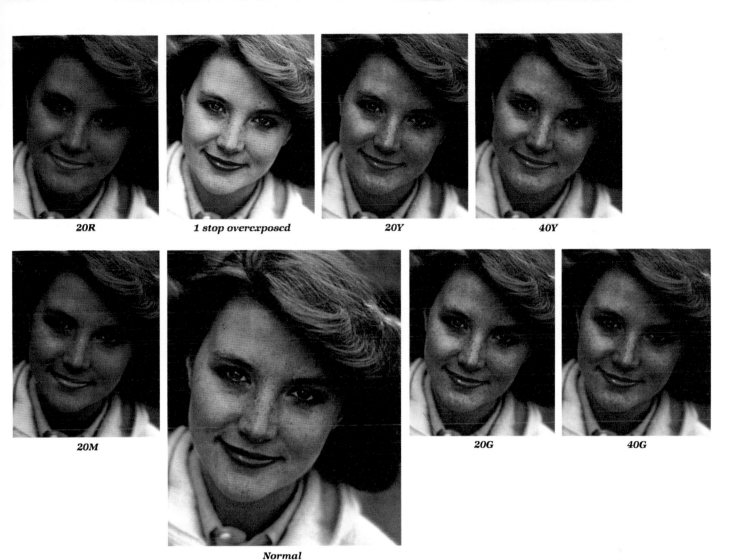
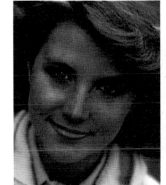
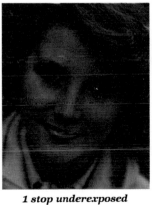

20B	**1 stop underexposed**	**20C**	**40C**

Color Corrections

If color balance is	Subtract these filters	Or add these filters
Yellow	Yellow	Magenta + cyan
Magenta	Magenta	Yellow + cyan
Cyan	Cyan	Yellow + magenta
Blue	Magenta + cyan	Yellow
Green	Yellow + cyan	Magenta
Red	Yellow + magenta	Cyan

Together with the table at left, the picture series above can be used as a guide for correcting filtration when printing from slides. The numbers under each picture show the amount of excess color that needs to be subtracted.

Processing Black-and-White Film

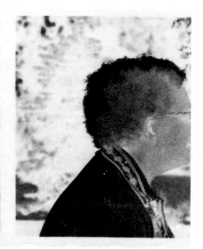

Processing black-and-white film is in many ways much easier than working in color. For both developing and printing, you need less equipment, and the temperature is less critical. You can also use a brighter safelight during printing, and your darkroom can be much smaller. If there is water in an adjacent room, you can set up a usable darkroom in a closet as small as three feet by four feet.

There are, however, more variables in black-and-white work. Unlike color materials, which are usually designed so that certain films must be used with certain chemicals, black-and-white supplies offer you more opportunity to experiment. For example, there are many film developers. Ones such as KODAK Developer D-76, which is used in the sample at far right, give good overall results. Fine-grained developers, on the other hand, inhibit the formation of clumps of silver but require longer development time. Rapid developers cut development time and are good for push-processing film, but they increase contrast and grain. Like developers, black-and-white printing papers vary greatly in their characteristics, as we will see on page 279.

Developing Times in a Small Tank* (in minutes)

KODAK Film name and packaged Developer	65°F (18.5°C)	68°F (20°C)	70°F (21°C)	72°F (22°C)	75°F (24°C)
PANATOMIC-X					
D-76	6	5	4½	4¼	3¾
D-76 (1:1)†	8	7	6½	6	5
MICRODOL-X	8	7	6½	6	5
MICRODOL-X (1:3)‡	13	12	11	10	8½
PLUS-X Pan					
D-76	6½	5½	5	4½	3¾
D-76 (1:1)†	8	7	6½	6	5
MICRODOL-X	8	7	6½	6	5½
MICRODOL-X (1:3)‡			11	10	9½
TRI-X Pan					
D-76	9	8	7½	6½	5½
D-76 (1:1)†	11	10	9½	9	8
MICRODOL-X	11	10	9½	9	8
MICRODOL-X (1:3)‡			15	14	13
DK-50 (1:1)†	7	6	5½	5	4½

Primary recommendations are in bolder type
* *Agitate every 30 seconds throughout development*
† *Diluted to 1 part developer, 1 part water*
‡ *For greatest sharpness (see developer instructions)*

Tools:
Totally dark room or changing bag
Film tank and reel
Scissors
Hook-type can opener
Thermometer accurate to 1° F (0.6° C)
Timer
Graduate
Premixed chemicals OR
 Chemicals
 Mixing vessel
 Storage bottles
 Stirring paddle
Water-bath tray (optional)
Clips
Negative storage envelopes

Load black-and-white film into a film tank the same way you load color negative film (see page 253). Like all 35 mm films, it must be loaded in total darkness. But once the film is in a light-tight tank, you can work with the room lights on. You can also load the film in a changing bag—a lightproof cloth bag with openings for your arms. Remember, though, that you have to put the film, the tank, and the tools in the bag before you start so that you can open the film cassette, remove the film, and load and close the tank in total darkness.

The standard temperature for black-and-white processing is 68° F (20° C). You can maintain that temperature, if you want, by using a water bath as described for color negative processing. If your developer temperature is between 65° and 75° F (18° and 24° C), however, you can change the developing time to compensate for the developer's increase or decrease in speed. Lengthen the time for lower temperatures and shorten it for higher ones. The table at left shows the range for some KODAK Films and Developers. The different time and temperature combinations are also usually listed on the film's instruction sheet. Only the developer temperature is crucial. The other solutions, including the wash water, can be within 5° F (3° C) of 68° F (20° C) or the processing temperature used. You'll get the most consistent results, however, if you keep all the solutions at the same temperature.

Only three chemicals are necessary for black-and-white processing. Besides the developer, you need a stop bath, to halt the action of the developer, and a fixer, or "hypo," to make the image permanent. Two other chemicals, however, are very useful—a hypo clearing agent, to remove the fixer and cut the wash time, and a wetting agent, to help prevent water from spotting the developed film and to hasten its drying time. For best results, use the chemicals recommended for your film. Most come with instructions for mixing and storing as well as with details on whether they can be reused and how many times. Diluted developer cannot be reused.

The following steps are for processing KODAK PLUS-X Pan Film in a small tank at 68° F (20° C), using Developer D-76, diluted 1:1—that is, one part developer mixed with one part water. The times given also assume you are using KODAK Indicator Stop Bath and KODAFIX Solution—and, in the optional steps, KODAK Hypo Clearing Agent and KODAK PHOTO-FLO wetting agent. Times may differ with other chemicals. Drain the tank completely before proceeding to the next step.

Processing PLUS-X Pan Film using KODAK D-76 (1:1) at 68° F (20° C)

Processing step	Minutes	Action
1. Developer	7	Agitate 5 seconds initially; then for 5 seconds every half minute
2. Stop bath	½	Agitate moderately the entire time
3. Fixer	2-4	Agitate 5 seconds initially; then for 5 seconds every half minute
4. Wash	30	Remove tank top; wash under a moderate stream of running water
OR Rinse	½	Remove tank top; wash under running water
Hypo clearing agent	1-2	Agitate moderately entire time
Wash	5	Wash under running water
5. Drying	As needed	Hang film and wipe gently with a damp viscous sponge to remove excess water
OR Wetting agent	½	Bathe in solution; drain briefly
Drying	As needed	Hang film; do not wipe

Making prints from black-and-white negatives affords you enormous control over contrast and tonal values. The negative that produced this print is shown at top left.

Making Black-and-White Prints

Exposing the Black-and-White Print
Tools:
Totally dark room
Enlarger with 50 mm lens and carrier
for 35 mm negatives
Easel
Timer or timer switch for enlarger
Enlarging paper
Safelight with filter recommended for
paper
Camel's-hair brush

Before printing pictures from a roll of
developed black-and-white film, make a
contact print of the negative strips so that you
can preview the images. Follow the
procedure on page 251 to expose the contact
print and then develop it as shown on the
facing page.

1. Dust the negative carefully with the brush,
put in the carrier, and load it into the
enlarger with the emulsion (dull) side down.

2. Adjust the enlarger for the image size you
want. Focus the image sharply on a piece of
plain white typing paper in the easel with the
lens at maximum aperture. Then stop down
to $f/8$ for a negative of normal density.

3. With the enlarger light off and only the
safelight on, insert a sheet of 8 × 10-inch
enlarging paper in the easel with the
emulsion (grey, shiny) side up. Cover all but
one-sixth of the paper with a piece of dark
cardboard, as shown in the picture at
right above.

4. Set the timer for one full minute and turn
on the enlarger. Expose the strip of paper for
ten seconds. Then, every ten seconds, move
the cardboard to expose an additional one-
sixth of the paper. The paper will have
exposures of ten, twenty, thirty, forty, fifty,
and sixty seconds.

5. Process the test print as shown on the
facing page. Then, in room light, examine
the test print to determine the best exposure
for making an improved final print. In
making a test print, be sure to include an
image area that shows a sensitive middle
tone, such as skin, since such areas are
extremely important to the quality of the
final print.

*Make a test print by turning
on the enlarger for one minute
and moving a cardboard mask
across the paper every ten
seconds to give the print six
different exposure times.*

*When the test print is
processed, you will be able to
see the effect of the different
exposures and choose the best
one for the final print.*

276

Processing the Black-and-White Print
Tools:
Besides the equipment you will already have from processing the film and exposing the print, you will also need:
4 or 5 trays to match your paper's size (i.e., one size larger)
Squeegee or photo sponge
Developer
Stop bath
Fixer

The developer used to process paper usually differs from the one used for film. But you can use the same stop bath and fixer, and in a pinch, you can substitute water for stop bath. If you use fiber-based paper rather than resin-coated paper, you may want to use the hypo clearing agent described for film to reduce the wash time (see page 275). Arrange your trays side by side for a smooth, sequential work flow. Put about one-half inch of solution in each tray. If possible, place the wash tray in a sink under a moderate stream of water or use a special wash tray designed to hook up directly to a faucet, as shown here. If your darkroom lacks running water, rinse fixed prints in a tray of still water and occasionally take several of them out of the darkroom and wash them under a tap.

As with film, the standard temperature for the chemicals and wash in processing paper is 68° F (20° C), but temperature is less critical, and the solutions can remain between 65° and 75° F (18° and 24° C). In extreme conditions, you can maintain the developer at the recommended temperature by putting the developer tray in a water bath.

In the procedure given here, times are average ones for a KODAK RC Paper at 68° F

2. Immerse print briefly in stop bath.

1. Slip print into developer; agitate.

3. Put print into fixer and agitate.

4. Wash RC paper for four minutes.

5. Wipe with sponge; air dry.

(20° C), using KODAK DEKTOL Developer (mixed or diluted according to instructions), Indicator Stop Bath, and KODAFIX Solution. For other available chemicals and temperatures, the procedures will vary, as they will for fiber-based papers, so follow their instructions. Slip a print into a tray at an angle to immerse it fully; agitate it by gently rocking the tray; and drain it before putting it into the next tray. Work under a safelight. You can turn on the room light to examine the print after it has fixed for thirty seconds. Don't try to control a print's lightness or darkness in the developing tray. As with prints from color negatives, a dark black-and-white print has received too much exposure, whereas a light print has received insufficient exposure. If the print is off, discard it and make another with a new exposure.

Processing KODAK Black-and-White RC Paper

Processing step	Minutes*	Action
1. Developer	1½	Be sure print is fully immersed; agitate continuously
2. Stop bath	▶	Immerse for 5-10 seconds while agitating
3. Fixer	2	Agitate frequently
4. Wash	4	Use running water and agitate; do not leave print in water
5. Drying	As needed	Sponge or squeegee both sides of print; dry face up on a towel or hang on a line with spring clothespins

** Times may vary for other papers and chemical combinations; the long washing times required by fiber-based papers, for example, can be shortened considerably by immersing the print in hypo clearing agent for thirty seconds after fixing and before washing.*

Black-and-White Prints

2 seconds	4 seconds	8 seconds	16 seconds

 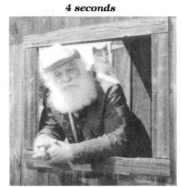 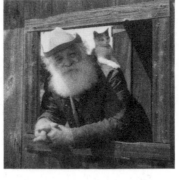 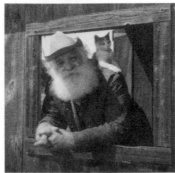

Filter No. 1

Filter No. 2½

Filter No. 4

As the sequence above shows, variable contrast filters affect not only contrast but also exposure. The normal response of the paper without a filter is a contrast grade of 2. The No. 2 1/2 filter (middle row) makes only a slight adjustment and will require little or no change in exposure. But a No. 1 filter (top row), which softens the contrast, and a No. 4 (bottom row), which hardens it, may require different exposure because of individual paper and filter characteristics. Making and using a ringaround such as this can help you solve contrast and exposure problems with more difficult negatives.

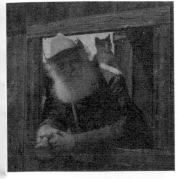

32 seconds

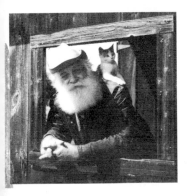

Adjusting the Black-and-White Print

You can create a wide variety of effects with your prints by choosing from a broad range of black-and-white papers. Paper for black-and-white work is available in various thicknesses (or weights), surface textures, and surface sheens. The paper can be a stark white, a warm white, or a cream white, and the tone of the image that develops can be a neutral black, a warm black, or an even warmer brown-black. Like films, papers also have different speeds, or degrees of sensitivity to light. In general, you'll find that single- or medium-weight papers are economical and thick enough for most uses. A smooth surface gives the finest detail and a glossy sheen gives the richest blacks.

One of the most important controls in black-and-white printmaking is contrast. In a monochromatic medium, even subtle changes in the range of tones can make dramatic differences in the appearance of a print. If the blacks are dense and silky and the whites are blindingly bright, the contrast is high. If there is little difference between the darkest and lightest areas, the contrast is low.

There are two ways you can control overall contrast in a black-and-white print. When a poorly lighted original scene, a faulty camera exposure, or processing errors have produced a negative that makes a low- or high-contrast test print, you can improve the contrast of the final print by choosing a higher or lower contrast grade paper. If you are using a variable-contrast paper, you change filters.

Most black-and-white enlarger papers are available in five contrast grades, numbered 1 to 5. Number 2 is normal. Number 1 is softer—that is, it will reduce

the difference between the darkest and lightest areas on a print made on Number 2 paper. Numbers 3 to 5 are progressively harder; they will heighten the differences. Some papers are also simply labelled as soft, medium, hard, extra hard, and ultrahard.

If your negative image is contrasty, with very light and very dark areas, printing it on low-contrast paper will lighten the dark areas and darken the light ones enough to show detail. Conversely, if your image is flat and lifeless with grey-toned highlights and charcoal-toned shadows, printing it on a higher-contrast paper will lighten the highlights and deepen the shadows.

Keeping a supply of all the contrast grades, however, is rather expensive. A more economical approach is to use a variable-contrast paper. When used with the special filters that fit the enlarger, variable-contrast paper yields, in half-grade increments, contrast grades 1 through 4, enough for most situations. As always, you must adjust your exposure to compensate for the density of the filter used. The picture series at left shows the effect of the filters at different exposures. In short, the most convenient choice for all-around black-and-white printing is a variable-contrast RC paper.

For special purposes, however, you may want to use other papers. With an exhibition print, for example, you can use a double-weight paper for durability and a matte (nonglossy) surface to reduce reflection. To give more warmth to a portrait or a scene such as a sunset, you can use a cream-colored stock with a warm black or brown-black image. High-key and low-key pictures are especially effective on matte surfaces.

Basic Printing Controls

There are several darkroom techniques that you can use to obtain better prints. Among the most popular is *cropping.* Although darkroom cropping is no substitute for careful composition when you're taking a picture, many images can be improved considerably by cutting out unwanted details or changing the emphasis. To crop a print, raise the enlarger head, refocus, shift the easel around for improved composition, and reset the exposure (see page 265). Process the print as you normally would.

Two other techniques are used when an area of a print is too light or too dark. If an area is too light, *burning-in* will give it extra exposure and make it darker while exposing the rest of the print normally. To do this, cut a shape in a piece of cardboard so that it will mask the rest of the print yet let light through to the specific area. After giving the print its normal exposure, hold the mask a few inches above the print and expose only the area that is too light. To blur the edges of the area, make the edge of the cardboard ragged and move the mask up and down slightly during exposure.

Dodging makes a dark area lighter. Tape a piece of cardboard that is roughly the same shape and size as the area to be dodged to a piece of coathanger or wire and use it as a screen during part of the normal exposure. Keep this dodging tool moving during exposure to avoid a hard edge between the dodged area and the rest of the picture. Remember to reverse these procedures when printing from slides. Dodge an area to make it darker, and burn-in an area to make it lighter.

Vignetting is also done with a mask. From a piece of cardboard larger than your photographic paper, cut an oval hole to frame your subject. Hold the mask over the paper for the entire exposure. To keep the edges of the vignette soft, rag the edges of the cardboard and move it slightly during exposure. With negatives, your border will be white; with slides, the border will be black.

To a certain extent, the keystoning of buildings (see page 214) can be corrected by tilting the easel during enlargement. Be sure, however, to keep the entire image in focus with a small aperture on the enlarger lens.

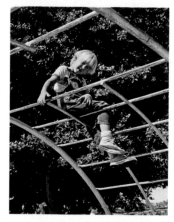

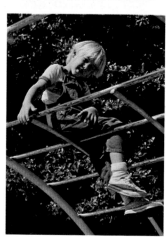

As the sequence above shows, darkroom cropping can increase the impact of a picture by making the subject larger and removing unnecessary foreground or background distractions.

When part of a picture is too light, as the blond child is in the right foreground of the top picture below, using a mask to burn the area in brings it into a more balanced relationship with the rest of the image.

Dodging—holding back light from an area—is often needed to lighten dark subjects that have been backlighted. In the series at left, the young woman's face and clothes were lightened while the rest of the print stayed the same.

A vignette eliminates distracting backgrounds. The easiest tool for producing one, as shown in the center picture at right, is a piece of cardboard with a ragged oval hole cut in it.

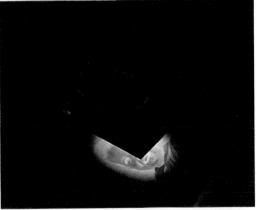

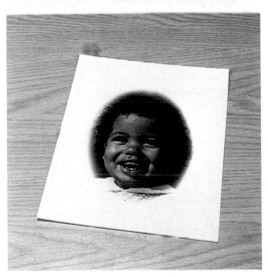

Creative Darkroom Effects

Once you're familiar with the standard processing procedures, there are a wide variety of striking special effects that you can achieve in the darkroom. One of the simplest techniques is adding a textured pattern to the print. Most photo dealers sell special **texture screens**, in both a small size that you can sandwich with the negative in the carrier and in a larger size that can be placed directly on the print in a printing frame. You can also make your own. For sandwiching, shoot a picture of a textured surface and then produce an underexposed, underdeveloped negative of it. For direct contact, try a fine, loosely woven gauze or a sheet of textured glass or plastic.

Other darkroom effects may require drastic treatment of your images, so you may want to make duplicate negatives or transparencies to preserve your originals. One easy approach is to photograph prints or make copies of slides with close-up equipment. With black-and-white negatives and color slides you can contact print the originals onto sheet film, which you can then process like a print. Black-and-white negatives produce positives that can be contact printed—or enlarged—onto another sheet of film to make a negative. Transparency sheet film produces slides. Sheet films are available in many sizes (4 × 5- and 8 × 10-inch are popular). Black-and-white sheet films are available that give normal, continuous-tone rendition or special high-contrast images (litho film). Both slides and black-and-white negatives produce good results with litho film, but color negatives are slightly less successful. (Color negatives can be contact-printed on special color films, giving positive transparent images that can then be used with any process requiring slides.) In addition, many special techniques use high-contrast images to produce other startling effects, both black-and-white and color, as the pictures on page 284 show. Some black-and-white darkroom films—both continuous-tone and litho—allow the use of a red safelight—a real advantage for detailed processes. Since the results of some techniques are unpredictable, it's often wise to make several copy negatives.

The **Sabattier effect,** more commonly (and mistakenly) known as solarization (top far right), results in a partially reversed

A network of fine lines in a screen placed on the paper during exposure makes this bullfighting scene look as if it was executed in oil. The screen printed alone is at left center.

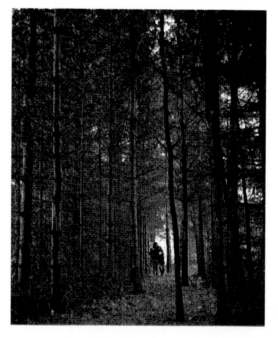

Fabric textures, such as this canvas one, are effective with gentle outdoor shots such as this. A section of the screen is shown at right center.

The Sabattier effect results when a photosensitive material is exposed to light during development, causing a partial reversal of the image. It works best with film because images on paper tend to become muddy.

In posterization, a continuous-tone image is converted into a number of single flat tones by printing several high-contrast negatives of varying exposure on the same piece of paper.

In reticulation, drastic changes in temperature during processing can create a regular pattern such as this one on a film's emulsion.

image that is a unique blend of positive and negative. You can produce it by turning on the room light briefly while your duplicate negative is midway through development. After processing, print the negative normally.

Reticulation (lower picture) is a pattern of wrinkles and cracks in a film's emulsion caused by a sudden change in temperature. One way to produce it is to develop the copy negative normally, then rinse it in an acetic acid stop bath at 140°–150° F for one minute, immerse it in a cold water bath (below 40° F) for one minute, and fix the film in your normal way. Wash the film in running water for twenty to thirty minutes and air-dry the film quickly with a portable hair dryer. To intensify the effect, repeat the hot and cold steps with water only, increasing the temperature differences. Before drying, consider freezing the film for another effect.

Much trickier is **posterization,** or tone separation (center), which turns a normal, continuous-tone image into one with three or four distinct and separate flat tones. It is usually produced by making two or three copy negatives at different exposures on litho film, and then printing them, one at a time, on the same piece of paper, either in color or black and white. For color work, use filters to produce the hues you want. Since registration is crucial, it's best to make oversize copy negatives with your enlarger and use them to contact print directly on the paper.

Multiple exposures, like the one of the boy with a kite shown on page 285, are easier to make in the darkroom than in the camera. One method of creating a multiple exposure (montage) is to sandwich two slides, emulsion sides together, in the negative carrier. Another is to print each full image separately on the same piece of paper. This method is an aid to composition since the images can receive different degrees of enlargements, but be careful not to overexpose the print. The third method is to make masks, as shown for burning-in on the preceding pages, and to print part of one image with one mask and part of another image with another mask. Preplanning your composite image by making tissue tracings under the enlarger is a great help.

Creative Effects

The multiple image at right was made by sandwiching the slide of the boy with a cropped enlargement of the sunset and printing them together (see page 283).

To create the high-contrast image at center from the continuous-tone image at top, the photographer printed the original negative on high-contrast film. The resulting film positive was in turn contact-printed with another sheet of high-contrast film to yield a high-contrast negative. Extra detail was opaqued on the negative and the center print was made. The image at lower left was made by sandwiching a high-contrast film positive and a high-contrast negative with a piece of unexposed high-contrast film. Holding a desk lamp at an angle, the photographer slowly turned the tightly contacted films so that all sides had equal exposure. The resulting film was then contacted with another sheet of high-contrast film, which, after processing, was printed on paper for the final tone-line image.

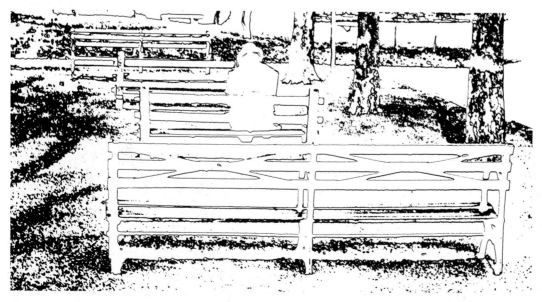

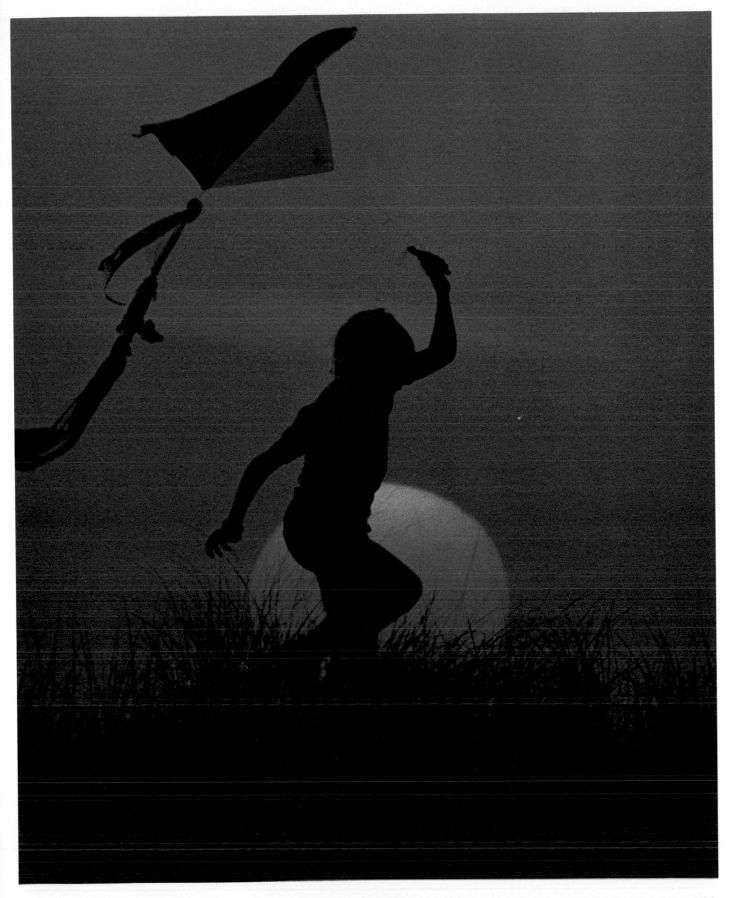

Caring for Photographs

Even the most sophisticated photographer looks forward to getting film processed and showing the results to others. A prerequisite for the long-term enjoyment of all your photographs is preserving them by handling and storing them properly.

Whether you are working with slides, negatives, or prints, the cardinal rule for handling is always to hold them by the edges. With slides and negatives especially, fingerprints and other stains are extremely difficult to remove from the emulsion. You should also be sure that any surface you place slides or negatives on is clean and dust-free. For slides that are going to be handled a lot, you can buy inexpensive plastic sleeves that slip over the slide's regular cardboard mount. For more permanent protection, remount slides in special holders that sandwich the film between two thin sheets of glass. For prints that will be looked at frequently, the safest place is protected pages. If you prefer to keep prints loose, put them in plastic sleeves and envelopes or spray them with a photographically safe fixative.

However you store slides and prints, you should always buy holders designed for photographic material—and even then, you should make sure that they are clearly marked "acid-free." The material and adhesives used to make most common boxes and envelopes contain acids, which, in time, can cause discoloration. An alternative is to use the original packaging that photographic materials come in, as it is generally free of harmful ingredients. Use the boxes that photographic paper comes in to store prints, and keep slides in the containers from processing labs.

Slides can also be stored in any of the boxes designed for them, preferably a metal one with an enamel finish. If you want to keep them in an album for quick reference, there are three-hole-punched plastic sheets with pockets for twenty slides. Slides that are set up for a show can be stored in the tray that fits on the projector—provided you keep the tray in its box.

There are two common ways to store negatives. One is to put each strip in a long plastic sleeve or envelope and then file it in a box or drawer. Be sure to keep the strips separate since they can scratch each other. The other approach is to keep negatives in a plastic sheet with pockets that accommodate all the strips from one roll of film. The sheets are punched to fit in a binder, and if you have contact prints made from the negatives on 8 × 10-inch paper, they can be stored right alongside the strips of negatives.

The traditional way to organize negatives is chronologically—with perhaps the year, roll number, and subject matter noted on the sheet or sleeve. If the back of a print is labeled with the same number, you can then find its negative immediately. It is more useful, however, to organize slides and prints by subject matter—vacation trips, nature shots, sports photos, or other categories. Most photographers also keep all of their negatives, unless an entire roll is bad, but they are fairly ruthless about throwing out slides and prints that aren't good examples of their work. It simplifies filing and keeps the quality of their collection high.

In storing and filing all your photographic materials, keep in mind that they have a long list of enemies—particularly heat, humidity, dust, and bright light. This means that they should be kept away from heaters, radiators, and direct sunlight and out of hot, dusty attics, damp basements, and especially darkrooms. In humid climates, a package of silica gel will help keep your materials dry in an airtight container. Replace it regularly.

There are many ways to store your negatives and prints—from plastic sleeves or envelopes, to binders that hold negatives and contact print sheets, to filing boxes for categorizing prints, negatives, and slides.

It's easy to find matching prints and negatives if you've labeled both with the same identification numbers. The print below, for example, is negative #12 from roll #46 in 1979.

You can identify the date and subject of your slides right on the cardboard slide mounts, but be sure to handle them by the edges.

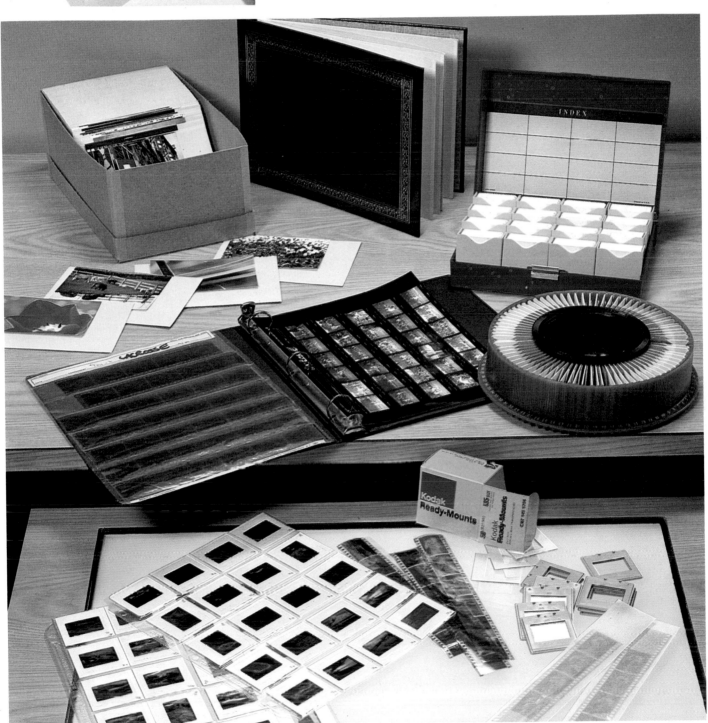

Displaying Prints

Although a photo album is the safest way to preserve your favorite pictures and keep a continuous record of your photographic interests, some photographs cry out for enlargement and display. If you don't do your own darkroom work, you'll find that reputable photo dealers offer enlargements, usually made at a high-speed photo finishing plant, which are suitable for most displays. But unusual negatives, tricky subjects, and prints larger than 16 × 24 inches need special care. You may find it better to pay the price charged by a low-volume, quality custom lab, which will work to your exact specifications. Don't expect them to work wonders with a bad negative, however. Some labs are also equipped to produce mural-size prints, and many specialty shops can reproduce photographs on cloth, glass, and other materials, as the photographs at far right show.

The simplest way to display printed enlargements of a standard size is to use commercially available frames. The products available today cover a wide range—from ornate casings to modern plastic boxes. The choice depends on the mood of the picture or your decor. In addition, you can purchase framing kits at most art supply stores, and for a professional job on a special picture you may want to go to a custom frame-maker. Many frames come with mats, which are also available separately, but with a special tool for cutting beveled edges and a little practice, it's fairly easy to make one.

Some photographers prefer to mount their pictures, either before putting them in a frame or to show separately. Mounting boards are available in a variety of weights, colors, and textures, but for greater permanance, you should pick one with 100 percent rag content. The most common way to mount photographs is to use dry mounting tissue. The only tool you need is a household iron, but using it can be tricky until you get the knack, so it's best to practice with some

of your "reject" prints. If you prefer pasting down your pictures, use a neutral photo mounting cement that won't stain them after a time, as some rubber cements and pastes might.

Usually prints are mounted on a larger board that also provides a border or serves as the base for a mat. Another popular practice is to mount a picture flush on a rigid material, such as hardboard, lightweight foam board, or even plywood if it is first resurfaced with a thin sheet of mounted board. Cut the board slightly smaller than the print so that after it is mounted you can trim the edges of the picture flush with the board. The raw edges of the board can be finished using a marking pen. This technique is especially effective with thick material, since it gives the print a three-dimensional appearance.

There are many ways to enhance the beauty of photographs. You can mount them on a variety of materials, and with a beveling knife, you can create professional-looking mats (left). Choose matboard in a color that blends with your photograph and does not distract the viewer.

When you mount a picture flush on plywood or hardboard, be sure to place the board squarely on the photo before you cement it. Trim the edges of the print (top) and darken the raw edges of the board with a marking pen or crayon (above).

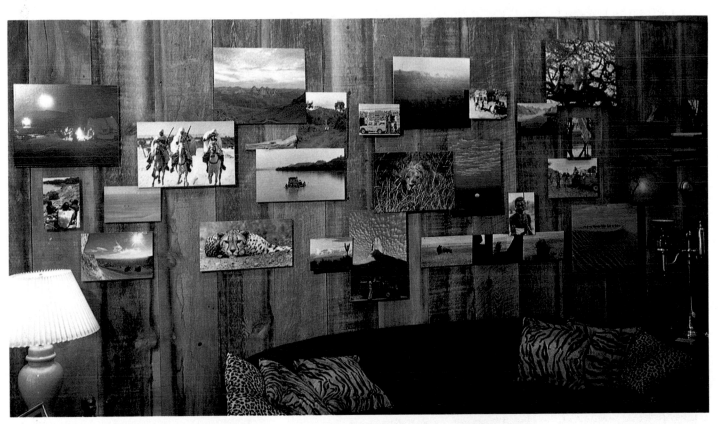

In making a wall arrangement, look for thematically related images that complement each other, much like a photo essay, and try balancing a large picture with two or three smaller ones. In selecting the pictures themselves, look for striking, simple compositions that can be seen easily from a distance.

If you are going to have a picture reproduced on an unusual material such as cloth or glass (above and at right), it's usually best to pick a simple image with a strong dominant subject against an uncluttered background.

Slide Shows

It makes little difference whether you use a professional light table (top) or a makeshift slide sorter like the one in the center here. The key to a good slide show is sequencing.

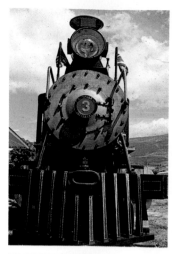

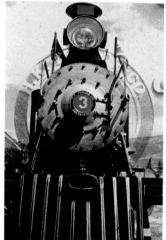

A slide show can be as simple as one tray of slides in a single projector or as complex as dozens of projectors synchronized by a computer and accompanied by taped sound and narration. The key to any effective slide presentation, however, is good organization. Like a photo essay, a slide show should open with one or more shots that establish the location or mood. Each successive slide should unfold your idea or story in a logical fashion. Although you have to keep this in mind while photographing, the real shape of a slide show is decided during editing.

The best way to edit your slides is to spread them out on a light box or one of the inexpensive illuminated slide sorters sold by most photo dealers. Even a makeshift light table, such as the storm window, tissue paper, and desk lamp shown at left, can be used. In editing, pick only the best-quality images, discarding poorly composed, blurred, and repetitive pictures. When you organize them, try to avoid jarring changes between brighter- and darker-toned slides, and look for common elements such as shapes, lines, and colors that can link succeeding images together. Try not to jump back and forth between horizontal and vertical formats frequently.

When you have a sequence you like, it's helpful to mark the bottom lefthand side of the slide as it faces you (looking like the original scene). When you load the projector's tray, the mark should appear on the upper righthand corner facing the slide that will appear after it. Using marks of different colors or shapes for different sequences or trays will help you return a slide to its proper place if you pull it out for some reason. It is also useful to insert a 2 × 2-inch piece of thin, opaque cardboard at the end of a tray so that the screen will not turn bright white. Some new projectors have an automatic "dark slide" that darkens the screen after the last slide has been projected. The timing of slide changes is a personal

A multi-image mask allows you to combine parts of three different slides into one image. To hold the pieces in place, use very thin strips of tape only on the edges of the transparencies.

As this sequence shows, a dissolve unit provides a smooth transition from one picture to the next by dimming the image from one projector while brightening the image from the next. The darkened projector changes slides while the other one is projecting.

matter, but for most subjects, a brisk pace is most effective.

Beyond these basic guidelines, your options are virtually limitless. With a macro lens or other close-up attachments on your camera, you can shoot title slides. You can use a special multi-image mask to make a slide with more than one picture. You can record background music, narration, or both, and play it along with your slides. You can use a dissolve-control unit, which fades the image from one projector as it brightens the image from another, avoiding the normal abrupt change that briefly darkens the screen. And with a simple device called a sound synchronizer, you can coordinate slide changes with a stereo tape by putting the sound on one tape track and slide-changing impulses on the other.

In buying projection equipment, keep in mind that there is a wide variety available, and the choice depends as much on your needs as your pocketbook. Projectors vary in slide capacity, lamp brightness, and the amount of automatic or remote control. Their lenses vary in aperture and are available in different focal lengths—including zooms—to accommodate different room sizes. For example, you have to be eighteen feet away to produce an image forty inches wide with a 7 inch lens, whereas you can produce the same size projection with a 3 inch lens from only eight feet. Some lenses have a curved field for cardboard-mounted slides that bulge slightly when projected, whereas others have a flat field for rigid, glass-mounted slides. Viewing screen surfaces also differ. Of the two most common types, a matte screen gives excellent sharpness and a wide angle of view, whereas a beaded glass one gives substantially brighter images. However, the images on beaded glass screens are slightly softer and the viewing area is much more restricted. Synchronizers and dissolve units also vary greatly in their degree of sophistication.

An almost professional-level home slide show can be produced with the equipment shown above—two projectors joined by a dissolve unit and controlled by a sound synchronizer and a tape recorder.

With a macro lens or other close-up equipment, you can easily make title slides from lettering sets, hand-drawn signs, or even road maps, as shown here. But don't forget that there are many natural titles to photograph—road signs, for example, make good title slides for a travelogue.

Putting Photographs to Work

There is a variety of other ways that photography can play a part in your life—some practical, some social. For settling insurance claims or verifying tax deductions after a fire, theft, or natural disaster, you will find it very helpful to have photographs of valuables and other property to supplement written inventories. In general, it is best to take a series of pictures—overall views of the rooms and exterior of your home; close-ups of antiques, jewelry, electronic and photographic equipment, and other, smaller valuables; and detailed shots of larger possessions such as cars, boats, or farm equipment. Store the photographs in a protected place, such as a bank safe-deposit box.

Photographs may also help solve consumer complaints. Pictures accompanying a letter about a malfunctioning product can clearly illustrate what is wrong. Likewise, photographs taken at different stages in the construction or repair of a house may later help prove a complaint or show the source of difficulty.

Socially, sending photographs to friends and relatives is both thoughtful and fun. The standard $3\frac{1}{2} \times 5$-inch print on double-weight paper makes a perfect postcard, and whether you make them yourself in the darkroom or have them prepared commercially by a local photo dealer, photographic greeting cards let you send a highly individualized and personal visual message.

One of the greatest social benefits of photography is getting to know other photographers, to share information and interests. One way to meet photographers is to take photography courses at local schools, colleges, or community centers. Another is to join a photography club. Most are formed by photographers with similar interests—such as nature photographers, portraitists, or color slide enthusiasts—and activities usually center on lectures, field trips, classes, competitions, and exhibitions. In the United States, you can find a photo club in your area by writing the Photographic Society of America, 2005 Walnut Street, Philadelphia, Pennsylvania 19103.

Photographs are useful for taking inventory, settling insurance claims, or filing consumer complaints. Be sure to keep the negatives stored in a safe, fire-proof place.

Standard 35 mm prints from your photo dealer make perfect postcards (above). Most photo dealers can also arrange for you to turn your favorite photographs into greeting cards, social announcements, or invitations (left).

Photo contests and exhibitions are often divided into categories of interest—nature photography, still lifes, or photojournalism, for example. Check your local paper for announcements of open contests and photography club meetings.

Bibliography

Adams, Ansel. *Natural Light Photography.*
New York: New York Graphic Society, 1977.

Carroll, John S. *Photographic Lab Handbook.* 5th ed.
Garden City, New York: Amphoto Books, 1979.

Craven, George M. *Object and Image:
An Introduction to Photography.*
Englewood Cliffs, New Jersey: Prentice-Hall, 1975.

Cole, Stanley. *Amphoto Guide to Basic Photography.*
Garden City, New York: Amphoto Books, 1978.

Davis, Phil. *Photography.* 2nd ed.
Dubuque, Iowa: William C. Brown Company, 1975.

Editors of Eastman Kodak Company, Rochester, New York:
Adventures in Color-Slide Photography (AE-8). **1975.**
Adventures in Existing-Light Photography (AC-44). 1978.
Basic Developing, Printing, Enlarging in Black-and-White
(AJ-2). 1979.
Basic Developing, Printing, Enlarging in Color (AE-13). 1978.
Basic Scientific Photography (N-9). 1977.
Close-Up Photography and Photomacrography (N-12). 1977.
Creative Darkroom Techniques (AG-18). 1975.
The Fifth and Sixth Here's How (AE-105). 1977.
*Filters and Lens Attachments for Black-and-White and Color
Pictures* (AB-1). 1978.
The Here's How Book of Photography, Volume II.
(AE-101). Seventh through tenth books. 1977.
*How to Process Black-and-White Film and Prints Using KODAK
Chemicals* (TC-1). 1975.
How to Process Color Negatives Using Process C-41 (TC-4). 1975.
How to Process Color Prints in Tubes Using KODAK Chemicals
(TC-8). 1977.
How to Process EKTACHROME Slides Using Process E-6 (TC-7). 1977.
KODAK Black-and-White Photographic Papers (G-1). 1978.
KODAK Color DATAGUIDE (R-19). 1979.

KODAK Darkroom DATAGUIDE (R-20). 1979.
KODAK EKTACOLOR FilterFinder Kit (R-30). 1978.
KODAK Films—Color and Black-and-White (AF-1). 1978.
KODAK Master Photoguide (AR-21). 1978.
Planning and Producing Slide Programs (S-30). 1978.
Printing Color Negatives (E-66). 1978.
The Third and Fourth Here's How (AE-104). 1975.

Editors of Eastman Kodak and editors of Amphoto Books.
Encyclopedia of Practical Photography, (AZ-1 through
AZ-14). 14 vols.
Rochester, New York, and Garden City, New York:
Eastman Kodak Company/Amphoto Books. 1978.

Eisenstaedt, Alfred. *Eisenstaedt's Guide to Photography.*
New York: Viking Press, 1978.

Feininger, Andreas. *Darkroom Techniques.* rev. ed.
Englewood Cliffs, New Jersey: Prentice-Hall, 1974.

Fineman, Mark B. *The Home Darkroom.* 2nd. ed.
Garden City, New York: Amphoto Books, 1976.

Gassan, Arnold. *Handbook for Contemporary Photography.*
Rochester, New York: Light Impressions. 1977.

Hedgecoe, John:
The Art of Color Photography.
New York: Simon & Schuster. 1978.
The Book of Photography.
New York: Alfred A. Knopf. 1976.
John Hedgecoe's Pocket Guide to Practical Photography.
New York: Simon & Schuster. 1979.
The Photographer's Handbook.
New York: Alfred A. Knopf. 1977.

Holland, John. *Photo Dècor* (O-22).
Rochester, New York: Eastman Kodak Company. 1978.

Lahue, Kalton C. *Petersen's Big Book of Photography*. Los Angeles, California: Petersen Publishing. 1977.

Langford, Michael:
Better Photography.
New York: Focal Press. 1978.
The Step-by-Step Guide to Photography.
New York: Alfred A. Knopf. 1978.

Nibbelink, Don D. *Picturing People* (E-99).
Garden City, New York: Amphoto Books. 1976.

Nibbelink, Don D., and Anderson, Rex.
Bigger and Better Enlarging (AG-19).
Garden City, New York: Amphoto Books. 1974.

Patterson, Freeman. *Photography for the Joy of It*.
New York: Van Nostrand Reinhold. 1978.

Rehm, Karl M. *Basic Black-and-White Photography*.
Garden City, New York: Amphoto Books. 1976.

Rhode, Robert B., and McCall, Floyd H. *Introduction to Photography*. 3rd ed.
New York: Macmillan. 1976.

Rosen, Marvin J. *Introduction to Photography: A Self-Directing Approach*.
Boston: Houghton Mifflin. 1976.

Shipman, Carl. *Understanding Photography*.
Tucson, Arizona: H.P. Books. 1974.

Stone, Jim. *Darkroom Dynamics: A Guide to Creative Darkroom Techniques*.
New York: Curtin & London/Van Nostrand Reinhold. 1979.

Swedlund, Charles. *Photography: A Handbook of History, Materials, and Processes*.
New York: Holt, Rinehart, and Winston. 1974.

Szarkowski, John. *Looking at Photographs: One Hundred Pictures from the Collection of the Museum of Modern Art*.
New York: Museum of Modern Art. 1973.

TIME-LIFE Library of Photography, Alexandria, Virginia: TIME-LIFE, Inc.:
The Art of Photography. 1971.
The Camera. 1970.
Caring for Photographs. 1972.
Color. 1970.
Documentary Photography. 1972.
Frontiers of Photography. 1972.
The Great Photographers. 1971.
The Great Themes. 1970.
Photographing Children. 1971.
Photographing Nature. 1971.
Photography as a Tool. 1970.
Photojournalism. 1971.
The Print. 1970.
Special Problems. 1971.
The Studio. 1971.
Travel Photography. 1972.

Upton, Barbara, and Upton, John. *Photography*.
Boston: Little, Brown and Company. 1976.

White, Minor. *Zone System Manual*.
Dobbs Ferry, New York: Morgan & Morgan. 1968.

Yulsman, Jerry:
Color Photography Simplified.
Garden City, New York: Amphoto Books. 1977.
The Complete Book of 35 mm Photography.
New York: Coward, McCann, Geoghegan. 1976.

Index

The Joy of Photography
was set in the Zapf International family of typefaces
by DEKR Corporation of Woburn, Massachusetts.

The color separations and camera work were supplied by
Rochester Prep, Inc., of Rochester, New York.

W. A. Krueger Company, of Brookfield, Wisconsin
printed and bound the book on 70 pound S.D. Warrenfloweb stock.